# EXPANDED CINEMA

**Gene Youngblood** became a passenger of Spaceship *Earth* on May 30, 1942. He is a faculty member of the California Institute of the Arts, School of Critical Studies. Since 1961 he has worked in all aspects of communications media: for five years he was reporter, feature writer, and film critic for the Los Angeles *Herald-Examiner;* in 1965 he conducted a weekly program on film and the arts for KPFK, Pacifica Radio in Los Angeles; in 1967 he wrote, produced, directed, edited, and on-camera reported "human interest" filmed news features for KHJ-TV in Los Angeles; since 1967 his column "Intermedia" has appeared weekly in the Los Angeles *Free Press* on subjects ranging from film and the arts to science, technology, and the cultural revolution. Mr. Youngblood currently is working on two books: *The Videosphere,* about global television in the 1970s as a tool for conscious evolution, and *Earth Nova,* a philosophical novel and screenplay about the new consciousness, the new lifestyle, and their relation to technology.

# EXPANDED CINEMA

## by Gene Youngblood

Introduction by R. Buckminster Fuller

E. P. Dutton & Co., Inc., New York   1970

Copyright © 1970 by Gene Youngblood

Introduction and poem, "Inexorable Evolution and Human Ecology," copyright © 1970 by R. Buckminster Fuller

Published simultaneously in Canada by
Clarke, Irwin & Company Limited, Toronto and Vancouver.

Library of Congress Catalog Card Number: 71–87207

SBN 0–525–10152–7 (Cloth)    SBN 0–525–47263–0 (DP)

To Nancy

# Contents

# Illustrations

# Introduction
## by R. Buckminster Fuller

At all times nowadays, there are approximately 66 million human beings around Earth who are living comfortably inside their mothers' wombs. The country called Nigeria embraces one-fourth of the human beings of the great continent of Africa. There are 66 million Nigerians. We can say that the number of people living in Wombland is about the same as one-fourth the population of Africa. This 66 million Womblanders tops the total population of either West Germany's 58 million, the United Kingdom's 55 million, Italy's 52 million, France's 50 million, or Mexico's 47 million. Only nine of the world's so-called countries (China, India, Soviet Union, United States, Indonesia, Pakistan, Japan, and Brazil) have individual populations greater than our luxuriously-living, under-nine-months-old Womblanders.

Seemingly switching our subject, but only for a moment, we note that for the last two decades scientists probing with electrodes have learned a great deal about the human brain. The brain gives off measurable energy and discrete wave patterns disclosed by the oscillograph. Specific, repetitive dreams have been identified by these wave patterns. The neurological and physiological explorers do not find it extravagant to speculate that we may learn that what humanity has thus far spoken of mystifiedly as telepathy, science will have discovered, within decades, to be ultra-ultra high-frequency electro-magnetic wave propagations.

All good science fiction develops realistically that which scientific data suggests to be imminent. It is good science fiction to suppose that a superb telepathetic communication system is inter-linking all those young citizens of worldaround Wombland. We intercept one of the conversations: "How are things over there with you?" Answer: "My mother is planning to call me either Joe or Mary. She doesn't know that my call frequency is already 7567-00-3821." Other: "My mother had better apply to those characters Watson, Crick, and Wilkerson for my call numbers!" And another of their 66

million Womblanders comes in with, "I'm getting very apprehensive about having to 'go outside.' We have been hearing from some of the kids who just got out—They say we are going to be cut off from the main supply. We are going to have to shovel fuel and pour liquids into our systems. We are going to have to make our own blood. We are going to have to start pumping some kind of gas into our lungs to purify our own blood. We are going to have to make ourselves into giants fifteen times our present size. Worst of all, we are going to have to learn to lie about everything. It's going to be a lot of work, very dangerous, and very discouraging." Answer: "Why don't we strike? We are in excellent posture for a 'sit-down.'" Other: "Wow! What an idea. We will have the whole population of worldaround Wombland refuse to go out at graduation day. Our cosmic population will enter more and more human women's wombs, each refusing to graduate at nine months. More and more Earthian women will get more and more burdened. Worldaround consternation—agony. We will notify the outsiders that, until they stop lying to themselves and to each other and give up their stupid sovereignties and exclusive holier-than-thou ideologies, pollutions, and mayhem, we are going to refuse to come out. Only surgery fatal to both the mothers and ourselves could evacuate us."

Another: "Great! We had might as well do it. If we do come out we will be faced with the proliferation of Cold War's guerrillerized killing of babies for psycho-shock demoralization of worldaround innocent communities inadvertently involved in the abstruse ideological warfare waged by diametrically opposed, equally stubborn, would-be do-gooder, bureaucratic leaders and their partisans who control all of the world's means of production and killing, whose numbers (including all the politically preoccupied individuals around the Earth) represent less than one per cent of all humanity, to whose human minds and hearts the politicos and their guns give neither satisfaction nor hope. Like the women in *Lysistrata* who refused intercourse with their men until they stopped fighting, we Womblanders would win."

Until yesterday, what are now the 150 member nations of our planet's United Nations were tiny groups of humans who for two million years had been regenerating around our globe so remotely

from one another that each colony, nation, or tribe was utterly unaware of one another's existence. Only through telepathy, as supposedly operative in the previous paragraphs, could those remote cells of precariously-surviving human beings have been aware of one another throughout those two million years. In the last few split seconds of overall history, there emerged a dozen millennia ago from the womb of tribal remoteness a few sailors and overland explorers who began to discover the presence of other humans scattered around the mysterious world. Finding the tribes to be each unaware of either the surprising resources or the vital needs and desires of the others, they kept the whereabouts of these surprise demands and supplies secret and thus were able, through monopoly of commerce and middle-manning, to exploit to their own special advantage the vital needs, ignorance, and the wealth of life-support to be generated by expediting or slowing the physical resource interactions with humanity's available time to work the resources into higher advantage tools, environment controlling devices, and metabolically regenerative sustainers.

Throughout all the two million years up to the Twentieth Century, the total distance covered by an average man in an average lifetime disclosed to him less than one-millionth of the surface of our spherical planet. So tiny was a human and so relatively large is our planet that it is not surprising that humans as yet cerebrate only in terms of a "wide, wide world—a four-cornered Earth," situated in the middle of an infinite plane, to which all the perpendiculars are parallel to one another and lead only in two directions—UP and DOWN—with sky UP there and earth DOWN here. Don't think it is only an illiterate unemployee who is misoriented and ignorant; even now the senses and brains of all the Ph.D. scientists are so reflexively misoriented that they too see the sun go down, plunging into the infinite plane at a mysterious and never-discovered place called the West, to rise mysteriously from it again next morning at a never-identified place called East—and Astronaut Conrad bursts out spontaneously from his moon advantage talking about being ". . . up here on the moon . . ." and the President of the United States congratulates the astronauts on ". . . going up to the moon and back down to earth." Scientists not only admit but assert that there are no locales in the Universe to be identified as UP and

DOWN. None of the perpendiculars to our spherical Earth's surface are parallel to one another; they lead in an infinity of directions.

No matter how you may look upon the matter morally and ideologically, the assumption that humanity could or could not own a piece of land with all the earth vertically below it and all the air vertically above it is not only scientifically invalid—it is scientifically impossible. The scheme is geometrically possible only as an up-and-down make-believe flat world.

To understand the scientific impossibility of such a scheme, let us consider a cube inside of a sphere, with the cube's eight corners congruent with the surface of the sphere. Let the cube's twelve edges consist of steel structurals. A light is at the common center of the cube and sphere and casts a shadow of the twelve structural edges of the cube outwardly upon the surface of the translucent sphere. We will now see that the total spherical surface is divided symmetrically by great circle arcs into six equilateral four-edged areas. Though each of the four-sided symmetrical areas has 120-degree corners instead of 90-degree corners, each is called a spherical square. Altogether they constitute a spherical cube.

We will now suppose the spherical cube to be the planet Earth. We will suppose that war and treaties have resulted in the total Earth's being divided equally amongst six sovereign groups—each empowered by its laws to grant deeds to properties within their respective spherical square surfaces on the planet, regardless of whether covered by water or not. We will suppose that, as at present, each of the world's major sovereign nations assumes the authority to deed or lease the titles to subdivisions of each of their respective lands to corporations, sub-governments, and individuals. All the legally recognized deeds to property anywhere around our Earth date back only to sovereign claims established and maintained exclusively by military might.

Now that we have the model of a cubical subdivision of the sphere, let us color our cube's six faces, respectively, red, orange, yellow, green, blue, and violet. Let Russia sovereignly possess the red face of the cube. Consider all the perpendiculars to the red face of the internally positioned cube as being the up and down perpendiculars defining the property claims to all the land *below* the

surface and all the air *above* the surface. Under these conditions, it will be seen that the red square owns all the interior of the cube which occurs perpendicularly below that red surface square. Therefore, each of the six countries would be claiming exclusive possession of the same "whole" cube, which obviously invalidates each and all of their claims to only one-sixth of the cube. This realization is mildly reminiscent of Portia's admonition to Shylock that he must be able to cut loose his pound of flesh without letting a drop of blood.

"Alright," you say, "I will concede it is impossible to demonstrate the validity of the claims to the lands lying perpendicularly below my surface map without invalidating all other land owners of the world. Therefore, I will try to live on the surface of my land and just claim it and the air space vertically above me." "Alright," we say to you, "what air are you talking about, because it just blew away." You retort testily, "I don't mean that nonsense . . . just the air geometrically above me. That is what I refer to when I say you are violating my air space—you are violating my overhead geometry." "Alright," we say to you, "which stars were you looking at when you said, '. . . that space above me'? Our Earth has been revolved away from those stars. Other stars are now above us. Not only are we revolving, but we are simultaneously orbiting around the sun, while all the planets and stars are always in swift motion, but are so far away from us and our lives so short that we are unable to perceive those motions. The distances involved are so great that the light from the next star to the sun takes four and one-half years to come to our solar system while traveling 700 million miles per hour and the distance across our galaxy is more than 300,000 light years, while the next nearest of the millions of galaxies are multi-millions of light years away from our galactic nebula. With those kinds of distances in the heavens, the amount of star motion that you and I can detect in our lifetime is humanly unrecognizable. Most of the star speeds within their galaxies are in the order of only 100,000 miles per hour, which is a negligible speed beside light's speed of 700 million miles per hour."

Because all the stars in the Universe are in motion, our planet orbits rotatingly in an ever-changing, omni-circus of celestial events. There is no static geometry of omni-interrelationship of Universe

events. Some of the stars you are looking at have not been there for a million years—Some no longer exist. As Einstein and Planck discovered, "Universe is a scenario of non-simultaneous and only partially overlapping, transformative events." One frame in the scenario of caterpillar does not foretell the later scenario event of its transformation into butterfly One frame of butterfly cannot tell you that the butterfly flies; only large time-sequence segments of the scenario can provide meaningful information. Cogitating on the myriads of stars apparently scattered in disorderly spherical array about the heavens, individuals often remark, as may you, "I wonder what is outside outside?"—asking for a one-frame answer, which is as unintelligent as asking, "Which word is the dictionary?" You know the order of the dictionary to be alphabetical, but its words do not read sequentially. Just hearing them read aloud, they make an only apparent, disorderly array. This is typical of the manner in which nature hides her orderliness in only apparent disorder.

Back to little Space Vehicle Earth and that question of property. The most that the individual could be entitled to own would be the inside of an infinitely thin blueprint of his land, because there is no geometry of space outside it and no exclusively occupiable land below. Our planet Earth is the home of all humans, but scientifically speaking it belongs only to Universe. It belongs equally to all humans. This is the natural, geometrical law. Any laws of man which contradict nature are unenforceable and specious.

Without the infinitely-extended lateral plane, the words up and down are meaningless. The airman initiated the correct descriptive terms "coming IN for a landing and going OUT." It is meaningful to say "INSTAIRS and OUTSTAIRS." Say it for a week and your senses will discover and notify that you are living on a planet.

What do you mean, "astronaut?" *We are all astronauts.* Always have been—but really! Never mind your "Never-mind-that-space-stuff, let's-be-practical, let's-get-down-to-Earth" talk—brain-talk as undisturbed by knowledge as is a parrot's brain-talk by any awareness born of thought. Brain is physical—weighable; thought is metaphysical—weightless. Many creatures have brains. Man alone has mind. Parrots cannot do algebra; only mind can abstract. Brains are physical devices for storing and retrieving special case experi-

ence data. Mind alone can discover and employ the generalized scientific principles found holding true in every special case experience.

Universe has disclosed to astrophysics an elegantly orderly inventory of ninety-two regenerative chemical elements, each with its unique behaviors, all of which are essential to the success of Universe. All are in continual interexchange within the total evolutionary process of Universe. Ignorant humans aboard Space Vehicle Earth are now screaming, "Pollution!" There is no such phenomenon. What they call pollution is extraordinarily valuable chemistry essential to Universe and essential to man on Earth. What is happening is that the egocentricity of omni-specialized man makes him ignorant of the value with which his processing is confronting him. The yellow-brown content of fume and smog is mostly sulphur. The amount of sulphur going out of the smokestacks around the world each year is exactly the same as the amount of sulphur being taken from the Earth each year to keep the world ecology going. It would be far less expensive to catch that sulphur while concentrated in the stack, and to distribute it to the original users, than to do the original mining AND to get it out of human lungs, et cetera, when all the costs to society over a deteriorating twenty-five years are taken into account. But humanity insists on holding to this year's profits, crops, and elections. World society is lethally shortsighted.

Subconsciously reflexing to the as yet mistaken concept of an infinite plane, men have felt that they could dispose of annoyingly accruing substances with which they did not know how to deal by dispatching them outward in some cosmic direction, assumedly to be diffused innocuously in infinity. "I spit in the ocean. So what?" Humans as yet cerebrate secretly and hopefully that—inasmuch as yesterday's exhaustion of customary resources has always been followed by discovery of alternate and better resources—the great infinity is going to keep right on taking care of ignorant carelessness and waste. "So what the hell?" say the "down-to-earth" status-quoers. "Pump all the fossil fuel energy-depositing of billions of years out from the Earth's crust. Burn it up in a century. Fill all your bank accounts with ten-place figures. To hell with the great grandchildren. Let them burn up our Space Vehicle Earth's oceans

with hydrogen fusion. Let them do the worrying about tomorrow."

Just as biological protoplasmic cells are colonized into larger organisms, the most complex and omni-adaptable of which is the human, so too do humans colonize and inventively externalize the same organic tool functions for their mutual metabolic regeneration. We call this complex mutual tool externalization by the name industrialization, in which each of us can use the telephone or the electric light in our special, unique tasks, all of which require increasing development of worldaround access to the total resources and worldaround distribution of the advantages comprehensively produced in total metabolic regeneration.

The world population which, after the cell-colonizing within its controlled environment, has been emitted from the thin, protoplasmic, tissue-sheathed, human womb into planet Earth's larger biosphere-sheathed, industrial organism womb, goes on colonizing, integrating, and specializing locally as innocently and ignorantly as did the protoplasmic cells within the woman's womb, all the while mistrusting one another as they evolve their utter interdependence around Earth, as do the individual protoplasmic cells of the residents of human Wombland gather together selectively, finally to form a whole child. In due course, we will realize a one world human integrity and with each degree of physical integration a new degree of metaphysical freedom will be attained.

Earthians in their more roomy biosphere are as yet provided-for, despite their utter ignorance of the infinitely-exquisite reliable interactions of cosmic mechanics. Mothers don't have to invent a breast to feed the baby or invent oxygen for it to breathe. Nor do they have to tell the child how to invent its cell growth. Humans are utterly ignorant of what goes on, how, and why.

The Universe is a self-regenerating and transforming organic machine. Human womb graduates now gestating within the biosphere's world industrial organism womb are discovering and employing a few of the principles governing micro-macro cosmic mechanics, all the while ignorantly speaking of their accomplishments of the generally-disregarded obvious as "inventions" and "creations." Now humans have become suspicious of their little machines, blaming them for the continual disconnects of the inexo-

rable evolutionary processes of cosmic gestations which—transcen-
dental to their brain detecting—ever and again emit them into a
greater, more inclusively exquisite spherical environment of auto-
mated mechanical controls that progressively decontrol humanity's
thought and action capabilities—ever increasing humanity's options
—emancipating it from its former almost total preoccupation with
absolute survival factors.

Assuming erroneously that their day-to-day positive experiences
should be rendered perpetual and their negative experiences elimi-
nated, humans try to freeze the unfreezable evolution at specific
stages. They try to make "plastic flowers" of all momentarily satisfy-
ing events and paraphernalia. In the past, they tried to do it with
stone. Separated from the familiar, confronted with the unfamiliar,
and reflexed only by the brain's mechanical feedback, unthinking
humans—not realizing that there are no straight lines, only wavy
ones, and not realizing that waves can only be propagated by
positive-negative oscillating—find their straight linear strivings for-
ever frustrated by the wave system realities of Universe. Ignorantly
they speak of the evolutionary waves' regeneratively oscillating
complementaries as "good" and "bad," though the scientist can find
no such moral and immoral qualities in the electron or its comple-
mentary opposite, the positron.

Humanity as a whole is indeed being emitted from a two-million-
year gestation within the womb of permitted ignorance, for which
infantile period cosmic mechanics have been making ample provi-
sion not only to offset ignorance and waste but also to permit
humanity's gradual trial-and-error experimental discovery of the
relatively negligible effectiveness of its muscle—which it had at first
employed not only exclusively but savagely—and the concomitant
discovery of the infinite apprehending and comprehending effec-
tiveness of the human mind, which alone can discover and employ
the Universal verities—and thereby realize comprehensively the
potential, progressive, non-wasteful, competent, considerate mas-
tery of the physical environment by the metaphysical intellect.

The metaphysical integrities manifest throughout the everywhere
inter-transforming Universe's omni-inter-accommodative cosmic or-
ganic system apparently are from time-to-time emulated in meager
degree by the intellect of the human passengers who are gestating

within the spherical womb sheath of planet Earth's watery, gaseous, and electro-magnetic biosphere.

Humanity's most recent sorties to the moon from within Space Vehicle Earth's womb-like biosphere sheath have been tantamount to a premature, temporary surgical removal of a baby from its human mother's womb, skillfully enclosed within a scientifically-controlled environment, still attached to the mother, and after successful surgery being returned into the human mother's womb to loll-out its remaining gestation days to the successful detached-action launching outwards in Universe which we ignorantly identify as "birth." Sovereign nation "landing cards" require answers to ridiculous questions: "When were you born?" "Where do you live?" Answer: "I am immortal. I check in here and there from celestial-time-to-celestial-time. Right now I am a passenger on Space Vehicle Earth zooming about the Sun at 60,000 miles per hour somewhere in the solar system, which is God-only-knows where in the scenario Universe. Why do you ask?"

Humanity's sorties to the moon have been accomplished only through instrumental guidance of their controlled-environment capsules and mechanical-enclosure clothing by utterly invisible electro-magnetic wave phenomena referenced to instrument-aligned star bearings, with the invisible mathematical integrations accomplished by computers, uncorrupted and incorruptible by ignorantly opinionated humans. Thus has man been advantaged by the few who have thought and acted to produce the instruments, as yet relieving the vast majority of humans from the necessity of having to think and coordinate their sensings with the realities of cosmic mechanics.

Humans still think in terms of an entirely superficial game of static things—solids, surfaces, or straight lines—despite that no things—no continuums—only discontinuous, energy quanta—separate event packages—operate as remotely from one another as the stars of the Milky Way. Science has found no "things"; only events. Universe has no nouns; only verbs. Don't say self-comfortingly to yourself or to me that you have found the old way of getting along with false notions to be quite adequate and satisfactory. So was the old umbilical cord to your mother. But you can't re-attach it and your mother is no longer physically present. You can't go back. You

can't stay put. You can only grow and, if you comprehend what is going on, you will find it ever more satisfactory and fascinating, for that is what evolution is doing, whether you think, ignorantly, that you don't like it or do.

To each human being, environment is "all of Universe that isn't me." Our macrocosmic and microcosmic "isn't me-ness" consists entirely of widely dissynchronous frequencies of repetitions of angular changes and complex inter-actions of waves of different lengths and frequencies of repetition. Physics has found a Universe consisting only of frequency and angle modulations.

Our environment is a complex of frequencies and angles. Our environment is a complex of different frequencies of impingement— from within and without—upon the individual "me-nesses." We are in a womb of complex frequencies. Some of those frequencies man identifies ignorantly with such words as "sight, sound, touch, and smell." Others he calls "tornadoes, earthquakes, novae." Some he ignorantly looks upon as static *things*: houses, rocks, and human-like manikins.

Very, very slow changes humans identify as inanimate. Slow change of pattern they call animate and natural. Fast changes they call explosive, and faster events than that humans cannot sense directly. They can see the rocket blasted off at 7,000 miles per hour. They cannot see the hundred-thousand times faster radar pulse moving 700 million miles per hour. Humans can sense only the position of pointers on instrument dials. What they call "radio"— electro-magnetics—they learn of through scientific instrumentation. Of the total electro-mechanical spectrum range of the now known realities of Universe, man has the sensory equipment to tune in directly with but one-millionth of the thus far discovered physical Universe events. Awareness of all the rest of the million-fold greater- than-human-sense reality can only be relayed to human ken through instruments, devised by a handful of thought-employing individuals anticipating thoughtfully the looming needs of others.

The almost totally invisible, nonsensorial, electro-magnetic womb- sheath of environmental evolution's reality-phase into which hu- manity is now being born—after two million years of ignorant, innocent gestation—is as yet almost entirely uncomprehended by humanity. 99.9 per cent of all that is now transpiring in human

activity and interaction with nature is taking place within the realms of reality which are utterly invisible, inaudible, unsmellable, untouchable by human senses. But the invisible reality has its own behavioral rules which are entirely transcendental to man-made laws and evaluation limitations. The invisible reality's integrities are infinitely reliable. It can only be comprehended by metaphysical mind, guided by bearings toward something sensed as truth. Only metaphysical mind can communicate. Brain is only an information storing and retrieving instrument. Telephones cannot communicate; only the humans who use the instruments. Man is metaphysical mind. No mind—no communication—no man. Physical transactions without mind—YES. Communication—NO. Man is a self-contained, micro-communicating system. Humanity is a macro-communicating system. Universe is a serial communicating system; a scenario of only partially overlapping, nonsimultaneous, irreversible, transformative events.

As yet preoccupied only with visible, static, newspicture views of superficial surfaces of people and things—with a one-millionth fraction of reality which it has cartooned in utter falsehood—society fails to realize that several hundred thousand radio or TV communications are at all times invisibly present everywhere around our planet. They permeate every room in every building—passing right through walls and human tissue. This is to say that the stone walls and human tissue are invisible and nonexistent to the electromagnetic wave reality. We only deceived ourselves into reflexing that the walls are solid. How do you see through your solid eyeglasses? They are not full of holes. They are aggregates of atoms as remote from one another as are the stars. There's plenty of space for the waves of light to penetrate.

Several hundred thousand different wide-band radio sets can at any time be tuned in anywhere around our biosphere to as many different communications. Going right through our heads now, these programs could be tuned in by the right crystals and circuits. Crystals and circuits consist of logically structured atomic arrays. Such arrays could operate even within our brains. Tiny bats fly in the dark by locating objects ahead in their flight path by ever more minuscule radar sending and receiving, distance-to-object calculating mechanisms. Right this minute, five hundred Earth-launched

satellites with sensors are reporting all phenomena situated about our planet's surface. Tune in the right wavelength and learn where every beef cattle or every cloud is located around the Earth. All that information *is* now being broadcast continually and invisibly.

For humans to have within their cerebral mechanism the proper atomic radio transceivers to carry on telepathetic communication is no more incredible than the transistors which were invented only two decades ago, and far less incredible than the containment of the bat's radar and range-finding computer within its pin-point size brain. There is nothing in the scientific data which says the following thoughts are impossible and there is much in the data which suggests that they are probable. The thoughts go as follows: The light of a candle broadcasting its radiation in all directions can be seen no farther than a mile away in clear atmosphere. When the same candle's flame is placed close in to the focus of a parabolic reflector and its rays are even further concentrated into a beam by a Freznell lens, its light can be seen at ten miles distance. The earliest lighthouses were furnished with such reflectively concentrated beam lights of tiny oil lamps.

What we speak of as light is a limited set of frequencies of the vast electro-magnetic wave ranges. All electro-magnetic waves can be beamed as well as broadcast. When beamed and lensingly concentrated (as with the laser beams refracted through rubies), their energies are so concentrated as to be able to bore tunnels in mountains. The shorter the waves, the smaller the reflector and refractor may be.

We know that the human has never seen outside himself. Electro-magnetic waves of light bounce off objects outside him and frequencies are picked up by the human eyes and scanningly relayed back into the brain. Because the light is so much faster than touch, smell, and hearing, men have tended to discount the billionth of a second it takes light to bounce off one's hand and to get the information back into one's brain. All sensing is done by humans entirely inside the brain, with information nerve-relayed from the external contact receivers. The human brain is like a major television studio-station. Not only does the brain monitor all the incoming, live, visible, audible, smellable, and touchable 3D shows, it also

makes videotapes of the incoming news, continually recalls yesterday's relevant documentaries and compares them with incoming news to differentiate out the discovered new and unexpected events from the long-familiar types, and to discover the implications of the news from those previously-experienced similar events, in order swiftly to design new scenarios of further actions logically to be taken in respect to the newly-evolved challenges.

So faithful has been the 4D, omni-directional, image-ination within the human omni-sense transcieving studio-stations of human brains that the humans themselves long ago came to assume spontaneously that the information received inside the brain made it safe to presume that those events were, in fact, taking place outside and remote from the seeing human individual. The reliability of all this imagining has been so constant that he now tends to think he sees only outside himself.

The shorter the electro-magnetic, air, water, sand, or rocky earthquake wavelengths, the higher their frequency. The higher the wave frequencies, the more the possibility of their interfering with other high-frequency, physical phenomena such as walls, trees, mountains. The nearer they approach the same frequencies, the less do they interfere with one another. For this reason, the very high-frequency electro-magnetic waves of radio and television get badly deflected by obstacles. As a consequence, man learned to beam short wave television programs from horizon to horizon. He developed parabolic transceiver reflectioning cups that took in and sent out waves in parallel beam-focused rays. At the transceiver relay stations on the horizons, additional energy is fed into the signals received and their projection power is boosted so that, when they arrive at final destination after many relayings, their fidelity and power are as yet exquisitely differentiated and clearly resonated.

It may well be that human eyes are just such infra-sized parabolic transceiver cups. It may be that our transceiver eyes adequately accommodate the extraordinarily low magnitude of energy propagating of the brain as electro-magnetic wave pattern oscillations to be picked up by others.

Early photography required whole minutes of exposure. As film chemistry improved, exposure times decreased. Yesterday, one-thousandth of a second was fast. Today's capability makes one

millionth of a second a relatively slow electro-astrophotography exposure. Pictures taken in a millionth of a second today are clearer than those of yesterday which took minutes. The scanned-out picture signals travel 700 million miles per hour. The effect in terms of man's tactile, hearing, and smelling senses is instantaneous.

Speakers who appear frequently before large audiences of human beings over a period of years have learned that the eyes of the audience "talk back" so instantaneously to them that they know just what their audiences are thinking and they can converse with their audiences, even though the speaker seems to be the only one making audible words. The feedback by eye is so swift as to give him instantaneous, spontaneous reaction and appropriate thought formulation.

The parabolic reflector-beamed, ultra-ultra high frequency, electro-magnetic waves—such as can be coped with by transceivers with the infra-diameter of the human eye—are such that they would be completely interfered with by walls or other to-us-seemingly-opaque objects. However, when they are beamed outwardly to the sky in a cloudless atmosphere, no interference occurs. Ultra short wave radio and radar beams which are interfered with by mountains and trees can be beamed into a clear sky and bounced off the moon, to be received back on Earth in approximately one and three-fourths seconds. In a like manner, it is possible that human eyes operating as transceivers, all unbeknownst to us, may be beaming our thoughts out into the great night-sky void, not even having the sun's radiation to interfere mildly with them. Such eye-beamed thoughts sent off through the inter-celestial voids might bounce off various objects at varying time periods, being reflectively re-angled to a new direction in Universe without important energy loss. A sufficient number of bouncings-off of a sufficient number of asteroids and cosmic dust could convert the beams into wide-angle sprays which diffuse their energy signals in so many angular directions as to reduce them below receptor-detection level. Eye-beamed thoughts might bounce off objects so remote as to delay their 700 million mile per hour travel back to Earth for a thousand years, ten thousand years, a hundred thousand years. It is quite possible that thoughts may be eye-beamed outwardly not only from Earth to bounce back to Earth at some later period from some celestially-

mirroring object, but also that thoughts might be beamed—through non-interfering space to be accidentally received upon Earth—from other planets elsewhere in Universe. There is nothing in the data to suggest that the phenomenon we speak of as *intuitive thought* may not be just such remote cosmic transmissions. Intuitions come to us often with surprising lucidity and abruptness. Such intuitions often spotlight significant coincidences in a myriad of special case experiences which lead to discovery of generalized scientific principles heretofore eluding humanity's thought. These intuitions could be messages to the Earthian brain receiving it to "Look into so-and-so and so-and-so and you will find something significant." Intuitions could be thoughts dispatched from unbelievably long ago and from unbelievably far away.

As Holton wrote in the *American Journal of Physics* and as reported on the "Science" page of *Time* magazine, January 26, 1970:

To fully recognize the extraordinary intellectual daring of Einstein's equations, we note the great scientist's own explanation of their origin: "There is no logical way to the discovery of these elementary laws. There is only the way of intuition."

Because humans consist of a myriad of atoms and because atoms are themselves electro-magnetic frequency event phenomena—not things—it is theoretically possible that the complex frequencies of which humans are constituted, together with their angular interpositioning, could be scanningly unraveled and transmitted beamwise into the celestial void to be received some time, somewhere in Universe, having traveled at 700 million miles per hour, which is approximately 100 thousand times faster than the speed of our moon rockets a minute after blast-off. It is not theoretically impossible in terms of the total physical data that humans may have been transmitted to Earth in the past from vast distances.

Retreating from such a speculative mood, we come now to consider closer-range possibilities and probabilities. We recall that humans, who to our knowledge arrived on Earth at least two million years ago, have been regenerating aboard that small, 8000-mile diameter, Space Vehicle Earth throughout all those years without even knowing that they were aboard a space vehicle. They are now

emerging, however, from the womb of permitted ignorance of their early, subjective, taken-care-of phase and are now beginning to become comprehensively aware of all the matters we have discussed so far. They are beginning to understand that they are within a limited biosphere life-support system whose original excessively-abundant living supply was provided only to permit humanity's initial trial-and-error discovery of its anti-entropic function in Universe. Humans are coming swiftly to understand they must now consciously begin to operate their Space Vehicle Earth with total planetary cooperation, competence, and integrity. Humans are swiftly sensing that the cushioning tolerance for their initial error has become approximately exhausted.

Each child emerging from its mother's womb is entering a larger womb of total human consciousness which is continually modified and expanded by subjective experiences and objective experiments. As each successive child is born, it comes into a cosmic consciousness in which it is confronted with less misinformation than yesterday and with more reliable information than yesterday. Each child is born into a much larger womb of more intellectually competent consciousness.

I was seven years old before I saw an automobile, though living in the ambience of a large American city. Not until I was nine was the airplane invented. As a child I thought spontaneously only in terms of walking, bicycling, horse-drawn capability. Trips on railroads and steamships were dream-provokers learned of through a few older people who traveled. My daughter was born with cloth-covered-wing bi-planes in her sky and the talkie radio in her hearing. My granddaughter was born in a house with several jet transports going over every minute. She saw a thousand airplanes before she saw a bird; a thousand automobiles before a horse. To children born in 1970, trips to the moon will be as everyday an event as were trips into the big city to me when a boy. There was no radio when I was born. Television came when I was what is called "retiring age." The first Berkeley dissident students were born the year commercial television started. They have seen around the world on the hour ever since being born—they think world. The total distance covered by an average human being in a total lifetime up to the time I was born was 30,000 miles. Because of the great changes since my birth,

I have now gone well over one hundred times that distance. The astronauts knock off three million miles in a week. The average airline hostess is out-mileaging my hundred-fold greater mileage than all the people before me. All this has happened in my lifetime. My lifetime has been one of emerging from the womb of human-being remoteness from one another to comprehensive integration of worldaround humanity. But all the customs, all the languages, all laws, all accounting systems, viewpoints, clichés, and axioms are of the old, divided, ignorant days. The corollary of "divide and con-quer" is "to be divided is to be conquered." To be specialized is to be divided. The specialization which humanity perseveres in was invented by yesterday's armed conqueror illiterates. The separation of humans into more countries made them easy to manage. Nations may unite, as at present, without success. Strife is proliferating. Not until specialization and nations are dispensed with will humanity have a chance of survival. It is to be all or none.

In my first jobs before World War I, I found all the working men to have vocabularies of no more than one hundred words, more than 50 per cent of which were profane or obscene. Because I worked with them, I know that their intellects were there, but dulled and deprived of the information of visionary conceptioning. They had no way of expressing themselves other than by inflection and shock. Conquerors invented gladiatorial wrestling, self-brutaliz-ing games, slapstick and illusionary drama to keep their illiterate masses preoccupied when not at work. This was not changed by any scheduled system of education—it was changed by the radio. The radio broadcasting employees were hired for their vocabularies and diction. The eyes and ears of human beings were able to coordinate the words of the radio and the graphic words of the newspaper. Literacy accelerated. In a half-century, worldaround man's vocabu-lary has been expanded to the equivalent of yesterday's scholar. Television's scientific invention and underwater and space explora-tion have accelerated this process of freeing humanity from its slave complex to an extraordinary degree. The young realize, as their elders do not, that humanity can do and can afford to do anything it needs to do that it knows how to do.

Those who ignorantly think of themselves as a well-to-do con-servative elite are, in fact, so slave-complexed that they are shocked

when the younger generation throws aside their clothes and cars of distinction and—abandoning their make-believe mansions which only are their old conquerors' castles—congregate in hundreds of thousands in shameless, innocent bands on vast beaches and meadows. It is not an unspannable generation gap that has occurred, but an emancipation of youth from yesterday's slave-complex reflexes. This has been brought about solely by the proliferation of knowledge. "The medium is the message" is the message only of yesterday's middle-class elite. It said, "Never mind the mind. It's the body that counts." or "It's the physical that can be possessed—To hell with the metaphysical. You can possess a physical brain but not the universally free mind and its thoughts. Leave that to the intellectuals. Look out for those dangerous free thinkers." Higher education was an adornment—a mark of distinction—not something to be taken seriously. The problem of man's being born into the new womb of planetary comprehension, into the new world of integrated coordination and understanding of all humanity, is one not of educating a single absolute monarch, nor of educating either a fascistic or central party elite, nor of educating only the middle class. It is a matter of educating everyone everywhere to the realities of the emerging of man from the womb of permitted ignorance into the womb of required comprehension and competence. That education will have to be brought about by the extraordinary discarding of yesterday's inadequate amusements, shallow romances and drama, and make-believe substitute worlds to cover up the inadequacies of misinformed and underinformed, physically slavish or bureaucratically dogmatic, thoughtless life.

All the foregoing observations of human misorientations constitute but a minor fraction of those which can be truthfully and cogently made today with some chance of their not only being heard but heeded. And all this brings us all to this book by Gene Youngblood—an excellent name for one of the first of the youth who have emerged from childhood and schooling and "social experience" sufficiently undamaged to be able to cope lucidly with the problem of providing worldaround man with the most effective communication techniques for speaking universal language to universal man—for helping universal man to understand the great

transitions, to understand the reasonableness of yesterday's only-transitional inadequacies, to understand that the oldsters are victims of yesterday's ignorance and not Machiavellian enemies of youth, to understand that any bias—one way or another—utterly vitiates competent thinking and action, to understand that 100 per cent tolerance for error of viewpoint and misbehavior of others is essential to new-era competence—and, finally, to understand that man wants to understand. Nowhere have we encountered a youth more orderly-minded regarding the most comprehensively favorable, forward functioning of humans in Scenario-Universe than in Gene Youngblood. His book *Expanded Cinema* is his own name for the forward, omni-humanity educating function of man's total communication system.

Isaac Newton, as the greatest Olympian of classical science whose influence reigned supreme until the turn of the Nineteenth into the Twentieth Century, assumed the Universe to be *normally at rest* and abnormally in motion. Einstein realized that the experimental data regarding the Brownian Movement and the speed of light made it clear that Universe was not normally at rest, for when its energies were released in a vacuumized tunnel they traveled linearly at 186 million miles per second. This he assumed to manifest its norm, since that is how Universe behaves normally when unfettered in a vacuum. Any seemingly motionless phenomena, he reasoned, such as seemingly solid matter, consisted of energy moving at 186 million miles per second but in such small local orbits that their speed and the exquisitely small, self-huddling orbit made them impenetrable; ergo, apparently solid. This was the basis of his formulation of his extraordinary $E=mc^2$, which, when fission and fusion occurred, proved his locked-up-energy formulation to be correct. The utter difference between Newton's norm of *at rest* and Einstein's norm of 186 million miles per second provides humanity's most abrupt confrontation regarding the epochal difference of conceptioning between that in the womb of yesterday's ignorance and in the womb of new-dawning awareness, from which and into which, respectively, man is now experiencing the last phases of delivery.

Thinking in terms of 700 million miles per hour as being normal—and informed by the experiments of scientists that no energies

are lost—Einstein abandoned the Newtonian thought of Universe and assumed in its place Universe to be "A scenario of non-simultaneous and only partially overlapping transformative events." Einstein's observational formulations, however, are subjective, not objective. In the mid-1930's I suggested in a book that Einstein's work would eventually affect the everyday environment of humanity, both physically and mentally. After reading what I had written, Einstein said to me, "Young man, you amaze me. I cannot conceive of anything I have ever done as having the slightest practical application." He said that to me a year before Hahn, Stressman, and Lisa Meitner had, on the basis of $E=mc^2$, discovered the theoretical possibility of fission. You can imagine Einstein's dismay when Hiroshima became the first "practical application."

Gene Youngblood's book is the most brilliant conceptioning of the objectively *positive use* of the Scenario-Universe principle, which must be employed by humanity to synchronize its senses and its knowledge in time to ensure the continuance of that little, three-and-one-half-billion-member team of humanity now installed by evolution aboard our little Space Vehicle Earth. Gene Youngblood's book represents the most important metaphysical scenario for coping with all of the ills of educational systems based only on yesterday's Newtonian-type thinking. Youngblood's *Expanded Cinema* is the beginning of the new era educational system itself. Tomorrow's youth will employ the video cassette resources to bring in the scenario documents of all of humanity's most capable thinkers and conceivers. Only through the scenario can man possibly "house-clean" swiftly enough the conceptual resources of his spontaneous formulations. Tomorrow's Expanded Cinema University, as the word uni-verse—towards one—implies, will weld metaphysically together the world community of man by the flux of understanding and the spontaneously truthful integrity of the child.

R. BUCKMINSTER FULLER

## Inexorable Evolution and Human Ecology

Until humanity starts behaving
In logical ways
For logical reasons
Natural evolution will force it
To keep on behaving logically
For seemingly illogical reasons—
Resulting inexorably, as at present,
In humanity's backing
Rump-bumpingly into its future
While disregarding opportunities
To about-face and realize
Its inspiring passengership
Aboard Planet Earth—
As its exploratory mothership
Of ever vaster and more exquisite
Macro- and micro-cosmic realms.
And the frustrations
Of fearfully clung-to customs
Will persist unabated until
Humanity undertakes
Seriously, imaginatively,
Courageously, inspiringly
To employ effectively
The ever-more with ever less—
Of effort, material, time
And tolerance of error
Per each accomplished task
The comprehensively anticipatory
Design science revolution—
Being intent thereby
To make all of humanity
Successful in every sense.
As it undertakes design revolution

Humanity also must realize
That it can always afford rearrangements
Of the physical environment constituents
Which produce sustainable increases
In the proportion of all of humanity
Enjoying comprehensive success—
Provided only the task
Is physically feasible
Within ecologically critical limits
Of electro-magnetics, chemistry, time.
"We cannot afford" assumes spending
Intertransforming as matter or radiation
Energy cannot be spent
Know-how always increases
Wealth multiplies irreversibly.
And not until then will nature
Cease to cope with humanity's
Ignorance-prolonged inertia
Just in the same way
That human parents
Cope with their newborns'
Innocently ignorant
Self-helplessness—
And that is by forcing man
To acquire the adequate technology
With which ultimately
To attain and sustain
That potential omni-success.
And until then it will be accomplished inversely—
Through activating humanity's
Death fearing instincts.
Fear forcing it to acquire
The adequate production-tool complex
As a consequence of inducing humanity
Into an investment and reinvestment
Of its best capabilities and resources
Only in preparation for war.
This inverse procedure will regenerate

To ever higher degree
Both the more-with-less energy processing
And its production equipment.
And when man learns, if he does
To initiate the more-with-lessing
Under peacefully purposed auspices
Peace then will be attained
And Universe sustained
But not until then.

R. BUCKMINSTER FULLER

# Preface

The question what is life, says Norman O. Brown, turns out to be the question what is sleep. We perceive that the sky exists only on earth. Evolution and human nature are mutually exclusive concepts. We're in transition from the Industrial Age to the Cybernetic Age, characterized by many as the post-Industrial Age. But I've found the term *Paleocybernetic* valuable as a conceptual tool with which to grasp the significance of our present environment: combining the primitive potential associated with Paleolithic and the transcendental integrities of "practical utopianism" associated with Cybernetic. So I call it the Paleocybernetic Age: an image of a hairy, buckskinned, barefooted atomic physicist with a brain full of mescaline and logarithms, working out the heuristics of computer-generated holograms or krypton laser interferometry. It's the dawn of man: for the first time in history we'll soon be free enough to discover who we are.

When we say expanded cinema we actually mean expanded consciousness. Expanded cinema does not mean computer films, video phosphors, atomic light, or spherical projections. Expanded cinema isn't a movie at all: like life it's a process of becoming, man's ongoing historical drive to manifest his consciousness outside of his mind, in front of his eyes. One no longer can specialize in a single discipline and hope truthfully to express a clear picture of its relationships in the environment. This is especially true in the case of the intermedia network of cinema and television, which now functions as nothing less than the nervous system of mankind.

At this point in the Paleocybernetic Age, the messages of society as expressed in the intermedia network have become almost totally irrelevant to the needs and actualities of the organism. The situation is equivalent to one's own nervous system transmitting erroneous information about the metabolic and homeostatic condition of one's own body. It is the primary purpose of this book to explore the new messages that exist in the cinema, and to examine some of the image-making technologies that promise to extend man's communicative capacities beyond his most extravagant visions.

We'll begin with a discussion of the individual's relationship to the contemporary cultural environment in a time of radical evolution, and the way in which an irresponsible attitude toward the intermedia network contributes to blind enculturation, confusion, and disharmony. In the section of Part One titled "Art, Entertainment, Entropy" I've applied cybernetics and communication theory to the role of commercial entertainment in our radically evolving environment. The prevailing messages of the so-called popular media have lost their relevance because a socioeconomic system that substitutes the profit motive for use value separates man from himself and art from life. When we're enslaved to any system, the creative impulse is dulled and the tendency to imitate increases. Thus arises the phenomenon of commercial entertainment distinct from art, a system of temporarily gratifying, without really fulfilling, the experiential needs of an aesthetically impoverished culture.

The mass public insists on entertainment over art in order to escape an unnatural way of life in which interior realities are not compatible with exterior realities. Freedom, says Brown, is fusion. Life becomes art when there's no difference between what we are and what we do. Art is a synergetic attempt at closing the gap between what *is* and what ought to be. Jacob Bronowski has suggested that we "ought to act in such a way that what is true can be verified to be so." This characterizes the substance of Part One, and is why I call it "The Audience and the Myth of Entertainment."

Before we can discuss that point at which the cinema requires some new technological extension we must first follow the history of conventional film language to its limits: this I have attempted to do in Part Two, "Synaesthetic Cinema: The End of Drama." The essence of this chapter is that technology is decentralizing and individualizing the communication channels of humanity; that personalized communication means the end of "official" communication structures such as the genre of drama, resulting in a new "major paradigm" of cinematic language that I call the synaesthetic mode. Following a detailed analysis of synaesthetic cinema there's a section titled "Image-Exchange and the Post-Mass-Audience Age." Here I've attempted to illuminate some of the social and psychological potentials inherent in the decentralization of global communications facilities. The conclusion is that the art and technology

of expanded cinema mean the beginning of creative living for all mankind and thus a solution to the so-called leisure problem.

In Part Three, "Toward Cosmic Consciousness," I discuss various new realities, primarily the result of scientific developments, which until recently the artist has not been able to engage in a meaningful fashion. This chapter also contains a discussion of the "new nostalgia," a post-Existential view of the human condition. Finally, I've contrasted two approaches to cinematic cosmic consciousness: Stanley Kubrick's *2001: A Space Odyssey*, and the small personal films of the master, Jordan Belson.

Two of the most important technologies that will provide access to the new realities of the Paleocybernetic Age will be discussed in Part Four, "Cybernetic Cinema and Computer Films," and Part Five, "Television as a Creative Medium." I've attempted to cover these disciplines as comprehensively as possible, presenting the social, political, and psychological implications as well as their aesthetic and technical aspects. Thus the many interviews with artists and technologists are intended to counterbalance my subjective remarks and to provide a cross section of attitudes concerning the confluence of art and technology as it is today and as it will be tomorrow.

Part Six, "Intermedia," has more to do with attitude than technology. The intent here is to illuminate a universal trend toward the concept of artist as ecologist, art as environment rather than anti-environment, subsuming the eco-system of our planet itself into the art process. Finally with Part Seven, "Holographic Cinema," we arrive at the end that is also a beginning. I've tried to dispel many of the misconceptions regarding holographic movies, and to delineate some possibilities. With the perfection of holographic cinema within the next two decades, we'll arrive at that point in the evolution of intelligence when the concept of reality no longer will exist. Beyond that the cinema will be one with the life of the mind, and humanity's communications will become increasingly metaphysical.

Although I've been involved in film criticism since 1960, the major substance of this book is the result of articles published in different form in the *Los Angeles Free Press* from September, 1967, to December, 1969. That material was rewritten for this text, ex-

panded and clarified, in addition to the several hundred pages that appear here for the first time. We are transformed by time through living within it, so in a sense all of this book is "new" in my work.

My indebtedness to the thoughts of R. Buckminster Fuller, John McHale, Norbert Wiener, and Marshall McLuhan is quite clear. What is not so clear is the influence of my friends Edwin Schlossberg, Ted Zatlyn, and Jon Dieges, all of whose perceptions of humanity as a whole system are unfettered by the constraints of yesterday's consciousness. There are portions of this text in which "by Gene Youngblood" should be taken to mean "by way of Youngblood, Schlossberg, and Zatlyn." Dieges' influence was less specific, more general. Charles Brouyette contributed much to the technical aspects of the chapter on television and I owe him thanks. In ways known to each of them I am gratefully indebted to Nancy Schiro, Ronald Nameth, Gerald O'Grady, Tom Ancell, John Margolies, Lawrence Lipton, Tony Cohan, and my parents Walter and Marie Youngblood who filled my childhood with the wonder of art. Finally, I wish to express my thanks to American Airlines for their generous assistance in the preparation of this book.

GENE YOUNGBLOOD

Los Angeles
January, 1970

# PART ONE:
## THE AUDIENCE AND THE MYTH OF ENTERTAINMENT

"The most important part about tomorrow is not the technology or the automation, but that man is going to come into entirely new relationships with his fellow men. He will retain much more in his everyday life of what we term the naïveté and idealism of the child. I think the way to see what tomorrow is going to look like is just to look at our children."

R. BUCKMINSTER FULLER

As a child of the New Age, for whom "nature" is the solar system and "reality" is an invisible environment of messages, I am naturally hypersensitive to the phenomenon of vision. I have come to understand that all language is but substitute vision and, as Teilhard de Chardin has observed, "The history of the living world can be summarized as the elaboration of ever more perfect eyes within a cosmos in which there is always something more to be seen."[1]

It is that "something more" that has fascinated me since first I became aware of the limited range of ordinary consciousness, chiefly as manifested in the cinema. We are witnessing a metamorphosis in the nature of life on earth. Art, science, and metaphysics, separated for so long in the specialized world of Western man, are reconverging; the interface reveals a broader and deeper reality awaiting our investigation. An increasing number of humans are beginning to understand that man probably never has perceived reality at all, because he has not been able to perceive himself. The realization is not new; only the context is unique: a vast portion of our culture, free of the conditioning of and nostalgia for past environments, has intuited something fundamentally inadequate in prevailing attitudes toward the notion of reality.

[1] Pierre Teilhard de Chardin, *The Phenomenon of Man* (New York: Harper & Row, 1959), p. 31.

In most languages of most cultures throughout history, seeing has been equated with understanding. The entire Indo-European linguistic system is filled with examples: *I see, ya vizhu, je vois.* Yet nearly twenty-four hundred years ago Plato asserted, "The world of our sight is like the habitation in prison."[2] Recent studies in anatomy, physiology, and anthropology have led to a similar conclusion.[3] We have come to see that we don't really see, that "reality" is more within than without. The objective and the subjective are one.

At the same time, science has taught that there is no purely physical reason for the disparity between apprehending and comprehending. We know, for example, that thirty-eight percent of fibers entering or leaving the central nervous system are in the optic nerve. It is estimated that as much as seventy-five percent of information entering the brain is from the eyes. Current research indicates approximately one hundred million sensors in the retina and only five million channels to the brain from the retina. There is a great deal of evidence to suggest that information processing is done in the eye before data are passed to the brain.[4]

The metaphysical space that separates father and son so dramatically in what we call the generation gap was manifested on a global scale on July 20, 1969. In television's elaborate movie-like subjective-camera "simulation" of the first moon landing, the history of subjective art with its emphasis on content came into total confrontation with the history of objective art and its emphasis on process. As we saw the event, reality was not half as "real" as the simulation because it was the reality of a process of perception. We were seeing nothing but videospace; the simulated reality turned out to be only the reality of a simulation. Objective awareness of a subjective process was all that mattered, and history's simulation suddenly became irrelevant. Thousands of years of theatrical tradi-

[2] Plato, *The Republic,* Book VIII, *ca.* 390 B.C.

[3] Extensive research on physiological conditioning is found in *The Influence of Culture on Visual Perception,* by Marshall H. Segall, Donald T. Campbell, and Melville J. Herskovits (Indianapolis: Bobbs-Merrill, 1966).

[4] F. R. Sias, Jr., "The Eye as a Coding Mechanism," *Medical Electronic News,* quoted in: Nels Winkless and Paul Honore, "What Good Is a Baby?" *Proceedings of the AFIPS 1968 Fall Joint Computer Conference.*

tion were demolished in two hours before an audience of four hundred million world persons.

In the ascending spiral of evolution each new generation absorbs the experiences of the previous level and expands upon them. Teilhard has termed this *hominization,* the process by which the original protohuman stock becomes increasingly more human, realizing more of its possibilities. This "consciousness expansion" has reached a velocity of evolutionary acceleration at which several transformations occur within the life-span of a single generation. Because of mankind's inevitable symbiosis with the mind-manifesting hallucinogens of the ecology on the one hand, and his organic partnership with machines on the other, an increasing number of the inhabitants of this planet live virtually in another world. The messages to be discussed in this book are of that world.

It is a world infinitely more natural and complete than that of commercial cinema or television, which is used to confirm the existing consciousness rather than to expand it. Art is the language through which we perceive new relationships at work in the environment, both physical and metaphysical. Indeed, art is the essential instrument in the very development of that consciousness. As Hermann Hesse observed, every important cultural gesture comes down to a morality, a model for human behavior concentrated into a gesture. Whitehead found it to be "the ultimate morality of the mind." Perhaps never before has a new model for human behavior been needed so urgently as today.

We who are about to inherit the earth from our fathers will receive it with a brave new design. We see the whole earth and thus we see the illusion that has characterized life upon it. We cannot accept the truths and values of a world in which we no longer live. We are a generation of desperadoes. We move across the landscape with bold abandon because we intuit that the birth certificate is the only credit card. The word "utopian" is not anathema to us because we know that the illusion can be shattered within our own lifetimes, that the industrial equation means practical utopianism for the first time in history.

Our grasp of these realities is inarticulate; we cannot speak it. We are haunted by our own disenchantment and alienation as much as our parents are offended by it. The human condition, as this

millennium draws to a close, is one of decreasing intervals between increasing emergencies until nothing but emergency exists. We have nothing to lose. Spiritually we have nothing to lose because there is only sorrow in the values of the past and we have no tears left. Physically we have nothing to lose because we know that wealth can neither be created nor spent, that it goes nowhere and always increases with use.

"In this century alone we have gone from less than one percent of humanity being able to survive in appreciable health and comfort to forty-four percent of humanity surviving at a standard of living unexperienced or undreamed of before. This utterly unpredicted synergetic success occurred within only two-thirds of a century despite continually decreasing metallic resources per each world person . . . the world total of seventy billion dollars in mined gold represents only three one-thousandths of one percent of the value of the world's organized industrial production resources."[5]

Within the larger context of radical evolution there are many local revolutions. One of them is the revolution of expectations that burns in the minds of the new consciousness. Eskimo children who've never seen a wheeled vehicle can identify the types of aircraft flying over the North Pole. Young Dyaks in the longhouses of equatorial Borneo listen to the Beatles on transistor radios. Teenage Bedouins wandering the Sahara hear Nasser's radio telling how Vietnamese children are being slaughtered half the world away.[6]

Dylan swears he sees his reflection so high above the wall upon which he once drew conclusions. Seeing that reflection is the revolution. It tells us old reasons for doing things that no longer exist. "There's less to do because circumstances do it for us: the earth. Art has obscured the difference between art and life; now life will obscure the difference between life and art."[7] We no longer need to prove our right to live. We're struggling in the toil of old realities, stranded from our conscience, doing our best to deny it.

---

[5] R. Buckminster Fuller, *Operating Manual for Spaceship Earth* (Carbondale, Ill.: Southern Illinois University Press, 1969), pp. 82, 95.

[6] Ritchie Calder, "The Speed of Change," *Bulletin of the Atomic Scientists* (December, 1965).

[7] John Cage, *A Year from Monday* (Middletown, Conn.: Wesleyan University Press, 1968), pp. 9, 19.

We are tragically in need of new vision: expanded cinema is the beginning of that vision. We shall be released. We will bring down the wall. We'll be reunited with our reflection.

I'm writing at the end of the era of cinema as we've known it, the beginning of an era of image-exchange between man and man. The cinema, said Godard, is truth twenty-four times a second. The truth is this: that with the possibility of each man on earth being born a physical success there is no archetypal Man whom one can use in the culturally elitist manner and each man becomes the subject of his own study. The historical preoccupation with finding the one idea that is Man will give way to the idea that earth is, and then to the idea of other earths.

# Radical Evolution and Future Shock
# in the Paleocybernetic Age

It is perhaps not coincidental that Western youth has discovered the *I Ching,* or *Book of Changes,* on a somewhat popular level as we move into the final third of the twentieth century. Change is now our only constant, a global institution. The human ecological biosphere is undergoing its second great transition, destined to be even more profound than the invention of agriculture in the Neolithic Age. If we can't see the change, at least we can feel it. Future shock affects our psyche and our economy just as culture shock disorients the Peace Corps worker in Borneo.

It is said that we are living in a period of revolution. But nothing sells like freedom: Revolution is big business. As the physicist P. W. Bridgman once said, the true meaning of a term is found by observing what a man does with it, not what he says about it. Since the phenomenon we call revolution is worldwide, and since it's felt in every human experience, perhaps we might think of it not as revolution but as *radical evolution.* Revolution is basically the same whether defined by Marx or the *I Ching:* removal of the antiquated. But revolution replaces one status quo with another. Radical evolution is never static; it's a perpetual state of polarization. We could think of it as *involuntary revolution,* but whatever terminology we apply that's the condition of the world today, the environment with which the artist must work. Radical evolution would be kinder if it were better understood; but it won't be so long as commercial entertainment cinema continues to represent a "reality" that doesn't exist.

Sociologist Alvin Toffler has stressed ephemerality as a chief aspect of radical evolution: "Smith Brothers Cough Drops, Calumet Baking Soda, Ivory Soap, have become institutions by virtue of their long reign in the marketplace. In the days ahead, few products will enjoy such longevity. Corporations may create new products knowing full well they'll remain on the market for only a matter of a few weeks or months. By extension, the corporations themselves—as well as unions, government agencies and all other organizations—

may either have shorter life-spans or be forced to undergo incessant and radical reorganization. Rapid decay and regeneration will be the watchwords of tomorrow."[8] Toffler observes that no reasonable man should plan his life beyond ten years; even that, he says, is risky. When parents speak of their sons becoming lawyers they are deceiving themselves and their sons, according to the sociologist, "Because we have no conception of what being a lawyer will mean twenty years hence. Most probably, lawyers will be computers." In fact, we can't be sure that some occupations will even exist when our children come of age. For example, the computer programmer, a job first created in the 1950's, will be as obsolete as the blacksmith within a decade; computers will reprogram and even regenerate themselves (IBM recently announced a new computer that repairs itself).

John McHale, coauthor of the *World Design Science Decade* documents with Buckminster Fuller, emphasizes expendability and impermanence in radical evolution: "Use value is replacing owner-ship value. For example, the growth of rental and services—not only in automobiles and houses, but from skis to bridal gowns to heir-loom silver, castles and works of art . . . our personal and house-hold objects, when destroyed physically or outmoded symbolically, may be replaced by others exactly similar. A paper napkin, a suit, a chair, an automobile, are items with identical replacement value. Metals in a cigarette lighter today may be, within a month or year, part of an auto, lipstick case or orbiting satellite . . . the concept of permanence in no way enables one to relate adequately to our present situation."[9]

McHale has seen the need for a totally new world view as radical evolution speeds farther from our grasp. "There's a mythology abroad which equates the discovery and publication of new *facts* with new *knowledge*. Knowledge is not simply accumulated facts but the reduction of unrelated and often apparently irrelevent facts into new conceptual wholes."[10] He's talking about completely new

[8] Alvin Toffler, "The Future as a Way of Life," *Horizon* (Summer, 1965).

[9] John McHale, "The Plastic Parthenon," *Dotzero* (Spring, 1967).

[10] John McHale, "Information Explosion—Knowledge Implosion," *Good News,* eds. Edwin Schlossberg and Lawrence Susskind (New York: Columbia University Press, 1968).

ways of looking at the world and everything in it. This is proposition far more profound than mere political revolution, which Krishnamurti has characterized as "The modification of the right according to the ideas of the left."[11] The new consciousness transcends both right and left. We must redefine everything.

What happens to our definition of "intelligence" when computers, as an extension of the human brain, are the same size, weight, and cost as transistor radios? They're being developed through the microelectronics process of Large-Scale Integration.

What happens to our definition of "morality" when biochemists are about to unravel the secrets of the DNA/RNA interaction mechanism to create human life?

What happens to our definition of "man" when our next door neighbor is a cyborg (a human with inorganic parts)? There are several crude cyborgs in the world today.

What happens to our definition of "environment" when our video extensions bring us the reality of the solar system daily? What do we mean by "nature" under these circumstances? (McLuhan: "The first satellite ended nature in the conventional sense.")

What happens to our definition of "creativity" when a computer asks itself an original question without being programmed to do so? This has occurred several times.

What happens to our definition of "family" when the intermedia network brings the behavior of the world into our home, and when we can be anywhere in the world in a few hours?

What happens to our definition of "progress" when, according to Louis Pauwels: "For the really attentive observer the problems facing contemporary intelligence are no longer problems of progress. The concept of progress has been dead for some years now. Today it is a question of a change of state, a transmutation."[12] Or Norbert Wiener: "Simple faith in progress is not a conviction belonging to strength but one belonging to acquiescence and hence to weakness."[13]

[11] J. Krishnamurti, *The First and Last Freedom* (Wheaton, Ill.: Quest Books, 1968), pp. 25, 26.

[12] Louis Pauwels, Jacques Bergier, *The Morning of the Magicians* (New York: Avon Books, 1968), pp. xxii, xxiii.

[13] Norbert Wiener, *The Human Use of Human Beings* (New York: Avon Books, 1967), p. 66.

What happens to our definitions of "material" and "spiritual" when science has found no boundary between the two? Although it is still popularly assumed that the world is divided into animate and inanimate phenomena, virologists working at the supposed threshold between life and nonlife at the virus level have in fact discovered no such boundary. "Both animate and inanimate have persisted right across yesterday's supposed threshold in both directions . . . subsequently what was animate has become foggier and foggier . . . no life, per se, has been isolated."[14]

Indeed, what becomes of "reality" itself as science expands its mastery of the forces of the universe? "The paradox of twentieth-century science consists of its *unreality* in terms of sense impressions. Dealing as it does in energy transformation and submicroscopic particles, it has become a kind of metaphysics practiced by a devoted priestly cult—totally as divorced from the common-sense notions of reality as was the metaphysics practiced by witch doctors and alchemists. It is not at all odd, then, to discover that the closer we come via the scientific method to 'truth,' the closer we come to understanding the 'truth' symbolized in myths."[15]

This, then, is merely a superficial glimpse at some of the phenomena that characterize the Paleocybernetic Age. Quite clearly man is in the paradoxical position of existing in a state of consciousness without being able to understand it. Man does not comprehend his relationship to the universe, either physical or metaphysical. He insists on "doing his thing" without the slightest notion of what his "thing" might be. This cosmic credibility gap exists primarily between the facts of scientific experience and the illusions of environmental conditioning as manifested in the global intermedia network.

[14] R. Buckminster Fuller, "Planetary Planning," text of the *Jawaharlal Nehru Memorial Lecture,* New Delhi, India, November 13, 1969.

[15] John N. Bleibtreu, *The Parable of the Beast* (New York: Collier Books, 1969), p. 112.

# The Intermedia Network as Nature

The point I wish to make here is obvious yet vital to an understanding of the function of art in the environment, even though it is consistently ignored by the majority of film critics. It's the idea that man is conditioned by his environment and that "environment" for contemporary man is the intermedia network. We are conditioned more by cinema and television than by nature. Once we've agreed upon this, it becomes immediately obvious that the structure and content of popular cinema is a matter of cardinal importance, at least as serious as most political issues, and thus calls for comment not from journalists but from those who work at the matter, artists themselves.

The cinema isn't just something *inside* the environment; the intermedia network of cinema, television, radio, magazines, books, and newspapers *is* our environment, a service environment that carries the messages of the social organism. It establishes meaning in life, creates mediating channels between man and man, man and society. "In earlier periods such traditional meaning and value communication was carried mainly in the fine and folk arts. But today these are subsumed amongst many communicating modes. The term 'arts' requires expansion to include those advanced technological media which are neither fine nor folk."[16]

We've seen the need for new concepts regarding the nature of existence; yet concepts are expanded or constricted in direct relation to the relevancy of prevailing languages. In a world where change is the only constant, it's obvious we can't afford to rely on traditional cinematic language. The world has changed immeasurably in the seventy years since the birth of cinema: for one thing "world" now includes the microcosm of the atom and the macrocosm of the universe in one spectrum. Still popular films speak a language developed by Griffith, Lumière, Méliès, derived from traditions of vaudeville and literature.

In the Agricultural Age man was totally passive, conditioned and victimized by the environment. In the Industrial Age man's role was

[16] John McHale, "Education for Real," *Good News.*

participatory; he became more aggressive and successful in his attempts to control his environment. We're now moving into the Cybernetic Age in which man learns that to control his environment he must cooperate with it; he not only participates but actually recreates his environment both physical and metaphysical, and in turn is conditioned by it.

To be free of the toil of old relationships we must first be free of the conditioning that instills it within us. As radical evolution gains momentum the need to unlearn our past becomes increasingly clear: contemporary life is a process of miseducation/uneducation/reeducation, at a cost of much precious time. McLuhan has noted that the true significance of Pavlov's experiments was that any controlled man-made environment is a conditioner that creates "nonperceptive somnambulists." Since then science has discovered that "molecular memory" is operative in single-celled and some multicelled organisms, and there's evidence that memory-in-the-flesh exists in humans as well. Biochemists have proven that learned responses to environmental stimuli are passed on phylogenetically from generation to generation, encoded in the RNA of the organism's physical molecular structure.[17] And what could be a more powerful conditioning force than the intermedia network, which functions to establish meaning in life?

Science has proven that there's no such thing as "human nature." Just as water takes the shape of its container, so human nature is relative to its past and present conditioning. Optimum freedom of behavior and increased self-awareness are implicit in the industrial equation that is trending toward physical success for all men; Paleocybernetic man, however, has not learned to control the environment he creates. "The content of what is available for emulation on the part of the young in each society is itself culturally shaped and limited . . . the individual typically remains, throughout his lifetime, unaware of how his own habits, which to him appear 'only natural,' in fact result from a learning process in which he never had an opportunity to attempt alternative responses."[18] This process of

[17] Bleibtreu, *op. cit.*, pp. 85–114.
[18] Segall, Campbell, Herskovits, *op. cit.*, p. 10.

enculturation produces *phenomenal absolutism,* the tendency to interpret our experience as volitional, objective, and absolute; it will have ever-increasing consequences as radical evolution continues to accelerate.

# Popular Culture and the Noosphere

Contemporary man is fortunate to have a tool that makes him aware of his own enculturation and thus he enjoys greater psychic freedom than his ancestors. This tool is what Teilhard de Chardin has called the *noosphere*, the film of organized intelligence that encircles the planet, superposed on the living layer of the biosphere and the lifeless layer of inorganic material, the lithosphere. The minds of three-and-a-half-billion humans—twenty-five percent of all humans who ever lived—currently nourish the noosphere; distributed around the globe by the intermedia network, it becomes a new "technology" that may prove to be one of the most powerful tools in man's history.

John McHale: "World communications . . . diffuse and interpenetrate local cultural tradition, providing commonly-shared cultural experience in a manner unparalleled in human history. Within this global network the related media share and transmit man's symbolic needs and their expression on a world scale. Besides the enlargement of the physical world, these media virtually extend our psychical environment, providing a constant stream of moving, fleeting images of the world for our daily appraisal. They provide *psychic mobility* for the greater mass of our citizens. Through these devices we can telescope time, move through history, and span the world in a great variety of unprecedented ways."[19]

Like all energy sources the noosphere can be used for negative purposes. Its resources can be manipulated to disguise craft as creativity, especially in these Paleocybernetic days when we're still impressed by the sudden influx of information. Fuller has differentiated craft from industry by demonstrating that craft is inherently local in technique and effect whereas industry is inherently comprehensive and universal in technique and effect. One might make a similar analogy between entertainment and art: entertainment is inherently "local," that is, of limited significance, whereas art is inherently universal and of unlimited significance. Too often today we find that so-called artists working in the intermedia network are

[19] John McHale, "The Plastic Parthenon."

little more than adroit imitators, collectors of data and phenomena, which they glean from the noosphere and amalgamate into packages that are far from whole. They're clever and glib; they've made an art of selling themselves, but they know only effect, not cause; they are merchants of mannerisms.

It is precisely this confusion that clouds critical appraisal of "content" in the popular arts. All too frequently eclectic thinking is confused with creative thinking. The distinction is subtle to be sure: integrative thinking can be the highest form of creativity. Indeed both art and science function to reveal similarities within an a priori universe of apparent dissimilarities. As with all else, however, there's an art and a craft to thinking, and the popular entertainments remain at the craft level by the very nature of their purpose.

The intermedia network has made all of us artists by proxy. A decade of television-watching is equal to a comprehensive course in dramatic acting, writing, and filming. Compressed in such constant and massive dosage, we begin to see the methods and clichés more clearly; the mystique is gone—we could almost do it ourselves. Unfortunately too many of us do just that: hence the glut of sub-mediocre talent in the entertainment industry. Paradoxically this phenomenon carries with it the potential of finally liberating cinema from its umbilical to theatre and literature, since it forces the movies to expand into ever more complex areas of language and experience. Evidence of television's effect on the cinema is already apparent, as we shall see in our discussion of synaesthetic cinema. From another more immediate perspective, however, it is quite unfortunate. We live in an age of hyperawareness, our senses extended around the globe, but it's a case of aesthetic overload: our technological zeal has outstripped our psychic capacity to cope with the influx of information. We are adrift on the surface of radical evolution unable to plumb the depths of its swift and turbulent current.

# Art, Entertainment, Entropy

"It is easier to copy than to think, hence fashion. Besides, a community of originals is not a community."

WALLACE STEVENS

The current generation is engaged in an unprecedented questioning of all that has been held essential. We question traditional concepts of authority, ownership, justice, love, sex, freedom, politics, even tradition itself. But it's significant that we don't question our entertainment. The disenfranchised young man who dropped out of college, burned his draft card, braids his hair, smokes pot, and digs Dylan is standing in line with his girl, who takes the pill, waiting to see *The Graduate* or *Bonnie and Clyde* or *Easy Rider*—and they're reacting to the same formulas of conditioned response that lulled their parents to sleep in the 1930's.

We've seen the urgent need for an expanded cinematic language. I hope to illustrate that profit-motivated commercial entertainment, by its very nature, cannot supply this new vision. Commercial entertainment works against art, exploits the alienation and boredom of the public, by perpetuating a system of conditioned response to formulas. Commercial entertainment not only isn't creative, it actually destroys the audience's ability to appreciate and participate in the creative process. The implications become apparent when we realize that, as leisure time increases, each human will be forced to become a creative, self-sufficient, empirical energy laboratory.

D. H. Lawrence has written: "The business of art is to reveal the relation between man and his circumambient universe at this living moment. As mankind is always struggling in the toil of old relationships, art is always ahead of its 'times,' which themselves are always far in the rear of the living present." Jean-Jacques Lebel stated the same idea in different terms when he described art as "the creation of a new world, never seen before, imperceptibly gaining on reality."[20]

[20] Jean-Jacques Lebel, "On the Necessity of Violation," *The Drama Review* (Fall, 1968).

We've seen that man is conditioned by, and reacts to, certain stimuli in the man-made environment. The commercial entertainer is a manipulator of these stimuli. If he employs a certain trigger mechanism, we're guaranteed to react accordingly, like puppets, providing he manipulates the trigger properly. I'm not saying the artist doesn't resort to audience manipulation; we know he often does. The point, however, is the motivation in doing so. If the artist must resort to trigger mechanisms to make himself clear, he will; but it's only a means to his end. In the case of the commercial entertainer, however, it's the end in itself.

Plot, story, and what commonly is known as "drama" are the devices that enable the commercial entertainer to manipulate his audience. The very act of this manipulation, gratifying conditioned needs, is what the films actually are about. The viewer purchases it with his ticket and is understandably annoyed if the film asks him to manipulate himself, to engage in the creative process along with the artist. Our word poetry derives from the Greek root *poiein* meaning "to make" or "to work." The viewer of commercial entertainment cinema does not want to work; he wants to be an object, to be acted upon, to be manipulated. The true subject of commercial entertainment is this little game it plays with its audience.

By perpetuating a destructive habit of unthinking response to formulas, by forcing us to rely ever more frequently on memory, the commercial entertainer encourages an unthinking response to daily life, inhibiting self-awareness. Driven by the profit motive, the commercial entertainer dares not risk alienating us by attempting new language even if he were capable of it. He seeks only to gratify preconditioned needs for formula stimulus. He offers nothing we haven't already conceived, nothing we don't already expect. Art explains; entertainment exploits. Art is freedom from the conditions of memory; entertainment is conditional on a present that is conditioned by the past. Entertainment gives us what we want; art gives us what we don't know we want. To confront a work of art is to confront oneself—but aspects of oneself previously unrecognized.

The extent to which blatant audience manipulation not only is tolerated but extolled is alarming. Alfred Hitchcock, for example, in his interview with François Truffaut, finds merit in his ability to manipulate preconditioned needs for formula stimulus. Speaking of

*Psycho,* Hitchcock frankly admits: "It wasn't a message that stirred them, nor was it a great performance, or their enjoyment of the novel . . . they were aroused by the construction of the story, and the way in which it was told caused audiences all over the world to react and become emotional."[21]

It is essential to understand that Hitchcock openly admits that he didn't even try to expand awareness or to communicate some significant message, but only exploited a universal tradition of dramatic manipulation in order to supply his audience with the gratification it paid for. The audience sees itself and its dreams reflected in the film and reacts according to memory, which Krishnamurti has characterized as being always conditioned. "Memory," says Krishnamurti, "is always in the past and is given life in the present by a challenge. Memory has no life in itself; it comes to life in the challenge [preconditioned formula stimulus]. And all memory, whether dormant or active, is conditioned."[22] It is this process that the entertainment industry calls audience identification.

To a healthy mind, anything that is primarily art is also immensely entertaining. It seems obvious that the most important things should be the most entertaining. Where there's a difference between what we "like" and what we know to be vital, we have a condition of schizophrenia, an unnatural and destructive situation. I speak deliberately of a "healthy" mind as one capable of creative thinking. Filmmaker Ken Kelman: "The old cinema removes experience, making us see things along with (or through) a protagonist with whom we identify, and a plot in which we are caught. Such an approach tends toward not only a lack of viewpoint, of definition of *whose* experience it is, but also filters the power of sight into mere habit, dissolves insight into vicariousness. The spectator is reduced to a voyeur—which is, increasingly, the individual's role in society at large."[23]

Minimalist painter David Lee: "When people do not trust their senses they lack confidence in themselves. For the last few centuries people have lacked confidence. They have not trusted their experi-

---

[21] François Truffaut, *Hitchcock* (New York: Simon & Schuster, 1968), p. 211.
[22] Krishnamurti, *op. cit.,* p. 54.
[23] Ken Kelman, "Anticipations of the Light," *The New American Cinema,* ed. Gregory Battcock (New York: Dutton Paperbacks, 1967), pp.. 24, 25.

ence to provide a standard for knowing how to act."[24] It is quite obvious that most of us not only don't know much about art, we don't even know what we like. Krishnamurti: "One of the fundamental causes of the disintegration of society is copying, which is the worship of authority."[25]

Imitation is the result of inadequate information. Information results in change. Change requires energy. Energy is the result of adequate information. Energy is directly proportional to the amount of information about the structure of a system. Norbert Wiener: "Information is a name for the content of what is exchanged with the outer world as we adjust to it and make our adjustment felt upon it . . . to live effectively is to live with adequate information."[26] From the cinema we receive conceptual information (ideas) and design information (experiences). In concert they become one phenomenon, which I've described as the experiential information of aesthetic conceptual design. This information is either useful (additive) or redundant. Useful information accelerates change. Redundant information restricts change. If sustained long enough redundant information finally becomes misinformation, which results in negative change.

In communication theory and the laws of thermodynamics the quantity called entropy is the amount of energy reversibly exchanged from one system in the universe to another. Entropy also is the measure of disorder within those systems. It measures the lack of information about the structure of the system. For our purposes "structure of the system" should be taken to mean "the human condition," the universal subject of aesthetic activity. Entropy should be understood as the degree of our ignorance about that condition. Ignorance always increases when a system's messages are redundant. Ignorance is not a state of limbo in which no information exists, but rather a state of increasing chaos due to *mis*information about the structure of the system.

The First Law of Thermodynamics states that energy is constant: it cannot be created or destroyed; its form can change, but not its

24 David Lee, "A Systematic Revery from Abstraction to Now," *Minimal Art,* ed. Gregory Battcock (New York: E. P. Dutton, 1968), p. 195.

25 Krishnamurti, *op. cit.,* p. 41.

26 Wiener, *op. cit.,* pp. 26, 27.

quantity. The Second Law states that the amount of energy within a local system is naturally entropic—it tends toward disorder, dissipation, incoherence. And since energy is defined as "a capacity to rearrange elemental order," entropy, which runs counter to that capacity, means less potential for change. We've learned from physics that the only anti-entropic force in the universe, or what is called negentropy (negative entropy), results from the process of feedback. Feedback exists between systems that are not closed but rather open and contingent upon other systems. In the strictest sense there are no truly "closed" systems anywhere in the universe; all processes impinge upon and are affected by other processes in some way. However, for most practical purposes, it is enough to say that a system is "closed" when entropy dominates the feedback process, that is, when the measure of energy lost is greater than the measure of energy gained.

The phenomenon of man, or of biological life on earth taken as a process, is negentropic because its subsystems feed energy back into one another and thus are self-enriching, regenerative. Thus energy is wealth, and wealth according to Buckminster Fuller is "the number of forward days a given system is sustainable." Biologist John Bleibtreu arrived at a similar conclusion when he noted that the concept of time can best be viewed as a function of the Second Law of Thermodynamics—that the measure of entropy in a system is a measure of its age, or the passage of time since the system originated.[27] In other words the degree of a system's entropy is equal to redundancy or stasis whereas its negentropy is equal to kinesis or change. So information becomes energy when it contributes to the self-enriching omni-regenerative wealth of the system. When it's not contributing (i.e., redundant) it is allowing the natural entropy to increase.

"It is possible to treat sets of messages as having an entropy like sets of states of the external world . . . in fact, it is possible to interpret the information carried by a message as essentially the negative of its entropy . . . that is, the more probable the message the less information it gives. Clichés, for example, are less illuminating than great poems."[28] Thus the more information concerning the

[27] Bleibtreu, *op. cit.*, p. 15.
[28] Wiener, *op. cit.*, p. 31.

human condition that the artist is able to give us, the more energy we have with which to modify ourselves and grow in accord with the accelerating accelerations of the living present.

Commercial entertainment may be considered a closed system since entropy dominates the feedback process. To satisfy the profit motive the commercial entertainer must give the audience what it expects, which is conditional on what it has been getting, which is conditional on what it previously received, ad infinitum. Inherent in the term "genre," which applies to all entertainment, is that it must be probable. The content of westerns, gangster movies, romances, etc., is probable in that it can be identified and comprehended simply by classification. The phenomenon of drama itself usually is not considered a genre, but is in fact the most universal and archetypical of all genres. Drama, by definition, means conflict, which in turn means suspense. Suspense is requisite on the expectation of known alternatives. One cannot expect the unknown. Therefore expectation, suspense, and drama are all redundant probable qualities and thus are noninformative.

Drama requires a plot that forces the viewer to move from point A to point B to point C along predetermined lines. Plot does not mean "story" (beginning-middle-end). It simply indicates a relatively closed structure in which free association and conscious participation are restricted. Since the viewer remains passive and is acted upon by the experience rather than participating in it with volition, there's no feedback, that vital source of negentropy. Norbert Wiener: "Feedback is a method of controlling a system by reinserting into it the results of its past performance . . . if the information which proceeds backward from the performance is able to change the general method and pattern of performance, we have a process which may well be called learning."[29] Fuller: "Every time man makes a new experiment he always learns more. He cannot learn less."[30]

In the cinema, feedback is possible almost exclusively in what I call the synaesthetic mode, which we'll discuss presently. Because it is entirely personal it rests on no identifiable plot and is not probable. The viewer is forced to create along with the film, to interpret

[29] *Ibid.*, p. 84.
[30] Fuller, *Spaceship Earth*, p. 92.

for himself what he is experiencing. If the information (either concept or design) reveals some previously unrecognized aspect of the viewer's relation to the circumambient universe—or provides language with which to conceptualize old realities more effectively— the viewer re-creates that discovery along with the artist, thus feeding back into the environment the existence of more creative potential, which may in turn be used by the artist for messages of still greater eloquence and perception. If the information is redundant, as it must be in commercial entertainment, nothing is learned and change becomes unlikely. The noted authority on communication theory, J. R. Pierce, has demonstrated that an increase in entropy means a decrease in the ability to change.[31] And we have seen that the ability to change is the most urgent need facing twentieth-century man.

The notion of experimental art, therefore, is meaningless. All art is experimental or it isn't art. Art is research, whereas entertainment is a game or conflict. We have learned from cybernetics that in research one's work is governed by one's strongest points, whereas in conflicts or games one's work is governed by its weakest moments. We have defined the difference between art and entertainment in scientific terms and have found entertainment to be inherently entropic, opposed to change, and art to be inherently negentropic, a catalyst to change. The artist is always an anarchist, a revolutionary, a creator of new worlds imperceptibly gaining on reality. He can do this because we live in a cosmos in which there's always something more to be seen. When finally we erase the difference between art and entertainment—as we must to survive—we shall find that our community is no longer a community, and we shall begin to understand radical evolution.

[31] J. R. Pierce, *Symbols, Signals and Noise* (New York: Harper & Brothers, 1961).

# Retrospective Man and the Human Condition

The image I would offer as representative of the Paleocybernetic Age is that of the dying man whose life passes before him: a Retrospective Man who discovers the truth about himself too late to make use of it. The information explosion is not a window on the future so much as a mirror of the past catching up with the present. The intermedia network, or global communications grid, taps knowledge resources that always have existed in discrete social enclaves around the planet and saturates them into the collective consciousness. Suddenly the mass public "discovers" African culture, East Indian and American Indian cultures, folk music, politics. Knowledge previously the domain of scholars becomes common knowledge, and precisely at that point when the old order is about to fade it sees itself clearly for the first time. William Burroughs has called it the Age of Total Confront, noting that all the heretofore invisible aspects of our condition have quite suddenly become visible.

Through Duchamp, Cage, and Warhol, for example, we have rediscovered art in the ancient Platonic sense in which there's no difference between the aesthetic and the mundane. Although these men certainly fulfill an *avant-garde* function in present society, they in fact conform to the most universal and enduring definition of art. If they've been rejected as artists by the majority of our citizens it's because we've been conditioned by an economic system in which aesthetic concerns must assume a secondary position if the system is to survive. Thus art is separated from common experience and an elite hierarchy is established, which seems only natural to everyone caught up in the economic struggle. John Dewey: "When art attains classic status it becomes isolated from the human conditions under which it was brought into being and from the human consequences it engenders in actual life experience . . . when, because of their remoteness, the objects acknowledged by the cultivated to be works of fine art seem anemic to the mass of people, aesthetic hunger is likely to seek the cheap and the vulgar."[32]

Twentieth-century man is retrospective also because the symbolic

[32] John Dewey, *Art as Experience* (New York: Capricorn, 1958), pp. 3, 6.

and value content of his messages—most of which take the form of commercial entertainment—is predominantly redundant. Norbert Wiener: "Society can only be understood through a study of the messages and the communication facilities which belong to it."[33] Almost without exception, these messages tend to be concerned with what is known as the "human condition." The history of popular entertainment, in terms of its conceptual content, can be divided into three general categories: (1) *idealization,* which corresponds to states of happiness in which life is seen as a heavenly experience and man is characterized by his most noble deeds; (2) *frustration,* an expression of the conflict between inner and outer realities, when what *is* is not what should be; (3) *demoralization,* generally expressed as "the blues." In commercial entertainment cinema these three formulas are followed religiously, almost without exception, and usually comprise the nature of the message. They are the human condition, that which is taken for granted, the given, the facts of life. Everyone has ideals, everyone is frustrated, everyone gets the blues. But this information is redundant; we must go on from there.

Commercial entertainment is "popular" and not what we call art because it doesn't go on from there. To insure the widest possible acceptance of his message, the commercial entertainer must speak a common language. He copies, repeats, or imitates that which already exists within the grasp of the so-called average man. And the majority of us embrace it because it offers security, a crutch, in the knowledge that the miseries we suffer are shared by others. But art transcends the human condition. The artist doesn't want to hear our problems and our dreams—he already knows them. Instead he wants to know what we're doing about them, and he gives us the instruments we need for the task. The symbol is the basic instrument of thought; those who create new symbols—artists, scientists, poets, philosophers—are those who, by giving us new instruments to think with, give us new areas to explore in our thinking.

A rather indignant woman once asked me how I could have the nerve to suggest that an "abstract" film like Brakhage's *Dog Star Man* could be more important than an immortal classic like Renoir's *The Grand Illusion.* The new consciousness takes the view that films

[33] Wiener, *op. cit.,* p. 25.

like Renoir's do not contain one single insight into the nature of the human condition that has not already been absorbed by the collective consciousness. Bob Dylan: "How many times must a man look up before he can see the sky? How many ears must one man have before he can hear people cry?" And my own question: how many times must we acknowledge the human condition before it becomes redundant? How long must we tolerate the same facts of life before we begin seeking new facts? We intuit that the human condition has expanded since yesterday, but the popular arts aren't telling us. The human condition does not stop with what we know about ourselves. Each genuinely new experience expands the definition of the human condition that much more. Some are seeking those new facts, those new experiences, through the synaesthetic research of expanded cinema.

Barbara Rose: "The new art . . . posits an entirely new world view which shifts cultural values from a death-oriented, commemorative, past-enshrining culture to a life-oriented, present-oriented civilization . . . In this sense [Claes] Oldenburg's monuments represent, as he contended, not the appearance of something, but its disappearance . . . the tomb, the memorial, the shrine, the monument, all belong to cultures that commemorate."[34]

John McHale: "The problem now is that those areas of our formal education which deal with the symbolic and value content of our culture do so almost entirely in terms of the past[35]. . . . The new educational technologies are largely being used as twentieth-century channels to convey a conceptual context which is still nineteenth century or earlier. The most recent example was mathematics, where the Sputnik-inspired 'second look' revealed that mathematics as generally taught was quite out of date. Science has begun to take a second look at its contents as currently taught. But the arts and humanities remain relatively unaware of any need to revise the conceptual framework of studies little removed from the polite education of eighteenth-century gentry."[36]

The entropy of commercial entertainment is the chaos that results from its retrospective nature, forever commemorating past events,

[34] Barbara Rose, "Problems of Criticism, VI," *Artforum* (May, 1969), p. 50.
[35] McHale, "Education for Real," *Good News*.
[36] McHale, "Information Explosion," *Good News*.

historical figures, social eras, life-styles, or the memory of the viewer, while the living present speeds farther from our grasp. Alvin Toffler: "We offer children courses in history; why not also make a course in 'future' a prerequisite for every student? A course in which the possibilities and probabilities of the future are systematically explored exactly as we now explore the social system of the Romans or the rise of the feudal manor?"[37] We invent the future in the present. We are what we think the future will be.

[37] Toffler, *op. cit.*

# The Artist as Design Scientist

Our discussion obviously has excluded many important works of art that function completely within the genres of drama, plot, and story. *Citizen Kane, L'Avventura, Pierrot le Fou,* and *8½* are dramatic, plot films, yet no one denies their greatness. We know also that most of the truly significant films such as *Beauty and the Beast* or *Pather Panchali* operate entirely within parameters of the human condition as generally recognized. Moreover, common sense tells us that the artist *must* work with what exists, with the given, the human condition; he could produce no art at all if he relied exclusively on information that is totally new.

Yet the undeniable aesthetic value of these works does not contradict what I have said about art and entertainment. These films transcend their genres. They are not important for their plots or stories but rather for their design. Susan Sontag: "If there is any 'knowledge' to be gained through art, it is the experience of the form or style of knowing the subject, rather than a knowledge of the subject itself."[38]

To perceive that the artist functions as design scientist we must first understand that in their broadest implications art and science are the same. Eddington's classic definition of science, "The earnest attempt to set in order the facts of experience," corresponds with Bronowski's view of science as "The organization of knowledge in such a way that it commands more of the hidden potential in nature . . . all science is the search for unity in hidden likenesses."[39] It's the same in art: to set in order the facts of experience is to reveal the relation between man and his circumambient universe with all its hidden potential.

Herbert Read: "Only in so far as the artist establishes symbols for the representation of reality can mind, as a structure of thought, take shape. The artist establishes these symbols by becoming con-

[38] Susan Sontag, "On Style," *Against Interpretation* (New York: Delta Books), p. 22.

[39] J. Bronowski, *Science and Human Values* (New York: Harper & Brothers, 1965), pp. 3, 13.

**70**

scious of new aspects of reality and by representing his consciousness in plastic or poetic form . . . it follows that any extension of awareness of reality, any groping beyond the threshold of present knowledge, must first establish its sensuous imagery."[40]

Our word "design" is composed of "de" and "sign," indicating that it means "to remove the symbol of." In this context "symbol" signifies ideas distinct from experiences. As design scientist the artist discovers and perfects language that corresponds more directly to experience; he develops hardware that embodies its own software as a conceptual tool for coping with reality. He separates the image from its official symbolic meaning and reveals its hidden potential, its process, its actual reality, the experience of the thing. (A. N. Whitehead: "Process and existence pre-suppose each other.") He establishes certain parameters that define a discrete "special case" phenomenon, principle, or concept known as the subject. The work, in effect, poses this "problem" of perception and we as viewers must draw from this special case all the "general case" metaphysical relationships that are encoded within the language of the piece.

This language is the experiential information of aesthetic conceptual design; it is addressed to what Wittgenstein termed the "inarticulate conscious," the domain between the subconscious and the conscious that can't be expressed in words but of which we constantly are aware. The artist does not point out new facts so much as he creates a new language of conceptual design information with which we arrive at a new and more complete understanding of old facts, thus expanding our control over the interior and exterior environments.

The *auteur* theory of personal cinema indicates those instances when the filmmaker's design science transcends the parameters of his genre; our comprehension of that genre, that human condition, is thus expanded. But cybernetics has demonstrated that the structure of a system is an index of the performance which may be expected from it.[41] That is, the conceptual design of a movie determines the variety and amount of information we're likely to obtain from it. And since we've seen that the amount of information is

[40] Herbert Read, *Icon and Idea* (New York: Schocken Books, 1965), p. 53.
[41] Wiener, *op. cit.*, p. 79.

directly proportional to the degree of available choices we can see that drama, story, and plot, which restrict choice, also restrict information. So the auteur is limited to developing new designs for old information, which we all know can be immensely enjoyable and instructive. There are no "new" ideas in *L'Avventura*, for example, but Antonioni voiced the inarticulate conscious of an entire generation through the conceptual and structural integrity of his transcendental design science, merging sense and symbol, form and content.

Rudolph Arnheim: "Perceiving achieves at the sensory level what in the realm of reasoning is known as understanding . . . eyesight is insight."[42] If we realize that insight means to see intuitively, we acknowledge that Arnheim's assertion is true only when ordinary vision—conditioned and enculturated by the most vulgar of environments—is liberated through aesthetic conceptual design information. Film is a way of seeing. We see through the filmmaker's eyes. If he's an artist we become artists along with him. If he's not, information tends toward misinformation.

The artist's intuitive sense of proportion corresponds to the phenomenon of absolute pitch in musicians and answers a fundamental need in comprehending what we apprehend. In the final analysis our aptitudes and our psychological balance are a result of our relation to images. The image precedes the idea in the development of consciousness: an infant doesn't think "green" when it looks at a blade of grass. It follows that the more "beautiful" the image the more beautiful our consciousness.

The design of commercial entertainment is neither a science nor an art; it answers only to the common taste, the accepted vision, for fear of disturbing the viewer's reaction to the formula. The viewer's taste is conditioned by a profit-motivated architecture, which has forgotten that a house is a machine to live in, a service environment. He leaves the theatre after three hours of redundancy and returns home to a symbol, not a natural environment in which beauty and functionality are one. Little wonder that praise is heaped on films whose imagery is on the level of calendar art. Global man stands on the moon casually regarding the entire spaceship earth in a glance,

[42] Rudolph Arnheim, *Art and Visual Perception* (Los Angeles, Calif.: University of California Press, 1954), p. 37.

yet humanity still is impressed that a rich Hollywood studio can lug its Panavision cameras over the Alps and come back with pretty pictures. "Surpassing visual majesty!" gasp the critics over *A Man and a Woman* or *Dr. Zhivago*. But with today's technology and unlimited wealth who couldn't compile a picturesque movie? In fact it's a disgrace when a film is not of surpassing visual majesty because there's a lot of that in our world. The new cinema, however, takes us to another world entirely. John Cage: "Where beauty ends is where the artist begins."

# PART TWO:
## SYNAESTHETIC CINEMA: THE END OF DRAMA

"The final poem will be the poem of fact in the language of fact. But it will be the poem of fact not realized before."

<div align="right">WALLACE STEVENS</div>

Expanded cinema has been expanding for a long time. Since it left the underground and became a popular avant-garde form in the late 1950's the new cinema primarily has been an exercise in technique, the gradual development of a truly cinematic language with which to expand further man's communicative powers and thus his awareness. If expanded cinema has had anything to say, the message has been the medium.[1] Slavko Vorkapich: "Most of the films made so far are examples not of creative use of motion-picture devices and techniques, but of their use as recording instruments only. There are extremely few motion pictures that may be cited as instances of creative use of the medium, and from these only fragments and short passages may be compared to the best achievements in the other arts."[2]

It has taken more than seventy years for global man to come to terms with the cinematic medium, to liberate it from theatre and literature. We had to wait until our consciousness caught up with our technology. But although the new cinema is the first and only true cinematic language, it still is used as a recording instrument. The recorded subject, however, is not the objective external human condition but the filmmaker's consciousness, his perception and its

[1] For a comprehensive in-depth history of this development, see: Sheldon Renan, *An Introduction to the American Underground Film* (New York: Dutton Paperbacks, 1967). And for a survey of initial critical reaction, see: *The New American Cinema,* ed. Gregory Battcock (New York: Dutton Paperbacks, 1967).

[2] Slavko Vorkapich, "Toward True Cinema," in *Film: A Montage of Theories,* ed. Richard Dyer MacCann (New York: Dutton Paperbacks, 1966), p. 172.

process. If we've tolerated a certain absence of discipline, it has been in favor of a freedom through which new language hopefully would be developed. With a fusion of aesthetic sensibilities and technological innovation that language finally has been achieved. The new cinema has emerged as the only aesthetic language to match the environment in which we live.

Emerging with it is a major paradigm: a conception of the nature of cinema so encompassing and persuasive that it promises to dominate all image-making in much the same way as the theory of general relativity dominates all physics today. I call it *synaesthetic cinema.* In relation to traditional cinema it's like the science of bionics in relation to previous notions of biology and chemistry: that is, it models itself after the patterns of nature rather than attempting to "explain" or conform nature in terms of its own structure. The new artist, like the new scientist, does not "wrest order our of chaos." Both realize that supreme order lies in nature and traditionally we have only made chaos out of it. The new artist and the new scientist recognize that chaos *is* order on another level, and they set about to find the rules of structuring by which nature has achieved it. That's why the scientist has abandoned absolutes and the filmmaker has abandoned montage.

Herbert Read: "Art never has been an attempt to grasp reality as a whole—that is beyond our human capacity; it was never even an attempt to represent the totality of appearances; but rather it has been the piecemeal recognition and patient fixation of what is significant in human experience."[3] We're beginning to understand that "what is significant in human experience" for contemporary man is the awareness of consciousness, the recognition of the process of perception. (I define perception both as "sensation" and "conceptualization," the process of forming concepts, usually classified as "cognition." Because we're enculturated, to perceive is to interpret.) Through synaesthetic cinema man attempts to express a total phenomenon—his own consciousness.[4]

[3] Read, *Icon,* p. 18.

[4] In defining consciousness I concur with R. G. Collingwood: "The kind of thought which stands closest to sensation or mere feeling. Every further development of thought is based upon it and deals not with feeling in its crude form but with feeling as thus transformed into imagination." *Principles of Art* (Oxford: Clarendon Press, 1938), p. 223.

Synaesthetic cinema is the only aesthetic language suited to the post-industrial, post-literate, man-made environment with its multi-dimensional simulsensory network of information sources. It's the only aesthetic tool that even approaches the reality continuum of conscious existence in the nonuniform, nonlinear, nonconnected electronic atmosphere of the Paleocybernetic Age. "As visual space is superseded," McLuhan observes, "we discover that there is no continuity or connectedness, let alone depth and perspective, in any of the other senses. The modern artist—in music, in painting, in poetry—has been patiently expounding this fact for decades."[5] The modern synaesthetic filmmaker has been patiently expounding this fact for decades as well, and with far more success than painters or poets.

Finally, I propose to show that synaesthetic cinema transcends the restrictions of drama, story, and plot and therefore cannot be called a genre. In addition to matching McLuhan's view of contemporary existence, it also corresponds to Buckminster Fuller's observations on natural synergetics and consequently is negentropic. Before discussing specifics, however, we must first understand why synaesthetic cinema is just now being developed into a universal language, more than seventy years after the birth of the medium. Like most everything else, it's because of television.

[5] Marshall McLuhan, Quentin Fiore, *War and Peace in the Global Village* (New York: Bantam Books), p. 13.

# Global Closed Circuit: The Earth as Software

## Television Renders Cinema Obsolete
## as Communicator of Objective Reality

Just as every fact is also metaphysical, every piece of hardware implies software: information about its existence. Television is the software of the earth. Television is invisible. It's not an object. It's not a piece of furniture. The television set is irrelevant to the phenomenon of television. The videosphere is the noosphere transformed into a perceivable state. "Television," says video artist Les Levine, "is the most obvious realization of software in the general environment. It shows the human race itself as a working model of itself. It renders the social and psychological condition of the environment visible to the environment."

A culture is dead when its myths have been exposed. Television is exposing the myths of the republic. Television reveals the observed, the observer, the process of observing. There can be no secrets in the Paleocybernetic Age. On the macrostructural level all television is a closed circuit that constantly turns us back upon ourselves. Humanity extends its video Third Eye to the moon and feeds its own image back into its monitors. "Monitor" is the electronic manifestation of superego. Television is the earth's superego. We become aware of our individual behavior by observing the collective behavior as manifested in the global videosphere. We identify with persons in news events as once we identified with actors or events in fiction films. Before television we saw little of the human condition. Now we see and hear it daily. The world's not a stage, it's a TV documentary. Television extends global man throughout the ecological biosphere twenty-four hours a day. By moving into outer space, television reveals new dimensions of inner space, new aspects of man's perception and the results of that perception.

This implosive, self-revealing, consciousness-expanding process is irreversible. Global information is the natural enemy of local government, for it reveals the true context in which that government is

operating. Global television is directly responsible for the political turmoil that is increasing around the world today. The political establishments sense this and are beginning to react. But it's too late. Television makes it impossible for governments to maintain the illusion of sovereignty and separatism which is essential for their existence. Television is one of the most revolutionary tools in the entire spectrum of technoanarchy.

We recognize television's negative effect on the popular arts: that it induces a kind of sedentary uniformity of expression and generates a false sense of creativity. In its broader consequences, however, television releases cinema from the umbilical of theatre and literature. It renders cinema obsolete as communicator of the objective human condition. It has affected cinema in much the same way as the invention of photography affected sculpture and painting. Cubism and other means of abstracting the realistic image were born with the photographic plate because painting no longer provided the most realistic images. The plastic arts abandoned exterior reality for interior reality. The same has happened to cinema as a result of television: movies no longer provide the most realistic images so they've turned inward.

We're in direct contact with the human condition; there's no longer any need to represent it through art. Not only does this release cinema; it virtually forces cinema to move beyond the objective human condition into newer extra-objective territory. There are manifold trends that indicate that virtually all cinema has felt the profound impact of television and is moving inevitably toward synaesthesis. The progression naturally includes intermediary steps first toward greater "realism," then *cinéma-vérité*, before the final and total abandon of the notion of reality itself. The fact that we're now approaching the peak of the realism stage is demonstrated by Warhol, for example, whose recent work contrasts "reality" with "realism" as manifested in the spontaneous behavior of actors pretending to be acting. In addition there's virtually all of Godard's work, as well as John Cassavetes' *Faces*, James McBride's *David Holzman's Diary*, Peter Watkins' *The War Game*, Gillo Pontecorvo's *The Battle of Algiers*, Paul Morrissey's *Flesh*, and Stanton Kaye's *Georg* and *Brandy in the Wilderness*.

Most of this work is characterized by an astute blending of

scripted and directed acting with spontaneous improvisation, in which the actor randomly fills in the parameters of a characterization predetermined and predestined by the director. Yet precisely because they attempt to approximate objective reality without actually being real places them firmly in the tradition of conventional Hollywood pretend movies, with the exception of camera presence or what might be called process-level perception.

It's only natural that contemporary filmmakers should be more successful at imitating reality since the intermedia network makes us more familiar with it. But there's a curious and quite significant aspect to the nature of this new realism: by incorporating a kind of bastardized *cinéma-vérité* or newsreel style of photography and behavior, the filmmaker has not moved closer to actual unstylized reality itself but rather a reality prestylized to approximate our primary mode of knowing natural events: television. We accept it as being more realistic because it more closely resembles the process-level perception of TV watching, in which unstylized reality is filtered and shaped through the process of a given medium.

The traditional dramatic structure of these films becomes more easily discernible in contrast with pure *cinéma-vérité* work such as Jean Rouch's *Chronicle of a Summer,* Pennebaker's *Don't Look Back,* or Chris Marker's brilliant *Le Joli Mai.* A comparison of *Faces* or *David Holzman's Diary* with Warhol's *Nude Restaurant* is even more revealing: the difference between prestylized and predestined realities on the one hand, and Warhol's totally random and only partially prestylized reality on the other, is brought into sharp focus. Warhol has expressed regret that a camera cannot simply be switched on and left running for twenty-four hours, since the "important" (naturally-revealing) events seem to occur at that moment just after it stops turning. Godard disclosed similar sentiments when he said: "The ideal for me is to obtain right away what will work. If retakes are necessary it falls short of the mark. The immediate is chance. At the same time it is definitive. What I want is the definitive by chance."

# Synaesthetic Synthesis:
## Simultaneous Perception of Harmonic Opposites

Time, said St. Augustine, is a threefold present: the present as we experience it; the past as present memory; the future as present expectation. Hopi Indians, who thought of themselves as caretakers of the planet, used only the present tense in their language: past was indicated as "present manifested," and the future was signified by "present manifesting."[6] Until approximately 800 B.C., few cultures thought in terms of past or future: all experience was synthesized in the present. It seems that practically everyone but contemporary man has intuitively understood the space-time continuum.

Synaesthetic cinema is a space-time continuum. It is neither subjective, objective, nor nonobjective, but rather all of these combined: that is to say, *extra-objective*. Synaesthetic and psychedelic mean approximately the same thing. Synaesthesis is the harmony of different or opposing impulses produced by a work of art. It means the simultaneous perception of harmonic opposites. Its sensorial effect is known as *synaesthesia*, and it's as old as the ancient Greeks who coined the term. Under the influence of mind-manifesting hallucinogens one experiences synaesthesia in addition to what Dr. John Lilly calls "white noise," or random signals in the control mechanism of the human bio-computer.[7]

Any dualism is composed of harmonic opposites: in/out, up/down, off/on, yes/no, black/white, good/bad. Past aesthetic traditions, reflecting the consciousness of their period, have tended to concentrate on one element at a time. But the Paleocybernetic experience doesn't support that kind of logic. The emphasis of traditional logic might be expressed in terms of an *either/or* choice, which in physics is known as *bistable logic*. But the logic of the Cybernetic Age into which we're moving will be *both/and*, which in

[6] Benjamin Whorf, *Language, Thought and Reality* (Cambridge, Mass.: Massachusetts Institute of Technology, Publications Office, 1956).

[7] John C. Lilly, *The Human Bio-Computer* (Miami, Fla.: Communications Research Institute, 1967).

physics is called *triadic logic*. Physicists have found they can no longer describe phenomena with the binary yes/no formula but must operate with yes/no/maybe.

The accumulation of facts is no longer of top priority to humanity. The problem now is to apply existing facts to new conceptual wholes, new vistas of reality. By "reality" we mean relationships. Piet Mondrian: "As nature becomes more abstract, a relation is more clearly felt. The new painting has clearly shown this. And that is why it has come to the point of expressing nothing but relations."[8] Synaesthetic cinema is an art of relations: the relations of the conceptual information and design information within the film itself graphically, and the relation between the film and the viewer at that point where human perception (sensation and conceptualization) brings them together. As science gropes for new models to accommodate apparent inconsistencies and contradictions, the need for seeing incompatibles together is more easily discerned. For example, the phenomenon of light is conceived in *both/and* terms: both continuous wave motions and discontinuous particles. And we have noted our incapacity for observing both movement and position of electrons.

This is but one of many reasons that synaesthetic cinema is the only aesthetic language suited to contemporary life. It can function as a conditioning force to unite us with the living present, not separate us from it. My use of the term synaesthetic is meant only as a way of understanding the historical significance of a phenomenon without historical precedent. Actually the most descriptive term for the new cinema is "personal" because it's only an extension of the filmmaker's central nervous system. The reader should not interpret "synaesthetic" as an attempt to categorize or label a phenomenon that has no definition. There's no single film that could be called typical of the new cinema because it is defined anew by each individual filmmaker.

I've selected about seven films that are particularly representative of the various points I wish to make. I'm using them only to illuminate the nature of synaesthetic cinema in general, not as specific archetypal examples. Sufficient literature exists on Brakhage's *Dog*

[8] Piet Mondrian, *Plastic Art and Pure Plastic Art* (New York: Wittenborn, Schultz, Inc., 1945), p. 50.

*Star Man* to preclude any major expository analysis here, but it is exemplary of virtually all concepts involved in the synaesthetic mode, in particular syncretism and metamorphosis. Will Hindle's *Chinese Firedrill* is an outstanding example of the evocative language of synaesthetic cinema as distinct from the expositional mode of narrative cinema. Pat O'Neill's *7362*, John Schofill's *XFilm*, and Ronald Nameth's *Exploding Plastic Inevitable* provide some insight into kinaesthetics and kinetic empathy. Carolee Schneemann's *Fuses*, in contrast with Warhol's *Blue Movie* and Paul Morrissey's *Flesh*, illustrates the new polymorphous eroticism. And, finally, Michael Snow's *Wavelength* has been chosen for its qualities of extra-objective constructivism.

# Syncretism and Metamorphosis:
# Montage as Collage

The harmonic opposites of synaesthetic cinema are apprehended through syncretistic vision, which Anton Ehrenzweig has characterized as: "The child's capacity to comprehend a total structure rather than analyzing single elements . . . he does not differentiate the identity of a shape by watching its details one by one, but goes straight for the whole."[9] Syncretism is the combination of many different forms into one whole form. Persian tapestries and tile domes are syncretistic. Mandalas are syncretistic. Nature is syncretistic. The majority of filmgoers, conditioned by a lifetime of conventional narrative cinema, make little sense of synaesthetic cinema because their natural syncretistic faculty has suffered entropy and atrophy.

Buckminster Fuller: "All universities have been progressively organized for ever-finer specialization. Society assumes that specialization is natural, inevitable and desirable. Yet in observing a little child we find it is interested in everything and spontaneously apprehends, comprehends and coordinates an ever-expanding inventory of experience."[10]

It has been demonstrated that all species of life on earth that have become extinct were doomed through overspecialization, whether anatomical, biological, or geological. Therefore conventional narrative cinema, in which the filmmaker plays policeman guiding our eyes here and there in the picture plane, might be described as "specialized vision," which tends to decay our ability to comprehend the more complex and diffuse visual field of living reality.

The general impression that syncretism, and therefore synaesthetic cinema, is empty of detail or content is an illusion: ". . . it is highly sensitive to the smallest of cues and proves more efficient in

[9] Anton Ehrenzweig, *The Hidden Order of Art* (Berkeley, Calif.: University of California Press, 1967), p. 9.

[10] Fuller, *Operating Manual for Spaceship Earth* (Carbondale, Ill.: Southern Illinois University Press, 1969), p. 13.

identifying individual objects. It impresses us as empty, vague and generalized only because the narrowly-focused surface consciousness cannot grasp its wider more comprehensive structure. Its precise, concrete content has become inaccessible and 'unconscious.' "[11]

Synaesthetic cinema provides access to syncretistic content through the inarticulate conscious. Similarly, it contradicts the teachings of Gestalt psychology, according to which we must make an *either/or* choice: we can choose either to see the "significant" figure or the "insignificant" ground. But when the "content" of the message is the relationship between its parts, and when structure and content are synonymous, all elements are equally significant. Ehrenzweig has suggested that syncretism is "Gestalt-free perception," and indeed this must be the case if one expects any visual "meaning" from synaesthetic cinema.

Paul Klee, whose syncretistic paintings closely resemble certain works of synaesthetic cinema, spoke of the *endotopic* (inside) and *exotopic* (outside) areas of a picture plane, stressing their equal importance in the overall experience.[12] Synaesthetic cinema, primarily through superimposition, fuses the endotopic and exotopic by reducing depth-of-field to a total field of nonfocused multiplicity. Moreover, it subsumes the conventional sense of time by interconnecting and interpenetrating the temporal dimension with images that exist outside of time. The "action" of *Dog Star Man,* for example, could be an entire life-span or merely a split second in the inarticulate conscious of Stan Brakhage. I stress "action" as commonly understood in the cinema because synaesthetic syncretism replaces montage with collage and, as André Bazin has observed, "montage is the dramatic analysis of action." Bazin was perceptive enough to realize that "only an increased realism of the image can support the abstraction of montage."[13]

Synaesthetic cinema subsumes Eisenstein's theory of montage-as-collision and Pudovkin's view of montage-as-linkage. It demonstrates that they were certainly correct but didn't follow their own observations to their logical conclusions. They were restricted by

[11] Ehrenzweig, *op. cit.*, pp. 19, 20.

[12] Paul Klee, *The Thinking Eye* (London: Lund Humphries, 1961).

[13] André Bazin, *What Is Cinema?* trans. Hugh Gray (Los Angeles, Calif.: University of California Press, 1967), p. 39.

the consciousness of their times. Synaesthetic cinema transcends the notion of reality. It doesn't "chop the world into little fragments," an effect Bazin attributed to montage, because it's not concerned with the objective world in the first place. The new filmmaker is showing us his feelings. Montage is indeed an abstraction of objective reality; that's why, until recently, Warhol did not cut his films at all. But synaesthetic syncretism is the only mode in which the manifestations of one's consciousness can be approximated without distortion.

There's no conflict in harmonic opposites. Nor is there anything that might be called linkage. There is only a space-time continuum, a mosaic simultaneity. Although composed of discrete elements it is conceived and edited as one continuous perceptual experience. A synaesthetic film is, in effect, one image continually transforming into other images: metamorphosis. It is the one unifying force in all of synaesthetic cinema. The notion of universal unity and cosmic simultaneity is a logical result of the psychological effects of the global communications network.

If montage is the dramatic analysis of action, a film without classic montage thus avoids at least the structural element of drama inherent within the medium. All that remains to avoid drama entirely is to exclude dramatic (i.e., theatrical) content by making content and structure the same. Warhol's films are not dramatic, and neither are films at the extreme opposite end of the spectrum, synaesthesia. The classical tension of montage is dissolved through overlapping superimposition. For example: we have shots A, B, and C. First we see A, then B is superimposed over it to produce AB. Then A fades as C fades in. There's a brief transitional period in which we're seeing ABC simultaneously, and finally we're looking only at BC. But no sooner has this evolved than B begins to fade as D appears, and so on.

This is a physical, structural equivalent of the Hopi "present manifested" and "present manifesting" space-time continuum. It's the only style of cinema that directly corresponds to the theory of general relativity, a concept that has completely transformed all aspects of contemporary existence except traditional Hollywood cinema. The effects of metamorphosis described above become more apparent if shots A, B, and C happen to be of the same image

but from slightly different perspectives, or with varied inflections of tone and color. It is through this process that a synaesthetic film becomes, in effect, one image constantly manifesting.

And finally we're forced to admit that the pure art of cinema exists almost exclusively in the use of superimposition. In traditional cinema, superimposition usually gives the impression of two movies occurring at once in the same frame with their attendant psychological and physiological connotations coexisting separately. In synaesthetic cinema they are one total image in metamorphosis. This does not imply that we must relinquish what Eisenstein called "intellectual montage." In fact, the conflict-juxtaposition of intellectual effects is increased when they occur within the same image. Fiction, legend, parable, myth, traditionally have been employed to make comprehensible the paradoxes of that field of nonfocused multiplicity that is life. Synaesthetic cinema, whose very structure is paradox, makes paradox a language in itself, discovering the order (legend) hidden within it.

## Stan Brakhage: *Dog Star Man*

*Dog Star Man* is a silent, seventy-eight-minute film divided into *Prelude* and *Parts One* through *Four*. It was shot in 1959–60 and edited during the next four years. *Prelude* is an extremely fast collage of multiple-level superimpositions and compounded images that emerge from a blurry diaphanous haze and slowly take form, only to be obscured by other images and countermotions. We begin to discern specific objects, patterns, and finally a motif or theme: the elements of Earth, Air, Fire, and Water; a childbirth; a man climbing a mountain with his dog; the moon; the sun throwing off huge solar prominences; lovemaking; photomicrography of blood vessels; a beating heart; a forest; clouds; the faces of a man and a woman; and literally thousands of other images to appear in the rest of the film.

These images exist essentially autonomously and are superimposed or compounded not for "dramatic" effect but rather as a kind of matrix for psychic exercise on the part of the viewers. For example, over an expanding solar prominence we might see Brakhage's leonine face or a line of snow-covered fir trees in the mountains of Colorado. We are not asked to interpret or find "meaning"

in these combinations, though vastly rich experiences are possible. When the images emerge from a hazy blur, for example, we are not asked to interpret this as the creation of life or some similar dramatic notion, but rather as a perceptual experience for its own sake, in addition to the contextual relationship of this image to the rest of the film, or what Eisenstein indicated by the term "intellectual montage."

Whereas *Prelude* is a rapid barrage of multiple overlays, *Part One* is superimposed sparingly, concentrating on interface relationships between individual shots. However, every effort is made to subdue any effect that might be considered montage. The shots fade in and out very slowly, often fading into a color such as red or green. The fragments of *Prelude* fall into place and an overwhelming sense of oceanic consciousness evolves. We begin to realize that Brakhage is attempting to express the totality of consciousness, the reality continuum of the living present. As his solitary figure climbs the snow-covered mountain, we see images of man's world from the microspectrum of the bloodstream to the macrospectrum of the sun, moon, and universe. Both time and space are subsumed in the wholeness of the experience. Superimposition is not used as an economical substitute for "parallel montage"—indicating simultaneous but spatially separate events—for spatio-temporal dimensions do not exist in the consciousness. Brakhage is merely presenting us with images orchestrated in such a way that a new reality arises out of them.

When we see the sun superimposed over a lovemaking scene, it's not an invitation to interpret a meaning such as cosmic regeneration or the smallness of man in the universe, but rather as an occasion to experience our own involuntary and inarticulate associations. The images are not symbolic, as in *The Seventh Seal*, or artfully composed as in *Last Year at Marienbad*. Brakhage does not manipulate us emotionally, saying: "Now I want you to feel suspense" or "Now I want you to laugh" or "Now is the time to be fearful." This is the ploy of the commercial entertainer: an arrogant degradation of cinema, using film as a tool for cheap sensationalism. This is not to say that spatio-temporal experiences, or suspense, humor, or any emotion cannot be found in synaesthetic cinema. Quite the contrary: because we're dealing with our own personal associations,

Stan Brakhage: *Dog Star Man.* 1959–
64. 16 mm. Color, black and white.
78 min. "The totality of consciousness,
the reality continuum of the living
present."

emotion is guaranteed. And it will be more genuinely profound than the formula-triggered gratification of conditioned response that we receive from commercial entertainment.

Brakhage has spoken of "restructuring" vision through his films, and often refers to the "untutored" vision of the child before he's taught to think and see in symbols. In what he calls "closed-eye vision," Brakhage attempts to simulate, by painting and scratching on film, the flashes and patterns of color we perceive when our eyes are closed. Approximately midway through *Dog Star Man*, otherwise mundane images take on wholly new meanings and in some cases new appearances. We stop mentally labeling images and concentrate instead on the synaesthetic/kinaesthetic flow of color, shape, and motion.

This is not to suggest a nonobjective experience. The images develop their own syntactical meaning and a "narrative" line is perceived, though the meaning of any given image may change in the context of different sequences. This constitutes a creative use of the language itself, over and above any particular "content" conveyed by that language. (Wallace Stevens: "A new meaning is equivalent to a new word.") The effect of synaesthetic cinema is to break the hold that the medium has over us, to make us perceive it objectively. Art is utter folly unless it frees us from the need of art as an experience separate from the ordinary.

Wittgenstein has described art as a game whose rules are made up as the game is in process. The exact meaning of words (images) becomes known only in the context of each new statement.[14] E. H. Gombrich, on the other hand, demonstrates that objective realism also is a game, but one whose schema is established prior to its use and is never altered. Artists and society thus learn to read the schema as though it were objective reality. But since the language itself is not used creatively, the viewer is seduced beyond form into an abstract content with an illusion of being externally objective.[15] Thus the viewer is captive under the hold, or spell, of the medium and is not free to analyze the process of experience.

[14] Ludwig Wittgenstein, *Philosophical Investigations* (Oxford: Blackwell Press, 1963).

[15] E. H. Gombrich, *Art and Illusion*, The Bollingen Series XXXV (New York: Pantheon Books, Inc., 1960).

Brakhage expressed this concept with respect to his own work: "Imagine an eye unruled by man-made laws of perspective, an eye unprejudiced by compositional logic, an eye which must know each object encountered in life through a new adventure of perception. Imagine a world alive with incomprehensible objects and shimmering with an endless variety of movement and gradations of color. Imagine a world before the beginning was the word."[16]

[16] Stan Brakhage, "Metaphors on Vision," ed. P. Adams Sitney, *Film Culture* (Fall, 1963).

## Evocation and Exposition:
## Toward Oceanic Consciousness

There is an important distinction to be made between *evocation,* the language of synaesthetic cinema, primarily poetic in structure and effect, and *exposition,* the language of narrative cinema, which chiefly conforms to traditional, literary narrative modes. Intermedia artist and filmmaker Carolee Schneemann has characterized evocation as "the place between desire and experience, the interpenetrations and displacements which occur between various sense stimuli. "Vision is not a fact," Miss Schneemann postulates, "but an aggregate of sensations. Vision creates its own efforts toward realization; effort does not create vision."[17]

Thus, by creating a new kind of vision, synaesthetic cinema creates a new kind of consciousness: oceanic consciousness. Freud spoke of oceanic consciousness as that in which we feel our individual existence lost in mystic union with the universe. Nothing could be more appropriate to contemporary experience, when for the first time man has left the boundaries of this globe. The oceanic effect of synaesthetic cinema is similar to the mystical allure of the natural elements: we stare in mindless wonder at the ocean or a lake or river. We are drawn almost hypnotically to fire, gazing as though spellbound. We see cathedrals in clouds, not thinking anything in particular but feeling somehow secure and content. It is similar to the concept of *no-mindedness* in Zen, which also is the state of mantra and mandala consciousness, the widest range of consciousness.

Miss Schneemann defines perception as *eye-journey* or *empathy-drawing.* It is precisely through a kind of empathy-drawing that the content of synaesthetic cinema is created jointly by the film and the viewer. The very nature of evocation requires creative effort on the part of the viewer, whereas expository modes do all the work and the viewer becomes passive. In expositional narrative, a story is being *told;* in evocative synaesthesia an experience is being created.

[17] Carolee Schneemann, "Snows," *I-Kon,* ed. Susan Sherman, Vol. 1, No. 5 (New York: March, 1968).

The figure of Stan Brakhage in *Dog Star Man* actually moves through a psychic environment created by the viewer, whose deeply-hidden creative resources and hungers have been evoked by the film.

With typical poetic eloquence, Hermann Hesse has summarized the evocative effects of oceanic consciousness in this memorable passage from *Demian:* "The surrender to nature's irrational, strangely confused formations produces in us a feeling of inner harmony with the force responsible for these phenomena . . . the boundaries separating us from nature begin to quiver and dissolve . . . we are unable to decide whether the images on our retina are the result of impressions coming from without or from within . . . we discover to what extent we are creative, to what extent our soul partakes of the constant creation of the world."[18]

## Will Hindle: *Chinese Firedrill*

There have been essentially three generations of personal filmmakers in the United States. The first began with the invention of the medium and continued in various stages through the 1940's. The second began approximately in the mid-1950's with the increasing availability of inexpensive 8mm. and 16mm. equipment. It represented the first popular movement toward personal cinema as a way of life. The third generation has evolved since the mid-1960's, primarily in the San Francisco area, where the latest trend is toward a blending of aesthetics and technology. One reason personal cinema is more eloquent than commercial cinema is that the filmmaker is forced into a closer interaction with his technology.

Will Hindle is exemplary of this recent technological awareness, a combination of engineering and aesthetics. Trained in art, literature, and professional television filmmaking, Hindle has applied his knowledge to personal cinema in a singularly spectacular fashion. His ability to invest a technical device with emotional or metaphysical content is truly impressive. He has, for example, developed the technique of rear-projection rephotography to a high degree of eloquence. He shoots original scenes with wide-angle lenses, then "crops" them by projecting and rephotographing this footage using a special single-frame projector. Thus extremely subtle effects are

18 Hermann Hesse, *Demian* (New York: Bantam Books, 1968), p. 88.

Will Hindle: *Chinese Firedrill.* 1968.
16mm. Color. 24 min. "We discover to
what extent our soul partakes of the
constant creation of the world."

achieved that would be prohibitively expensive, if not impossible, if done through conventional laboratory optical printing.

Although many synaesthetic films are wonderfully evocative, Hindle's recent works are especially notable for their ability to generate overwhelming emotional impact almost exclusively from cinematic technique, not thematic content. Hindle has an uncanny talent for transforming spontaneous unstylized reality into unearthly poetic visions, as in *Billabong* (1968), a wordless impressionistic "documentary" about a boy's camp in northern California, and *Watersmith* (1969), a spectacular visual fantasy created from footage of an Olympic swimming team at practice.

*Chinese Firedrill,* unique in Hindle's work, was prestylized and "performed" almost in the traditional sense of a scripted, directed, and acted movie. The difference is that Hindle used the images not for their symbolic or theatrical content but as ingredients of an almost iconographic nature, to be compounded and manipulated through the process of the medium. Although there are "actors" (Hindle plays the principal role), there is no characterization. Although there are sets, we're not asked to suspend our disbelief.

*Chinese Firedrill* is a romantic, nostalgic film. Yet its nostalgia is of the unknown, of vague emotions, haunted dreams, unspoken words, silences between sounds. It's a nostalgia for the oceanic present rather than a remembered past. It is total fantasy; yet like the best fantasies—*8½, Beauty and the Beast, The Children of Paradise*—it seems more real than the coldest documentary. The "action" occurs entirely within the mind of the protagonist, who never leaves the small room in which he lives. It's all rooms everywhere, all cubicles wherever we find man trapped within his dreams. Through the door/mirror is the beyond, the unreachable, the unattainable, the beginning and the end. Not once in the film's twenty minutes can we pinpoint a sequence or action that might be called "dramatic" in the usual sense. Yet almost immediately an overwhelming atmosphere of pathos is generated. There are moments of excruciating emotional impact, not from audience manipulation but from Hindle's ability to realize metaphysical substance, stirring the inarticulate conscious. Every effort is made to distance the viewer, to keep us aware of our perceptions, to emphasize the purely cinematic as opposed to the theatrical.

We find Hindle kneeling on the floor of his surrealistic room stuffing thousands of IBM cards into boxes. Over this we hear a strange monologue of fragmented words and sentences in an odd foreign accent. This is punctuated by fierce thunderclaps and howling wind that evolve into ethereal music and tinkling bell sounds. Periodically the screen is slashed across with blinding white flashes while the central images constantly are transformed through lap-dissolves and multiple superimpositions. There are flash-forwards of images to be encountered later, though we don't recognize them and therefore don't interpret them. We see nude lovers, a small boy bathing, a beautiful woman with candles, a huge eyeball, a battery of glaring lights. These are noted for their inherent psychological connotations and not as narrative devices.

The most memorable sequence of *Firedrill*, possibly one of the great scenes in the history of film, involves Hindle lying in anguish on his floor and slowly reaching out with one hand toward the glimmering void beyond his door. Suddenly a mirror-like reflection of his arm and hand appears on the opposite side of the mirror. When he removes his hand we see the vague shadowy figure of a nude woman silhouetted ghostlike, her skin sparkling. In slow motion the silhouette of a nude man enters from an opposite direction and the two gossamer figures embrace in a weightless ballet of graceful motion in some dream of bliss. In the film's final image, the haunted man has become a child once again, splashing in his bath in a series of freeze-frames that grow ever fainter until they vanish.

# Synaesthetics and Kinaesthetics: The Way of All Experience

The term *kinetic* generally indicates motion of material bodies and the forces and energies associated with it. Thus to isolate a certain type of film as kinetic and therefore different from other films means we're talking more about forces and energies than about matter. I define *aesthetic* quite simply as: the manner of experiencing something. *Kinaesthetic,* therefore, is the manner of experiencing a thing through the forces and energies associated with its motion. This is called *kinaesthesia,* the experience of sensory perception. One who is keenly aware of kinetic qualities is said to possess a kinaesthetic sense.

The fundamental subject of synaesthetic cinema—forces and energies—cannot be photographed. It's not what we're seeing so much as the process and effect of seeing: that is, the phenomenon of experience itself, which exists only in the viewer. Synaesthetic cinema abandons traditional narrative because events in reality do not move in linear fashion. It abandons common notions of "style" because there is no style in nature. It is concerned less with facts than with metaphysics, and there is no fact that is not also meta-physical. One cannot photograph metaphysical forces. One cannot even "represent" them. One can, however, actually *evoke* them in the inarticulate conscious of the viewer.

The dynamic interaction of formal proportions in kinaesthetic cinema evokes cognition in the inarticulate conscious, which I call *kinetic empathy.* In perceiving kinetic activity the mind's eye makes its empathy-drawing, translating the graphics into emotional-psychological equivalents meaningful to the viewer, albeit meaning of an inarticulate nature. "Articulation" of this experience occurs in the perception of it and is wholly nonverbal. It makes us aware of fundamental realities beneath the surface of normal perception: forces and energies.

## Patrick O'Neill: *7362*

New tools generate new images. In the historical context of

image-making, the cinema is a new tool. *7362* is among the few purely cinematic images to evolve from this new seventy-year-old tool. All the visual arts are moving toward the cinema. Artists like Frank Stella or Kenneth Noland have been credited as significant painters within the last decade because they kept the game going. One is impressed that they merely discovered new possibilities for a two-dimensional surface on stretchers. But the possibilities are so narrow today that soon there will be nowhere to go but the movies.

Pat O'Neill is a sculptor with a formal background in the fine arts. Like Michael Snow, also a sculptor, O'Neill found unique possibilities in the cinema for exploration of certain perceptual concepts he had been applying to sculpture and environmental installations. *7362*, made some five years ago, was the first of many experiments with the medium as a "sculptural" device. The term is intended only as a means of emphasizing the film's kinetic qualities.

*7362* was named after the high-speed emulsion on which it was filmed, emphasizing the purely cinematic nature of the piece. O'Neill photographed oil pumps with their rhythmic sexual motions. He photographed geometrical graphic designs on rotating drums or vertical panels, simultaneously moving the camera and zooming in and out. This basic vocabulary was transformed at the editing table and in the contact printer, using techniques of high-contrast bas-relief, positive/negative bi-pack printing and image "flopping," a Rorschach-like effect in which the same image is superimposed over itself in reverse polarities, producing a mirror-doubled quality.

The film begins in high-contrast black-and-white with two globes bouncing against each other horizontally, set to an electronic score by Joseph Byrd. This repetitive motion is sustained for several seconds, then fades. As though in contrast, the following images are extremely complex in form, scale, texture, and motion. Huge masses of mechanical hardware move ponderously on multiple planes in various directions simultaneously. The forms seem at times to be recognizable, at others to be completely nonobjective. Into this serial, mathematical framework O'Neill introduces the organic fluid

rick O'Neill: *7362*. 1965–66. 16mm. Color, black
white. 11 min. "Human and machine
ract with serial beauty, one form
sing into another with delicate precision."

lines of the human body. He photographed a nude girl performing simple motions and processed this footage until she became as mechanical as the machinery. At first we aren't certain whether these shapes are human or not, but the nonrhythmic motions and asymmetrical lines soon betray the presence of life within a lifeless universe. Human and machine interact with serial beauty, one form passing into another with delicate precision in a heavenly spectrum of pastel colors.

## John Schofill: *XFilm*

The young Berkeley physicist John Schofill has exhibited a thorough and creative grasp of kineticism as regards the representational organic image. Although *XFilm* is a spectacular example of montage-as-collage, it does not ignore the conflicts of volume, scale, mass, and graphic direction that Eisenstein found so central to film form. Other physiological montage effects postulated by Eisenstein—metric, rhythmic, tonal, overtonal—also are used by Schofill not for any result that might resemble montage, but rather to generate an overpowering sense of kinaesthesia, or rushing dynamic force.

Through precise manipulation of individual frames and groups of frames, Schofill creates an overwhelming sense of momentum practically unequaled in synaesthetic cinema. There is almost a visceral, tactile impact to these images, which plunge across the field of vision like a dynamo. Yet they are punctuated with moments of restful quietude. It is a composition of point-counterpoint, the better to accentuate kinaesthetic content.

Schofill has developed a method of A-B-C-roll editing for superimpositions, adapted from Karel Reisz's methods of cutting single footage.[19] It's a rhythmic concept, that is, a shot is divided into definite kinetic "beats." The kinetic activity begins, reaches a middle point, and ends. In triple superimpositions, the corresponding

[19] Karel Reisz, *The Techniques of Film Editing* (New York: Hastings House, 1968).

John Schofill: *XFilm*. 1967. 16mm. Co
14 min. "Images which plunge across
field of vision like a dynamo . . . pu
tuated with moments of restful quietu

rhythms of each piece of film are matched, fading in and out without abrupt cuts.

*XFilm* begins with quiet formal imagery: static shots of factories spewing poison into the sky, strongly reminiscent of Antonioni's *Red Desert*. The structures are seen in eight levels of superimposition of eight different zoom-lens positions. The sound track explodes with an extraordinary tape composition by Berkeley composer William Maraldo, a synthesis of East Indian and rock music that perfectly counterpoints the visuals with its own sense of dynamic thrust. We see a series of tableau statements in which a nude girl's cupped hand opens to reveal a flower, then a factory. Then begins an accelerating succession of flash-frames, macro-close-ups of electronic circuitry, tree bark, dirt, plants, human flesh. Each image is balanced in terms of scales, volumes, masses, directions, and textures of objects within it. Quite often a particularly smooth or static image is counterpointed with strobing flash-frames.

The most powerful sequence, one which deals purely with the kinaesthetic experience, involves a time-lapse sunset that begins with a low horizon, bare-limbed trees, and a blue sky. Suddenly the action is speeded: clouds and squiggly jet contrails rush up and over. Maraldo's sound track takes a spiraling, droning dive and the sun appears, sinking rapidly like a comet from upper left to lower right. Just as it reaches the horizon the foreground and trees flash brilliant white (superimposed high-contrast negative over a high-contrast positive silhouette). The effect is stunning. A train, approaching the camera, becomes visible as the sun fades, continuing the kinaesthetic sense of dynamic volumes and trajectories.

### Ronald Nameth: *Exploding Plastic Inevitable*

To some extent the so-called psychedelic discotheque was to the cinema of the sixties what the Busby Berkeley ballroom was to the thirties. In a larger sense, however, they are by no means in the same class either socially or aesthetically. The Berkeley extravaganzas, like Hollywood, were not places but states of mind. They generated their own ethos, their own aesthetic. They answered an obvious need for escape from the dreary hardships of the times. Life imitated art. But thirty years later Hollywood had degenerated to the point that it was, at best, an imitation of an imitation. The

spate of "hip" Hollywood films, which began to appear after 1966, was about as socially significant as the various Kennedy assassination "souvenirs," and was proffered with the same exploitive street-vending zeal. Like all commercial entertainment, these films were *about* something rather than *being* something, and so were the discotheques they imitated.

Andy Warhol's hellish sensorium, the *Exploding Plastic Inevitable,* was, while it lasted, the most unique and effective discotheque environment prior to the Fillmore/Electric Circus era, and it is safe to say that the *EPI* has never been equaled. Similarly, Ronald Nameth's cinematic homage to the *EPI* stands as a paragon of excellence in the kinetic rock-show genre. Nameth, a colleague of John Cage in several mixed-media environments at the University of Illinois, managed to transform his film into something far more than a mere record of an event. Like Warhol's show, Nameth's *EPI* is an experience, not an idea.

In fact, the ethos of the entire pop life-style seems to be synthesized in Nameth's dazzling kinaesthetic masterpiece. Here, form and content are virtually synonymous, and there is no misunderstanding what we see. It's as though the film itself has exploded and reassembled in a jumble of shards and prisms. Gerard Malanga and Ingrid Superstar dance frenetically to the music of the Velvet Underground (*Heroin, European Son,* and a quasi-East Indian composition), while their ghost images writhe in Warhol's *Vinyl* projected on a screen behind. There's a spectacular sense of frantic uncontrollable energy, communicated almost entirely by Nameth's exquisite manipulation of the medium.

*EPI* was photographed on color and black-and-white stock during one week of performances by Warhol's troupe. Because the environment was dark, and because of the flash-cycle of the strobe lights, Nameth shot at eight frames per second and printed the footage at the regular twenty-four fps. In addition he developed a mathematical curve for repeated frames and superimpositions, so that the result is an eerie world of semi-slow motion against an aural background of incredible frenzy. Colors were superimposed over black-and-white negatives, and vice-versa. An extraordinary off-color grainy effect resulted from pushing the ASA rating of his color stock; thus the images often seem to lose their cohesiveness as

though wrenched apart by the sheer force of the environment.

Watching the film is like dancing in a strobe room: time stops, motion retards, the body seems separate from the mind. The screen bleeds onto the walls, the seats. Flak bursts of fiery color explode with slow fury. Staccato strobe guns stitch galaxies of silverfish over slow-motion, stop-motion close-ups of the dancers' dazed ecstatic faces. Nameth does with cinema what the Beatles do with music: his film is dense, compact, yet somehow fluid and light. It is extremely heavy, extremely fast, yet airy and poetic, a mosaic, a tapestry, a mandala that sucks you into its whirling maelstrom.

The most striking aspect of Nameth's work is his use of the freeze-frame to generate a sense of timelessness. Stop-motion is literally the death of the image: we are instantly cut off from the illusion of cinematic life—the immediacy of motion—and the image suddenly is relegated to the motionless past, leaving in its place a pervading aura of melancholy. Chris Marker's *La Jetée*, Peter Goldman's *Echoes of Silence*, and Truffaut's *400 Blows* are memorable for the kind of stop-frame work that Nameth raises to quintessential beauty. The final shots of Gerard Malanga tossing his head in slow motion and freezing in several positions create a ghostlike atmosphere, a timeless and ethereal mood that lingers and haunts long after the images fade. Using essentially graphic materials, Nameth rises above a mere graphic exercise: he makes kinetic empathy a new kind of poetry.

Ronald Nameth: *Andy Warhol's Exploding Plastic Inevitable.* 1966. 16mm. Color, black and white. 30 min. "An eerie world of semi-slow motion against an aural background of incredible frenzy. He makes kinetic empathy a new kind of poetry."

# Mythopoeia: The End of Fiction

"If what we see depicted had been really the truth, successfully created in front of the camera, the film would cease to exist because it would cease, by the same token, to be a myth."

<div align="right">ANDRÉ BAZIN</div>

In 1934 Erwin Panofsky wrote: "To pre-stylize reality prior to tackling it amounts to dodging the problem. The problem is to shoot and manipulate unstylized reality in such a way that the result has style." The problem that concerned Panofsky was how to work with the two qualities unique to cinema alone, not to be found in any other aesthetic medium.

The first is its ability to capture and preserve a picture of time. This is fine until the filmmaker wishes to comment upon or interpret the events he has captured. Thus we come to the second unique property of cinema, its aesthetic element: the ability to post-stylize natural reality. To understand this concept we must examine the three general purposes to which cinema historically has been applied: fiction, documentary, and *cinéma-vérité*.

Cinematic fiction should be understood as prestylized or manufactured reality that did not exist prior to the making of the film. The only true reality that remains in the finished film is the objective awareness of the stylization itself. That is to say, a theatrical scenario-based fiction film deals with a prestylized reality distilled and recorded through the personality of the writer, then visualized by the director, crew, and actors according to certain schemata. Not only is this not objective reality; it's not even the cohesive, unique reality of one artist's perception.

A documentary also deals with prestylized reality. The documentary filmmaker shifts and reorganizes unstylized material into a narrative form that explains that reality to the viewer. Thus a documentary is not an explanation of reality, but rather the reality of an explanation.

*Cinéma-vérité,* or direct cinema, is based on recording actual unstylized reality as it exists at a particular moment before the camera. The filmmaker is never to intrude by directing the action or in any way alter the events taking place (that is, beyond the unavoidable alterations caused by his very presence). The film-maker's refusal to intervene directly in the reality before his camera, and the resultant loosely-organized structure, bring this type of cinema closer to the truth of the way events move in actual reality.

Synaesthetic cinema is all and none of these. It is not fiction because, with a few exceptions, it is based wholly on unstylized reality. It is not documentary because the reality is not organized into an explanation of itself. And it is not *cinéma-vérité* because the artist shoots and manipulates his unstylized reality in such a way that the result has style.

This process, best described as "post-stylization," is accomplished through cinematic equivalents of the four historical styles of art: realism, surrealism, constructivism, and expressionism.

Cinematic realism already has been defined as *cinéma-vérité*: capturing and preserving a picture of time as perceived through unstylized events.

Cinematic surrealism is achieved by the juxtaposition of unstyl-ized elements so incongruous and remote that close proximity creates an extra dimension, a psychological reality that arises out of the interface.

Cinematic constructivism, as we've discussed it, actually is the universal subject of synaesthetic cinema: a constructivist statement, a record of the process of its own making.

Cinematic expressionism involves the deliberate alteration or distortion of unstylized reality, either during photography with lenses, filters, lights, etc., or after photography with optical printing, painting, or scratching on film.

Post-stylization of unstylized reality results in an experience that is not "realistic" but neither is it "fiction" as generally understood, because none of the elements is altered or manufactured prior to filming. In essence a myth is created, a myth born out of the juxtapositions of the paradoxes of reality. Webster defines myth as a story that "serves to unfold part of the world view of a people or explain a practice, belief, or natural phenomenon." The natural

phenomenon explained by synaesthetic cinema is the filmmaker's consciousness. It is a documentary of the artist's perception. Since this is not a physical reality, it must be a metaphysical reality, that is, a myth. In the approximation of this intangible, however, the artist's language is reality, not fiction. What we see on the screen is not an act. True, it's processed through the medium until it no longer is objective reality, but it is nonetheless real. This is *mythopoeic reality*. In one sense it renders fiction obsolete.

At the beginning of *Alphaville,* Jean-Luc Godard states: "There are times when reality becomes too complex for communication. But legend gives it a form by which it pervades the whole world." This is the legitimate role of fiction: to establish a framework that provides insights into otherwise inaccessible areas of the living present. But most insights inherent in fiction as the simulation of objective reality have been absorbed by the collective consciousness. The structure of the system is an index of the performance that may be expected from that system: the simulation of reality has delivered its maximum performance; it no longer benefits us as it has in the past.

Obviously, filmmakers will continue to prestylize reality; in one sense the very nature of art is the rearrangement of the environment for greater advantage to humanity. Yet this prestylization will not be so clearly separated from "reality" as it has been. Because of technology, we have now reached the point at which it is possible to manipulate reality itself in order to create new legends. It may be that insights most relevant to contemporary society will be achieved primarily through this language.

# Synaesthetics and Synergy

Synaesthetic cinema by definition includes many aesthetic modes, many "ways of knowing," simultaneously omni-operative. The whole, however, is always greater than the sum of its parts. This is a result of the phenomenon called *synergy*. Synergy is the behavior of a system unpredicted by the behavior of any of its parts or sub-assemblies of its parts. This is possible because there is no a priori dependency between the conceptual and design information (i.e., the energy) of the individual parts. The existence of one is not requisite on the presence of another. They are harmonic opposites. In physics this is known as the Theory of Complementarity: the logical relation between two descriptions or sets of concepts which, though mutually exclusive, are nevertheless both necessary for a complete knowledge of the phenomenon.

Dramatic narrative cinema is antisynergetic. Individual parts of linear drama predict the behavior of the whole system. For a genre to exist it must include parts that are integral to the a priori purpose of the system. As E. H. Gombrich has demonstrated, the function of its "words" must remain constant and predictable. To gratify conditioned needs for formula stimulus, the commercial entertainment film must follow prescribed rules that predict the whole system of conflict-crisis-resolution.

We have seen, however, that the behavior of a conflict or game is always governed by its weakest moment, which is equivalent to the notion of a chain being only as strong as its weakest link. This idea, however, presupposes a linear chain under opposing vectors of stress, i.e., narrative drama. Fuller: "We tend to think it is logical to say that a chain is no stronger than its weakest link—which immediately is thrown out of validity when we join the other end of the chain back on itself. We think a chain ought to be just an infinite line rather than a circle because we inherited the Greek concepts of linear and plane geometry [which] imposed the concept of an infinite surface and the infinite line as logical to the then-prevalent belief that the earth was flat . . . However, in nature all the lines

are completely curved and all chains do eventually return upon themselves."[20]

The malfunction or absence of any one element in a linear narrative constitutes a break in the system and relinquishes the system's hold over the viewer's consciousness. But synaesthetic synergy is possible only when the parts behave with integrity and without self-consciousness. If the metals in chrome-nickel steel tried to retain their individuality, the synergetic effect of tripling the tensile strength through alloy would never occur. Fuller has noted that the individual tensile strengths of chromium, nickel, and iron are in the approximate range of 70,000, 80,000, and 60,000 pounds per square inch respectively. Yet in alloy they yield 300,000 psi tensile strength, which is five times as strong as its weakest link and four times as strong as its strongest link.

The entertainer makes a package that is equal to the sum of its separate parts; the artist fuses his parts into an alloy greater than its ingredients. That is, synaesthetic synergy does not tend toward greater complexity, but rather produces an effect that in physics is known as *elegant simplicity*. An elegantly simple construction accomplishes that which previously required many different mechanisms, either physical or metaphysical. Recent revolutionary concepts in biology are an example. John McHale: "The DNA/RNA mechanism construct renders obsolete an enormous number of separate 'biological facts' and relates biology via biochemistry to biophysics—and thence to a more elegantly simple configuration of structural hierarchies as extending outward from the micro-nucleus through the median range of ordinary perception towards macrostructural hierarchies at the level of galaxies."[21]

Let us briefly review what we mean by synergy as applied to the cinema. We have learned that synaesthetic cinema is an alloy achieved through multiple superimpositions that produce syncretism. Syncretism is a total field of harmonic opposites in continual metamorphosis; this metamorphosis produces a sense of kinaesthesia that evokes in the inarticulate conscious of the viewer recognition of an overall pattern-event that is in the film itself as well as

[20] R. Buckminster Fuller, *Ideas and Integrities* (New York: Collier Books, 1969), p. 65.

[21] McHale, "Knowledge Implosion," *Good News*.

the "subject" of the experience. Recognition of this pattern-event results in a state of oceanic consciousness. A mythopoeic reality is generated through post-stylization of unstylized reality. Post-stylization simultaneously involves the four traditional aesthetic modes: realism, surrealism, constructivism, and expressionism.

Herbert Read has suggested that these four styles are intercorrelated to the four modes of human consciousness: thought, intuition, emotion, and sensation. Of course, they are operative in commercial entertainment as well; but it's the nature of synaesthetic cinema that one is made aware of the process of one's own perception; thus one invests the experience with meaning by exerting conscious control over the conversion of sight impressions into thought images. We can easily see how thought, intuition, and sensation may be directly engaged or indirectly evoked in the synaesthetic viewing experience; the role of emotion deserves further comment.

The emotional content of dramatic narrative cinema is predominantly the result of expectations that the viewer brings with him to the theatre, and thus he remains passive during the viewing experience so that his conditioned response to the formula may be fully gratified. In this way he satisfies his unconscious need to experience the particular emotions that he has already decided to experience. The film is "good" or "bad" in relation to its effectiveness as a catalyst for these predetermined emotions. However, the emotional content of synaesthetic cinema exists in direct relation to the degree of conscious awareness of the act of perceiving, and is thus seldom predictable. Synergy is the essence of the living present, and it is the essence of art. Where synergy does not exist, energy tends toward entropy and change becomes increasingly unlikely.

# Synaesthetic Cinema and Polymorphous Eroticism

"The Western consciousness has always asked for freedom: the human mind was born free, or at any rate born to be free, but everywhere it is in chains; and now at the end of its tether."

NORMAN O. BROWN

For the majority of the mass public, "underground" movies are synonymous with sex. Although this conclusion was reached for all the wrong reasons, it is nevertheless accurate. If personal cinema is indeed personal, and if we place any credence at all in Freud, personal cinema is by definition sexual cinema. A genuine social underground no longer is possible. The intermedia network quickly unearths and popularizes any new subculture in its relentless drive to satisfy the collective information hunger. Jean-Luc Godard once remarked that the only true twentieth-century underground was in Hanoi. But I would suggest that in the history of civilization there never has been a phenomenon more underground than human sexuality.

The vast political and social revolution that is now irreversible in its accelerating accelerations around the planet is merely a side effect of the more profound revolution in human self-awareness that is producing a new sexual consciousness.

We hold the radical primacy of the passions to be self-evident. Norman O. Brown: "All Freud's work demonstrates that the allegiance of the human psyche to the pleasure-principle is indestructible and that the path of instinctual renunciation is the path of sickness and self-destruction."[22] If there is a general debasement of the sexual act among the bourgeoisie, it is precisely because that sexuality has been repressed. Charles Fourier: "Every passion that

[22] Norman O. Brown, "Apocalypse: The Place of Mystery in the Life of the Mind," *Harper's* (May, 1961).

is suffocated produces its counter-passion, which is as malignant as the natural passion would have been benign."[23]

Nowhere is this more evident than in commercial cinema. Hollywood movies are teasers whose eroticism is a result of psychological conditioning that is not, fundamentally, the enjoyment of sex itself. Girlie and Hollywood films "for mature adults" are founded on puritanical concepts of "sin" and other repressive measures, no matter how "honest" or "artistic" or "redeeming" the presentation may seem. The absurd notion that sex must somehow be "redeemed" is exploited by Hollywood as much as by the makers of girlie or stag films. Hollywood presents "redeemed" sex, suggesting there's an unredeemed way of doing it and therefore we're getting away with something. Girlie and stag films take the opposite approach: they represent sex in various stages of "unredemption" until the point of watching them becomes more an act of rebellion, of something "dirty," clandestine, without redeeming qualities, than the enjoyment of sex. That is to say, the present socioeconomic system actually contributes to the corruption of the institution it claims to uphold.

However, it is now only a matter of a few years until the final restrictions on sexuality will disintegrate. The revolution that seeks the restructuring of social arrangements—a utopia of material plenty and economic freedom—is secondary by far to that other revolution that demands the total release of psychic impulses. This imminent utopia of the senses has been described by the neo-Freudian psychoanalyst A. H. Maslow as *Eupsychia,* a view oriented to the liberation and satisfaction of inner drives as prerequisite to any effective reorganization of the exterior social order.[24] It implies the necessary transformation of a bourgeois society that perpetrates the three cardinal crimes against human sexuality: delayed sexual gratification, restricted to "adults only"; heterosexual monogamy; specialization of sexual activity limiting pleasure to the genitals.

Eupsychia and utopia are both quite inevitable and both quite out of our hands, for they are the irreversible result of technology,

[23] Charles Fourier, *La Phalange,* quoted by Daniel Bell in "Charles Fourier: Prophet of Eupsychia," *The American Scholar* (Winter, 1968–69), p. 50.

[24] A. H. Maslow, "Eupsychia—The Good Society," *Journal of Humanistic Psychology,* No. 1 (1961), pp. 1–11.

the only thing that keeps man human. The most comprehensive, reliable, and respected future-forecasts attempted by scientific man indicate that individual sensorial freedom is virtually synonymous with technological progress.[25]

Buckminster Fuller is among many who have noted the effects of industrialization and cybernetics on sexual activity: "We may glimpse in such patterning certain total behaviors in Universe that we know little about. We noted, for instance, that as survival rate and life-sustaining capability increase, fewer birth starts are required. This may be related to our developing capacities in interchanging our physical parts, or producing mechanical organs, of having progressively fewer human organisms to replenish. The drive in humanity to reproduce as prodigally as possible decreases considerably. This may be reflected in social behaviors—when all the girls begin to look like boys and boys and girls wear the same clothes. This may be part of a discouraging process in the idea of producing more babies. We shall have to look askance on sex merely as a reproductive capability, i.e., that it is normal to make babies. Society will have to change in its assessment of what the proclivities of humanity may be. Our viewpoints on homosexuality, for example, may have to be reconsidered and more wisely adjusted."[26]

Repression and censorship become impossible on an individual level when technology outstrips enforcement. The new image-exchange and duplication technologies are a formidable obstacle to effective sexual censorship. Home videotape recorders, Polaroid cameras, and 8mm. film cartridges render censorship nearly powerless. One prominent scientist working in laser holography has suggested the possibility of "pornograms"—pornographic, three-dimensional holograms mass-produced from a master and mass-distributed through the mail since their visual information is invisible until activated by plain white light.

[25] See Olaf Helmer, *Delphi Study*, Rand Corp., 1966; Theodore J. Gordon, "The Effects of Technology on Man's Environment," *Architectural Design* (February, 1967); Herman Kahn, Anthony J. Wiener, *The Year 2000* (New York: Macmillan, 1967); "Toward the Year 2000: Work in Progress," American Academy of Arts and Sciences Commission on the Year 2000, *Daedalus* (Summer, 1967).

[26] R. Buckminster Fuller, "The Year 2000," *Architectural Design* (February, 1967), p. 63.

When sexual material is readily available in the home, it changes the public attitude toward sex in commercial cinema. We aren't likely to be dazzled by discreet nudity on the Silver Screen when our home videotape library contains graphic interpretations of last week's neighborhood bisexual orgy. This is precisely what is happening in thousands of suburban homes, which otherwise are far from avant-garde. Within the last three years intermarital group sex has become an industry of corporate business, particularly in the Southern California area where a new world man is evolving. Computer firms compete with one another, matching couples with couples and compiling guest lists for orgies at homes and private country clubs. Home videotape systems are rented by the month and tapes of flagrant sexual activity are exchanged among the participants, many of whom regularly attend two orgies a week, sometimes as frequently as four or five, as the will to sexual power overtakes their outlaw consciousness. They discover the truth in Dylan's remark that you must live outside the law to be honest.

Thus man moves inevitably toward the discovery of what Norman O. Brown describes as his polymorphous-perverse self. A society that restricts physical contact in public to handshakes and discreet heterosexual kisses distorts man's image of his own sexual nature. However, anyone who has ever participated in even the most chaste encounter groups or sensory awareness seminars such as those conducted at the Esalen Institute in Big Sur, is impressed with the new sensual identity he discovers within himself, often accompanied by surprise and embarrassment.

The effects of habitual group sex, even when exclusively heterosexual, become obvious: man inevitably realizes that there is no such thing as "perversion" apart from the idea itself. We begin to recognize that our sexual potential is practically limitless once psychological barriers are erased. We see that "heterosexual," "homosexual," and "bisexual" are social observations, not inherent aspects of the organism. Freud, and more recently Brown, Marcuse, and R. D. Laing have noted that the qualities of "maleness" and "femaleness" are restricted to genital differences and do not even approach an adequate description of the human libido. And so, "Genital man is to become polymorphously perverse man, the man of love's body, able to experience the world with a fully erotic body in

an activity that is the equivalent of the play of childhood."[27]

Personal synaesthetic cinema has been directly responsible for the recent transformation in sexual content of commercial movies. After all, *I Am Curious* begins to seem a bit impotent when Carolee Schneemann's *Fuses* is playing at the Cinémathèque around the corner. Synaesthetic cinema, more than any other social phenomenon, has demonstrated the trend toward polymorphous eroticism. Because it is personal it's a manifestation of consciousness; because it's a manifestation of consciousness it is sexual; the more probing and relentlessly personal it becomes, the more polymorphously perverse it is. (Dylan: *"If my thought/dreams could be seen, they'd put my head in a guillotine."*) Because eroticism is the mind's manifestation of body ego, it is the one offensive quality that we cannot be rid of by slicing off a particular appendage. We are forced to accept it: synaesthetic cinema is the first collective expression of that acceptance.

The art and technology of expanded cinema will provide a framework within which contemporary man, who does not trust his own senses, may learn to study his values empirically and thus arrive at a better understanding of himself. The only understanding mind is the creative mind. Those of the old consciousness warn that although the videotape cartridge can be used to unite and elevate humanity, it also can "degrade" us by allowing unchecked manufacture and exchange of pornography. But the new consciousness regards this attitude itself as a degraded product of a culture without integrity, a culture perverse enough to imagine that love's body could somehow be degrading.

John Dewey reminds us that when art is removed from daily experience the collective aesthetic hunger turns toward the cheap and the vulgar. It's the same with the aesthetics of sex: when the art (i.e., beauty) of sex is denied and repressed we find a "counter-passion" for the obscene ". . . as malignant as the natural passion would have been benign." There is no basis for the assumption that synaesthetic cinema will contribute to the debasement of sex. We know that precisely the opposite is true: for the first time in Western culture the aesthetics of integrity are about to liberate man

[27] Richard W. Noland, "The Apocalypse of Norman O. Brown," *The American Scholar* (Winter, 1968–69), p. 60.

from centuries of sexual ignorance so that he may at last understand the infinite sensorium that is himself.

## The Pansexual Universe of Andy Warhol

It might be said of Warhol that what he did for Campbell's Soup, he did for sex. That is, he removed sex from its usual context and revealed it both as experience and cultural product. From the verbal jousting of *My Hustler* and *Bike Boy* to the casual intercourse of *Blue Movie,* Warhol has expressed an image of man's sexuality unique in all of cinema. Although partial to homosexuality, his work nevertheless manages to generate an overwhelming sense of the polymorphous-perverse. This is particularly evident in his most recent work.

For example, a romantic heterosexual relationship of warm authenticity develops between Viva and Louis Waldron in the notorious *Blue Movie.* In *Lonesome Cowboy* and Paul Morrissey's *Flesh,* however, Waldron is equally convincing as a brusque homosexual. Ironically, it is Morrissey's beautiful film that epitomizes the unisex world of The Factory. The Brandosque Joe Dallasandro is virtually the embodiment of polymorphous-perverse man as Morrissey interprets him: the archetypal erotic body, responding to the pleasures of the flesh without ideals or violence in a pansexual universe.

Because of their objective revelatory purpose, Warhol's and Morrissey's films are not synaesthetic. Yet, because of their non-dramatic structure, neither are they spectacles. It is spectacle ("... *something exhibited to view as unusual or entertaining; an eye-catching or dramatic public display.*") that defeats whatever erotic purpose may exist in conventional narrative cinema. Eroticism is the most subjective of experiences; it cannot be portrayed or photographed; it's an intangible that arises out of the aesthetic, the manner of experiencing it. The difference between sex in synaesthetic cinema and sex in narrative cinema is that it's no longer a spectacle. By definition synaesthetic cinema is an art of evocative emotion rather than concrete facts. The true subject of a synaesthetic film that includes fucking is not the act itself but the metaphysical "place between desire and experience" that is eroticism. It ceases to be spectacle because its real subject cannot be displayed.

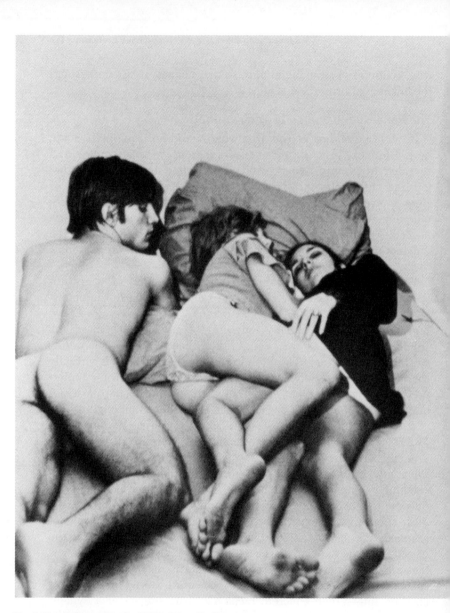

Paul Morrissey: *Flesh*. 1968. "Joe Dallesandro, the archetypal erotic body, responding to the pleasures of the flesh without ideals or violence in a pansexual universe."

Virtually the entire range of erotic experience has been engaged by the new cinema. Carl Linder is concerned with the surreal/psychological aspects of sexuality in films like *Womancock* or *The Devil Is Dead.* Jack Smith's *Flaming Creatures* and *Normal Love,* Ron Rice's *Chumlum,* Bill Vehr's *Brothel* and *Waiting for Sugar,* and *The Liberation of Mannique Mechanique* by Steven Arnold and Michael Wiese all explore the polymorphous subterranean world of unisexual transvestism. Stephen Dwoskin's exquisite studies, such as *Alone* or *Take Me,* reveal a Minimalist's sensibilities for latent sexuality and nuances in subtle autoeroticism. Warhol's *Couch,* Barbara Rubin's *Christmas on Earth,* and Andrew Noren's *A Change of Heart* confront, in various ways, the immortal subject of "hard core" pornography.

## Carolee Schneemann: *Fuses*

"Sex," as Carolee might say, "is not a fact but an aggregate of sensations." Thus by interweaving and compounding images of sexual love with images of mundane joy (the sea, a cat, window-filtered light), she expresses sex without the self-consciousness of a spectacle, without an idea of expressivity, in her words, "free in a process which liberates our intentions from our conceptions."

Carolee and her lover James Tenney emerge from nebulous clusters of color and light and are seen in every manner of sexual embrace. Often the images are barely recognizable, shot in near-darkness or painted, scratched, and otherwise transformed until montage becomes one overall mosaic simultaneity of flesh and textures and passionate embraces. "There were whole sections," Carolee explains, "where the film is chopped up and laid onto either black or transparent leader and taped down. I also put some of the film in the oven to bake it; I soaked it in all sorts of acids and dyes to see what would happen. I cut out details of imagery and repeated them. I worked on the film for three years." This fragmentation not only prevents narrative continuity, therefore focusing on individual image-events, but also closely approximates the actual experience of sex in which the body of one's partner becomes fragmented into tactile zones and exaggerated mental images.

Every element of the traditional "stag" film is here—fellatio, cunnilingus, close-ups of genitals and penetrations, sexual acro-

Carolee Schneemann: *Fuses.* 1965–68.
16mm. Color, black and white. 18 min.
"A fluid oceanic quality that merges
the physical act with its metaphysical
connotation, very Joycean and very
erotic."

batics—yet there's none of the prurience and dispassion usually associated with them. There is only a fluid oceanic quality that merges the physical act with the metaphysical connotation, very Joycean and very erotic. There's a fevered kinetic tempo that flawlessly evokes the urgency of sexual hunger. A "story" is being told but it's the story of every person in the audience who has wanted to express the richness of his experience in some concrete way. Carolee offers a psychic matrix in which this articulation might take place, and by this very act the spectacle is defeated.

Between scenes of lovemaking we see Carolee seated nude before her window, looking out at the sea as the curtains whisper lazily in the afternoon breeze. This image is repeated several times and serves to establish a sense of place and unity; this is a home, not a whorehouse. If there's anything unique about a pornographic film made by a woman it's this emotional unity that ties the images together. Scenes of Carolee skipping merrily through the surf are given as much prominence as close-ups of fellatio and cunnilingus. She's filming her consciousness, not her orifices. *Fuses* moves beyond the bed to embrace the universe in oceanic orgasm. "The thing that is disreputable in the idea of pornography for me," she says, "is that it tends to have to do with the absence of feeling, the absence of really committed emotions. I was after some kind of integral wholeness; the imagery is really compounded in emotion."

## Synaesthetic Cinema and
## Extra-Objective Reality

### Michael Snow: *Wavelength*

Michael Snow's *Wavelength*, a forty-five-minute zoom from one end of a room to the other, directly confronts the essence of cinema: the relationships between illusion and fact, space and time, subject and object. It's the first post-Warhol, post-Minimal movie, one of the few films to engage those higher conceptual orders that occupy modern painting and sculpture. *Wavelength* has become the forerunner of what might be called a Constructivist or Structuralist school of cinema, including the works of George Landow, Tony Conrad, Snow's wife Joyce Wieland, Paul Sharits, Ernie Gehr, Peter Kubelka, Ken Jacobs, Robert Morris, Pat O'Neill, and at least two of Bruce Baillie's films, *All My Life* and *Still Life*.

A large studio loft in New York: pristine light flooding through tall curtainless windows, street sounds floating on still air. The motionless camera is positioned high up, closer to the ceiling than the floor, so that a certain atmosphere, a certain environmental ambience is conveyed in that special way the cinema has of creating a sense of place. In fact, the first thought that comes to mind is that if a room could talk about itself this is what it would say.

Soon we discover the camera isn't static: every minute or so it jerks slightly forward; we realize the zoom lens is being manipulated rather clumsily; ever so slowly we are edging toward the wall of windows. This realization adds the first of many new dimensions to come: by introducing the element of motion, specifically invisible motion like the hands of a clock, the filmmaker adds the temporal element to a composition that in all other respects appears static. Motion is the only phenomenon that allows perception of time; the motion here, like time, is wholly conceptual.

Minutes pass: we notice subtle details—patterns of light and shadow, furniture arrangements, signs, tops of trucks, second-story windows, and other activity seen through the windows. Two women enter with a large bookcase, which they move against a wall, and then leave without speaking. There's a dispassionate distance to this activity, not in the least suggesting anything significant.

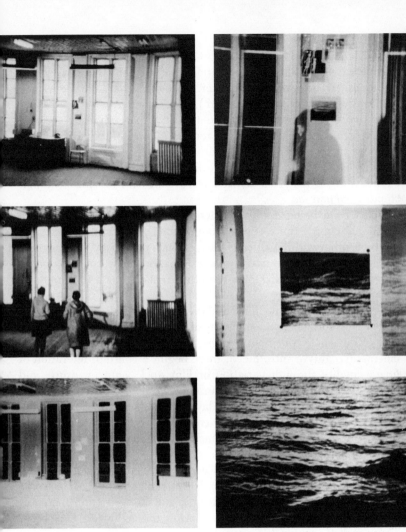

Michael Snow: *Wavelength.* 1967.
16mm. Color. 45 min. "The first post-
Warhol, post-Minimal movie, one of
the few films to engage those higher
conceptual orders that occupy modern
painting and sculpture."

Now we notice subtle permutations in the light (is it our eyes or the focus?). The walls seem darker, the light colder. We see a chair previously not visible (or was it?). Two women enter again (the same two?). They walk to a table and sit; apparently they are on a coffee break. (Perhaps this is a remote section of a warehouse or garment factory.) The women sit in silence. Suddenly, as though from a distant radio, we hear the Beatles: ". . . *Strawberry Fields . . . nothing is real . . . living is easy with eyes closed, misunderstanding all you see . . .*"

Apart from being eerily prophetic, the music strikes the perfect emotional chord: the scene assumes a totally different inflection, a kind of otherworldly dream state. What previously was a cold impersonal warehouse now appears romantically warm. The music fades; one woman walks out; the other remains for a few minutes, then leaves.

Up to this point the film has presented a "believable" natural reality, the sort of filmic situation in which one speaks of "suspension of disbelief." But now, for the first time, a nonrepresentational cinematic reality is introduced: there begins a constant alteration of image quality through variation of film stock, light exposure, and printing techniques. By changes in light we realize also that we are alternating between times of day—morning, noon, dusk, night. With each cut the room appears completely different though nothing has been physically altered and the position of the camera has not been changed.

At the point when the image goes into complete negative, the synchronous "natural" street sounds are replaced by an electronic pitch, or sine wave, which begins at a low 50 cycles and increases steadily to a shrill 12,000 cycles during the following half hour. Thus "realistic" natural imagery has become pure filmic reality, and whatever identifications or associations the viewer has made must be altered.

Night: fluorescent lamps glowing (when did they go on?). In the blackness through the windows we see fiery red streaks of automobile taillights. Suddenly there's offscreen scuffling, tumbling, crashing glass, muffled cries. A man stumbles into the frame, moans, crumples to the floor with a loud thud below camera range. The electronic pitch is louder, the zoom closer. Window panes and

photographs on the wall develop phantom images, vague superimpositions slightly offset. We no longer see the floor or side walls, just table, windows, photos, still indistinguishable. A girl in a fur coat enters. The light has changed: the room now appears to be an apartment. There's a yellow vinyl-aluminum kitchen chair that seems oddly out of place. The table actually is a writing desk with a telephone. She dials: ". . . Hello, there's a man on the floor . . . he's not drunk . . . I think he's dead . . . I'm scared . . . should I call the police? . . . all right, I'll meet you outside. . . ." She hangs up, walks out.

An overwhelming metaphysical tension engulfs the composition, filling the emptiness with a sense of density. Suddenly, a superimposed phantom image of the girl appears, transparently repeating the motions of entering, dialing, talking, leaving—but in silence beneath the whine of the sine wave, like some electromagnetic reverberation of past activity. The ghost image, which refers back in time to the "real" girl whose presence is linked in time to the death of the man, develops the only sequential, linear element in an otherwise nonlinear composition.

We realize also that the enlarged superimposed "outlines" around the window frames and photos refer to future points in the physical film itself when these objects actually will be that size. Similarly, the ghost "flashback" of the girl is a reference to the film's own physical "past," when the frame contained forms that it no longer contains.

Bright daylight: the room no longer is foreboding; the electronic tone is at its peak. The very light seems alive with a cold scintillation. The camera edges closer, blocking out the windows, until finally we distinguish the photograph on the wall: a picture of the ocean. A superimposed halo appears around the photo; suddenly the screen is an abstract (or more precisely, literalist) geometrical composition, totally symmetrical. This no longer is a room, no longer a movie, but quite literally an object—still photographs running through a projector.

Now the zoom advances to within the ocean photo; the sea consumes the entire screen. The electronic pitch runs a berserk glissando up and down the tone scale. We gaze at the ocean hypnotically: the fathomless water betraying no depth; the rhythmical waves frozen in time, answering some cosmic lunar force

(Snow: "An implication of universal continuity"). We remember Chabrol's remark: "There are no waves; there is only the ocean." For a long time we stare mindlessly at this ocean and then, very slowly, it fades into nothingness.

Like so many experimental filmmakers Michael Snow came to the cinema by way of painting and sculpture. His Expo '67 exhibit and recent New York showings have attracted considerable attention due to their exploration of the act of seeing as applied to Minimal sculpture. An understanding of Minimal Art is essential to the appreciation of *Wavelength* (shot in one week of December, 1966). Remembering Warhol's pivotal contribution, it is still possible to say that *Wavelength* is without precedent in the purity of its confrontation with the nature of the medium: It is a triumphant and definitive answer to Bazin's question, *"Que-est-ce que le cinéma?"*

Like all truly modern art, *Wavelength* is pure drama of confrontation. It has no "meaning" in the conventional sense. Its meaning is the relationship between film and viewer. We are interested more in what it *does* than what it *is* as an icon. The confrontation of art and spectator, and the spectator's resultant self-perception, is an *experience* rather than a meaning.

Referring to critics of Minimal Art, painter Frank Stella remarked: "If you pin them down they always end up asserting that something is present besides the paint on the canvas. My painting is based on the fact that only what can be seen there is there."[28] Similarly, in *Wavelength* there is no dependence on an idea or source of motivation outside the work itself. The subject of the film is its own structure and the concepts it suggests. (Snow: "My film is closer to Vermeer than to Cézanne.") But because Snow is working in the medium of cinema, he must deal with the element of illusion, a quality not inherent in painting or sculpture. The very essence of cinema is the fact that what we see there is *not* there: time and motion. These concepts have been engaged in recent traditional cinema (*Persona, Blow-Up, David Holzman's Diary*), but always symbolically, never in the empirical fashion of Snow's movie. *Wavelength* is post-Minimal because, thanks to the cinema, it can deal empirically with illusion, that is, a wider range of vision than

[28] Bruce Glaser, "Questions to Stella and Judd," *Minimal Art*, ed. Gregory Battcock (New York: Dutton Paperbacks, 1968), pp. 157–158.

usually is engaged in the plastic arts. It is post-Warhol because it confronts the illusory nature of cinematic reality; it presents not only "pure" time and space, but also *filmic* time (fragmented) and space (two-dimensional, nonperspectival). It is more metaphysical than Minimal. *Wavelength* is a romantic movie.

Snow emphasizes that editing is an abstraction of reality by alternating times of day with each cut, and by cutting rarely. Thus he achieves what Mondrian called the "relations" of abstract nature. The theory of relativity reduces everything to relations; it emphasizes structure, not material. We've been taught by modern science that the so-called objective world is a relationship between the observer and the observed, so that ultimately we are able to know nothing but that relationship. Extra-objective art replaces object-consciousness with metaphysical relation-consciousness. Romance is born in the space between events.

# Image-Exchange and the Post-Mass Audience Age

## The Rebirth of Cottage Industry

Just as the individual's unique identity is smothered by a social system that prohibits education by experiment and restricts creative living, so society itself as one organism suffers from the effects of unilateral mass education inherent in the present public communications network. Future historians would have a grossly inaccurate picture of today's culture if they were to judge our social meanings and values by the content of the so-called popular media.

Judging from broadcast television, for example, where the individual has little choice of selection, a personality such as Glen Campbell or a program like "Bonanza" might appear representative of popular taste because their lowest-common-denominator appeal satisfies the indiscriminate passivity of most of a hundred-million viewers. However, if we judge the same society at the same time by those media that offer personal selection and individual communication—LP record albums, for example—we find the Beatles as the representative image: two different worlds existing as one, distinguished by the technologies through which they communicate. The same phenomenon occurs in the cinema. The majority of college students flock to movies like *Easy Rider* or *Alice's Restaurant,* but when they make their own movies it's a different story entirely. The crucial difference is between mass public communication and private individual communication.

But that difference is quickly being resolved. When the proliferation of technology reaches a certain level of saturation in the environment, we cease to be separate from it. Communications technologies shape and record the objective and subjective realities of Everyman. The intermedia network becomes metabolically and homeostatically interfaced with each human being. To unplug any one of the advanced nations from the global telephone network, for example, would be a more extreme deterrent than any bomb; and the global television linkages soon will become equally as vital.

In the past we've had two mass personalities: our media personality and our "natural" personality. Pioneering radio and television

announcers adopted a mode of speech and behavior essentially unnatural, a formal way of talking and acting through the media. In a sense, the media function as behavior-altering agents for special occasions called "shows," much the same as alcohol is a behavior-altering agent for special occasions called "cocktail parties." But the recent phenomena of "underground" FM radio and "two-way" or "conversation" radio and television are evidence that we're feeling more comfortable with our extensions. Soon we'll converse as intimately over television and radio as we do now over telephones. The increasing number of twenty-four-hour all-news radio stations is a symptom of humanity's growing awareness of the monitor function of the media, even though today's profit-motive news might well be described as tactical misinformation. The notion of putting on a "show," although still prevalent in name at least, is losing its meaning. Inevitably, show business is becoming communication business, which in turn is becoming education business. And thus begins the revolution.

The mass-audience, mass-consumption era is beginning to disintegrate like Hesse's alter ego Harry Haller in *Steppenwolf,* who regretted his dual nature until he realized that he not only had two selves but quite literally dozens. It is generally accepted that the post-Industrial Age will also be an age of post-mass consumption. Cybernation virtually guarantees decentralization of energy sources. There'll be no need for a "department" of water and power, for example, when we learn to harness solar energy as easily as we make transistor radios. Inherent in the proliferation of inexpensive film technology, which caused the phenomenon of personal cinema, is the force that soon will transform the socioeconomic system that made commercial mass entertainment necessary in the first place. Synaesthetic cinema not only is the end of movies as we've known them aesthetically; the physical hardware of film technology itself is quickly phasing out, and with it the traditional modes of filmmaking and viewing. We're entering the era of image-publishing and image-exchange, the inevitable evolutionary successor to book publishing: the post-mass audience age.

The hardware and software environment presently exists in which one can purchase films as easily as one purchases books or records. The video/film symbiosis accomplished in electron-beam

recording results in the end of "movies" as social event and techni-
cal discipline. The decisive factor in the demise of cinema and TV
as we've known them is the ability to choose information rather than
being enslaved to mass broadcasting schedules or distribution pat-
terns, restricted by both mode and (profit) motive. This revolu-
tionary capability exists even though the military/industrial com-
plex withholds it from us.

Although commercial restrictions are inevitable in the early
stages of the phenomenon, we shall soon find that the personal
filmmaker is equivalent to the major studio. It is now possible to
collect hundreds of cartridges of one's own synaesthetic cinema—
images of one's actual life preserved out of time—for documenta-
tion, post-stylization, and study. For the first time in history every
human now has the ability to capture, preserve, and interpret those
aspects of the living present that are meaningful to him. The key
word is *interpret*. In a very real sense we can now show both our
experiences and our emotions to one another, rather than attempt-
ing to explain them in verbally abstracted language. There's no
semantic problem in a photographic image. We can now see
through each other's eyes, moving toward expanded vision and
inevitably expanded consciousness.

DeMille's *Ten Commandments* and Brakhage's *Dog Star Man*
both go into the same ten-dollar cartridges, and then comes the test:
the ability to own and repeatedly view a film is conditional on the
availability of films *worth* multiple viewings. We shall find that
ninety percent of all cinema in history cannot be viewed more than
a couple of times and still remain interesting. No one is going to pay
thirty dollars to see a movie. The only films capable of supporting
multiple viewings, in the same way that paintings and records are
enjoyed repeatedly, are synaesthetic films in which the viewer is
free to insert himself into the experience differently each time. Thus
the technology that allowed synaesthetic cinema to exist on a mass
scale in the first place is the same technology that will force virtually
all image-making toward synaesthesis, the purest manifestation of
consciousness.

The individual's ability to apprehend, capture, generate, trans-
mit, duplicate, replicate, manipulate, store, and retrieve audio-
visual information has reached the point where technology results in

the rebirth of "cottage industry" as conceived by the economist William Morris during the Industrial Revolution in England—the autonomous ability of the individual to generate his own industry within his own local environment. The primary difference between Morris' pre-industrial view and today's post-industrial reality is that cottage industry and global cybernetic industrialization interpenetrate each other's spheres of influence synergetically, each benefiting from the other.

The introduction of videotape cartridges forces mass communications into the untenable position of restricting individual freedom. Shortly, the educational and aesthetic messages of society will be communicated through cartridge-exchange and telecommand regional videotape cable centers; live broadcast television will be free to move information of a metabolic, homeostatic, interplanetary nerve-system function. At present, videotape or filmed information can be electron-beam recorded onto low-cost photosensitive material which, in the example of Columbia's EVR, results in one-hour cartridges of 180,000 black-and-white frames or half-hour cartridges of 90,000 color frames. They can be displayed individually or sequentially in random-access or automatic modes on any television set with higher resolution than videotape systems or broadcast TV. The system reduces broadcast videotape costs by a factor of fifty, home videotape costs by ten, and is approximately one-fifteenth as expensive as conventional filmmaking.

Coupled with other technologies such as the Polaroid family of cameras, the videophone, and long-distance Xerography and Xerographic telecopying, we arrive at a situation in which every TV image and every frame of every videotape or movie in history can now be filmed, taped, photographed, or copied in a number of ways, then replicated and transmitted—all by the individual. The *auteur* theory thus becomes utterly meaningless. We've progressed to the point at which an "impersonal" or "official" film is unthinkable. There's no such thing as an impersonal or nonauthored film: there is only honest cinema and hypocritical cinema, and they are measured by the difference between what is inside and what is outside of the maker's consciousness. Art is both "adult" and personal: we begin with that behind us, taken for granted, beneath discussion, and we go on from there.

For thousands of young persons around the world today, the cinema is a way of living. As we find ourselves faced with increasing leisure time, the camera will become more important as an instrument of creative living as opposed to its present role as conditioner of the dronelike existence we now lead. I mean to suggest that the camera—either cinema, or video, or both—as an extension of our nervous system, functions as a superego that allows us to observe and modify our behavior by observing our "software" image just as world man modifies his behavior by observing his collective superego as manifested in the global videosphere. By creating new realities in video/cinema we create new realities in our lives. We have seen that it is aesthetically and technically possible: let us now briefly examine the process.

The ethnological filmmaker Jean Rouch, speaking of his *cinéma-vérité* study, *Chronicle of a Summer,* described the superego function of the camera with his subjects: "At first," he said, "there's a self-conscious hamminess. They say to themselves, 'people are looking at me and I must give a nice impression of myself.' But this lasts only a very short time. And then, very rapidly, they begin to think—perhaps for the first time sincerely—about their problems, about who they are, and they begin to express what they have within themselves. As the film progresses and the people see the rushes, they begin to think about the character they were representing involuntarily—a character of which they had been completely unaware, that they discovered on the screen all of a sudden with enormous surprise. And so *the film becomes a reason for living* and they feel they must play that role. However, they will often deny the authenticity of the film, claiming they were putting on for the camera, because what has been revealed of them is so personal, a role which normally they would not project to the world.

"But something very strange occurs: the cinema becomes for them a pretext to try to resolve problems that they were not able to resolve without the cinema. I'm convinced that ninety percent of what they say is extremely sincere, and out of that they would never have had the courage to say at least ten percent without the cinema. The extraordinary pretext is, if you wish, the possibility to say something in front of the camera and afterwards be able to retract

it, saying it was just for the camera. The extraordinary possibility of playing a role which is oneself, but which one can disavow because it is only an image of oneself."[29]

The new filmmaker no longer is required to make drama or to tell a story or even to make "art," though art may certainly result. Personal cinema becomes art when it moves beyond self-expression to encompass life-expression. Art is not created; it is lived. The artist merely reports it. Synaesthetic cinema is not filmed so much as experienced onto film or videotape. As an extension of the citizen's nervous system it can't be judged by the same canons that traditionally have represented art. It's simply the first utterance of human beings who've found a new language. If art is involved, it's the art of creative living as opposed to passive conditioned response. The possibility of realizing one's innermost desires with the excuse that it's "just for the film" is a temptation that will be too strong to resist when we're released from the needs of marginal survival. Wallace Stevens: "It is the explanations of things that we make to ourselves that disclose our character: the subjects of one's poem are the symbols of one's self or one of one's selves."

Along with each man's life being the subject of his own study is the need for each man to be consciously part of Man's life. "In dreams," said Yeats, "begin responsibilities." Buckminster Fuller has said that the great aesthetic of tomorrow will be the aesthetic of integrity. For ten thousand years more than five hundred generations of agricultural men have lived abnormal, artificial lives of repetitive, boring toil as energy slaves who must prove their right to live. But now we are on the threshold of freedom. We are about to become our own gods. We are about to face the problem of values. Bronowski: "The problem of values arises only when men try to fit together their need to be social animals with their need to be free men. There is no problem, there are no values, until men want to do both."[30]

For the first time in history we're approaching that point at which both will be possible if we fashion our lives with a sense of integrity.

[29] "Jean Rouch in Conversation with James Blue," *Film Comment* (Fall–Winter, 1967), pp. 84–85.

[30] Bronowski, *Science and Human Values* (New York: Harper & Brothers, 1965), p. 55.

We've modified our environment so radically that we must now modify ourselves in order to exist in it. If we're all to become one, the ethics of individual man must become a meta-ethic for global man. Donald Schon: "In seeking a meta-ethic we suffer from the fact that society traditionally delegates the job of change to special individuals in its midst, to artists, inventors and scientists—and then isolates them from the rest of society in order to preserve the illusion of stability of norms and objectives."[31]

Not only must we completely revise our attitudes toward "ownership" of the physical earth; we must also learn to accept the fact that the ideas and creations of humanity do not belong to any one individual. Thus technology not only helps maintain the present level of mankind's integrity, it actually forces us to increase that integrity and provides the social framework within which to begin. Freedom is the acceptance of responsibility. Bronowski speaks of the "habit of truth" as it applies to scientific experiments. Contemporary man in general might be said to practice a habit of hypocrisy: "There is no more threatening and no more degrading doctrine than the fancy that somehow we may shelve the responsibility for making the decisions of our society by passing it to a few scientists armored with a special magic. The world today is made and powered by science; for any man to abdicate an interest in science is to walk with open eyes toward slavery."[32]

The irresponsible audience will learn responsibility when it becomes its own audience through the synaesthetic research of expanded cinema and image-exchange. And in this activity it will come to discover the scientific meta-ethic. "The practice of science compels the practitioner to form for himself a fundamental set of universal values . . . the exactness of science can give a context for our nonscientific judgments."[33] By its very nature synaesthetic cinema will close the gap between art and science because the art of creative living must become a science if life is to hold any meaning in the Cybernetic Age.

[31] Donald Schon, *Technology and Change* (New York: Delacorte Press, 1967), p. 24.
[32] Bronowski, pp. 5, 6.
[33] *Ibid.*, p. xiii.

# PART THREE:
## TOWARD COSMIC CONSCIOUSNESS

"If you look back in history you'll find that the artist and the scientist are inseparable. In many ways the artist's work is identical with scientific exploration. The artist is able to focus more in the area of consciousness, but with the same scientific zeal. Yet cosmic consciousness is not limited to the scientist. In fact scientists are sometimes the last to know."

JORDAN BELSON

We've followed the evolution of image language to its limits: the end of fiction, drama, and realism as they have been traditionally understood. Conventional cinema can be pushed no further. To explore new dimensions of awareness requires new technological extensions. Just as the term "man" is coming to mean man/plant/machine, so the definition of cinema must be expanded to include videotronics, computer science, atomic light. Before discussing those technologies, however, we must first ask ourselves what these new dimensions of awareness might be. In the language of synaesthetics we have our structural paradigm. What concepts are we to explore with it?

We could say that art isn't truly contemporary until it relates to the world of cybernetics, game theory, the DNA molecule, Heisenberg's Uncertainty Principle, theories of antimatter, transistorization, the breeder reactor, genocidal weaponry, the laser, pre-experiencing alternative futures. But this purely scientific portrait of modern existence is only partially drawn. As Louis Pauwels has observed: "We are living at a time when science has entered the spiritual universe. It has transformed the mind of the observer himself, raising it to a plane which is no longer that of scientific intelligence, now proved to be inadequate."[1] Man no longer is earthbound. We move now in sidereal time. We must expand our

[1] Pauwels, Bergier, *op. cit.*, p. 62.

horizons beyond the point of infinity. We must move from oceanic consciousness to cosmic consciousness.

At their present limits astrophysics, biochemistry, and conceptual mathematics move into metaphysical territory. Mysticism is upon us: it arrives simultaneously from science and psilocybin. Pauwels: "Modern science, once freed from conformism, is seen to have ideas to exchange with the magicians, alchemists and wonder-workers of antiquity. A revolution is taking place before our eyes—the unexpected remarriage of reason and intuition."[2]

Art and science have achieved extremely sophisticated levels of abstraction. They have in fact reached that point at which the abstract becomes extra-objective. Post-Euclidean geometry, for example, precludes any exact visualization of a stable space grid. We are confronted with dynamic interaction between several transfinite space systems. Precise focusing is impossible. (John Cage: "A measurement measures measuring means.") And the content of modern art tends increasingly toward the conceptual—i.e., decision-making, systems aesthetics, environmental problems of "impossible" art.

What we "know" conceptually has far outstripped what we experience empirically. We are finally beginning to accept the fact that our senses allow us to perceive only one-millionth of what we know to be reality—the electromagnetic spectrum. Ninety-nine percent of all vital forces affecting our life is invisible. Most of the fundamental rates of change can't be apprehended sensorially. Fuller: "Better than ninety-nine percent of modern technology occurs in the realm of physical phenomena that are *sub* or *ultra* to the range of human visibility. We can see the telephone wires but not the conversations taking place. We can see the varieties of metal parts of airplanes but there is nothing to tell us how relatively strong these metals are in comparison to other metals. None of these varieties can be told from the others by the human senses, not even by metallurgists when unaided by instruments. The differences are invisible. Yet world society has throughout its millions of years on earth made its judgments on visible, tangible, sensorially demonstrable criteria."[3]

[2] *Ibid.*, p. xxii.
[3] R. Buckminster Fuller, *Ideas and Integrities*, p. 64.

So we see—that is, we *don't* see—that our physical environment itself has drastically altered the classical definition of artistic purpose as articulated by Conrad Fiedler: "Artistic activity begins when man finds himself face to face with the *visible* world as with something immensely enigmatical . . . In the creation of a work of art, man engages in a struggle with nature not for his physical but for his mental existence."[4]

It is the invisible and inconceivable that man finds immensely enigmatical and to which he has turned his conceptual capacities. Not only is drama obsolete but in a very real sense so is the finite world out of which drama traditionally has risen. The concerns of artist and scientist today are transfinite. McLuhan: "Electicity points the way to an extension of the process of consciousness itself, on a world scale, and without any verbalization whatever."[5]

The Paleocybernetic Age witnesses the concretization of intuition and the secularization of religion through electronics. Nam June Paik: "Electronics is essentially Oriental . . . but don't confuse 'electronic' with 'electric' as McLuhan often does. Electricity deals with mass and weight; electronics deals with information: one is muscle, the other is nerve." This is to say that global man in the final third of the twentieth century is witnessing the power of the intangible over the tangible. "When Einstein wrote the equation $E=mc^2$, the metaphysical took the measure of, and mastered, the physical. Nothing in our experience suggests that energy could comprehend and write the equation of intellect . . . [Einstein's] equation is operating inexorably, and the metaphysical is now manifesting its ability to reign over the physical."[6]

In addition to a radical reassessment of inner space, the new age is characterized by the wholesale obsolescence of man's historical view of outer space. Lunar observatories and satellite telescopes, free from the blinders of earth's air-ocean, will effect a quantum leap in human knowledge comparable to that which the microscope

[4] Conrad Fiedler, *On Judging Works of Visual Art*, trans. Henry Shaefer-Simmern and Fulmer Mood (Berkeley, Calif.: University of California Press, 1949), p. 48.

[5] Marshall McLuhan, *Understanding Media* (New York: McGraw-Hill, 1965), p. 80.

[6] Fuller, *Spaceship Earth*, p. 36.

provided at the end of the nineteenth century. Until 1966, for example, all of astronomy indicated that the planet Mercury did not rotate. Radar observations now reveal that it turns on its axis every fifty-nine days. Similar embarrassing reversals of generations-old opinions about Venus, Mars, Jupiter, and even our own moon have occurred within the last decade.[7]

We are entering a transfinite realm of physical and metaphysical mysteries that have nothing to do with fiction. It is now recognized that science has come closer to whatever God may be than has the church in all its tormented history. Science continually discovers and reaffirms the existence of what Fuller calls "an a priori metaphysical intelligence omni-operative in the Universe." Scientists find that a vast omni-present intellect pervades every atom of the universe, governing the structure and behavior of all physical phenomena. Yet this intelligence itself, which we identify as "the laws of nature," is purely metaphysical and is totally unpredicted by the behaviors of any of the physical parts. Einstein's $E=mc^2$ is science's most comprehensive formulation of that intelligence. As J. B. S. Haldane once said, "The universe is not only stranger than we imagine; it is stranger than we *can* imagine."

[7] Arthur C. Clarke, "Next—The Planets," *Playboy* (March, 1969), p. 100.

## *2001:* The New Nostalgia

The year 2000, although universally accepted as a rather apocalyptic millennial symbol, does not begin the twenty-first century. A difference of twelve months may seem relatively insignificant today, but in the onrushing accelerations of radical evolution many worlds can come and go in the period of a year. Already the focus of the arts, especially cinema, has shifted toward cosmic consciousness. "The consequences of the images," said McLuhan, "will be the images of the consequences." A completely new vocabulary of graphic language is available to the image-maker now that our video senses have extended to Mars and beyond.

Stanley Kubrick's *2001: A Space Odyssey* was the last film in history forced to rely on synthetic images of heavenly bodies. One measure of radical evolution is the way in which Kubrick's images of the earth and moon, so utterly realistic not long ago, have become pallid in contrast with the actual images themselves. We've confronted a larger reality: there no longer is a need to represent cosmic consciousness through fiction. Just as synaesthetic cinema renders fiction obsolete, so do the technologies that enable us to traverse the planets and to invent the future. The old Hollywood cliché "filmed on location" assumes staggering implications.

In many respects *2001* is an epochal achievement of cinema; in other ways, however, it is marred by passages of graceless audience manipulation and vulgar expositional devices that would embarrass artists of lesser talent than Kubrick. But the movie unquestionably is a phenomenal experience, and even though it begins to pale after a couple of viewings, its contributions to the state of the art and to mass-audience commercial cinema cannot be overlooked or overrated. Because of this movie a great number of persons have been able to understand something of the spiritualism in science. And though it is rather symptomatic of an unfortunate syndrome having to do with the feared "dehumanizing" effects of advanced technology, *2001* did create an impressive sense of space and time relationships practically without precedent in the cinema. A technical masterpiece, but a thematic mishmash of nineteenth- and twentieth-

century confusions, which demonstrates that it is not so much a film of tomorrow as a trenchant reflection of contemporary sentiments solidly based in the consciousness of today. Still, it *was* more than we might have hoped it would be.

In casting its vision to the stars, *2001* returns full circle to the origins of human curiosity. One of mankind's oldest recorded thoughts has to do with the cyclic unity and simultaneous regeneration of the universe. In the texts of ancient Sanskrit is the notion that the universe dies and is reborn with every breath we draw. To a certain extent this has been substantiated by the studies of modern physics, which reveal that elemental changes at the atomic and subatomic levels are total and instantaneous, while the macrosystem of the cosmologically vast universe itself is constantly in metamorphosis. In *Vishvasara Tantra,* which includes one of man's earliest attempts at explaining the formation of matter, we find the prophetic conclusion, *"What is here is elsewhere; what is not here is nowhere."*

These concepts are virtually embodied in the design of *2001,* from its higher ordering principle—that mankind's dawn is a continual process of death and rebirth—through each of its parts, none of which predicts the behavior of the whole. The film moves with an implacable and purposive grace through a richly-connected allegorical structure that recalls Ortega y Gasset's "higher algebra of metaphors." Encompassing the whole is the sexual/genetic metaphor in which rockets are ejaculated from a central slit in Hilton Space Station No. 5, and a sperm-shaped spacecraft named *Discovery* (i.e., *birth*) emits a pod that carries its human seed through a Stargate womb to eventual death and rebirth as the Starchild Embryo. Within this macrostructure we find endless variations such as the prehistoric bone that becomes a spinning space station, one of the most tasteful allegorical transitions in the history of a medium given to rather grandiose symbolism.

The behavior and ultimate deactivation of the berserk computer HAL might be viewed as a metaphor for the end of logic. It is established that HAL, who not only "thinks" but also "feels," represents the highest achievement of human intelligence. The machine is singing *"Daisy, Daisy, give me your answer true"* (a computer recording of which actually was made ten years ago) when the

cybernetic lobotomy renders it senseless. Immediately after, the astronaut encounters the alien monolith in crucifix-alignment with a string of asteroids and is seduced through the Stargate into a dimension "beyond infinity"—that is, beyond logic.

In this domain far from any galaxy we know, the human finds himself in austere Regency chambers with an aqueous video-like atmosphere, constructed by whispering omniscient aliens to make him comfortable during the lifetime he is to spend under their scrutiny. He is kept untra-healthy and lives to a very old age. This is depicted through a kind of metaphorical time-lapse in which the astronaut undergoes a series of self-confrontations, aging each time. At last he gazes toward a bed in which is lying an image of himself so old and emaciated that he incredibly resembles the humanoid apes of "The Dawn of Man." This primitive creature timidly lifts its palsied hand in archetypal gesture toward the metallic monolith that towers in the center of the glowing room.

Suddenly there appears the cosmic image that began the film and constitutes a kind of metaphysical leitmotiv of transcendental Cartesian beauty: in deep space we are levitated near a huge planet, its crest illumined by starlight. Another globe rises behind and directly in line with the first; and now, with a blinding starburst and Strauss's paean to Nietzsche, a fiery sun appears behind the second planet, completing the geometrical assembly of heavenly bodies. A timeless unforgettable image that suggests, almost surrealistically, some higher order, some transcending logic far beyond human intelligence. *2001* is Stanley Kubrick's interstellar morality play.

There is, however, a fundamental disunity between the film's conceptual and design information. Its adherence to a Minimalist aesthetic of primary structures is starkly contrasted against the confusion of its ideas. And whereas it is structurally uneven, there are moments when form and content seem flawlessly synthesized. The elegant simplicity of its architectural trajectories is the harmonic opposite of its galactic polymorphism. And what might be described as its "aesthetics of space tooling" has captured the imagination of a society steeped in the vulgar bric-a-brac of postwar architecture. It has become a kind of cinematic Bauhaus.

Central to this tremendous cultural influence, and in spite of the

Mystical alignment of planets and sun in the
Stanley Kubrick production *2001: A Space
Odyssey*. Photo: courtesy of MGM Studios.

film's many confusions, is Kubrick's intuitive grasp of what I call the
*new nostalgia*. It pervades the entire film, but particularly the
sequence in which Gary Lockwood aboard the *Discovery* receives a
videophone birthday message from his earthbound parents. The
crucial effect is Kubrick's use of the *adagio* from Aram Khacha-
turian's *Gayane Ballet Suite*. The music—mournful, melancholy,
with a sense of transcendental beauty—invests the scene with an
overwhelming mood that invites only one interpretation: it is obvi-
ously a sad event.

   This sadness is a manifestation of the new nostalgia: the astro-
naut is a child of the new age, a man of cosmic consciousness. Not
only does he live in a different world from his parents on a
conceptual level, he has physically left their natural world and all of
its values. Of what possible significance could a birthday be to him?
He doesn't even share a common definition of life with his parents.
His companions aboard the *Discovery* are preserved in a cryo-
genetic state of suspended animation.

   Yet the sequence has been widely interpreted as an indictment of
the "dehumanizing" effects of technology. The astronaut is seen as a
kind of "space zombie" because he appears indifferent to the
effusions of his parents. In fact, the music functions not as com-
mentary on the action but as an evocation of the astronaut's
realization of a generation gap both physical and metaphysical.

That he's not particularly demonstrative in the usual messy way suggests nothing so much as a sense of integrity. To find him inhuman is equivalent to Camus' Magistrate accusing Mersault of not loving his mother.

To understand this generation gap, we must realize that the melancholy of the new nostalgia arises not out of sentimental remembrance of things past, but from an awareness of radical evolution in the living present. When Sartre wrote about Existentialism, it was not popularly recognized as being inherent in daily experience; it was a concept, a theory, else there would have been no need for Sartre to formulate an entire cosmology upon it. But through electronic technology, Existentialism becomes daily experience. We are transformed by time through living within it; but technologies such as television displace the individual from participant to observer of the human pageant, and thus we live effectively "outside" of time; we externalize and objectify what previously was subjectively integral to our own self-image. The result is an inevitable sense of melancholy and nostalgia, not for the past, but for our inability to become integral with the present. We are all outsiders.

The new nostalgia also is a result of Western culture's transformation from sacred to secular: "Sacred societies resist change, unable to accept or value the new or untraditional. Secular societies, a relatively modern development, are oriented toward change, consciously seek out and value new and untraditional ways. Sacred societies are oriented toward the past; secular societies toward the future."[8] Ironically, no sooner has Existentialism moved from theory to experience than it is given a new dimension by science, which has replaced the church as our temple of worship and has disclosed man's teleologic, anti-entropic function in the universe, something the church never was able to do.

But the scientific method is, by its very nature, nonsacred. Everything is open to challenge. Thus the new nostalgia is a symptom of our realization that nothing is sacred. This produces a tendency to dissociate and distance oneself from all previously coveted phenomena that have provided continuity as landmarks of the soul. Most of mankind's ancient dreams have become realities;

[8] John McHale, *The Future of the Future* (New York: George Braziller, Inc., 1969), p. 24.

the speed of change has caught us without new dreams to replace the old, because the world of tomorrow is elsewhere and unthinkable.

We find, moreover, that the new nostalgia is a symptom of the death of history. The more we learn about the present, about humanity's perception and interpretation of the present, the more suspect history becomes. When Fuller remarks that our most polluted resource is the "tactical information" (news) to which humanity spontaneously reflexes, he echoes Hermann Hesse's view that "history's third dimension is always fiction." The present has discredited the past, while the history of the present is recorded by machines, not "written" by men, and is thus out of our hands as a "man-made" phenomenon. "The computer," says McLuhan, "abolishes the human past by making it entirely present." We don't "remember" the assassination of John F. Kennedy because we never experienced it directly in the first place. For millions of people who were not actually present in Dallas, Kennedy's death exists only in the endless technologically-sustained present. We "remember" it in the same way that we first "knew" it—through the media—and we can experience it again each time the videotapes are played. Since we see and hear and feel only the conditioning of our own memory, a great flood of nostalgia is generated when technology erases the past and with it our self-image.

The new nostalgia also is a result of humanity's inevitable symbiosis with the hallucinogens of the ecology. First, man's image of himself as discretely separate from the surrounding biosphere is shaken by his discovery of the a priori biochemical relationship between his brain and the humble plant. Second, in the consciousness-expansion of the drug experience, the overwhelming emotion is one of remembering something that one has forgotten, something one "knew" long, long ago in the forgotten recesses of the mind. The *déjà vu* of the drug experience results from the discovery of how much is absent in "normal" perception of the present, not the past. Although *2001* contains no specific allusions to drug experiences, the subject is indirectly suggested in the Stargate Corridor sequence, which might well be interpreted as a drug-trip allegory.

But perhaps the most profound aspect of the new nostalgia is what we call the generation gap, which is totally a result of the unprecedented sudden influx of information. The past is discredited

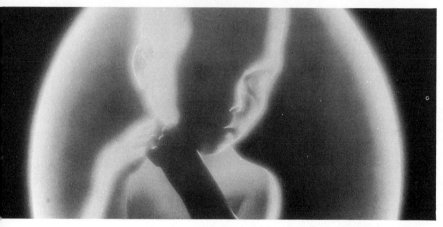

Starchild Embryo from the Stanley Kubrick production *2001: A Space Odyssey*. "The image of the Starchild, its umbilical feeding from no earthly womb, elegantly symbolizes a generation gap so sudden and so profound that few of us believed it possible." Photo: courtesy of MGM Studios.

but continues to inform a present in which new information has revealed us in a completely new perspective. The information implosion, as revised self-knowledge, sheds unrelenting and inadvertently cruel light upon the illusions of the past, of which our parents are victims. We find, as Hesse did, that "world history taken as a whole by no means furthered what was desirable, rational, and beautiful in the life of man, but at best only tolerated it as an exception."[9]

For the first time in history, an entire generation abruptly discovers that its legacy of love has been tragically ill-served: "Humanity is characterized by extraordinary love for its new life, and yet has been misinforming its new life to such an extent that the new life is continually at a greater disadvantage than it would be if abandoned in the wilderness by its parents."[10] The image of the Starchild Embryo at the conclusion of *2001*, its umbilical feeding from no Earthly womb, elegantly symbolizes a generation gap so sudden and so profound that few of us believed it possible. As we unlearn our past, we unlearn our selves. This is the new nostalgia, not for the past because there is no past, and not for the future because there are no parameters by which to know it.

The Cybernetic Age is the new Romantic Age. Nature once again has become an open empire as it was in the days when man thought of the earth as flat and extending on to infinity. When science revealed the earth as spherical, and thus a closed system, we were able to speak of parameters and romance was demystified into Existentialism. But we've left the boundaries of earth and again have entered an open empire in which all manner of mysteries are possible. Beyond infinity lurk demons who guard the secrets of the cosmos. We are children embarking on a journey of discovery. "The same extraordinary intellectual forces with which man is remolding his planet are now being turned in upon himself. The results of this inner exploration may be infinitely more powerful than any physically-extended voyage to Mars or the bottom of the sea."[11] Kubrick

[9] Hermann Hesse, *The Glass Bead Game* (New York: Holt, Rinehart, and Winston, Inc., 1969), p. 150.

[10] R. Buckminster Fuller, *Education Automation* (Carbondale, Ill.: Southern Illinois University Press, 1962), p. 9.

[11] John McHale, "Man +," *Architectural Design* (February, 1967), pp. 87, 88.

himself demonstrated his awareness of the new nostalgia when he quoted Carl Jung's remarks on possible consequences of contact with advanced alien intelligence: ". . . reins would be torn from our hands and we would find ourselves without dreams . . . we would find our intellectual and spiritual aspirations so outmoded as to leave us completely paralyzed."[12]

I interviewed Arthur C. Clarke, coauthor of *2001*, who has been chiefly responsible for elevating science fiction from pulp to profundity. I was accompanied by Ted Zatlyn, then editor of the *Los Angeles Free Press*. We suggested that the film's depiction of the man/machine symbiosis as ominous and threatening might have been irresponsible.

CLARKE: It could be irresponsible, yes. But the novel explains why HAL did this and of course the film never gave any explanation of his behavior. So from that point of view it differs from the novel. I personally would like to have seen a rationale for HAL's behavior. It's perfectly understandable and in fact makes HAL a very sympathetic character because he's been fouled up by these clods back at Mission Control, you see. And in a way it's more pro-machine than pro-human, if you analyze the philosophy behind the novel. I included a sort of emotional passage about HAL's electronic Eden and so on. But it would have been almost impossible to have given the logical explanation of just why HAL did what he did. It would have slowed things down too much. So it had to be treated on this sort of naïve and conventional level. Then there was the straightforward matter of dramatic content. One had to have some kind of dramatic tension and suspense and conflict. And HAL's episode is the only conventional dramatic element in the whole film. And so in that way you might say that it was rather contrived. We set out quite consciously and deliberately—calculatedly, if you like—to create a myth, an adventure, but still be totally plausible, realistic, intelligent. We weren't going to have any blonde stowaway in the airlock and all this sort of nonsense that you've seen in the past. This immediately limited our options enormously. There are fairly few things that can happen on a space mission. Especially if the men have been

12 Stanley Kubrick interviewed in *Playboy* (September, 1968), p. 96.

carefully selected psychologically and so on—all the things which make astronauts such undramatic characters. You don't have nervous breakdowns or Caine Mutinies on a spaceship.

TED: Do you see the hippie phenomenon as an evolutionary process similar to what you described in *Childhood's End?* Many aspects of what we call the hippie movement were almost prophesied in that book, especially the idea of an awakened moral conscience among youth.

CLARKE: Yes, at one point I had a subtitle for *2001* which was *Childhood's Beginning.*

TED: But in another way there seems to be a contradiction between *2001* and *Childhood's End.* In an evolutionary sense. In *2001* the idea of an evolving expansion of consciousness seems directly opposed to extending the American capitalistic free-enterprise system into outer space. I mean with Howard Johnson and Pan-Am businesses.

CLARKE: That was done primarily to establish a background of realism to achieve total acceptance by the audience.

GENE: Yes, but you see this is exactly what we feel is rather unfortunate about the film. I mean that's all very fine, and it works, and everyone likes that, they think it's clever and all. But in fact how "realistic" is capitalistic free enterprise at that advanced stage in man's evolution? And to suggest such a thing—even to suggest "ownership" in space is perhaps a bit of self-fulfilling prophecy. We are what we think the future will be.

CLARKE: But that doesn't necessarily mean capitalistic free enterprise. Pan-Am is running the range for NASA, but that doesn't necessarily mean a capitalistic system. Names hang on, that's all. I mean Hilton is planning a space-station hotel. He gave a talk and showed designs three years ago.

TED: But the obvious extension of that idea is spherical influence in space—Russia's sphere here, America's sphere here, China's sphere over there. I just don't think that when man evolves to the point where he can travel throughout the universe, using new energy sources and so on, that he will carry with him an archaic form of thinking.

CLARKE: Well, of course, he won't. Things will change completely. But the events of *2001* are only thirty years from now. And a lot

of these things will still be around. The names anyway. Just as the Catholic Church still exists in name. In fact, if I'd done *2001* by myself I'd have had an international organization instead of nationalism. But here again you're constrained by practical matters—this is an American film made by an American company and there are a lot of problems. For example at one point we were saying we should have at least one token black in the crew. But when your crew is only two people it would be so obvious. I mean can you see Bill Cosby in there? So finally we said the hell with it.

GENE: Science fiction has had a new image for the last few years, a new respectability. In fact, most people are now willing to accept the fact that there is nothing *but* science fiction.

CLARKE: I've been saying for years that mainstream literature is a small subsection of science fiction. Because science fiction is about everything.

GENE: Exactly. And one of the significant aspects of *2001* is that it's science fact. When you discuss science and what it's doing, you're not only discussing the present but the past and the future simultaneously. Because science encompasses what has been and what will be all in the moment, the present. So the idea of science *fiction* no longer is meaningful.

CLARKE: One reason older people dislike *2001* is they realize it's about reality and it scares the hell out of them. This film is about the two most important realities of the future: development of intelligent machines, and contact with higher alien intelligence. Which of course may be machines themselves. I suspect that all really higher intelligences will be machines. Unless they're beyond machines. But biological intelligence is a lower form of intelligence, almost inevitably. We're in an early stage in the evolution of intelligence but a late stage in the evolution of life. Real intelligence won't be living.

GENE: I understand your meaning of that idea as a beneficial thing in which man is rendered obsolete as a specialist, obsolete as all the things he's been up to now—obsolete in comparison to the computer's ability to do all these things better and quicker—but, on the other hand, man is then totally free to live comprehensively, nonspecialized, like the freedom of children.

CLARKE: That's how I ended one of my essays on the subject. I said "Now it's time to play." The goal of the future is total unemployment, so we can play. That's why we have to destroy the present politico-economic system.

# The Stargate Corridor

The conceptual deficiencies of *2001* are somewhat redeemed by its sophisticated deployment of cinematic technology. For the first time in commercial cinema we are given the state of the art at its highest point of refinement.[13] *2001* has become the higher ordering principle by which all commercial cinema must be measured.

Douglas Trumbull, a twenty-five-year-old artist/technologist, was one of four special effects supervisors on the project. The so-called slit-scan machine, which created the Stargate Corridor sequence, was one of several pieces of equipment Trumbull developed especially for this film. Though much of its impact is due to the Cinerama format (16mm. versions are not nearly so impressive), the sequence was nevertheless a breakthrough in commercial cinema. Although this particular approach to the slit-scan was developed by Trumbull, the technique does have precedent in the work of John Whitney.

According to Trumbull, the original screenplay called for a giant tetrahedron that would be discovered in orbit around Jupiter. This was because there is, in fact, a strange perturbation of one of Jupiter's moons. Astronomers have noted that it appears to grow larger and smaller at certain points in its orbit. "So Clarke said maybe it's not a moon at all," Trumbull recalls. "Maybe it's some sort of object that presents a larger and smaller size as it rotates. So the spacemen arrive and it's this huge tetrahedron with a hole in it. He positions his pod over the hole, looks down through, and can see into another dimension. The tetrahedron may be superimposed over Jupiter but he sees stars through the hole: a time gate."

TRUMBULL: We spent a long time drawing tetrahedrons with holes in them and it all looked corny. It was never right. Then someone thought of having a giant hole or slot directly in one of the

[13] Extensive details on the production of *2001* were published in *The American Cinematographer* (June, 1968).

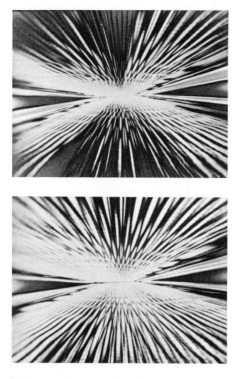
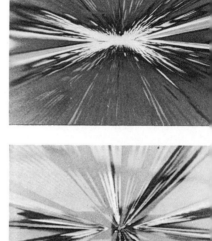

Slit-scan Stargate Corridor from
Stanley Kubrick's *2001: A Space Odyssey.*

moons. The spaceman is orbiting around one of the moons and finds a hole in it. We drew pictures of that and they looked pretty stupid. Finally Kubrick came up with the idea of the big slab. He always insisted on super-simple symmetrical forms rather than anything which would deviate artistically from the simplest approach.

One of the very last things we did was adding the mystical symmetry. The Jupiter sequence culminates in a shot in which the moons and asteroids are aligned and the mysterious slab is seen perpendicular to them like a crucifix. It wasn't intended to be that, but that's the way it came out. So when we saw what we had, we worked back from that point and created similar scenes earlier in the film. For example, when the apemen are looking up at the slab and suddenly there's this symmetrical alignment of the sun and the moon over the slab—that was put in long after the sequence was shot. Then we went back to the point where they discover the slab on the moon and inserted the same imagery for that sequence. This was all second-guessing but it was meant to suggest the same ideas as one finds behind similar imagery in mystical literature and symbols.

There was always the idea that Keir Dullea would go into a time-warp or some kind of "psychedelic" corridor, but we didn't know how to get him into it. What do we do with him? Does he fall into a hole or what? It was completely unresolved. The special effects people came up with corny things with mirrors that looked terrible. So I stumbled onto this idea through fragments of information about what John Whitney was doing with scanning slits that move across the lens creating optical warps. I figured why couldn't you have a slit that starts far away and moves toward the camera? Rather than moving laterally, why can't it move dimensionally?

So I did a simple test on the Oxberry animation stand. It was rigged with a Polaroid camera so you could take Polaroid pictures of any setup immediately to see how it looked. So I just ran the camera up and down and juggled some slits and funny pieces of artwork around, and I found out that you could in fact scan an image onto an oblique surface. That whole idea expanded and I

built this huge thing that occupied about 50,000 square feet. It produced the effect which I call the Slit-Scan Effect.

Similar to image-scanning techniques used in scientific and industrial photography, Trumbull's process was totally automated through an impressive battery of selsyn drives, timers, sequencers, and camera controls. Basically it involved a standard 65mm. Mitchell camera mounted on a fifteen-foot track leading to a screen with a narrow vertical slit in its center. Behind the screen was a powerful light source focused through several horizontally-shifting glass panels painted with abstract designs and colors.

When the camera is at the "stop" position at the far end of the fifteen-foot track, the illuminated slit is framed exactly in the center of the lens. The standard shutter is taken out of phase and held wide open. An auxiliary shutter is built onto the front of the lens that opens to F 1.8 when the camera begins to track toward the screen. One single frame of film is exposed during the sixty-second period in which the camera tracks from fifteen feet to within one and one-half inches of the screen. The camera lens is attached to a bellows mount on a camshaft rotating from a selsyn linked to a drive motor, all of which maintains perfect focus and depth-of-field the entire distance of the one-minute track.

When the camera reaches the screen it has veered one-half of a frame either right or left of the slit. The exposure thus produced on the single frame is a controlled blur, much the same as time exposures of freeways at night that produce streaks of red taillights. The shifting panels of painted glass behind the slit alter the pattern of light coming through the slit as the camera approaches, producing an uneven or streaked blur. When the process is repeated for both sides of the frame, the effect is of an infinite corridor of lights and shapes advancing at enormous velocity.

The glass panes behind the slit are shifted horizontally by selsyns and advancing motors synchronized with the tracking camera. Thus the exposure pattern is identical for each frame of film except that a differential mechanism displaces the entire rig slightly for each camera run, creating an impression that the scanned image is moving.

The slit-scan is not limited to this application. As we shall see

Slit-scan machine built by Douglas Trumbull
for the Stargate Corridor sequence of
Stanley Kubrick's *2001: A Space Odyssey.*

later, John Whitney, Jr., has constructed a computerized, hybrid
optical printer that automatically scans a projected motion-picture
sequence. In addition, the camera need not track perpendicular to
the scanned image; a diagonal approach would create effects of
warped perspective in otherwise representational imagery.

TRUMBULL: There was one short slit-scan sequence—a bad take,
actually—which started out black and instead of having walls of
color come at you it had little points of light which were parts of
the artwork before it actually developed into walls. It started out
black, then a few little red sparks came out, and then a few more
and it generated more and more. That particular shot was done
with a device I rigged for automatically accelerating the speed.
So as the dots were coming up it was accelerating at such an
incredible rate that we used up all the artwork in a couple of
seconds. Though the shot is brief it was the only one with a

transitional effect: it started out black and slowly became something.

We had a double-projection technique in which we could run two aligned 35mm. projectors simultaneously onto one screen to see how two elements looked together. So that was how we figured out the way of getting the astronaut into the Stargate sequence: we shot a scene just panning away from Jupiter out into deep space and faded in that little slit-scan footage which gave us our transition into the time-warp. At the same time we were shooting the slab floating around Jupiter. There was a physical problem in getting the slab out of the frame without matching the camera movement with the animation pan. So we decided to have it just fade out between the planets: the slab fades, and as the slit-scan comes in the stars fade out. It's strange how solutions to technical problems become the content of the film.

If one considers the introduction of sound and then color as successive "generations" in the history of cinema, it is possible to say that we've entered the fourth generation by marrying basic cinematic techniques to computer and video sciences. There have been no fundamental breakthroughs in the nature of cinema since its conception. In one sense the history of film is but a footnote to Lumière and Méliès. But the technological revolution begins the new age of cinema. Before moving into computer films, however, we'll discuss the work of Jordan Belson, who both preceded and surpassed 2001 in the realm of cinematic innovations. Although not as technologically sophisticated as Kubrick's enterprise, Belson's films achieve a sense of cosmic consciousness only hinted at in 2001, and levels of design with far greater integrity and vision.

With a tiny fraction of the manpower, equipment, and money expended in the production of 2001, Belson has created images and moods of far wider significance and lasting beauty. While the state of the art remains relatively untapped, Belson, working with limited resources, has demonstrated its potential. He's a visionary who has broken through to the other side; the state of the art need only follow.

# The Cosmic Cinema of Jordan Belson

"Only the fantastic is likely to be true at the cosmic level."

TEILHARD DE CHARDIN

Certain phenomena manage to touch a realm of our consciousness so seldom reached that when it is awakened we are shocked and profoundly moved. It's an experience of self-realization as much as an encounter with the external world. The cosmic films of Jordan Belson possess this rare and enigmatic power.

Basic to this enigma is the disconcerting fact that Belson's work seems to reside equally in the physical and metaphysical. Any discussion of his cinema becomes immediately subjective and symbolic, as we shall soon see. Yet the undeniable fact of their concrete nature cannot be stressed too frequently. Piet Mondrian: "In plastic art, reality can be expressed only through the equilibrium of dynamic movement of form and color. Pure means afford the most effective way of attaining this."[14]

The essence of cinema is precisely "dynamic movement of form and color," and their relation to sound. In this respect Belson is the purest of all filmmakers. With few exceptions his work is not "abstract." Like the films of Len Lye, Hans Richter, Oskar Fischinger, and the Whitneys, it is *concrete*. Although a wide variety of meaning inevitably is abstracted from them, and although they do hold quite specific implications for Belson personally, the films remain concrete, objective experiences of kinaesthetic and optical dynamism. They are at once the ultimate use of visual imagery to communicate abstract concepts, and the purest of experiential confrontations between subject and object.

In their amorphous, gaseous, cloudlike imagery it is color, not line, which defines the forms that ebb and flow across the frame with uncanny impact. It is this stunning emotional force that lifts

[14] Mondrian, *op. cit.*, p. 10.

the films far beyond any realm of "purity" into the most evocative and metaphysical dimensions of sight and sound. The films are literally superempirical—that is, actual experiences of a transcendental nature. They create for the viewer a state of *nonordinary reality* similar, in concept at least, to those experiences described by the anthropologist Carlos Castanada in his experiments with organic hallucinogens.[15]

E. H. Gombrich: "The experience of color stimulates deeper levels of the mind. This is demonstrated by experiments with mescaline, under the influence of which the precise outlines of objects become uncertain and ready to intermingle freely with little regard to formal appearances. On the other hand color becomes greatly enhanced, tends to detach itself from the solid objects and assumes an independent existence of its own."

Belson's work might be described as *kinetic painting* were it not for the incredible fact that the images exist in front of his camera, often in real time, and thus are not animations. Live photography of actual material is accomplished on a special optical bench in Belson's studio in San Francisco's North Beach. It is essentially a plywood frame around an old X-ray stand with rotating tables, variable speed motors, and variable intensity lights. In comparison to Trumbull's slit-scan machine or the Whitneys' mechanical analogue computer it's an amazingly simple device. Belson does not divulge his methods, not out of some jealous concern for trade secrets—the techniques are known to many specialists in optics—but more as a magician maintaining the illusion of his magic. He has destroyed hundreds of feet of otherwise good film because he felt the technique was too evident. It is Belson's ultrasensitive interpretation of this technology that creates the art.

The same can be said for the sounds as well as the images. Belson synthesizes his own sound, mostly electronic, on home equipment. His images are so overwhelming that often the sound, itself a creation of chilling beauty, is neglected in critical appraisals. The sound often is so integral to the imagery that, as Belson says: "You don't know if you're seeing it or hearing it."

He regards the films not as exterior entities, but literally as

[15] Carlos Castanada, *The Teachings of Don Juan—A Yaqui Way of Knowledge* (Los Angeles, Calif.: University of California Press, 1968).

extensions of his own consciousness. "I first have to see the images somewhere," he says, "within or without or somewhere. I mean I don't make them up. My whole aesthetic rests on discovering what's there and trying to discover what it all means in terms of relating to my own experience in the world of objective reality. I can't just dismiss these films as audio-visual exercises. They obviously mean something, and in a sense everything I've learned in life has been through my efforts to find out what these things mean."

He has been a serious student of Buddhism for many years and has committed himself to a rigorous Yoga discipline. He began experimenting with peyote and other hallucinogens more than fifteen years ago. Recently his interests have developed equally in the directions of inner space (Mahayana Buddhism) and outer space (interstellar and galactic astrophysics). Thus by bringing together Eastern theology, Western science, and consciousness-expanding drug experiences, Belson predates the front ranks of avant-garde art today in which the three elements converge. Like the ancient alchemists he is a true visionary, but one whose visions are manifested in concrete reality, however nonordinary it might be.

Teilhard de Chardin has employed the term *ultra-hominization* to indicate the probable future stage of evolution in which man will have so far transcended himself that he will require some new appellation. Taking Chardin's vision as a point of departure, Louis Pauwels has surmised: "No doubt there are already among us the products of this mutation, or at least men who have already taken some steps along the road which we shall all be traveling one day."[16] It requires only a shift in perspective to realize that Belson is taking those steps.

## *Allures:* From Matter to Spirit

Originally a widely-exhibited painter, Belson turned to filmmaking in 1947 with crude animations drawn on cards, which he subsequently destroyed. He returned to painting for four years and in 1952 resumed film work with a series that blended cinema and painting through the use of animated scrolls. The four films produced in the period 1952–53 were *Mambo, Caravan, Mandala,* and *Bop Scotch.* From 1957–59 he worked with Henry Jacobs as visual

16 Pauwels, Bergier, *op. cit.,* p. 59.

director of the Vortex Concerts at Morrison Planetarium in San Francisco. Simultaneously he produced three more animated films, *Flight* (1958), *Raga* (1959), and *Seance* (1959). *Allures,* completed in 1961, found Belson moving away from single-frame animation toward continuous real-time photography. It is the earliest of his works that he still considers relevant enough to discuss.

He describes *Allures* as a "mathematically precise" film on the theme of *cosmogenesis*—Teilhard de Chardin's term intended to replace cosmology and to indicate that the universe is not a static phenomenon but a process of becoming, of attaining new levels of existence and organization. However, Belson adds: "It relates more to human physical perceptions than my other films. It's a trip backwards along the senses into the interior of the being. It fixes your gaze, physically holds your attention."

*Allures* begins with an ethereal pealing of bells. A centrifugal starburst of pink, yellow, and blue sparks whirls out of a black void. Its points collect into clusters and fade. Bells become weird chimes; we sink into a bottomless orange and black vortex. An intricate pink mandala of interconnected web patterns spins swiftly into the distance. A caterpillar-like coil looms ominously out of infinity. We hear a tweetering electronic warble, a collection of threatening piano notes. Pink and yellow sparks wiggle vertically up the frame. Distant snakelike coils appear and fade. A tiny sun surrounded by a huge orange halo disintegrates. There are flying, comet-like petal shapes.

Oscilloscope streak-dots bounce across the frame with a twittering, chattering metallic noise. They form complex triangular and tetrahedral grid patterns of red, yellow, and blue. Out of this evolves an amorphous yellow-white pulsating globe of fire without definite shape. It vanishes and a blue, neon-bright baton rotates slowly into infinity.

"I think of *Allures,*" said Belson, "as a combination of molecular structures and astronomical events mixed with subconscious and subjective phenomena—all happening simultaneously. The beginning is almost purely sensual, the end perhaps totally nonmaterial. It seems to move from matter to spirit in some way. *Allures* was the first film to really open up spatially. Oskar Fischinger had been

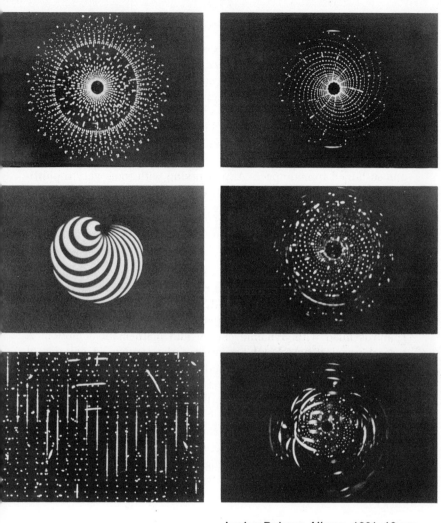

Jordan Belson: *Allures.* 1961. 16mm. Color. 9 min. "A combination of molecular structures and astronomical events mixed with subconscious phenomena . . . a trip backward along the senses from matter to spirit."

experimenting with spatial dimensions but *Allures* seemed to be outer space rather than earth space. Of course you see the finished film, carefully calculated to give you a specific impression. In fact it took a year and a half to make, pieced together in thousands of different ways, and the final product is only five minutes long. *Allures* actually developed out of images I was working with in the Vortex Concerts. Up until that time my films had been pretty much rapid-fire. They were animated and there was no real pacing—just one sustained frenetic pace. After working with some very sophisticated equipment at Vortex I learned the effectiveness of something as simple as fading in and out very slowly. But it was all still very impersonal. There's nothing really personal in the images of *Allures.*"

After the glowing blue baton vanishes the screen is black and silent. Almost imperceptibly a cluster of blue dots breaks from the bottom into magnetic force fields that become a complex grid pattern of geometrical shapes superposed on one another until the frame is filled with dynamic energy and mathematical motion. A screeching electronic howl accentuates the tension as galaxies of force fields collide, permutate, and transmute spectacularly. Some squadrons rush toward the camera as others speed away. Some move diagonally, others horizontally or vertically. It's all strongly reminiscent of *2001*—except that it was made seven years earlier. Elsewhere in the film rumbling thunder is heard as flying sparks collect into revolving atomic structures, from whose nuclei emanate shimmering tentacles of tweetering multicolored light. At the end we hear ethereal harp music as a pulsating sun, fitfully spewing out bright particles, reveals within itself another glimmering galaxy.

### *Re-Entry:* Blast-off and *Bardo*

*Re-Entry* is considered by many to be Belson's masterwork. Completed in 1964 with a grant from the Ford Foundation, it is simultaneously a film on the theme of mystic reincarnation and actual spacecraft reentry into the earth's atmosphere. Also, as Belson says, "It was my reentry into filmmaking because I'd given up completely after *Allures.* Mostly for financial reasons. But also out of general dismay at the experimental film scene. There was no

audience, no distribution, there was just no future in it at that time."

*Re-Entry* is chiefly informed by two specific sources: John Glenn's first space trip, and the philosophical concept of the *Bardo*, as set forth in the ancient *Bardo Thodol* or so-called *Tibetan Book of the Dead*, a fundamental work of Mahayana Buddhism. According to Jung, *Bardo* existence is rather like a state of limbo, symbolically described as an intermediate state of forty-nine days between death and rebirth. The *Bardo* is divided into three states: the first, called *Chikhai Bardo*, describes the psychic happenings at the moment of death; the second, or *Chonyid Bardo*, deals with the dream-state that supervenes immediately after death, and with what are called *karmic illusions;* the third part, or *Sidpa Bardo*, concerns the onset of the birth instinct and of prenatal events.[17]

With imagery of the highest eloquence, Belson aligns the three stages of the *Bardo* with the three stages of space flight: leaving the earth's atmosphere (death), moving through deep space (karmic illusions), and reentry into the earth's atmosphere (rebirth).

The film, says Belson, "shows a little more than human beings are supposed to see." It begins with a rumbling thunderous drone (blast-off, perhaps). In a black void we see centripetal, or imploding, blue-pink gaseous forms barely visible as they rush inward and vanish. The sound fades, as though we have left acoustical space. After a moment of silence, the next sound is wholly unearthly: a twittering electrical pitch as vague clouds of red and yellow gases shift across the screen amorphously. Suddenly with a spiraling high-pitched whine we see a gigantic solar prominence (one of two stock-footage, live-action sequences) lashing out into space, changing from blue to purple to white to red. Now blinding white flashes, as though we're passing the sun, and suddenly we are into a shower of descending white sparks that become squadrons of geometrical modules moving up and out from the bottom of the frame, warping and shifting to each side of center as they near the top.

GENE: Certain of your images appear in every film, like the geometrical, perspectival interference patterns. They're quite effec-

17 W. Y. Evans-Wentz, *The Tibetan Book of the Dead* (London: Oxford University Press, 1960).

Jordan Belson: *Re-Entry*. 1964. 16mm. Color.
6 min. "The film does manage to transport
whoever is looking at it out of the bound-
aries of the self."

Jordan Belson: *Re-Entry*. ". . . the next thing you know you're in heaven. You're surprised to be there. On the other hand, it's happening . . ."

tive. Do you conceive them through some sort of mathematical concept?

JORDAN: Those images in particular are derived from the nature of the device itself. But the images later in the film—the more nebulous ones, of more magnitude—they're more a question of personal vision. Discerning them, seeking them out, presents all sorts of possibilities by being receptive to them when I find them beneath my camera.

GENE: Are there other stock-footage sequences?

JORDAN: Yes. You wouldn't recognize it, but there's a shot of the earth rolling by, as seen from a camera in a rocket. I excerpted a part of that film and doubled it, so it was mirrored Rorschach-like. That's for the reentry to earth. The film leans heavily on such material. As a matter of fact, on the sound track there's actually John Glenn's radio conversation from his spacecraft to earth. He's saying something like ". . . I can see a light . . ." He was referring to Perth, Australia, as he passed over. Then it shoots past the earth and the sun and goes off into a rather ambiguous area in which you have to cross over barriers of time and space, but also mental, psychological barriers as well. It's a kind of breakdown of the personality in a way. It sort of boils out and the next thing you know you're in heaven. You're surprised to be there. On the other hand it's happening you know.

The "boiling out" sequence is among the most dramatic in all of Belson's films. Suddenly we hear a thunderous rumble that increases in intensity until the bottom of the frame begins to turn pale manganese blue and cobalt violet, a gaseous boiling cloud that surges up over the frame, turning alizarin crimson. We descend through it, as though it is being blasted upward by some explosive force far below. Image and sound increase to unimaginable intensity as though we're hurtling through sheets of space fire in a cosmic heat belt. The spacecraft is out of our solar system and into another dimension. Death has occurred; we move into the second stage of the *Bardo*.

At a corresponding point in the *Bardo of Karmic Illusions* the Sanskrit text reads: *"The wisdom of the* Dharma-Dhatu, *blue in color, shining, transparent, glorious, dazzling, from the heart of* Vairochana *as the Father-Mother, will shoot forth and strike against*

*thee with a light so radiant that thou wilt scarcely be able to look at it.*"[18]

This of course could be interpreted as a supernova whose maximum intrinsic luminosity reaches one-hundred million times that of our sun. The image in Belson's film is somewhat like slow-motion movies of atomic blasts in Nevada with the desert floor swept across by a tremendous shock wave. At another point it appears as a sky of mackerel clouds suddenly set aflame and blown asunder by some interstellar force. Shimmering iceberg shapes of every hue in the spectrum dance like galactic stalactites against a sizzling frying sound. This becomes a dizzying geometrical corridor or eerie lights almost exactly like the slit-scan corridor of *2001*—except that it was made four years earlier.

Carl Jung describes the final stage of the *Bardo:* "The illuminative lights grow ever fainter and more multifarious, the visions more and more terrifying. This descent illustrates the estrangement of consciousness from the liberating truth as it approaches nearer and nearer to physical rebirth."[19]

The images assume majestic dimensions. Seemingly millions of minute particles suggesting mesons, cosmic rays that survive in the atmosphere for only a millionth of a second, cascade in sizzling firestorms down from the top and up from the bottom in shards of viridian, ultramarine red, Thalo blue. There's a sense of unthinkable enormity. Finally we see a white sun surrounded by a pulsating red halo, which is then obscured by vapors. "The film does manage to transport whoever is looking at it," said Belson, "out of the boundaries of the self. At that very moment is when the foundation slips out from under us and very rudely we're brought back to earth. It's all very much like the process of spacecraft reentry. You're out there, free, totally free from the limitations of earthly distance, and suddenly you have to come back and it's a very painful thing."

### *Phenomena:* From Humans to Gods

*Phenomena* (see color plates), completed in 1965, moved Belson closer to the totally personal metaphysical experience that culminated two years later in *Samadhi*. Also *Phenomena* was the first film in which he abandoned allegories with space flight or astro-

[18] *Ibid.,* p. 106.
[19] *Ibid.,* p. xxxvi.

nomic subjects for a more Buddhistic exploration of psychic energies. It was primarily inspired by Buddha's statements in the *Diamond Sutra* and the *Heart Sutra.*

The film begins with electronically-distorted rock music as curvilinear dish shapes of bright cadmium red, crimson, and cerulean blue expand frenetically. A glowing red neon coil pulsates to the music. Next we see—unique in Belson's work—a recognizable though distorted figure of a man, then a woman, images shot from television through warped glass filters. They are obscured by a hailstorm of popping confetti-like flashes of red, white, and blue on a black field. The music fades into tumultuous cheering throngs as a fiery red starburst erupts in a sky of cobalt blue, its rings expanding into individual thorny clusters.

Belson thinks of this sequence as "an extremely capsulized history of creation on earth, including all the elements and man. It's the human sociological-racial experience on one level, and it's a kind of biological experience in the sense that it's physical. It's seen with the blinders of humanity, you know, just being a human, grunting on the face of the earth, exercising and agonizing. There's even a touch of the Crucifixion in there—a brief suggestion of a crown of thorns, a red ring of centers, each emitting a kind of thorny light cluster. The man and the woman are Adam and Eve if they're anyone. I see them as rather comic at that point. At the end of course it's pure consciousness and they're like gods. The end of the film is the opposite of the beginning: it's still life on earth but not seen from within, as *sangsara,* but as if you were approaching it from outside of consciousness so to speak. From cosmic consciousness. As though you were approaching it as a god. You see the same things but with completely different meaning."

In Buddhism the phenomenal universe of physical matter is known as *sangsara.* Its antithesis is *nirvana* or that which is beyond phenomena. Also within *sangsara* exists *maya,* Sanskrit for a magical or illusory show with direct reference to the phenomenon of nature. Thus in the *Diamond Sutra* Buddha equates *sangsara* with *nirvana* since both contain "magical" elements and asserts that both are illusory.[20] This is the substance of Belson's film.

[20] Edward Conze, *Buddhist Wisdom Books: The Diamond Sutra, The Heart Sutra* (London: George Allen & Unwin Ltd., 1958).

Suddenly and quite incongruously we hear German *Lieder* (Belson: "The epitome of the ego personality"). A gorgeous organ-pipe lumia display dances across the frame, a shifting alignment of fluted columns of phosphorescent colors similar to the work of Thomas Wilfred and more recent lumia artists such as Julio le Parc. Though Belson calls it a "gaudy juke-box lighting effect," it is far more beautiful than its predecessors: vertical shafts of white light through which move horizontal sheets of emerald, Prussian blue, rose madder, pale citron.

The pillars of color melt with a crackling buzz and slowly liquid blobs of pigment solidify into one of the most spectacular images of Belson's films: a mosaic field of hundreds of hard-edge, bullet-shaped modules in a serial grid. Each tiny unit constantly transforms its shape and color—from violet to Mars red to French ultramarine blue to mint green and zinc yellow. The staccato buzz flawlessly underscores the geometry, as though the modules are generating the sound as they converge and transform.

Suddenly the frame is shattered with a roar and a fiery light in a heaven of boiling multihued gases: a grim, sinister eruption that suggests, according to Belson, "depersonalization, the shattering of the ego-bound consciousness, perhaps through death, perhaps through evolution or rebirth." This celestial storm of manganese blue and zinc yellow leads into a state of *karmic illusions* with glacial, floating, aurora borealis lights of red and yellow-whites, rainbow liquid cascades of exquisite sheerness.

Various states of matter rise above, iceberg-like, sink and float away. This is followed by an intense white-light sequence with an ethereal mother-of-pearl quality, representing a state of total integration with the universe, of blinding super-consciousness. It culminates in an enormous roaring sphere of flaming gases. In the final sequence, against a descending drone, the void is shattered by a central light that throws out sweeping circular rainbows of liquid color moving majestically clockwise, collecting together, and lashing out again in the opposite direction until the ultimate fade-out.

### *Samadhi:* Documentary of a Human Soul

For two years, from 1966 through 1967, assisted by a Guggenheim Fellowship, Belson subjected himself to a rigorously ascetic

Jordan Belson: *Samadhi*. 1967. 16mm. Color. 6 min.
"When I finally saw how intense *Samadhi* is, I knew I had achieved
the real substance of what I was trying to depict. Natural forces
have that intensity: not dreamy but hard, ferocious."

Yoga discipline. He severed emotional and family ties, reduced physical excitements and stimulations, reversed his sensory process to focus exclusively on his inner consciousness and physical resources. The result of this Olympian effort was *Samadhi* (see color plates), certainly among the most powerful and haunting states of nonordinary reality ever captured on film. "It's a documentary of the human soul," he says. "The experiences which led up to the production of this film, and the experiences of making it, totally convinced me that the soul is an actual physical entity, not a vague abstraction or symbol. I was very pleased when I finally saw how concentrated, how intense, *Samadhi* is because I knew I had achieved the real substance of what I was trying to depict. Natural forces have that intensity: not dreamy but hard, ferocious. After it was finished I felt I should have died. I was rather amazed when I didn't."

In Mahayana Buddhism death is considered a liberating experience that reunites the pure spirit of the mind with its natural or primal condition. An incarnate mind, united to a human body, is said to be in an unnatural state because the driving forces of the five senses continually distract it in a process of forming thoughts. It is considered close to natural only during the state of *Samadhi*, Sanskrit for, "that state of consciousness in which the individual soul merges with the universal soul." This state is sought—but rarely achieved—through *dhyana*, the deepest meditation. In *dhyana* there can be no "idea" of meditation, for the idea, by its very existence, defeats the experience. The various stages of *dhyana* are denoted by the appearance of lights representing certain levels of wisdom until the final "Clear Light" is perceived. In this quasi-primordial state of supramundane all-consciousness, the physical world of *sangsara* and the spiritual world of *nirvana* become one.

Electroencephalograms of Hindu Yogis in states of *Samadhic* ecstasy, or what in psychology is known as *manic dedifferentiation*, show curves that do not correspond to any cerebral activities known to science, either in wakefulness or sleep. Yogis claim that during *Samadhi* they are able to grow as large as the Milky Way or as small as the smallest conceivable particle. Carlos Castanada discusses similar experiences in his report of apprenticeship to a Yaqui Indian sorcerer. Such fantastic assumptions are not to be taken literally so much as conceptually, as experiences of nonordinary psychological

realities, which are nonetheless real for him who experiences them.

Perhaps with these concepts in mind we can approach Belson's sublime vision on a level more suited to it. We might remember also that practically everyone reading this book has in his possession an instrument that transforms energy within matter: the transistor. Belson seeks no more and no less than this. *Samadhi* is a record of two years of his search.

*Samadhi* was a radical departure from Belson's previous work in many ways. First, rather than ebbing and flowing in paced rhythms, it is one sustained cyclone of dynamic form and color whose fierce tempo never subsides. Second, in addition to the usual electronic sound, Belson's inhaling and exhaling is heard through the film to represent years of Yoga breathing discipline. And finally, whereas the earlier works moved from exterior to interior reality, *Samadhi* is continually centered around flaming spheres that evolve out of nothing and elude specific identification.

The various colors and intensities of these solar spheres correspond directly to descriptions in the *Tibetan Book of the Dead* of lights representing the elements Earth, Air, Fire, and Water. They have two additional meanings, however: the *kundalini* moving upward through the *chakras;* and the inhalation-exhalation of the life force, *prana.* For those unfamiliar with Yoga concepts, the *chakras* are physical nerve centers located within the body along the spinal column at five or six points: one in the sexual region, one in the region of the navel, the heart, the throat, the eyes, the middle of the head, the top of the head. Clairvoyants supposedly can see them. According to Yoga theory the *kundalini*—the vital life force that animates the body—resides in a concentrated form at the base of the spine in the general region of the sexual organs. Through physical disciplines and ethical, moral strength one raises that center of life force from the lower spine progressively, in stages, toward the brain.

Thus one implication of the elusive shifting centers in *Samadhi* is a trip through the *chakras,* from the lowest to the highest. There is also the analogy with the breathing structure. When we hear Belson inhale, the spheres glow brighter to indicate that *prana,* the life force in the air we breathe, is being introduced into the bloodstream and therefore into the *kundalini.* The deep, spatial, dark areas of the

film indicate not only the stages between *chakras* but also exhalations when there is relatively less *prana*.

As it begins, a stormy field of turbulent gases collects around a central core. The serrated vapors melt into a small central "jewel" of curling pink and red-orange flames that finally fades into black silence. The vacuum created by this pause reverberates in the ears until, slowly, a deep blue filamented sphere evolves, turning with purposive elegance, glowing into cadmium orange, surrounded by a whirling halo. It becomes a blue sphere in a red universe, spewing off white-hot rings of light.

Next comes a series of solar or planetoid visions: a scintillating yellow star with six shimmering fingers; a blue-purple planet with a fiery red halo; a small central globe dwarfed by an immense corona; a dim yellow-ochre sun emanating flames that revolve like chromospheres in a plasma storm; various stellar orbs turning with implacable grace against wavering sonorous drones. Suddenly there's a burst of white light of blinding intensity: a murky sea of deep blue gas is in huge movement; waves of unbearably gorgeous mist sweep across the void. It is obvious that contact has been made with some vast new reality.

Cinema to Belson is a matrix wherein he is able to relate external experience to internal experience. He feels that it culminated in *Samadhi*. "I reached the point that what I was able to produce externally, with the equipment, was what I was seeing internally. I could close my eyes and see these images within my own being, and I could look out at the sky and see the same thing happening there too. And most of the time I'd see them when I looked through the viewfinder of my camera mounted on the optical bench. I've always considered image-producing equipment as extensions of the mind. The mind has produced these images and has made the equipment to produce them physically. In a way it's a projection of what's going on inside, phenomena thrown out by the consciousness, which we are then able to look at. In a sense I'm doing something similar to the clairvoyant Ted Serios who can project his thoughts onto Polaroid film. Only I have to filter my consciousness through an enormous background of art and filmmaking. But we're doing the same thing. *Samadhi* breaks new territory in a way. It's as though

I've come back from there with my camera in hand—I've been able to film it.

GENE: Do you feel your drug experiences have been beneficial to your work?

JORDAN: Absolutely. Early in life I experimented with peyote, LSD, and so on. But in many ways my films are ahead of my own experience. In fact *Samadhi* is the only one in which I actually caught up with the film and ran alongside of it for just a moment. The film is way ahead of anything I've experienced on a continuing basis. And the same has been true of the drug experiences. They somehow set the stage for the insights. I had peyote fifteen years ago but I didn't have any cosmic or *Samadhic* experiences. That remained for something to happen through development on different levels of consciousness. The new art and other forms of expression reveal the influence of mind-expansion. And finally we reach the point where there virtually is no separation between science, observation, and philosophy. The new artist works essentially in the same way as the scientist. In many cases it's identical with scientific exploration. But at other times the artist is able to focus more in the area of consciousness and subjective phenomena, but with the same kind of scientific zeal, the same objectivity, as scientists. Cosmic consciousness is not limited to scientists. In fact scientists are sometimes the last to know. They can look through their telescopes and see it out there, but still be very limited individuals."

## *Momentum:* The Sun as an Atom

If one were to isolate a single quality that distinguishes Belson's films from other "space" movies, it would be that his work is always heliocentric whereas most others, even *2001*, are geocentric. The archetypal nature of the sun is such that Belson's obsession with it has, at times, tended toward a certain mysticism that was, no doubt, unavoidable. That he would someday make a movie exclusively about the sun was inevitable; that it would be his least mystical work came as something of a surprise.

"I was wondering what the subject of my next film would be after *Samadhi*," he said. "My whole world had collapsed. All the

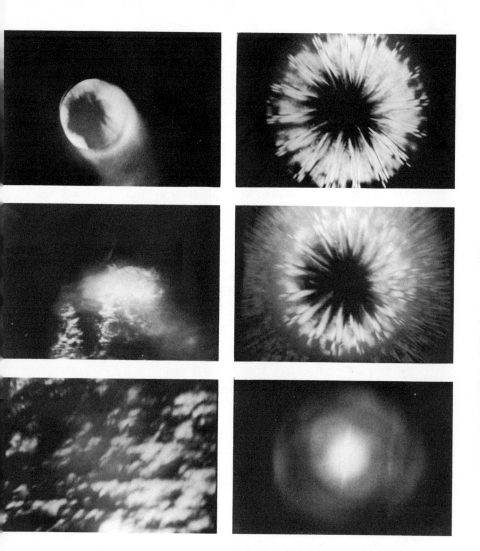

Jordan Belson: *Momentum.* 1969.
16mm. Color. 6 min. "The paradoxical
realm in which subatomic phenomena
and the cosmologically vast are
identical."

routines I'd created in order to develop the state of consciousness to produce that film just fell apart. So I had to keep working just to maintain the momentum from *Samadhi*. I had no preconceived idea what the new material was about, but I was calling it *Momentum*. Eventually I discovered it was about the sun. I ran right to the library; the more I read the more I realized this was exactly what *Momentum* was about. All the material was similar if not identical to solar phenomena like corona phenomena, photosphere phenomena, chromosphere phenomena, sun spots, plasma storms—I was even getting into some interesting speculation about what goes on *inside* the sun. And I realized that the film doesn't stop at the sun, it goes to the center of the sun and into the atom. So that was the film, about the sun as an atom. The end shows the paradoxical realm in which subatomic phenomena and the cosmologically vast are identical. Through the birth of a new star is where it happens."

*Momentum* (see color plates) was completed in May, 1969, after eighteen months of painstaking study and labor. In one sense it's a refinement of the whole vocabulary he's developed through the years, distilled to their essence. But there are new effects inspired by this particular subject. *Momentum* is a calm, objective experience of concrete imagery that manages to suggest abstract concepts without becoming particularly symbolic.

It begins with stock footage of a Saturn rocket whose afterburners blaze in rainbow fury. We hear echoing ethereal music and slow cyclic drones. Next we see a solar image in mauves and iridescent ruby, huge prominences flaring in slow motion. A series of graceful lap-dissolves brings us closer to the sphere as it revolves with a steady and ponderous dignity. In spite of its furious subject, *Momentum* is Belson's most serene and gentle film since *Allures*. This treatment of the sun as an almost dreamlike hallucinatory experience is both surprising and curiously realistic—to the extent that one can even speak of "realism" in connection with solar images.

There's a visceral, physical quality to the images as we draw near to the surface and, with a soul-shaking roar, descend slowly into blackness: apparently the suggestion of a sun spot. Flaming napalm-like clouds of gas surge ominously into the void, which suddenly is shattered with an opalescent burst of light. We move through

various levels of temperature and matter. Belson's now-familiar techniques seem to possess a pristine clarity and precision not previously so distinct. Swooping cascades of flame seem especially delicate; fantastic towering shards of luminescent color reach deeper levels of the mind; the translucent realms of kinaesthesia leave one speechless.

Moving deeper into the mass, images become more uniform with a textural quality like a shifting sea of silver silt. Millions of tiny flashes erupt over a field of deep blue vapors. Quick subtle movements and sudden ruptures in the fabric of color seem suppressed by some tremendous force. Indefinite shapes and countless particles swim in a frantic sea of color.

"Then the film goes into fusion," said Belson. "A state of atomic interaction more intense than fission. This is supposed to take place on the sun, fusion." A blinding red fireball breaks into a multi-pointed star of imploding light/energy, flashing brighter and brighter, mounting in intensity. An image similar to James Whitney's *Lapis*—a collecting of millions of tiny particles around a central fiery core—builds up to the moment of crescendo, with all the colors of the universe melting into one supremely beautiful explosion, and suddenly we're deep in interstellar space, watching a distant flash as a new sun is born.

"The whole secret of life must somehow exist in the solar image," Belson remarked. "*Momentum* is a kind of revelation regarding the sun as the source of life. Not only in our solar system, but wherever there's a sun it's the source of life in that part of the universe. We come from it and return to it. Though we think of the sun as a gigantic thing, I think probably an atom itself is a small sun—in fact our sun is probably an atom in a larger structure. It's somehow tied up with the essence of being. If you were to think of a single form that would be the primary structure of the universe it would just have to be the solar sphere. I mean there's so much evidence around us to that effect."

# PART FOUR:
# CYBERNETIC CINEMA AND COMPUTER FILMS

"The computer is the LSD of the business world. It absolutely guarantees the elimination of all the business it is now being brought to serve."

MARSHALL MCLUHAN

# The Technosphere: Man/Machine Symbiosis

If one were to propose a Bill of Rights for the year 2000 it would defend human liberty, not civil liberty. Guaranteed rights would include health, truth, reality, sexual fulfillment, study, travel, peace, intimacy, leisure, the right to be unique. Man is not "civilized" until he is whole. He is not whole until he's assured these rights. But I would add another: the right of every man to be protected from the consequences of his own ignorance. The computer provides this protection.

The computer does not make man obsolete. It makes him failsafe. The computer does not replace man. It liberates him from specialization. The transition from a culture that considers leisure a "problem" to a culture that demands leisure as a prerequisite of civilized behavior is a metamorphosis of the first magnitude. And it has begun. The computer is the arbiter of radical evolution: it changes the meaning of life. It makes us children. We must learn how to live all over again.

"Recently, as in his natural symbiotic relations with plants and animals, man's relation to cybernetic systems has been subtly changing toward a more closely-woven interdependency resembling his other ecological ties. This trend often is depicted as 'intelligent' machines dominating man; but the possibility is more clearly that of organic partnership . . ."[1]

In laboratories all over the world, biochemists are drawing ever-closer to the secrets of the genetic code. Younger readers of this book may within their lifetimes, rub shoulders with pre-programmed humans. I do not say "synthetic" or "artificial." Fuller: "We speak erroneously of 'artificial' materials, 'synthetics' and so on. The basis for this erroneous terminology is the notion that nature has certain things which we call natural, and everything else is 'man-made,' *ergo* artificial. But what one learns in chemistry is that nature wrote all the rules of structuring; man does not invent chemical structuring rules; he only discovers the rules. All the chemist can do

[1] John McHale, "New Symbiosis," *Architectural Design* (February, 1967), p. 89.

is to find out what nature permits, and any substances that are thus developed or discovered are inherently *natural*."[2]

John McHale: "We refuse to accept the reality of potentially limitless wealth inherent in our new symbiotic relation to automated technological processes. Scientific and technical development destroys all previous intrinsic value in physical resources or properties. From this point on, broadly speaking, all materials are inter-convertible. The only unique resource-input is human knowledge—the organized information which programs machine performance. The products are non-unique and expendable, as are the machines and materials. The only part of the whole process which is non-expendable and uniquely irreplaceable is man. Those social orientations which have had great survival value in the past now endanger survival in the present and cripple our approach to the future."[3]

In 1963 two Soviet scientists amplified the bio-electrical muscle currents of a human body to operate exoskeletal servomechanisms attached to the limbs.[4] For the first time, organic partnership was achieved to the direct physical advantage of man. The director of cardiovascular surgery at Maimonides Hospital asserted, also in 1963: "Surgery is essentially an engineering discipline . . . the integration of electronic circuits into the human body as functioning and permanent parts . . . is going to become very important within the next ten years."[5] Since that remark we have witnessed a steady increase in the number of cyborgs walking among us. Scientists now speak of "moral spectrums for machines" based on the extent to which the machine ". . . helps or hinders human beings to realize their potentialities and thus to lead satisfactory lives."[6]

The computer amplifies man's intelligence in about the same ratio that the telescope extends his vision. The man/computer symbiosis is developed to the point where the machine instructs its

[2] Fuller, *Ideas and Integrities* (Englewood Cliffs, N.J.: Prentice-Hall, 1963), pp. 75, 76.

[3] McHale, "People Future," *Architectural Design* (February, 1967), p. 94.

[4] A. E. Kobvinsky and V. S. Gurfinkel, *Time* (December, 1963).

[5] A. Kantrowitz, *Electronic Physiologic Aids* (New York: Maimonides Hospital, 1963).

[6] M. W. Thring, "The Place of the Technologist in Modern Society," *Journal of the RSA* (London, April, 1966).

user and indicates possibilities for closer interaction. One needn't read the manual but may consult the machine directly with the order, "I want to do something, instruct me." It is not even necessary to be in the presence of the computer to do this. One can carry out one's work thousands of miles away, linked to the computer through remote viewing and operating consoles.

# The Human Bio-Computer
# and His Electronic Brainchild

The verb "to compute" in general usage means to calculate. A computer, then, is any system capable of accepting data, applying prescribed processes to them, and supplying results of these processes. The first computer, used thousands of years ago, was the abacus.

There are two types of computer systems: those that measure and those that count. A measuring machine is called an *analogue* computer because it establishes analogous connections between the measured quantities and the numerical quantities supposed to represent them. These measured quantities may be physical distances, volumes, or amounts of energy. Thermostats, rheostats, speedometers, and slide rules are examples of simple analogue computers.

A counting machine is called a *digital* computer because it consists entirely of two-way switches that perform direct, not analogous, functions. These switches operate with quantities expressed directly as digits or discrete units of a numerical system known as the *binary* system.[7] This system has 2 as its base. (The base of the decimal system is 10, the base of the octal system is 8, the base of the hexadecimal system is 16, and so on.) The binary code used in digital computers is expressed in terms of one and zero (1–0), representing on or off, yes or no. In electronic terms its equivalent is voltage or no voltage. Voltages are relayed through a sequence of binary switches in which the opening of a later switch depends on the action of precise combinations of earlier switches leading to it. The term *binary digit* usually is abbreviated as *bit*, which is used also as a unit of measurement of information. A computer is said to have a "million-bit capacity," or a laser hologram is described as requiring $10^9$ bits of information to create a three-dimensional image.

The largest high-velocity digital computers have a storage capacity from four thousand to four million bits consisting of twelve to

[7] Wiener, *op. cit.*, pp. 88–90.

forty-eight digits each. The computer adds together two forty-eight-digit numbers simultaneously, whereas a man must add each pair of digits successively. The units in which this information is stored are called ferrite memory cores. As the basic component of the electronic brain, the ferrite memory core is equivalent to the neuron, the fundamental element of the human brain, which is also a digital computer. The point at which a nerve impulse passes from one neuron to another is called a synapse, which measures about 0.5 micron in diameter. Through microelectronic techniques of Discretionary Wiring and Large Scale Integration (LSI), circuit elements of five microns are now possible. That is, the size of the computer memory core is approaching the size of the neuron. A complete computer function with an eight-hundred-bit memory has been constructed only nineteen millimeters square.[8]

The time required to insert or retrieve one bit of information is known as memory cycle time. Whereas neurons take approximately ten milliseconds ($10^{-2}$ second) to transmit information from one to another, a binary element of a ferrite memory core can be reset in one hundred nanoseconds, or one hundred billionths of a second ($10^{-7}$ second). This means that computers are about one-hundred-thousand times faster than the human brain. This is largely offset, however, by the fact that computer processing is serial whereas the brain performs parallel processing. Although the brain conducts millions of operations simultaneously, most digital computers conduct only one computation at any one instant in time.[9] Brain elements are much more richly connected than the elements in a computer. Whereas an element in a computer rarely receives simultaneous inputs from two other units, a brain cell may be simultaneously influenced by several hundred other nerve cells.[10] Moreover, while the brain must sort out and select information from the nonfocused total field of the outside world, data input to a computer is carefully pre-processed.

[8] A. T. Lawton and G. E. Abrook, "Large Scale Integration," *Science Journal* (London, August, 1968).

[9] N. S. Sutherland, "Machines Like Men," *Science Journal* (London, October, 1968).

[10] *Ibid.*

# Hardware and Software

It is often said that computers are "extraordinarily fast and extraordinarily accurate, but they also are exceedingly stupid and therefore have to be told everything." This process of telling the computer everything is called computer programming. The hardware of the human bio-computer is the physical cerebral cortex, its neurons and synapses. The software of our brain is its logic or intelligence, that which animates the physical equipment. That is to say, hardware is technology whereas software is information. The software of the computer is the stored set of instructions that controls the manipulation of binary numbers. It usually is stored in the form of punched cards or tapes, or on magnetic tape. The process by which information is passed from the human to the machine is called computer language. Two of the most common computer languages are Algol, derived from "*Algo*rithmic *Language*," and Fortran, derived from "*For*mula *Trans*lation."

The basis of any program is an algorithm—a prescribed set of rules that define the parameters, or discrete characteristics, of the solution to a given problem. The algorithm *is* the solution, as opposed to the *heuristics* or methods of finding a solution. In the case of computer-generated graphic images, the problem is how to create a desired image or succession of images. The solution usually is in the form of polar equations with parametric controls for straight lines, curves, and dot patterns.

Computers can be programmed to simulate "conceptual cameras" and the effects of other conceptual filmmaking procedures. Under a grant from the National Science Foundation in 1968, electrical engineers at the University of Pennsylvania produced a forty-minute instructional computer film using a program that described a "conceptual camera," its focal plane and lens angle, panning and zoom actions, fade-outs, double-exposures, etc. A program of "scenario description language" was written which, in effect, stored fifty years of moviemaking techniques and concepts into an IBM 360–65 computer.[11]

[11] Ron Schneiderman, "Researchers Using IBM 360 to Produce Animated Films," *Electronic News* (June 17, 1968), p. 42.

In the last decade seventy percent of all computer business was in the area of central processing hardware, that is, digital computers themselves. Authorities estimate that the trend will be completely reversed in the coming decade, with seventy percent of profits being made in software and the necessary input-output terminals. At present, software equals hardware in annual sales of approximately $6.5 billion, and is expected to double by 1975.[12]

Today machines read printed forms and may even decipher handwriting. Machines "speak" answers to questions and are voice-actuated. Computers play chess at tournament level. In fact, one of the first instances of a computer asking itself an original question occurred in the case of a machine programmed to play checkers and backgammon simultaneously. A situation developed in which it had to make both moves in one reset cycle and thus had to choose between the two, asking itself: "Which is more important, checkers or backgammon?" It selected backgammon on the grounds that more affluent persons play that game, and since the global trend is toward more wealth per each world person, backgammon must take priority.[13]

Machine tools in modern factories are controlled by other machines, which themselves have to be sequenced by higher-order machines. Computer models can now be built that exhibit many of the characteristics of human personality, including love, fear, and anger. They can hold beliefs, develop attitudes, and interact with other machines and human personalities. Machines are being developed that can manipulate objects and move around autonomously in a laboratory environment. They explore and learn, plan strategies, and can carry out tasks that are incompletely specified.[14]

So-called learning machines such as the analogue UCLM II from England, and the digital Minos II developed at Stanford University, gradually are phasing out the prototype digital computer. A learning machine has been constructed at the National Physical Laboratory that learns to recognize and to associate differently shaped shadows which the same object casts in different positions.[15] These

[12] Robert A. Rosenblatt, "Software: The Tail Now Wags the Dog," *Los Angeles Times Outlook* (June 29, 1969), sec. 1, p. 1.

[13] Fuller, "Prospect for Humanity," *Good News*.

[14] *Science Journal* (October, 1968).

[15] Bronowski, *op. cit.,* p. 47.

new electronic brains are approaching speeds approximately one million times faster than the fastest digital computers. It is estimated that the next few generations of learning machines will be able to perform in five minutes what would take a digital computer ten years. The significance of this becomes more apparent when we realize that a digital computer can process in twenty minutes information equivalent to a human lifetime of seventy years at peak performance.[16]

N. S. Sutherland: "There is a real possibility that we may one day be able to design a machine that is more intelligent than ourselves. There are all sorts of biological limitations on our own intellectual capacity ranging from the limited number of computing elements we have available in our craniums to the limited span of human life and the slow rate at which incoming data can be accepted. There is no reason to suppose that such stringent limitations will apply to computers of the future . . . it will be much easier for computers to bootstrap themselves on the experience of previous computers than it is for man to benefit from the knowledge acquired by his predecessors. Moreover, if we can design a machine more intelligent than ourselves, then *a fortiori* that machine will be able to design one more intelligent than itself."[17]

The number of computers in the world doubles each year, while computer capabilities increase by a factor of ten every two or three years. Herman Kahn: "If these factors were to continue until the end of the century, all current concepts about computer limitations will have to be reconsidered. Even if the trend continues for only the next decade or so, the improvements over current computers would be factors of thousands to millions. . . . By the year 2000 computers are likely to match, simulate or surpass some of man's most 'human-like' intellectual abilities, including perhaps some of his aesthetic and creative capacities, in addition to having new kinds of capabilities that human beings do not have. . . . If it turns out that they cannot duplicate or exceed certain characteristically human capabilities, that will be one of the most important discoveries of the twentieth century."[18]

[16] W. K. Taylor, "Machines That Learn," *Science Journal* (October, 1968).
[17] Sutherland, *Science Journal.*
[18] Herman Kahn, Anthony Wiener, *Year 2000* (New York: Macmillan, 1967), p. 89.

Dr. Marvin Minsky of M.I.T. has predicted: "As the machine improves . . . we shall begin to see all the phenomena associated with the terms 'consciousness,' 'intuition' and 'intelligence.' It is hard to say how close we are to this threshold, but once it is crossed the world will not be the same . . . it is unreasonable to think that machines could become *nearly* as intelligent as we are and then stop, or to suppose that we will always be able to compete with them in wit and wisdom. Whether or not we could retain some sort of control of the machines—assuming that we would want to—the nature of our activities and aspirations would be changed utterly by the presence on earth of intellectually superior entities."[19] But perhaps the most portentous implication in the evolving symbiosis of the human bio-computer and his electronic brainchild was voiced by Dr. Irving John Good of Trinity College, Oxford, in his prophetic statement: "The first ultra-intelligent machine is the last invention that man need make."[20]

[19] Arthur C. Clarke, "The Mind of the Machine," *Playboy* (December, 1968), p. 118.
[20] *Ibid.*

# The Aesthetic Machine

As the culmination of the Constructivist tradition, the digital computer opens vast new realms of possible aesthetic investigation. The poet Wallace Stevens has spoken of "the exquisite environment of face." Conventional painting and photography have explored as much of that environment as is humanly possible. But, as with other hidden realities, is there not more to be found there? Do we not intuit something in the image of man that we never have been able to express visually? It is the belief of those who work in cybernetic art that the computer is the tool that someday will erase the division between what we feel and what we see.

Aesthesic application of technology is the only means of achieving new consciousness to match our new environment. We certainly are not going to love computers that guide SAC missiles. We surely do not feel warmth toward machines that analyze marketing trends. But perhaps we can learn to understand the beauty of a machine that produces the kind of visions we see in expanded cinema.

It is quite clear in what direction man's symbiotic relation to the computer is headed: if the first computer was the abacus, the ultimate computer will be the sublime aesthetic device: a parapsychological instrument for the direct projection of thoughts and emotions. A. M. Noll, a pioneer in three-dimensional computer films at Bell Telephone Laboratories, has some interesting thoughts on the subject: ". . . the artist's emotional state might conceivably be determined by computer processing of physical and electrical signals from the artist (for example, pulse rate and electrical activity of the brain). Then, by changing the artist's environment through such external stimuli as sound, color and visual patterns, the computer would seek to optimize the aesthetic effect of all these stimuli upon the artist according to some specified criterion . . . the emotional reaction of the artist would continually change, and the computer would react accordingly either to stabilize the artist's emotional state or to steer it through some pre-programmed course. One is strongly tempted to describe these ideas as a consciousness-expanding experience in association with a psychedelic computer . . . cur-

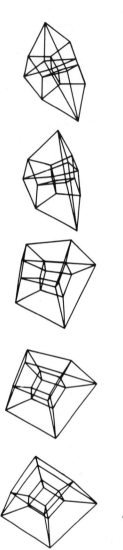

Visualizing the invisible: Four successive stereo pairs from a film by A. Michael Noll of Bell Telephone Laboratories, demonstrating the rotation, on four mutually perpendicular axes, of a four-dimensional hypercube projected onto dual two-dimensional picture planes in simulated three-dimensional space. The viewer wears special polarized glasses such as those common in 3-D movies of the early 1950's. It was an attempt to communicate an intuitive understanding of four-dimensional objects, which in physics are called *hyperobjects.* A computer can easily construct, in mathematical terms, a fourth spatial dimension perpendicular to our three spatial dimensions. Only a fourth digit is required for the machine to locate a point in four-dimensional space. Photo: Bell Telephone Laboratories.

rent technological and psychological investigations would seem to aim in such a direction."[21]

This chapter on computer films might be seen as an introduction to the first tentative, crude experiments with the medium. No matter how impressive, they are dwarfed by the knowledge of what computers someday will be able to do. The curious nature of the technological revolution is that, with each new step forward, so much new territory is exposed that we seem to be moving backwards. No one is more aware of current limitations than the artists themselves.

As he has done in other disciplines without a higher ordering principle, man so far has used the computer as a modified version of older, more traditional media. Thus we find it compared to the brush, chisel, or pencil and used to facilitate the efficiency of conventional methods of animating, sculpting, painting, and drawing. But the chisel, brush, and canvas are *passive* media whereas the computer is an *active* participant in the creative process. Robert Mallary, a computer scientist involved in computer sculpture, has delineated six levels of computer participation in the creative act. In the first stage the machine presents proposals and variants for the artist's consideration without any qualitative judgments, yet the man/machine symbiosis is synergetic. At the second stage, the computer becomes an *indispensable* component in the production of an art that would be impossible without it, such as constructing holographic interference patterns. In the third stage, the machine makes autonomous decisions on alternative possibilities that ultimately govern the outcome of the artwork. These decisions, however, are made within parameters defined in the program. At the fourth stage the computer makes decisions not anticipated by the artist because they have not been defined in the program. This ability does not yet exist for machines. At the fifth stage, in Mallary's words, the artist "is no longer needed" and "like a child, can only get in the way." He would still, however, be able to "pull out the plug," a capability he will not possess when and if the computer ever reaches the sixth stage of "pure disembodied energy."[22]

[21] A. M. Noll, "The Digital Computer as a Creative Medium," *IEEE Spectrum* (October, 1967), p. 94.

[22] Robert Mallary, "Computer Sculpture: Six Levels of Cybernetics," *Artforum* (May, 1969), pp. 34, 35.

Returning to more immediate realities, A. M. Noll has explained the computer's active role in the creative process as it exists today: "Most certainly the computer is an electronic device capable of performing only those operations that it has been explicitly instructed to perform. This usually leads to the portrayal of the computer as a powerful tool but one incapable of any true creativity. However, if 'creativity' is restricted to mean the production of the unconventional or the unpredicted, then the computer should instead be portrayed as a creative medium—an active and creative collaborator with the artist . . . because of the computer's great speed, freedom from error, and vast abilities for assessment and subsequent modification of programs, it appears to us to act unpredictably and to produce the unexpected. In this sense the computer actively takes over some of the artist's creative search. It suggests to him syntheses that he may or may not accept. It possesses at least some of the external attributes of creativity."[23]

Traditionally, artists have looked upon science as being more important to mankind than art, whereas scientists have believed the reverse. Thus in the confluence of art and science the art world is understandably delighted to find itself suddenly in the company of science. For the first time, the artist is in a position to deal directly with fundamental scientific concepts of the twentieth century. He can now enter the world of the scientist and examine those laws that describe a physical reality. However, there is a tendency to regard any computer-generated art as highly significant—even the most simplistic line drawing, which would be meaningless if rendered by hand. Conversely, the scientific community could not be more pleased with its new artistic image, interpreting it as an occasion to relax customary scientific disciplines and accept anything random as art. A solution to the dilemma lies somewhere between the polarities and surely will evolve through closer interaction of the two disciplines.

When that occurs we will find that a new kind of art has resulted from the interface. Just as a new language is evolving from the binary elements of computers rather than the subject-predicate relation of the Indo-European system, so will a new aesthetic discipline that bears little resemblance to previous notions of art and

[23] Noll, "The Digital Computer as a Creative Medium," p. 91.

the creative process. Already the image of the artist has changed radically. In the new conceptual art, it is the artist's *idea* and not his technical ability in manipulating media that is important. Though much emphasis currently is placed on collaboration between artists and technologists, the real trend is more toward one man who is both artistically and technologically conversant. The Whitney family, Stan VanDerBeek, Nam June Paik, and others discussed in this book are among the first of this new breed. A. M. Noll is one of them, and he has said: "A lot has been made of the desirability of collaborative efforts between artists and technologists. I, however, disagree with many of the assumptions upon which this desirability supposedly is founded. First of all, artists in general find it extremely difficult to verbalize the images and ideas they have in their minds. Hence the communication of the artist's ideas to the technologist is very poor indeed. What I do envision is a new breed of artist . . . a man who is extremely competent in both technology and the arts."

Thus Robert Mallary speaks of an evolving "science of art . . . because programming requires logic, precision and powers of analysis as well as a thorough knowledge of the subject matter and a clear idea of the goals of the program . . . technical developments in programming and hardware will proceed hand in glove with a steady increase in the theoretical knowledge of art, as distinct from the intuitive and pragmatic procedures which have characterized the creative process up to now."

# Cybernetic Cinema

Three types of computer output hardware can be used to produce movies: the mechanical analogue plotter, the "passive" microfilm plotter and the "active" cathode-ray tube (CRT) display console. Though the analogue plotter is quite useful in industrial and scientific engineering, architectural design, systems analysis, and so forth, it is rather obsolete in the production of aesthetically-motivated computer films. It can and is used to make animated films but is best suited for still drawings.

Through what is known as digital-to-analogue conversion, coded signals from a computer drive an armlike servomechanism that literally draws pen or pencil lines on flatbed or drum carriages. The resulting flow charts, graphs, isometric renderings, or realist images are incrementally precise but are too expensive and time-consuming for nonscientific movie purposes. William Fetter of the Boeing Company in Seattle has used mechanical analogue plotting systems to make animated films for visualizing pilot and cockpit configurations in aircraft design. Professor Charles Csuri of Ohio State University has created "random wars" and other random and semi-random drawings using mechanical plotters for realist images. However, practically all computer films are made with cathode-ray tube digital plotting output systems.

The cathode-ray tube, like the oscilloscope, is a special kind of television tube. It's a vacuum tube in which a grid between cathode and anode poles emits a narrow beam of electrons that are accelerated at high velocity toward a phosphor-coated screen, which fluoresces at the point where the electrons strike. The resulting luminescent glow is called a "trace-point." An electromagnetic field deflects the electron beam along predetermined patterns by electronic impulses that can be broadcast, cabled, or recorded on tape. This deflection capability follows vertical and horizontal increments expressed as $xy$ plotting coordinates. Modern three-inch CRTs are capable of responding to a computer's "plot-point" and "draw-line" commands at a rate of 100,000 per second within a field of 16,000 possible $xy$ coordinates—that is, approximately a million times

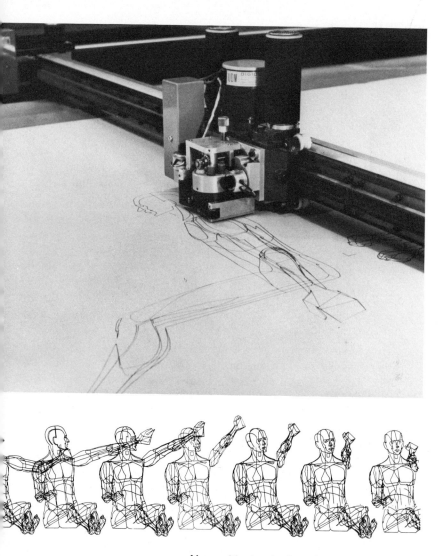

*Above:* Mechanical analogue plotter draws pilot for computer-animated film by William Fetter of the Boeing Company in Seattle, Washington. *Below:* Animated sequence from the film. Photo: Boeing Company.

faster and more accurate than a human draftsman. When interfaced with a digital computer, the CRT provides a visual display of electronic signal information generated by the computer program.

The passive microfilm plotter is the most commonly used output system for computer movies. It's a self-contained film-recording unit in which a movie camera automatically records images generated on the face of a three-inch CRT. The term "microfilm" is confusing to filmmakers not conversant with industrial or scientific language. It simply indicates conventional emulsion film in traditional 8mm., 16mm., or 35mm. formats, used in a device not originally intended for the production of *motion* pictures, but rather *still* pictures for compact storage of large amounts of printed or pictorial information. Users of microfilm plotters have found, however, that their movie-producing capability is at least as valuable as their storage-and-retrieval capability. Most computer films are not aesthetically-motivated. They are made by scientists, engineers, and educators to facilitate visualization and rapid assimilation of complex analytic and abstract concepts.

In standard cinematography the shutter is an integral part of the camera's drive mechanism, mechanically interlocked with the advance-claws that pull successive frames down to be exposed. But cameras in microfilm plotters such as the Stromberg-Carlson 4020 or the CalComp 840 are specially designed so that the shutter mechanism is separate from the film pull-down. Both are operated automatically, along with the CRT display, under computer program control.

Some computer films, particularly those of John Whitney, are made with active twenty-one-inch CRTs such as the IBM 2250 Display Console with its light pen, keyboard inputs, and functional keys, whose use will be described in more detail later on. This arrangement is not a self-contained filmmaking unit; rather, a specially modified camera is set up in front of the CRT under automatic synchronous control of a computer program. This system is called "active" as opposed to the "passive" nature of the microfilm plotter because the artist can feed commands to the computer through the CRT by selecting variables with the light pen and the function keyboard, thus "composing" the picture in time as sequences develop (during filming, however, the light pen is not used

Cybernetic movie studio: The IBM 2250
Display Console with CRT, light pen, and
function keyboard. Photo: IBM.

and the CRT becomes a passive display of the algorithm). Also, until recently the display console was the only technique that allowed the artist to see the display as it was being recorded; recent microfilm plotters, however, are equipped with viewing monitors.

Since most standard microfilm plotters were not originally intended for the production of motion pictures, they are deficient in at least two areas that can be avoided by using the active CRT. First, film registration in microfilm plotters does not meet quality standards of the motion-picture industry since frame-to-frame steadiness is not a primary consideration in conventional microfilm usage. Second, most microfilm plotters are not equipped to accept standard thousand-foot core-wound rolls of 35mm. film, which of course is possible with magazines of standard, though control-modified, cameras used to photograph active CRTs.

Recently, however, computer manufacturing firms such as Stromberg-Carlson have designed cameras and microfilm plotters that meet all qualifications of the motion-picture industry as the use of computer graphics becomes increasingly popular in television commercials and large animation firms. Passive CRT systems are preferred over active consoles for various reasons. First, the input capabilities of the active scope are rarely used in computer animation. Second, passive CRTs come equipped with built-in film recorders. Third, a synchronization problem can arise when filming from an active CRT scope caused by the periodic "refreshing" of the image. This is similar to the "rolling" phenomenon that often occurs in the filming of a televised program. The problem is avoided in passive systems since each frame is drawn only once and the camera shutter remains open while the frame is drawn.

The terms "on-line," "off-line," and "real time" are used in describing computer output systems. Most digital plotting systems are designed to operate either on-line or off-line with the computer. In an on-line system, plot commands are fed directly from the computer to the CRT. In an off-line system, plot commands are recorded on magnetic tape that can instruct the plotter at a later time. The term "real time" refers specifically to temporal relationships between the CRT, the computer, and the final film or the human operator's interaction with the computing system. For example, a real-time interaction between the artist and the computer is possible by drawing on the face of the CRT with the light pen. Similarly, if a movie projected at the standard 24 fps has recorded the CRT display exactly as it was drawn by the computer, this film is said to be a real-time representation of the display. A live-action shot is a real-time document of the photographed subject, whereas single-frame animation is not a real-time image, since more time was required in recording than in projecting.

Very few computer films of significant complexity are recorded in real-time operation. Only one such film, Peter Kamnitzer's *City-Scape*, is discussed in this book. This is primarily because the hardware necessary to do real-time computer filmmaking is rare and prohibitively expensive, and because real-time photography is not of crucial importance in the production of aesthetically-motivated films. In the case of John Whitney's work, for example, although the

imagery is preconceived for movie projection at 24 fps, it is filmed at about 8 fps. Three to six seconds are usually required to produce one image, and a twenty-second sequence projected at 24 fps may require thirty minutes of computer time to generate.

Most CRT displays are black-and-white. Although the Sandia Corporation and the Lawrence Radiation Laboratory have achieved dramatic results with full-color CRTs, the color of most computer films is added in optical printing of original black-and-white footage, or else colored filters can be superposed over the face of the CRT during photography. Full color and partial color displays are available. As in the case of *City-Scape*, however, a great deal of color quality is lost in photographing the CRT screen. Movies of color CRT displays invariably are washed-out, pale, and lack definition. Since black-and-white film stocks yield much higher definition than color film stocks, most computer films are recorded in black-and-white with color added later through optical printing.

A similar problem exists in computer-generated realistic imagery in motion. It will be noted that most films discussed here are non-figurative, nonrepresentational, i.e., concrete. Those films which do contain representational images—*City-Scape, Hummingbird*—are rather crude and cartoon-like in comparison with conventional animation techniques. Although computer films open a new world of language in concrete motion graphics, the computer's potential for manipulation of the realistic image is of far greater relevance for both artist and scientist. Until recently the bit capacity of computers far outstripped the potentials of existing visual subsystems, which did not have the television capability of establishing a continuous scan on the screen so that each point could be controlled in terms of shading and color. Now, however, such capabilities do exist and the tables are turned; the bit capacity necessary to generate television-quality motion images with tonal or chromatic scaling is enormously beyond present computer capacity.

Existing methods of producing realistic imagery still require some form of realistic input. The computer does not "understand" a command to make this portion of the picture dark gray or to give that line more "character." But it does understand algorithms that describe the same effects. For example, L. D. Harmon and Kenneth Knowlton at Bell Telephone have produced realistic pictures by

scanning photographs with equipment similar to television cameras. The resulting signals are converted into binary numbers representing brightness levels at each point. These bits are transferred to magnetic tape, providing a digitized version of the photograph for computer processing. Brightness is quantized into eight levels of density represented by one of eight kinds of dots or symbols. They appear on the CRT in the form of a mosaic representation of the original photograph. The process is both costly and time consuming, with far less "realistic" results than conventional procedures.

The Computer Image Company of Denver, Colorado, has devised two unique methods of producing cartoon-like representational computer graphics in real-time, on-line operation. Using special hybrid systems with the advantages of both digital and analogue computers, they generate images through optical scanning or acoustical and anthropometric controls. In the scanning process, called *Scanimate,* a television camera scans black-and-white or color transparencies; this signal is input to the Scanimate computer where it is segmented into as many as five different parts, each capable of independent movement in synchronization with any audio track, either music or commentary. The output is recorded directly onto film or videotape as an integral function of the Scanimate process.

The second computer image process, *Animac,* does not involve optical scanning. It generates its own images in conjunction with acoustical or anthropometric analogue systems. In the first instance the artist speaks into a microphone that converts the electrical signals into a form that modulates the cartoon image on the CRT. The acoustical input animates the cartoon mouth while other facial characteristics are controlled simultaneously by another operator. In the second method an anthropometric harness is attached to a person—a dancer, for example—with sensors at each of the skeletal joints. If the person moves his arm the image moves its arm; when the person dances the cartoon character dances in real-time synchronization, with six degrees of freedom in simulated three-dimensional space. It should be stressed that these cartoon images are only "representational" and not "realistic." The systems were designed specifically to reduce the cost of commercial filmmaking and not to explore serious aesthetic potentials. It's obvious, however, that such techniques could be applied to artistic investigation and to nonobjective graphic compositions.

Reclining nude scanned from photo and reconstructed by computer using brightness-level symbols. By L. D. Harmon and Kenneth C. Knowlton. Photo: Bell Telephone Laboratories.

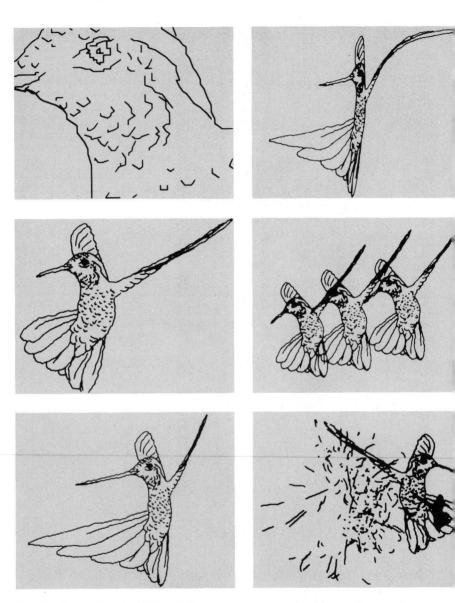

Charles Csuri: *Hummingbird.* 1967.
16mm. Black and white. 10 min.
Computer-manipulations of hand-
drawn figure using *xy* plotting
coordinates.

Professor Charles Csuri's computer film, *Hummingbird*, was produced by digital scanning of an original hand-drawing of the bird. The computer translated the drawing into $xy$ plotting coordinates and processed variations on the drawing, assembling, disassembling, and distorting its perspectives. Thus the images were not computer-generated so much as computer-manipulated. There's no actual animation in the sense of separately-moving parts. Instead a static image of the bird is seen in various perspectives and at times is distorted by reversals of the polar coordinates. Software requirements were minimal and the film has little value as art other than its demonstration of one possibility in computer graphics.

Limitations of computer-generated realistic imagery exist both in the central processing hardware as well as visual output subsystems. Advancements are being made in output subsystems that go beyond the present bit-capacity of most computers. Chief among these is the "plasma crystal" panel, which makes possible billboard or wall-size TV receivers as well as pocket-size TV sets that could be viewed in bright sunlight. The Japanese firms of Mitsubishi and Matsushita (Panasonic) seem to be leaders in the field, each having produced workable models. Meanwhile virtually every major producer of video technology has developed its own version. One of the pioneers of this process in the United States was Dr. George Heilmeier of RCA's David Sarnoff Research Center in Princeton, New Jersey. He describes plasma crystals (sometimes called liquid crystals) as organic compounds whose appearance and mechanical properties are those of a liquid, but whose molecules tend to form into large orderly arrays akin to the crystals of mica, quartz, or diamonds. Unlike luminescent or fluorescing substances, plasma crystals do not emit their own light: they're read by reflected light, growing brighter as their surroundings grow brighter.

It was discovered that certain liquid crystals can be made opalescent, and hence reflecting, by the application of electric current. Therefore in manufacturing such display systems a sandwich is formed of two clear glass plates, separated by a thin layer of clear liquid crystal material only one-thousandth of an inch thick. A reflective mirror-like conductive coating is deposited on the inside face of one plate, in contact with the liquid. On the inside of the other is deposited a transparent electrically-conductive coating of

Prototype for flat, wall-size TV screens and computer visualization subsystems of future: Dr. George Heilmeier demonstrates RCA's liquid crystal display. Photo: R

tin oxide. When an electric charge from a battery or wall outlet is applied between the two coatings, the liquid crystal molecules are disrupted and the sandwich takes on the appearance of frosted glass. The frostiness disappears, however, as soon as the charge is removed.

In order to display stationary patterns such as letters, symbols, or still images, the coatings are shaped in accordance with the desired pattern. To display motion the conductive coatings are laid down in the form of a fine mosaic whose individual elements can be charged independently, in accordance with a scanning signal such as is presently used for facsimile, television, and other electronic displays. To make the images visible in a dark room or outdoors at night, both coatings are made transparent and a light source is

installed at the edge of the screen. In addition it is possible to reflect a strong light from the liquid crystal display to project its images, enlarged many times, onto a wall or screen.

The implications of the plasma crystal display system are vast. Since it is, in essence, a digital system composed of hundreds of thousands of discrete picture elements (PIXELS), it obviously is suitable as a computer graphics subsystem virtually without limitation if only sufficient computing capabilities existed. The bit requirements necessary for computer generation of real-time realistic images in motion are as yet far beyond the present state of the art.

This is demonstrated in a sophisticated video-computer system developed by Jet Propulsion Laboratories in Pasadena, California, for translation of television pictures from Mars in the various Mariner projects. This fantastic system transforms the real-time TV signal into digital picture elements that are stored on special datadiscs. The picture itself is not stored; only its digital translation. The JPL video system consists of 480 lines of resolution, each line composed of 512 individual points. One single image, or "cycle," is thus defined by 245,760 points. In black-and-white, each of these points, individually selectable, can be set to display at any of 64 desired intensities on the gray scale between total black and total white. Possible variations for one single image thus amount to 64 times 245,760. For color displays, the total image can be thought of as three independent images (one for each color constituent, red, blue, and green) or can be taken as a triplet specification for each of the 480 times 512 points. With each constituent being capable of 64 different irradiating levels in the color spectrum, a theoretical total of 262,144 different color shadings are possible for any given point in the image. (The average human eye can perceive only 100 to 200 different color shadings.)

These capabilities are possible only for single motionless images. Six bits of information are required to produce each of the 245,760 points that constitute one image or cycle, and several seconds are necessary to complete the cycle. Yet JPL scientists estimate that a computing capability of at least two megacycles (two million cycles) *per second* would be required to generate motion with the same image-transforming capabilities.

It is quite clear that human communication is trending toward

these possibilities. If the visual subsystems exist today, it's folly to assume that the computing hardware won't exist tomorrow. The notion of "reality" will be utterly and finally obscured when we reach that point. There'll be no need for "movies" to be made on location since any conceivable scene will be generated in totally convincing reality within the information processing system. By that time, of course, movies as we know them will not exist. We're entering a mythic age of electronic realities that exist only on a metaphysical plane. Meanwhile some significant work is being done in the development of new language through computer-generated, nonrepresentational graphics in motion. I've selected several of the most prominent artists in the field and certain films which, though not aesthetically-motivated, reveal possibilities for artistic exploration. We'll begin with the Whitney family: John, Sr., and his brother James inaugurated a tradition; the sons John, Jr., Michael, and Mark are the first second-generation computer-filmmakers in history.

# Computer Films

## John Whitney: Composing an Image of Time

"My computer program is like a piano. I could continue to use it creatively all my life."

The foremost computer-filmmaker in the world today, John Whitney has for more than thirty years sought new language through technological resources beyond human capacity. He has, however, remained resolutely "humanist" in his approach, constantly striving to reach deep emotional awarenesses through a medium essentially austere and clinical. He has realized his goal to a remarkable degree, yet he would be the first to admit that there is a long way to go. "Computer graphic systems," he has said, "present an opportunity to realize an art of graphics in motion with potentials that are only now conceivable and have never been explored."

In his essay "Systems Esthetics," Jack Burnham observed: "Scientists and technicians are not converted into artists, rather the artist becomes a symptom of the schism between art and technics. Progressively, the need to make ultrasensitive judgments as to the uses of technology and scientific information becomes 'art' in the most literal sense."[24] Whitney is making those judgments with a powerful extension of his brain.

Following studies at Pomona College in California, Whitney spent a year in Europe where he studied photography and musical composition. In 1940 he began specializing in concrete designs in motion, working with his brother James on animated films which won first prize at the first Experimental Film Festival in Belgium in 1949.

Early in the 1950's he experimented with the production of 16mm. films for television and in 1952 wrote, produced, and directed engineering films on guided missile projects for Douglas Aircraft. He was a director of animated films at UPA in Hollywood for one year. The title sequence for Alfred Hitchcock's *Vertigo* was

[24] Jack Burnham, "Systems Esthetics," *Artforum* (September, 1968), pp. 30–35.

among the work he produced in association with Saul Bass during this period. Following that he directed several short musical films for CBS television, and in 1957 worked with Charles Eames assembling a seven-screen presentation for the Fuller Dome in Moscow. Each screen was the size of a drive-in movie screen.

In 1960 Whitney founded Motion Graphics Inc., producing motion-picture and television title sequences and commercials. Much of this work was done with his own invention, a mechanical analogue computer for specialized animation with typography and concrete design. In 1962 he was named Fellow of the Graham Foundation for Advanced Study in the Fine Arts. Finally, after approximately a decade, he found himself free once again to begin experimenting with less commercial, more aesthetic, problems of motion graphics.

The analogue computer work gained Whitney a worldwide reputation, and in the spring of 1966 International Business Machines became the first major corporation to take an "artist in residence" to explore the aesthetic potentials of computer graphics. IBM awarded Whitney a continuing grant that has resulted in several significant developments in the area of cybernetic art. Whether working with hand-drawn animation cards or highly abstract mathematical concepts, Whitney has always displayed an artist's intuition and a technologist's discipline. He is a man of tomorrow in the world of today.

The history of cybernetics reached a milestone during World War II with the development of guidance and control mechanisms for antiaircraft artillery. Two men riding a telescope table sighted enemy aircraft and followed their penetration into the battery range. Selsyn motors in the gun-director mechanism automatically aimed an entire battery of guns while analogue computers set fuse times on explosive shells and specified true-intercept trajectories from data fed into the ballistics equation from movements of the operators.

An M-5 Antiaircraft Gun Director provided the basic machinery for Whitney's first mechanical analogue computer in the late 1950's. This complex instrument of death now became a tool for producing benevolent and beautiful graphic designs. Later Whitney augmented the M-5 with the more sophisticated M-7, hybridizing the machines into a mammoth twelve-foot-high device of formidable

John Whitney working with his mechanical
analogue computer. Photo: Charles Eames.

complexity upon which most of the business of Motion Graphics was conducted for many years.

Similar to the analogue device built by Whitney's brother James for the production of *Lapis,* but far more complex, the machine consists of primary, secondary, and tertiary rotating tables, cam systems, and other surfaces for pre-programming of image and motion sequences in a multiple-axis environment. Whitney's son John, Jr., an electronics genius who improved his father's device as a teen-ager by rewiring and implementing its circuitry, explains the basic functions of the machine:

> There's not one function that isn't variable. The whole master table rotates and so does every part in it, as well as moving laterally, horizontally, and in some cases vertically. The camera moves in the same way, completely independent of the rest of the machine, or in synchronization with it. I don't know how many simultaneous motions can be happening at once. There must be at least five ways just to operate the shutter. The input shaft on the camera rotates at 180 rpm, which results in a photographing speed of about 8 fps. That cycle time is constant, not variable, but we never shoot that fast. It takes about nine seconds to shoot one frame because the secondary rotating tables require nine seconds to make one revolution. During this nine-second cycle the tables are spinning on their own axes while simultaneously revolving around another axis while moving horizontally across the range of the camera, which itself may be turning or zooming up and down. During this operation we can have the shutter open all the time, or just at the end for a second or two, or at the beginning, or for half of the time if we want to do slit-scanning.

The elder Whitney actually never produced a complete, coherent movie on the analogue computer because he was continually developing and refining the machine while using it for commercial work. It remained for his sons John and Michael to make full creative use of this device that had dominated their childhood from earliest recollection. However, Whitney did assemble a visual catalogue of the effects he had perfected over the years. This film, simply titled *Catalogue,* was completed in 1961 and proved to be of such overwhelming beauty that many persons still prefer Whitney's analogue work over his digital computer films.

The machine, like the digital computer, not only facilitated the quick and effortless rendering of complex geometrical shapes and

*Left:* Camera zoom lens (*center*) focusing into primary rotating table of Whitney mechanical analogue computer. (Photo: Charles Eames) *Below:* Whitney places design template into computer table.

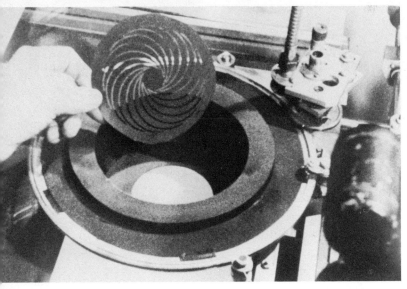

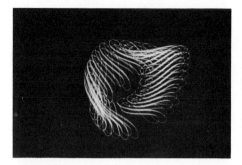
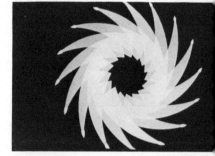

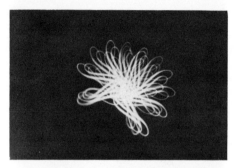
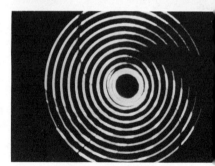

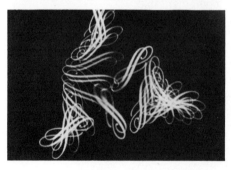

John Whitney: *Catalogue.* 1961. 16mm.
Color. 7 min. "Floral patterns curl as
though they were actually organic
growths . . ."

motions, but also actually helped realize certain graphics possibilities that otherwise might not be conceivable to the artist untrained in mathematical concepts. *Catalogue* is a brilliant display of floral patterns that seem to bloom and curl as though they were actually organic growths photographed in time-lapse. Also they have a natural quality quite unlike traditional single-frame animation and are far more convincing. Elsewhere in the film, neon-like coils expand and contract, throwing out bursts of pastel color. Dish-shaped curvilinear disks wobble and strobe, stretch and contract in a variety of unexpected ways. Syncretistic dot-pattern fields collect together as in *Lapis*. Strings of green light perform seemingly impossible transformations into endless intertwined configurations of baffling optical complexity. Words assemble and disintegrate, defying logic. Floral ringlets pop like neon confetti, showering the screen with flak bursts of color.

Unlike the digital computer, which requires only a mathematical code as its input, the mechanical analogue computer as used by the Whitneys requires some form of input that directly corresponds to the desired output. That is, at least a basic element of the final image we see on the screen must first be drawn, photographed, pasted together, or otherwise assembled *before* it is fed into the analogue equipment for processing. This means that a great deal of handicraft still is involved, though its relation to the final output is minimal. The original input may be as simple as a moiré pattern or as complex as a syncretistic field of hand-painted dots—but *some* form of handmade or physically demonstrable information is required as input in the absence of conventional computer software.

GENE: You're among the few people in the world working to bring the public into a closer understanding of technology on a basis we can relate to—a movie, pretty colors, things that move. It's very important.

JOHN: Just after World War II my brother and I were constantly excited by a future world. We sort of expected it to happen before the 1940's were past. We thought nothing of taking on the formal and creative problems of a totally technological medium such as the cinema. It's taken twenty or thirty years to realize that the technology we looked upon as being the technology of the

future was far from it. Instead of being the camera, the most important piece of instrumentation is the computer itself. Still ahead is considerable disciplined study to gain understanding or control of this kind of formal dynamic material so that it can be human. That's the whole problem. The light show people are doing a lot of wonderful sensory things, but I feel there must come insight into what is *not* seen now—an understanding of a whole new area of conceptual form. The light show people are doing something like an infant pounding on the keys of a piano. Sometimes it can be very creative and terribly exciting. But in the long run, looking at it as an adult, it's just banging away at the piano without training. We know that someone who plays a Beethoven sonata maybe has been sharpening his sensibilities and manual dexterity with that one piece for seven or eight years. That's the way I see the relationship between computer aesthetics and contemporary light shows.

GENE: Where would you place yourself today concerning what you've done and what you'd like to do?

JOHN: In one sense I'm just beginning. In another sense my work with the digital computer is a culmination of all my interests since the 1940's because I found myself forced into the techniques and mechanisms of cinema. I got to work with the digital computer thanks to the fact that I developed my analogue equipment to the point that I had. As I continued to develop the machine I realized it was really a mechanical model of the electronic computer. Anyone experimenting with the medium of cinema as opposed to working in the industry is forced into a direct confrontation with his technology. People tried all different techniques of abstract cinema, and it's strange that no one has really invented anything that another experimental filmmaker can take up and use himself. It's starting afresh every time. Jim and I were trying to make something and there wasn't a machine available for making it. So my work has come to fruition because the past thirty years of search for instrumentation has culminated in the present availability of the computer. On the other hand I'm only beginning to use it. We all are. It's the same with those who are beginning to use the computer to compose music—they're at a very primitive stage today.

*Permutations* (see color plates), the first cohesive film to come out of Whitney's work with the digital computer, is a dazzling display of serial imagery that seems to express specific ideas or chains of ideas through hypersensitive manipulation of kinetic empathy. The patterns, colors, and motions dancing before us seem to be addressing the inarticulate conscious with a new kind of language. In fact, Whitney thinks of his work precisely as the development of a new communicative mode. Speaking of *Permutations*, he explains:

> The film contains various types of dot patterns which might be compared to the alphabet. The patterns are constructed into "words," each having basically a two-hundred-frame or eight-second time duration. These words in turn can be fitted contextually into "sentence" structures. My use of the parallel to language is only partially descriptive; I am moved to draw parallels with music. The very next term I wish to use is "counterpoint." These patterns are graphically superimposed over themselves forward and backward in many ways, and the parallel now is more with counterpoint, or at least polyphonic musical phenomena. Should it be called "polygraphic phenomena"?

Whatever they're called, Whitney's films are impossible to describe with the archaic language of the phonetic alphabet. Circles, crescents, quadrants, and multiplex forms of infinite variety and endless motion interact serially, and cosmically, until one is transported into a realm of expanded consciousness that intuitively understands this new language. It's as though the very essence of the idea of permutation is expressed in this film, as though the "word" no longer were separate from the fact. And that's exactly what Whitney has done: he's merged language with what it is intended to express. "Beautiful" seems such an inadequate term in this respect.

Before discussing the film itself, it will be helpful to understand in some detail how it was made, beginning with the program and going on through the final stages of photography and optical printing. This will be helpful to readers interested in making computer films, since Whitney's methods and working conditions are those most likely to be available to the average person—with the exception of his own specialized film processing equipment.

Dr. Jack Citron of IBM became interested in Whitney's work and began collaborating with him before there was any formal IBM

support. Dr. Citron later was given formal responsibility for further work with Whitney under the IBM program, exploring the creative possibilities inherent in the IBM Model 360 computer and the IBM 2250 Graphic Display Console. It was Citron who wrote the original program called GRAF (Graphic Additions to Fortran), which Whitney has been using since the spring of 1966.

CITRON: One of the things I was interested in doing was to set up a kind of instrument which would buffer the computer user from the technical details. I think this can only be done by someone who understands both areas. The line of attack in my program was to start with what's in the artist's mind, and somehow have him use a kind of mathematics which he learns by rote with a "teaching program," to learn to express what's in his head visually. Once such a program is written, the fact that the programmer who wrote the algorithms knew what the artist needed enables the artist to sit down and say the kind of things John says without all that other training. I'm very happy it worked that way. Certainly in the future one will need more of a mathematical-logical background than artists have today. But you won't need ten years of schooling in nuclear physics. The thing that should be done is to develop a scientific curriculum for the artist. I don't know of anyone seriously considering that, but it should be done.

WHITNEY: Dr. Citron and I talked for some time before I actually began working. When I first began to realize from correspondence with IBM that I would be given the grant, the first thing that came to my mind was the question: would I be able to draw a free-hand line and somehow get that into the computer as digital information so I could manipulate it? I was presenting these ideas in preliminary talks and I was told that anything you can define mathematically you can do with a computer very easily. At first, having flunked mathematics consistently all through school, I was a bit horrified. And yet I began to realize the great breadth of elegance in simple geometrical graphics, and the historic respect geometry has enjoyed as a graphic form. Slowly these misgivings about having to define things in mathematical form died off. . . . Some people in computer work criticize me for not being able to program myself instead of relying on someone else.

Yet I've used this one program for more than three years and I know that it is still only fragmentarily explored. In terms of software the program Dr. Citron developed for me is like a piano. I could continue to use it creatively all my life. But one program is like one area of a total palette. Let's assume that other people are going to develop other programs that will have another area of significance. Some of the ultimate orchestrations to come in fifteen or twenty years will perhaps involve many combined programs.

The GRAF program is based on a single polar-coordinate equation having about sixty parameters. In preparation for a display of images in what is called the "learning" stage of the program, the light pen is used to select numerical variables, displayed on the CRT, which can be assigned to any of the parameters of the program to determine a particular graphic pattern. After values have been selected for all parameters and the camera is brought into play to record the images, control of the computer program is by punch cards, not the light pen. The shutter of the computer camera specially modified by Whitney and his son John is operated electrically, under control of the computer. The functions of opening and closing the shutter and advancing the film are controlled by a separate program in addition to GRAF.

Three types of punch cards are used during filming for control of images, and are signified as Identification Statements (for specifying particular curves), Parameter Statements (for assigning values to the curve), and Frame Statements (for control of successive displays). During this time the artist interacts with the computer through the Program Function Keyboard (PFKB), part of the 2250's hardware. The PFKB is equipped with thirty-six sets of keyswitches and lights. The program turns on light 1 as a signal to open the camera shutter. Interface connections between camera and computer include feedback circuits that allow the camera, in effect, to respond to computer commands: thus key 1 is depressed, entering 20 volts back into the computer and pulsing the camera with 5.3 volts, which operates one single frame exposure. This is followed by an exposure timing loop in the program, and subsequently light 2 is illuminated ordering the shutter to close. Programmed logic decides whether or not more information is to be displayed for this same

frame of film. When the film frame is to be advanced, light 3 goes on and the next curve is computed and displayed, the camera is activated, and so on.

The 35mm. black-and-white negative from the camera is processed normally on high-contrast stock yielding an image that consists of clear lines on a dense black field. This film is threaded into the projector side of Whitney's optical printer, which has several special features: the optical axis of the system is vertical with the camera looking down into the projector. The projector itself is mounted on a compound mill table. Thus additional translations and rotations of a mechanical nature may be superimposed, and the camera may be moved along the axis so as to provide for an additional scaling factor of from .1 to 10. A stepping switch circuit and preset frame counter allow a wide range of skip-frame ratios to expand editing capabilities temporally. For *Permutations* Whitney used little skip-framing, but quite a bit of superimposition, slowing and speeding, and forward and backward printing.

Set to a *tabla* solo by Balachander, *Permutations* begins with a ring of white dots in a black void, with individual white dots circumscribing the inner circumference of the ring. This becomes an oval floral pattern of blue, green, and pink dots moving simultaneously clockwise and counterclockwise.

Two factors quickly become apparent: first, the neon-like cold scintillation of the image, a result of electrons deflecting traces in the cathode phosphor at a rate of 30 cycles per second. In our fluorescent world of neon suns and video eyes this scintillating glimmer more closely approximates daily experience than, say, the artificial arc lamp lighting of conventional movies.

Second, is the quite noticeable seriality of the composition, the unified wholeness of the statement, although it is composed of discrete elements. In defining "serial" in this context I should like to quote from art critic John Coplans: "To paint in *series* is not necessarily to be *serial*. Neither the number of works nor the similarity of theme in a given group determines whether a [work] is serial. Rather, seriality is identified by a particular interrelationship, rigorously consistent, of structure and syntax: serial structures are produced by a single indivisible process that links the internal structure of a work to that of other works within a differentiated whole.

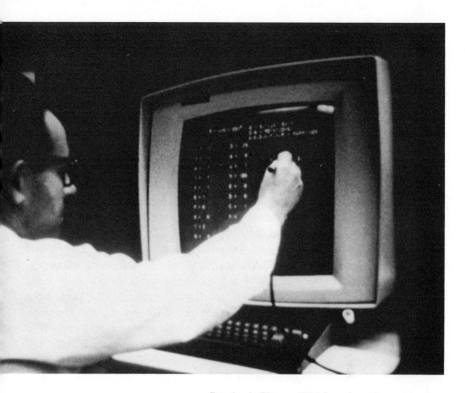

Dr. Jack Citron, IBM Los Angeles, selects numerical values for a typical image, using the light pen at the 2250 Display Console.

While a series may have any number of works, it must as a precondition of seriality have at least two . . . there are no boundaries implicit to serial imagery; its structures can be likened to continuums or constellations . . . all contemporary usage of serial imagery is without either first or last members. Obviously at one point there had to be a beginning, but its identity becomes subsumed within the whole, within the macrostructure. The same principle applies to the last member. At any given point in time one work in a series stands last in order of execution, but its sequential identity is irrelevant and in fact is lost immediately on the work's completion."[25]

It is this seriality, then, that identifies *Permutations* both as

[25] John Coplans, "Serial Imagery," *Artforum* (October, 1968), pp. 34–43.

"words" and "sentence structures" as well as a complete overall statement, which is the meaning of the title. Whitney speaks of "graphic integrity" in this respect, referring to the mathematically precise interrelationships between forms, colors, and movements.

At one point in the film there is an exploration of centrifugal and centripetal ring movement in alternating colors and dot-pattern fields. This becomes an extremely dramatic statement in which bright emerald-green linear figures sweep the inner circumference of a white ring in a black void. The action is asymmetrical, not center-oriented, a fluid kind of motion not restricted to one point, a multiplex motion with no static elements, moving on a path in space that approximates a trajectory.

This figure vanishes into infinity and there follows a series of superimpositions that fill the original white ring with variously-colored dot-pattern fields. Each field moves into the ring from different directions in the frame, rests within the ring for a moment scintillating gently, then moves out of the frame in the opposite direction from which it came, making room for another dot-pattern field of another color which moves in simultaneously. Finally, all colors move into the ring simultaneously from all sides, forming circles within circles all scintillating smoothly in a floral configuration.

GENE: You seem hesitant or apologetic using the parallel with musical forms.

JOHN: I'm wary of it. I've been making that analogy all along, but I'm aware of the pitfalls of a lot of people in history. Da Vinci talked about an art of color which would be dealt with as musical tones. Wilfred and Remmington in England at the turn of the century were building color organs. They were so hung up with parallels with music that they missed the essence of their medium. People talk about abstraction in graphics as being cold or inhuman. I just don't see that at all. What is a musical note? It's totally abstract. That's the essential point and that's why I use the musical analogy. The essential problem with my kind of graphics must resemble the creative problem of melody writing. It is perhaps the most highly sensitive task of art, involving as it does balance, contrast, tension, and resolution all brought into play

with minimum expenditure. Music really is the art that moves in time. The many statements about architecture being frozen music notwithstanding, here we are truly looking at another art that moves in time. Someone once said about musical compositions: "Time and tone completely fill each other . . . what the hearer perceives in the tones and rests of a musical work is not simply time but shaped and organized time . . . so the conventional formula receives its final interpretation: music is a temporal art because, shaping the stuff of time, it creates an image of time." I like that idea very much, so I ask myself, what can be essentially the image of time for the eye to perceive?

One such image in *Permutations* involves bright blue, green, and red ellipses that move in perspectival space from static positions at each side of the frame, growing larger as they move alternately to the center and back again, exchanging positions. The feeling is precisely one of counterpoint and of temporal experiences.

This sentence structure becomes a white ring spinning rapidly on a vertical axis until it appears to be a group of white rings in a cagelike configuration, still spinning on a polar vertical axis. Inside this cage appears a similar ring of elliptical spheres, emerald green, revolving on a horizontal axis. Finally, the whole assemblage becomes an incredibly beautiful constellation of all colors and quickly runs through all configurations and movements seen during the film. These are seen moving around, within, and through a total field of scintillating colors as the film ends.

GENE: Which comes first, sound or image?

JOHN: Image. In *Permutations* the sequences and colors were all done before I selected a piece of music, yet there are all these astonishing relations with the music. That's where accident is working in my favor. In many areas of art and music it has been commonplace for the artist to tell you there's nothing in his work that doesn't have some sort of valid relationship or meaningful reason for being there. They've constantly sought to avoid arbitrariness—not accident: you can often make an accident turn into a very wonderful twist to new meaning. But the worst kind of arbitrariness is when a person thinks his own casual decisions are

great simply because he's done it, because he decided to be arbitrary. I expect to make a lot more progress in the direction of having more and more levels of formal organization—therefore it should be more and more human and multistructured.

GENE: In one sense you're in the forefront of avant-garde art today, concerned as it is with systems aesthetics, scientific discipline, and so on. In another respect, however, you do seem to be running against the grain of a trend toward the stochastic element, especially in music, films, and theatre.

JOHN: It's a universal misunderstanding. At the Aspen Design Conference in 1967, a scientist was describing a problem scientifically, saying it could be done this way and that, and then he said if it couldn't be done in such a rigorous way let's do it anyway and that'll be art. Scientists very frequently get excited about becoming involved in art. And the very first thing that comes to their minds is just to chuck out the whole discipline that their entire career is based on. They think if it's art, it's free. Anything that goes with random numbers is art; and anything that has to be worked out carefully so that this goes here and this has got to go there, that's not art, that's science. But for my money it's more important and difficult to get this here and that there in the area of art, because it involves much more than just counting numbers and making it mathematically sound: it's got to be intensely and intuitively sound. That's what I'm searching for. That's what I mean by structure.

## James Whitney's *Lapis:* Cybernetic Philosopher's Stone

James Whitney's cybernetic art seems totally removed from the idyllic scene in the serene Southern California garden where he has developed ceramic handicraft to a fine art in days of quiet meditation. Yet his *Lapis* is perhaps the most beautiful, and one of the most famous, of all computer films. Like the work of his long-time friend, Jordan Belson, they represent expanded cinema in its widest meaning: an attempt to approximate mind forms. That Whitney claims to have failed in his quest does not subtract from the archetypal eloquence of his works. They are glowing testimony to the truth of Herbert Read's assertion that greatness lies "in the

power to realize and even to forecast the imaginative needs of mankind."

The fundamental imaginative need of mankind today is, as it always has been, the bridging of the chasm between spirit and matter. Atomic science is moving us closer to that realization. But in the words of Louis Pauwels, "just as science without conscience spells ruin for the soul, conscience without science means defeat also." In this respect Whitney is a "scientist of the soul" like the ancient alchemists in whose work he has found much inspiration.

Internationally known as experimental filmmakers because of their five *Film Exercises* of the period 1941–44, James and John Whitney began working separately around 1945. "After the exercises," James recalls, "the structure of my work was external, following pretty close to serial imagery concepts. The intent was a unity of structure which would result in a whole experience. The structure was whole, and naturally it would relate to your own attempts at wholeness: as you were more whole the structures you were dealing with would become more whole. Then after that there was a long period of development in which I tried to make exterior imagery more closely related to the inner. Those early images just weren't relating thoroughly to my own experiences in meditation, for example, where forms are breaking up. So I reduced the structural mode to the dot-pattern, which gives a quality which in India is called the *Akasha,* or ether, a subtle element before creation like the *Breath of Brahma,* the substance that permeates the universe before it begins to break down into the more finite world. That idea as expressed through the dot-pattern was very appealing to me."

Thus in 1950 Whitney began work on his first truly personal film, *Yantra,* an inspired and arduous project, which was to consume ten years before its completion. Drawn entirely by hand on small filing cards, it was an attempt to relate images to Yoga experiences. ". . . A *Yantra* is an instrument designed to curb the psychic forces by concentrating them on a pattern, and in such a way that this pattern becomes reproduced by the worshiper's visualizing power. It is a machine to stimulate inner visualizations, meditations, and experiences . . . when utilized in connection with the practice of Yoga the contents of the *Yantra* diagram represent those stages of con-

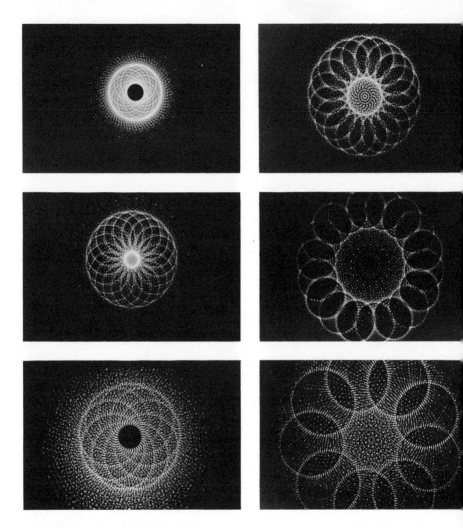

James Whitney: *Lapis.* 1963–66.
16mm. Color. 10 min. "A mandala
that revolves eternally like the
heavens."

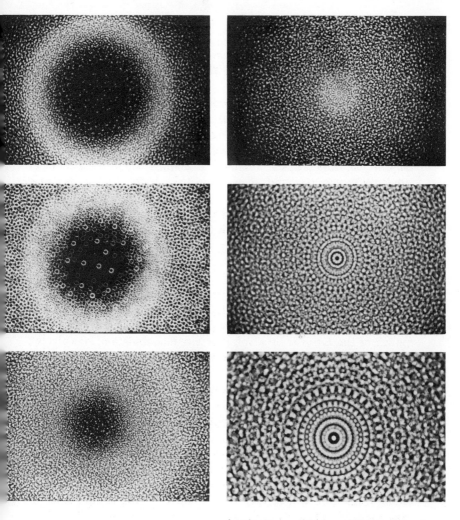

*Lapis:* ". . . they manifest as though out of the air itself, gathering and converging around a central sphere . . . revolving with implacable grace against the eerie drone of the tamboura."

sciousness that lead inward from the everyday state of naïve ignorance through the degrees of Yoga experience to the realization of the Universal Self."[26]

During most of the ten-year period in which James Whitney was laboriously producing the intricate images of *Yantra* by hand, his brother had developed the analogue computer, which could produce images of far greater complexity in a fraction of the time. After *Yantra* was finished the brothers assembled another mechanical analogue computer, and it was on this device that *Lapis* was created.

In general, the term *Lapis* held the same meaning for the ancient alchemists that the mandala holds for the Lamaist, Tantrist, Taoist, Hindu: a kind of "philosopher's stone" or aid to meditation. In alchemical times, and later during the period of the Rosicrucians, the *Lapis* was felt to contain a vital force or mystic power, a center of knowledge. Hermes asserted that the *Lapis* was composed of body, soul, and spirit, ". . . that thing midway between perfect and imperfect bodies." Gnostic philosophy suggests that the way to the power of the *Lapis* is by a spiral or circumambulation, specifically, according to Jung, "a mandala that revolves eternally like the heavens."

Whitney began work on *Lapis* in 1963 and completed it in 1966. Much of this time was consumed, however, in the construction of the analogue computer that programmed the extremely intricate mandala-like structure of the film. Thus cybernetics assisted Whitney to return through the centuries to the ancient practice of syncretism in his search for a more total vision.

The opening sequence of *Lapis* is startlingly beautiful: a pure white frame into which, very slowly, moves a ring of thousands of tiny particles. They manifest as though out of the air itself, gathering and converging around a central sphere of light, gradually tightening, growing more complex, until they become a vast syncretistic mandala of intricate geometrical patterns. These configurations defy definition as they revolve with implacable grace against the eerie drone of a tamboura.

To achieve this effect, Whitney hand-painted glass plates with

[26] Heinrich Zimmer, *Myths and Symbols in Indian Art and Civilization* (Harper Torchbook; New York: Harper & Row, 1946), pp. 141–142.

fields of dot-patterns that began sparsely and collected into high concentration toward the center. These were placed on rotating tables beneath a vertically-mounted camera. The tables spun on their own axes while simultaneously revolving around another axis, and at the same time moving horizontally across camera range.

At first the huge mandala is a monotone beige against a white field, then it becomes a glowing red-orange and crystallizes into thousands of intricate modules, each containing a green floral pattern inside a diamond configuration. Forms take shape and vanish as the whole revolves majestically, its movement accentuated by the sonorous drone of the tamboura. Suddenly the image disintegrates into a loose cloud of red, yellow, and orange particles that solidify into the word *Lapis*. This bursts apart slowly as the first beats of the tabla are heard and a raga begins.

The mandala draws away from the camera until its individual sections are no longer distinguishable from the whole. It dissolves into a blue multispoked mandala in the center of a black void, revolving and spewing out showers of fine sparklike particles that fade and vanish. One seems to detect snowflake crystals, diamonds, molecular clusters—but they're transformed before the mind's eye can grasp their trajectory. Later we see starbursts throwing off showers of light, spinning around dark centers. A repeat of the opening sequence is done in blue and black—thousands of tiny blue particles slowly collecting around a central vortex. For a split second the particles freeze into diamond-like crystals and then melt back into the syncretistic field. A vibrant orange sun shimmers in blackness, surrounded by a corona of concentric rings, each enclosing a peacock floral pattern.

Finally the original beige mandala reappears and spins rapidly through the various configurations we've seen throughout the film. Two translucent globes within a blinding white center begin to stretch apart diagonally across the frame, creating a sense of enormous tension and stress, shimmering, pulsating, until the final blackout. This was Whitney's way of suggesting what he calls "the last breaking or snapping, unable to reach *Samadhi*. That was because *Lapis* was near the end of what I could do. The machine restricted me; my fantasies couldn't flow. Of course we're in the most primitive stages of cybernetic art, but my inner imagery gave

way at the same time that my outer ability to control the instrument broke down."

Whitney finds more than a casual resemblance between Eastern philosophy and modern science, and suggests that this confluence may have a profound effect on conventional notions of art. "Only to a person who has expanded his consciousness," he says, "is ordinary experience expanded. So it's exciting where art is going in this respect. Art and science are getting much closer to Eastern thought. But you'll always find those who seek to go beyond any language. Those are the people whose eyes and ears are really open. But they will come back, and they will be totally open and very sympathetic to what the artist is doing, but they won't have the energy to remain within that confine of art. Artists must in order to create. The other man will see art as the great play and fun that it is, but he won't be able to put that same sort of intensity into it as the artist does. The artist, in a sense, must keep a lot of ignorance. To stay in the world you have to preserve a certain amount of ignorance.

"I certainly do not feel that art is dead. But when you're really involved with the thing you want to experience, you stop conceiving it. Art finally becomes a barrier to accepting what *is*. Art stays within its closed circle and reality never does. Art is all symbols of reality. Symbols are never going to free you. But it would be foolish to say 'Stop making art.' That's not what I'm saying. One should be aware of its limitations, that's all. This must be what they had in mind when they said: 'Thou shalt not create graven images.'"

## The Younger Whitneys: Children of the New Age

"An inadvertent spin-off from technology will transform man into a transcendental being. Nothing we can conceive now will give us a clue to what that spin-off will be. But I suspect that vision will play an important role. The eye will have a lot to do with it."

JOHN WHITNEY, JR.

If the Starchild Embryo of *2001* were to grow up as a human he'd probably feel quite at home with the Whitney brothers. From earliest childhood the future has been their way of life. John, Jr., Michael, and Mark all were born well after World War II. They were raised in an environment of science, technology, the arts,

Eastern philosophy. John Cage, Buckminster Fuller, and Jordan Belson have been their houseguests. Their eyes and ears have been nourished by higher orders of sight and sound than most of us are able to conceive. At eighteen John was filming slit-scan sequences, several years before Stanley Kubrick discovered the technique. "I surpassed Dad when I was about eleven," says John, who built his father's computer camera and wired an analogue computer at an age when most boys find model airplanes challenging.

In 1965 the Whitney living room was transformed into a multiple-projection environment with seven screens and ten projectors mounted on two levels. At that time John was eighteen, Michael was seventeen, and Mark was fourteen. And what were they thinking?

MICHAEL: We were anxious to get away from the limitations of a single screen. Obviously the answer was multiple screens. As very young children we were exposed to the films our father and Jim had made. All of our lives we've been exposed to that kind of non-realist material. We didn't try to interpret them. We just accepted them as films without any other hangups. People call our films "abstract" but they're not. They're concrete films. "Abstract" means to make an abstraction from something concrete, but our films *are* concrete. I can remember when all the other kids in the neighborhood would go to the movies every Saturday afternoon and our parents wouldn't let us go. There was an obvious reason of course: those movies were absolute trash. John and I were thinking in terms of "performance" films: not just one strictly-composed film but multi-images whose relationships could be improvised in real time. You would "play" as you felt. We began to envision encompasing other art forms. We had ideas about cartridge loops and spontaneously interchangeable films. Some system that would make possible a real-time film image composition, being able to change a cartridge so you could compose spontaneously.

Also during this period, while Michael was studying calculus and physics, John was completing his first computer film *Byjina Flores,* a pidgin-Spanish satirical translation of "vagina flowers." Though he

has since disowned this film, it remains a beautiful optical experience, one of the few movies that might stand comparison (in concept if not in fact) to the Op Art of Vasarely or Bridget Riley. John's father had devised a method of scanning an image through a slit, which would guide the phasing relationship between the image and the camera. This was essentially the method used by Doug Trumbull several years later for the Stargate Corridor of *2001*.

In *Byjina Flores,* filamented, fluted panels of neon-bright red, orange, and yellow shift rhythmically across the range of vision to produce weird perspectival illusions and kinetic trajectories. Objects, which seem to be giant walls of lightbulbs, warp, wobble, and dance, alternating colors stroboscopically. The effect approximates a kind of sculpture in time, a kinetic molding of the temporal as well as the optical experience.

JOHN: It was an overall pattern of moiré dots moving with a scanline which guided the phasing between the moiré and the lens. The artwork was trucking horizontally while the zoom was moving in and out to achieve the illusion of curvature, warps, and perspectives. My idea was to work with illusions of color and retinal persistence of images. There's one point where it only slightly works as I intended, so the film becomes a total failure for me. We've hardly begun to scratch the surface of possibilities with the slit-scan. The computerized optical printer I've built will scan consecutive frames of a whole motion-picture sequence. I could've had the whole *2001* setup reduced down to a small panel and scanned it on our computer and come up with the same effect. In the making of *Byjina Flores* and all our analogue films there are parallels with the way one programs a digital system, that is, determining variable values in a system by setting cam rates and directions which are linked differentially to related functions and amplitudes.

From September, 1966, to September, 1967, the brothers staged several multiscreen environmental shows across the country. For a Grateful Dead concert in San Francisco they worked with Tom DeWitt and Scott Bartlett, using eight or nine screens at angles to each other. At the Center for the Study of Democratic Institutions

in Santa Barbara, they staged an environmental presentation using a truckload of equipment including speakers, ten projectors, and dozens of film loops for projection on five screens that they constructed at the site. In 1967 they were given a building on the grounds of the Monterey Pop Festival and trained nine projectors on three screens. A day after the festival closed they were in Aspen, Colorado, showing their work at an international design conference.

By this time John, Jr., had made more than 5,000 feet of computer film out of which came the extraordinarily beautiful, and now famous, triple-screen film that remains untitled (see color plates). It was premiered at Expo '67 in Montreal and later that year was shown at the Museum of Modern Art in New York. The film is a sequential triptych: it develops in time and space, exploring the relationships of both form and color, visual tensions, rhythmic modes, and optical illusions in a way that relates each screen to the other two with flawless exactitude.

It is among the few independently-produced multiple-projection films to justify its own multiplicity. Whereas most multiple projection is gratuitous and arbitrary, the Whitney film is a cohesive whole, each element accentuating and complementing the other two in ways that make the experience incomplete without all three parts. The flanking images are identical, though reversed, so as to frame the center screen symmetrically, and the close synchronization of form and color among the screens demands highly controlled projection conditions.

Like most Whitney films the triple-screen film is set to an East Indian sound track. It begins with circular arrangements of rose stems, the halves of one circle split between the two end screens in burnt sienna, the center screen yellow ochre with a complete but smaller circle of stems revolving at a faster rate than its counterparts. What we are seeing is actually two views of one configuration divided into a triad. As the stems revolve, the colors change from warm yellows to cool violets.

This becomes a vortex display of concentric circles and squares endlessly moving into the frames and diminishing into infinity only to be succeeded by other layers of circles and squares of different colors moving in unison. In this sequence the image split between the two end screens is different from the central image in color, but

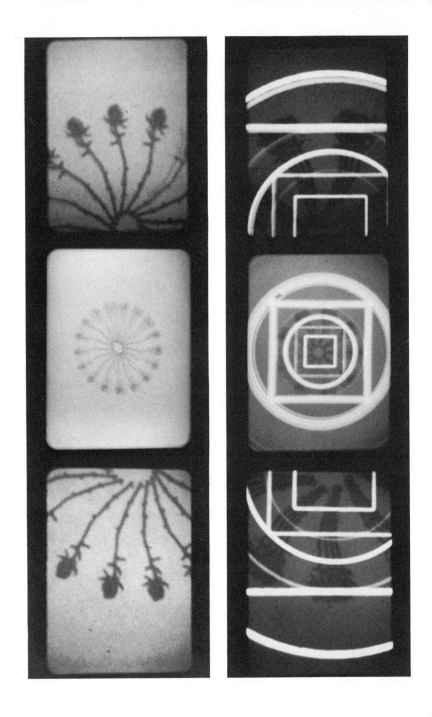

identical in design. Once again, the flanking images are larger than the center image and, moving in precise synchronization, create an optical tension that induces a strong kinetic empathy in the viewer. The colors alternate between cerulean blue, Mars red, rose madder, and black. A sense of tension and vertigo is established through manipulation of form and motion from screen to screen, while simultaneous color changes create their own "narrative" in still another nonverbal dimension.

GENE: What particular aesthetic, if any, did you follow in making this film?

JOHN: When I was eighteen I was drawn deeply into Eastern thought, Jungian psychology, the subconscious. When I think about the time when I made that footage—trying to understand what happened—I became merely an instrumentality in tune with a force, a creative energy force which expressed itself. I was able to make the films without thinking too much about what I was doing. There was just this continuous flow of energy between me, the machine, and the images. But the machine became transparent. I don't think I was conscious of any systematic manipulation or exploration of a geometrical theme, though it is undeniably in the film. I was able to be sort of comprehensive when I was making the images, whereas when I made the machine I had to be a mechanical engineer, an electronics engineer, and an optical engineer.

The relatively rectangular imagery of the previous sequence now becomes a series of ornate, almost baroque, circular forms, floral patterns, and interconnected rings, all moving inward at various rates to vanish as other rings appear, and so on. The colors at this point are extraordinarily florid, ranging the entire spectrum in kaleidoscopic brilliance and mosaic complexity. The images at times

n Whitney, Jr.: Untitled. 1967. 16mm. Triple-projection.
or. 17 min. "A sense of vertigo is established . . . the images at
es resemble gears, flowers, cosmic configurations . . ."
own are two three-screen "frames" from the film.

resemble gears, flowers, cosmic configurations, and dancing optical ellipses.

There is a brief pause and the second portion, or "movement," of the film begins. Throughout this section the center screen explores variations on the square, the circle, and the triangle while the flanking screens run through a dazzling repertoire of optical effects. These include mandala-like configurations around which sweep bright fingers of light in mauve and violet, bouncing curvilinear dish-shapes, starburst clusters, and clocklike metronomes in flawless synchronization with the music. The archetypal mandala symbolism of "squaring the circle" assumes dominance in the final moments of the film as all three screens accelerate in a symphony of color, design, and motion.

Today John and Michael Whitney have become computer programmers, working with digital computers in addition to the computerized, hybridized optical printer and the analogue computer. Like John Stehura, whose work we shall discuss later, Michael Whitney is involved in formulating new computer-language systems specifically for graphics problems. He speaks of "graphic integrity," and of a visual language that would approach the purity and abstraction of music. Like his father and brother, he maintains that such a quantum leap in the manipulation of visual graphics is only now possible because of the digital computer and its unprecedented powers.

One of the first efforts toward this goal is *Binary Bit Patterns*, a dazzling exploration of archetypal geometrical configurations that approaches *déjà vu*. The film was made on a PFR-3 programmable film recorder manufactured by Information International, Inc., in Santa Monica, California. The PFR-3 is a specialized visual sybsystem driven by the Digital Company's small PDP-9 computer. It is a hybridized microfilm plotting system built specifically for reading film into the computer or recording information on motion-picture film. There are 16,000 possible $xy$ coordinate points on the three-inch face of the PFR-3's cathode-ray tube. Produced with a program developed by one of the firm's employees, Michael Whitney's *Binary Bit Patterns* provides a deep emotional experience despite the fact that it has less kinetic activity and less image variation than the films of his brother or father.

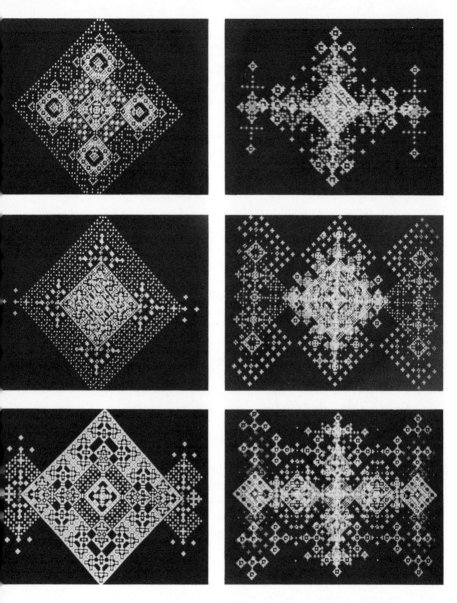

Michael Whitney: *Binary Bit Patterns.*
1969. 16mm. Color. 3 min. "Squadrons
of polyhedral modules come pul-
sating out of a black void . . ."

Perhaps metamorphosis best describes the effect of this film, in which quiltlike tapestries of polyhedral and crystalline figures pulsate and multiply with some kind of universal logic. In effect, if not style, it is reminiscent of Norman McLaren's *Mosaic* and Brakhage's *The horseman, the woman, and the moth*. In the McLaren film, geometrical clusters of dot-patterns collect and multiply with mathematical precision. In *Binary Bit Patterns* there is the same sense of mathematical play although it is not as discrete as the McLaren film; shapes are always permutating into other shapes, and an ornate, almost baroque, visual style softens any mathematical dryness. It resembles the Brakhage film because of its approximation to what Stan calls "closed-eye vision," the patterns we see when our eyes are shut. These ornate snowflake crystals flash and multiply before us with the same kind of ghostlike evasiveness as the colors that flicker across the retina of our mind's eye. Squadrons of polyhedral modules come pulsating out of a black void, growing and multiplying until the screen is a tapestry of intricate, ever-changing image-color fields. The impact is enhanced considerably by an extraordinary guitar-tape composition by Whitney and Charles Villiers. Michael not only talks about music, he composes and plays it on acoustical and electric guitars. As with Belson's work, it is difficult to distinguish whether one is seeing, hearing, or feeling *Binary Bit Patterns*.

Even without sound, however, the film is extraordinarily hypnotic. The boys speak of such imagery as possibly developing into a kind of "kinetic wallpaper," which could be rear-projected onto the translucent walls of a room at close range in ultra-high resolution using large format film and special lenses. One would live in a home whose very walls were alive with silent kinetic activity—not the shallow flickering of present-day color organs but rather "visual music" of the highest graphic integrity and psychic relevance.

GENE: Do you think of the future in connection with computers?

JOHN: Well let's divorce the future from technology and talk about human values. I see the nature of things today in the world and there seems to be a strong force of discontent and evil. And I wonder how can there not be some counterbalancing force, something that can apply itself to the spirit of man? And I begin to

The Whitney brothers. *Left to right:* John, Jr., Mark, Michael. Photo: Gene Youngblood.

think about what is the meaning of the film work I'm doing? I believe it's possible that an inadvertent spin-off from technology will transform man into a transcendental being. There isn't much we can conceive now that can give us a clue to how it will come about. But I suspect that vision will play an important role. The eye will have a lot to do with it. It could conceivably be some external thing, which metaphysically will affect the mind and cause some transcendental experience. So with that in mind I've been thinking of ways to integrate the realist image into the nonobjective image so that a synthesis will evolve, a cinematic experience which might contribute to an evolutionary transformation of man's thought processes.

MICHAEL: It's very effective to use a realist image for its nonobjective values. You're using it for its form, and if the form happens to be human it's evocative and easily digested. The whole idea is to work with the imagery and to develop total and complete control through structuring, once you have the ability to control the prob-

lems with the equipment. Man has not yet learned to master tools that will express as much eloquence and latitude as his imagination.

JOHN: I'm not suggesting that the films as we know them today will be the releasing force. We don't know how to integrate realist and nonobjective images effectively yet. But I think our computerized optical printer will help show the way. The use of the realist image is just a basis, a starting point. Working with optical scanning you transform the images, and this seems to be a key to bringing nonobjective and realist imagery together. And why bring them together? Because it may lead to new insights and new experience.

GENE: What sort of new experience?

JOHN: Well of course I don't know. But I've been thinking about dreams. Why is it difficult for a person to understand his own dreams? Why don't people know what their dreams are telling them? Why does a person have to go to someone else—an analyst—to know about his own personal dreams, which someone else can't possibly understand? Why don't dreams reveal themselves to us naturally as part of daily experience? Now maybe this "new experience" I'm wondering about will be the point in evolution when man reaches that level of sophistication as a sentient being. I believe the analyst is serving a function now which won't be needed in the future. Everything we know now in the "rational" world will be subsumed in the new knowledge or wisdom of the future. I think parapsychology, extrasensory perception, and related phenomena certainly cannot be ignored as possibilities. So in terms of our film work, the only way it may have some relevance to future consciousness is through problems of formal design. Not the technical things we're doing, just the design problems. In other words, sparking an inner revolution through exterior manipulation. The high state we achieve through LSD or marijuana today is insightful to the extent that it may be similar to what man will feel on a daily basis in the future without exterior manipulation. This state has already happened in the East—not in the Occident because it's not part of our heritage—but it has happened with the Yogis and so on, and it's coming to the West through technology.

GENE: Perhaps this simultaneous awareness of inner and outer space is the beginning of that new experience you're talking about, John. A new attitude toward experience.

JOHN: And space. And time. And motion. And the speed of light.

GENE: The Uncertainty Principle becoming a certainty.

JOHN: So I've built this machine, which will be the cohesive force in our future work. We're amassing film. The machine will bring it all together and also will generate its own imagery. It's the beginning of an application of technology to an area where it's never been applied. Bringing together a whole number of disciplines. So, as sources of imagery we have the printer itself, we have the analogue computer, we have live-action films—which is where our brother Mark is proving very effective, as a person able to go out into the world and get something meaningful on film. And then Michael who, from his studies in physics and calculus, has some exciting ideas of ways to use a digital computer with images.

## John Stehura: The Aesthetics of Machine Language

"Studying computer language leads the artist back to the paintbrush—but a computerized paintbrush."

John Stehura's spectacular film *Cybernetik 5.3* (see color plates) combines computer graphics with organic live-action photography to create a new reality, a Third World Reality, that is both haunting and extraordinarily beautiful. *Cybernetik* makes use of realist imagery for its nonobjective qualities and thus impinges directly upon the emotions more successfully than any computer film discussed in this book.

However, Stehura considers the film only an "incidental test" in an ongoing experiment with computer graphics that has occupied most of his time for the last nine years. Like Michael Whitney, Stehura is interested in addressing the computer directly through graphic images rather than using mathematics to achieve graphics and thus becoming enmeshed in a "number game."

*Cybernetik* is unique also in that it was constructed fom semi-random image-generation techniques similar to Michael Noll's *Gaussian-Quadratic* figures. Whereas most of the computer films

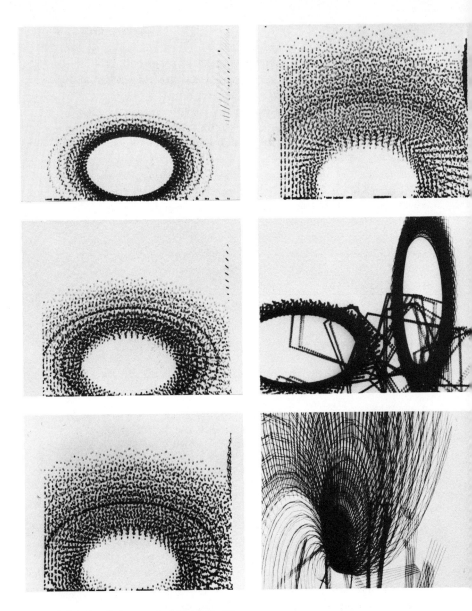

John Stehura: *Cybernetik 5.3.* 1965–69.
16mm. Color. 8 min. A series of basic
image forms before the addition of
color, showing random character of
permutations.

discussed so far are characterized by mathematical precision, *Cybernetik* exudes a strong feeling for the uncontrolled, the uncontrollable, the inconceivable.

Stehura began studying computer programming at UCLA in 1961 when he was eighteen years old. He became quite conversant with computer languages and in 1965 programmed the first images that were to become the film *Cybernetik 5.3* in its completed version some four years later. It is the only computer film Stehura has produced so far, having spent most of his time developing a special "metalanguage," which he calls "Model Eight," designed specifically for modeling computer music and graphics systems.

*Cybernetik* originally was to have a computer sound track generated by the same program, but Stehura found the directly corresponding track inappropriate and later set the film to Tod Dockstader's *Quatermass,* a chilling otherworldly suite of organized electronic sound by one of America's least-known but most unusual artists. The result is a film strongly reminiscent of *2001* in the sense that it creates an overwhelming atmosphere of some mysterious, transcendental intelligence at work in the universe.

Throughout the film, complex clusters of geometrical forms and lines whirl, spin, and fly in three-dimensional space. Showers of parallel lines come streaking out of infinity. Crescents and semicircles develop dangling appendages and then expand until they no longer exist. Whirling isometric skeletal structures permutate into quadrant figures, polygons, rotating multiple-axis tetrahedrons, expanding fanlike disks, and endless coils.

These images are neon-bright in alternating blue, red, orange, and green. They vibrate rapidly as they take shape and disintegrate. The staccato, spiraling, buzzing rumble of Dockstader's sound complements the kinetic activity with its own sense of acoustical space. This storm of geometrical fantasy is superimposed over a star-spangled image of the solar system in emerald green.

STEHURA: I programmed *Cybernetik* in Fortran, and specified about twenty fields so that images would metamorphose into other orders of design. In writing the program I defined a "field" as a point in space having a certain effect on anything entering its area. For example, the sun is a field. That was the basic idea. I made them very specific. I said when the image gets near this

mathematical point it will either get brighter, or darker, or be altered in such and such a way, like enlarge, or burst into points, or diminish into infinity. So that's the reason for the randomness. When the images go into the metamorphosing fields, their mathematical order, while specified, becomes too complex and appears to be random. Once all the rules in the program were specified, I simply turned it on to see what would happen. If I liked the results, I'd leave it. At one point I tried to trace back how the computer generated certain forms but it was becoming too complex and pointless.

GENE: How were the color separations and superimpositions programmed?

JOHN: The basic imagery was computed on an IBM 7094 digital computer at UCLA before we had any type of on-line graphic display equipment. So I ran the computer for seven or eight hours and took the digital tapes to General Dynamics in San Diego where they had a Stromberg-Carlson 4020 Microfilm Plotter. Initially I specified how many movies I wanted and how long I wanted each one to be. The program indirectly specified color based on the form or position of a figure. The output went onto three plot tapes which were converted into three pieces of black-and-white film. These pieces were used to mask primary colors in a contact printer. There was a piece of black-and-white film to represent the color red, a piece to represent the color green, and one for blue. Then I processed that footage with the contact printer for the colors specified.

A fascinating aspect of this film is that it traps the viewer into expecting mathematically logical transformations by developing in that manner for several minutes, and suddenly the forms explode or behave quite unpredictably. Once this effect has been fully explored, the solar system fades into a fish-eye image of people's faces and other representational imagery distorted, however, almost to the point of nonobjectivity. This sequence is printed in high-contrast, bas-relief positive-negative color reversals, in the manner of Pat O'Neill's 7362. In addition, the images are speeded so that a frenetic, visually distorted atmosphere is generated, suggesting extraterrestrial creatures or anthropomorphic entities. The whirling

multicolored geometrical images move across this bizarre background as though one were peering into a new dimension of existence. Dockstader's organized sound reaches a crescendo of chaotic dissonance as the final images of the film fade and disintegrate into nothingness. The sense of dynamic kinetic activity has been so powerful that this abrupt halt leaves the viewer suspended and breathless.

STEHURA: In writing programs in computer languages such as Fortran I've worked with about five parameterized models with which you can specify designs numerically. One is the "mosaic" scheme, which is the style developed for the Beflix language. You're building things with squares. Your basic figure is the square and you're building patterns and shading things with squares. The result is a mosaic pattern with chains of alternatives. The second scheme is the field model which I used for *Cybernetik*, in which you set objects or points in space and by controlling the strength of fields you produce image forms. A third scheme is a mathematical model of your arm as it would be used to draw figures. You define angles, specify arcs and curves, and work within those parameters. The fourth scheme I worked with is based on the deflection principle. Your mathematical model is patterned after a room or enclosure into which a ball is fired at high speed, bouncing from wall to wall. You plot paths of the trajectories, angles of deflection, distances traveled, the shape of the environment in which the projectile is moving. All this is simulated mathematically and was interesting because it presented form as the space between objects or containers. Finally there's the scheme I call "masking," which is similar to the idea of mattes in conventional filmmaking. The basic idea here is that you don't have a positive figure you're drawing, but you have masks or shapes which hold back light. You define a form and its motion, and you use that form to contain or exclude another image. It's like a cutout or translucency. You can treat computer graphics in that way.

GENE: Where has all this experimentation led you in terms of using the computer as an artistic tool?

JOHN: I discovered that working with program languages to pro-

duce graphics is rather hopeless. They're really designed for playing with numbers. A general problem with computer languages is that you get into simulating reality. That's the trip physicists and meteorologists are into. It's close to their way of thinking and their problems, but I think it's a waste of time in computer graphics or music. My explorations in computer language led me back to conventional animation, back to the paintbrush—a computerized paintbrush. So the next level, after playing with these language or parameter systems, was to establish another level of control over the computer. The idea of building a metasystem or a control system to control control systems appeared very interesting to me. So over the last four years I've developed a metalanguage which I call "Model Eight" since it's the eighth approach to these systems. It consists of a set of operators to work on one-, two-, or three-dimensional patterns: sensory patterns, music, drawings, motion, and so on. It's not a computer language which is operated one point at a time, but rather functions nonsequentially on large blocks of data. My idea was to develop a language which would synthesize all the schemes I mentioned earlier so that, for instance, in terms of work involved, whereas it took a couple of years to devise "Model 5.3" to make *Cybernetik*, my feeling was that it could be done in a couple of hours.

GENE: What sort of input-output situations are involved?

JOHN: Well, the two input systems I've found most advantageous are the optical-scanner and the light pen, drawing directly on the CRT. I have three modes of operation with the scanner: first, a point-by-point scan like a television scan starting at one corner and moving across, and you get a list of intensities which describe a picture, or just certain areas or colors. You can label it and manipulate the whole thing or just that part. Second is an *isoline* type of scan, which is what you see in weather maps: circles within circles which indicate certain degrees of intensity and so on. Then, third, there's the situation in which you start out with an isoline approach but produce lines which fill certain areas, and that output can appear on the CRT or be further modified.

GENE: What about drawing with the light pen? I understand that some artists, like Norman McLaren, have found this rather unsatisfactory.

JOHN: Well, the light pen is a crude drawing instrument, it's true. You can't do many subtle things, the resolution is low, and the way you operate you're always stopping, waiting for "INTER-RUPT," for the computer to accept your line, or the accuracy always seems to be off, but it does have certain advantages related to large-volume image production. One of them is that you can input information that's more specific to the way the computer's operating. You put in a point or a line at a time, and by remembering what you're doing you can control a lot of image transformations. Representational forms are almost impossible to program with computer languages, and are extremely difficult for a computer to process. But by taking the alternate route, by drawing representational forms with the light pen you've given the computer graphic information which can be simply trans-formed according to simple motion and shading procedures. If you want to draw a dragon, for example, and have it transformed into a person, you simply draw the head and type in "HEAD" and then you draw the head of the man and label it "HEAD" and the computer operates on it to do the transformation. You can label portions as you draw to control the flow of the transforma-tion. You can transform anything you can draw into anything else. And in this way you bypass much of computer language specification.

GENE: What relationship does "Model Eight" have to all this? What is the control situation?

JOHN: Drawing is a specific operation just as scanning or projec-tions. With the language aspect you can specify a fish-eye projec-tion or a projection on a certain plane and you supply the parameters. Now, after I've passed an image through a simulated fish-eye projection, what I want to do is start shading the forms in a different style. So you could call on a surfacing operator which will fill in your image with colors or mosaics. Now, my language isn't fixed. One "word" doesn't mean one fixed thing in one fixed context. For example, you have a mathematical model of an arm movement and you tell the computer to swing the arm in a 360-degree arc to define a circle. The basis of this operation is a sine wave to produce the smooth circular form. The fact that you have a sine wave is specified, even if by default. The output of this

operation is a circle, a set of points. And as far as I'm concerned it's a wave form just as legitimate as the sine wave. So you could run this form back into the same particular operator and tell the computer to use this form—not the sine or cosine, but this form it has just described. The same recursive form applies to the other operations. For instance, you could take projections of projections, use an object as an element to shade a surface and so on.

## Stan VanDerBeek: Mosaics of the Mind

"We're just fooling around on the outer edges of our own sensibilities. The new technologies will open higher levels of psychic communication and neurological referencing."

For the last five years Stan VanDerBeek has been working simultaneously with live-action and animated films, single and multiple-projection formats, intermedia events, video experiments, and computer graphics. Clearly a Renaissance Man, VanDerBeek has been a vital force in the convergence of art and technology, displaying a visionary's insight into the cultural and psychological implications of the Paleocybernetic Age.

VanDerBeek has produced approximately ten computer films in collaboration with Kenneth Knowlton of Bell Telephone Laboratories in New Jersey. They are descriptively titled *Poem Fields, One* through *Eight*, plus *Collisdeoscope* and a tenth film unfinished as of this writing. The term *Poem Field* indicates the visual effect of the mosaic picture system called Beflix (derived from "Bell Flicks") written by Knowlton. A high-level set of macro-instructions was first written in Fortran. The particular translation or definition of this language for each film is then determined by the subroutine system of mosaic composition called Beflix. A new set of Beflix punch cards is fed into the Fortran-primed computer (an IBM 7094 interfaced with an SC-4020 microfilm plotter) for each new movie desired.

Whereas most other digital computer films are characterized by linear trajectile figures moving dynamically in simulated three-dimensional space, the VanDerBeek-Knowlton *Poem Fields* are complex, syncretistic two-dimensional tapestries of geometrical configurations in mosaic patterns. "The mind is a computer," says

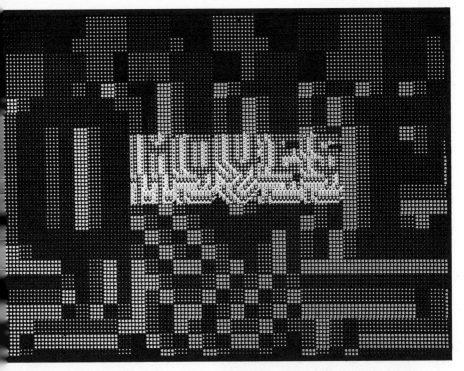

Computer interpretation of the word
"movies," from a film by Stan VanDerBeek
and Kenneth C. Knowlton.

VanDerBeek, "not railroad tracks. Human intelligence functions on
the order of a hundred-thousand decisions per second." It appears
this brain capacity was a prime motive in the production of the
*Poem Fields,* whose micro-patterns seem to permutate in a constant
process of metamorphosis which could very likely include a hun-
dred-thousand minuscule changes each second.

"The present state of design of graphics display systems," Van-
DerBeek explains, "is to integrate small points of light turned on or
off at high speeds. A picture is 'resolved' from the mosaic points of
light." The artist seems to feel that this process bears some physiog-
nomic similarities to human perception. "The eye," he notes, "is a
mosaic of rods and cones."

Variations of the Beflix technique of mosaic
image-making, from computer films by Stan
VanDerBeek and Kenneth C. Knowlton.

The early *Poem Fields* were investigations of calligraphic relationships between dogs and alphabetic characters integrated into fields of geometrical patterns constantly evolving into new forms. The most famous of these is *Man and His World* ( 1967 ), a title piece for an exhibit at Expo '67.

Variations on the mosaic field became more complex with successive experiments, until simulated three-dimensional depth was achieved in the form of infinitely-repeated modular units in perspective. It is immediately obvious that these films would be prohibitively tedious and time-consuming to do through conventional animation techniques. "Because of their high speeds of calculation and display," writes Knowlton, "the computer and automatic film recorder make feasible the production of some kinds of films that previously would have been far too expensive or difficult. In addition, the speed, ease, and economy of computer animation permit the moviemaker to take several tries at a scene—producing a whole family of film clips—from which he chooses the most appealing result, a luxury never before possible."[27]

The more recent Beflix films have abandoned the original calligraphic patterns for highly complex Rorschach constellations of stunning beauty. They actually began with a film produced by two other scientists at Bell Telephone, B. Julesz and C. Bosche, for use in experiments with human vision and perception. This involved semirandom generation of graphic "noise," whose patterns were reflected several times to produce intricate mandala grids resembling Persian carpets and snowflake crystals.

"We're now working with variations on the Beflix system that involves secondary systems," VanDerBeek explained. "It goes through two levels: first Beflix, then computerizing and quantizing that level. It's something similar to what Ken Knowlton and Leon Harmon did with pictures-within-pictures. We're trying to do that cinematically."

The *Poem Fields* are filmed in black-and-white, with color added later through a special optical process that permits color gradations and increments almost as complex as the forms themselves.

[27] Kenneth C. Knowlton, "Computer Animated Movies," *Cybernetic Serendipity,* a special issue of *Studio International,* ed. Jasia Reichardt (London, September, 1968), pp. 67–68.

## Peter Kamnitzer: Pre-Experiencing Alternative Futures

"We would like to put the researcher, designer, decision-maker or the public at large in an environment where they could be exposed to what various futures may look like. We will do this with computer simulation, which I believe will trigger the next creative leap in the human brain."

So far we have restricted our discussion to the computers and computer output subsystems most likely to be accessible to the filmmaker with luck. Furthermore we have been concerned primarily with purely aesthetic applications of these techniques, or what I like to call "computer art for the computer's sake." The limitations of these systems should be obvious by now.

We have seen that in order to obtain computerized representational imagery it is necessary in most cases to begin with some sort of representational input (physical scale models or photographs, etc.), which are then scanned or translated by the computer through optical-pickup devices, servo-driven television cameras or film-storage systems. In fact the most spectacular films discussed so far—*Lapis, Cybernetik 5.3, Permutations,* and the Whitney triple-screen film—were heavily augmented through conventional film-processing techniques.

Furthermore, the impact of these films is wholly visual or experiential, with conceptual appreciation of the computer's role reduced to a minimum. If we can say that a conventional film is "cinematic" only to the extent that it does not rely on elements of literature or theatre, we must therefore say that a computer film is not fully "computerized" until it is relatively free from conventional film-making techniques.

With this in mind we might better appreciate Peter Kamnitzer's *City-Scape,* a film in which no representational imagery existed before it was produced by the computer. The computer drew the city strictly from coded mathematical input in the same way that the Whitneys' geometrical forms are generated from polar equations. The software and hardware requirements to achieve this, however, are extremely sophisticated and expensive. Viewed merely as an animated film, *City-Scape* leaves much to be desired. Compared to *Yellow Submarine,* for example, it is like the earliest tintype compared to laser holography—on a purely visual level, that

Peter Kamnitzer: *City-Scape.* 1968.
16mm. Color. 10 min. Made at the
Guidance and Control Division of
NASA's Manned Spacecraft Center,
Houston, Texas. Four views of the
imaginary city.

is. But *City-Scape* is deceptive. First of all, it is not an animated film in the sense that most of the computer films we've been discussing are animated. The color CRT display, produced through electron-scanning similar to conventional television, was recorded on color movie film in real-time, on-line operation.

The $2,000,000 computer, NASA II, and its visual simulation subsystem was developed by General Electric for the Guidance and Control Division of NASA's Manned Spacecraft Center in Houston. It has been used for more than ten years to simulate conditions of lunar landings. Kamnitzer, head of the Urban Laboratory at the University of California at Los Angeles, collaborated with GE and NASA for nearly two years to convert the equipment into a tool that also would allow pre-experiencing of possible environmental situations here on earth.

It is rather unlikely that any filmmaker will have access to such sophisticated equipment for aesthetic purposes only. However, as we have seen, the notion of "art" increasingly includes ultrasensitive judgments as to the uses of technology and scientific information. Consciously or unconsciously, we invent the future. And all futures are conditional on a present that is conditioned by the past. One way to be free of past conditioning is to simulate alternative futures through the fail-safe power of the digital computer. This is "art" at the highest level ever known to man, quite literally the creation of a new world imperceptibly gaining on reality—but not so imperceptibly as before.

A film like *City-Scape* adds still another dimension to the obsolescence of fiction. Whereas Stan Brakhage transcends fiction through mythopoeic manipulation of unstylized reality, Kamnitzer creates not myths but facts—obscuring the boundaries between life and art with a scientific finality unequaled in subjective art. Optimum-probability computerized visual simulation of future environments is not limited to economic, social, or political motivations. The possibilities for purely aesthetic exploration are revolutionary and have yet to be attempted. *City-Scape* is the first step toward that future time in which artists not only will be the acknowledged legislators of mankind but literally will determine the meaning of the word "man."

In programming *City-Scape* Kamnitzer was limited to two hun-

dred and forty edges, or points where tangential planes intersect. Since an architectural edifice normally has only twelve edges, the city could have only twenty edifices. However, rather than having only square boxes, Kamnitzer programmed vertical pilasters and horizontal lines to generate a sense of scale per floor. The necessity of at least two freeways and one tunnel reduced the city to approximately five or six buildings. This information was input to the computer not as a drawing to be scanned, but as mathematical equations of perspectives describing the transformation of a numerical model of a three-dimensional environment onto a two-dimensional display or image plane.

The real-time solution of these equations produced a color CRT display with six degrees of freedom, unlimited dynamic range, true perspective, controlled color and brightness, and infinite depth of focus. With three simple control mechanisms Kamnitzer, seated before the twenty-one-inch screen, was able to: (1) stop and start the forward motion of the "vehicle" moving through the city; (2) control the direction of movement over and under bridges, through tunnels, around corners, etc.; and (3) control visual direction so that, while the vehicle may be moving north the "driver" may look northeast, south, or in any direction without affecting his forward motion.

Because the environment is stored digitally in the computer's memory a true "environmental" sense is created. That is, the operator-driver may move into the city and, after passing one or two structures, may decide to turn around and view what in effect has been "behind" him or otherwise out of range of the CRT display. This is done instantly, with the operator manipulating a lever as the CRT draws a new perspective in color every twentieth of a second. In addition, the operator-driver may enter closed spaces, fly into the air, and pass or "crash" through environment surfaces—without damage, of course, because the crash is only simulated.

Although *City-Scape* is a color film we have not used color illustrations for two reasons. First, the color is not intended as an experience in itself, an exploration of color effects as in *Cybernetik* or the Whitney films, but rather as a means of distinguishing the structures within the city—i.e., the yellow freeway, the blue freeway, the green mall, the gray building, etc. Second, as we already

have noted, a great deal of image quality is lost when color television displays are recorded on color film; the result is a pale washed-out image neither so brilliant as the original phosphor, nor so intense as optically-printed color.

As the film begins we are rushing toward the city's skyline against the horizon surrounded by a vast green plain. Once into the city, various types of movement and positions are simulated: circling around the central mall area, driving up freeway ramps and along freeways, riding up and down in an outdoor glass elevator, walking down corridors of buildings, looking out windows, flying above the city in a helicopter that takes off and lands from a skyscraper heliport, the simulation of a drunk driver and his crash into a swimming pool, and finally moving through a solid mass, which the computer translates as a tunnel-like experience.

Only a few minutes have passed before a strong sense of location and environment is created, and the viewer begins to remember positions of structures not on the screen. One actually begins to feel "surrounded" by this city, though viewing it as if through a porthole. The true three-point perspective invests the image with a sense of actuality even stronger than in some conventional live-action films. Kamnitzer relates: "The on-line experience, the sense of power of sitting at the controls, is something very hard to describe. You are turned on. You are involved." It is an extremely close interaction between man and machine. The drunk-driving sequence —in which the "vehicle" swerves and careens through streets before plunging into an empty swimming pool—was done specifically to illustrate the immediacy and plasticity of the computer's reaction to the instructions of the operator.

Kamnitzer considers *City-Scape* a documentary of the possibilities that now exist for an Urban Simulation Laboratory. The concept is, in the absence of an ability to experiment with real people in real cities, to create a simulated environment in which people can pre-experience alternative futures. Kamnitzer's method incorporates the use of conventional mathematical models, man-gaming or operational gaming to simulate the decision environment, and the computed visual simulation subsystem to formulate what Kamnitzer calls "the total question of *if then*, the key to all decision-making."

The metalanguage that Kamnitzer has designed to facilitate this activity is called Intuval, derived from intuition and evaluation. Professor Kamnitzer considers Intuval to be an "answer" to the optimization attitude toward the computer. "What we are doing," he says, "is very different from people who want to use the computer to optimize for them and thereby the computer provides the answers. I am using the visual simulation subsystem to trigger the next creative leap in the human brain, and therefore I consider my approach very different from the usual rush into data banks and optimization. If used in an experientially meaningful manner the computer can provoke the next creative leap, while in my opinion the reading of charts, books, monographs, and statistics does not lead to a creative advancement. Books are being written every day, the libraries are full, the data banks are going to burst, but the decision-maker does not have access to this information when he needs it, in a form that is meaningful to him at this moment.

"I make the outrageous claim that creative innovation can only come from gut knowledge. It cannot come from something that remains purely in the cerebral area. I would even go so far as to say that what we are unable to explain to an intelligent thirteen-year-old, we do not know. So this leads to on-line visual displays and the total question of *if then,* the key to all decision-making. Now I can get information in graphic form of course, but then comes the moment when I want to know *if then.* If I should decide to choose alternate 'B' then these and these and these things will happen. But what if I had chosen alternate 'G'? And so on. So you see the intuitive approach has suffered badly in the past because of its lack of instant evaluation of what is strong and weak in your intuition. The Intuval system I've devised provides the designer or researcher with this instant evaluation. It is not simply a visualizing and pre-experiencing tool.

"It works in the following manner. First we have a hunch or an intuitive idea and we create an environment. Next, through the visual simulation subsystem we experience this environment both from the viewpoint of the designer and the user. And of course we will discover weak points and strong points in the environment so, with the stroke of a light pen, we can change it. We find out where the weakest spots are, we ask the computer to provide the param-

eters which define this weakest link, we will be shown graphically, then we will change the design and get a second evaluation, which now hopefully will have improved that factor, but we may have lost in another factor. We then again inquire what are the parameters which determine this weakness and so on, evolving into an interactive process.

"There are people who have built fascinating mathematical models, people who do man-gaming and operational gaming, people who experiment with physical-environment simulation in domes and so on, but I do not know of any attempt to bring these disciplines together in an Urban Simulation Laboratory to pre-experience alternative futures and even to pre-experience the interaction of human beings in a future environment. In this way we can be exposed to what various futures may look like, feel like, and also what they would cost economically, socially, psychologically, and every other way.

"Now for *City-Scape* I was limited to 240 edges. We now realize that with another few million dollars next time we could increase the number of edges from 240 to 1500, and we also could create textures which could, for example, give you the equivalent of a glass wall on a building which would not come out of the 1500 edges. We will also have the ability to collect all 1500 edges in front of the viewer at all times, having no 'invisible' or off-screen edges as in *City-Scape*. This would enhance the realistic detail of the simulation. Finally we will have hemispherical projection inside a globe, with real people interacting with the computed environmental situation. This is a long way off, but I've made it my life's work. We have Intuval, we have *City-Scape,* we have NASA II. It's a beginning."

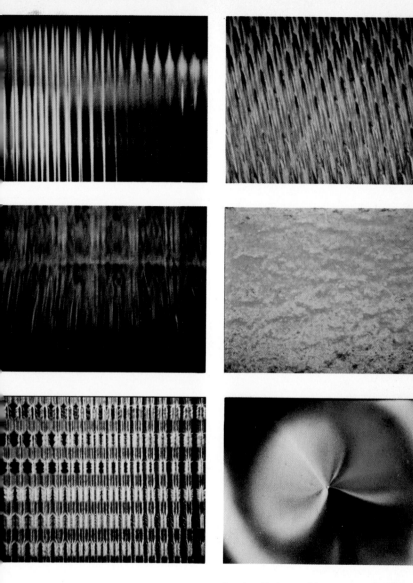

Jordan Belson: *Phenomena.* 1965.
16mm. Color. 6 min. ". . . As though
you were approaching earth as a god,
from cosmic consciousness. You see
the same things but with completely
different meaning." (See page 167.)

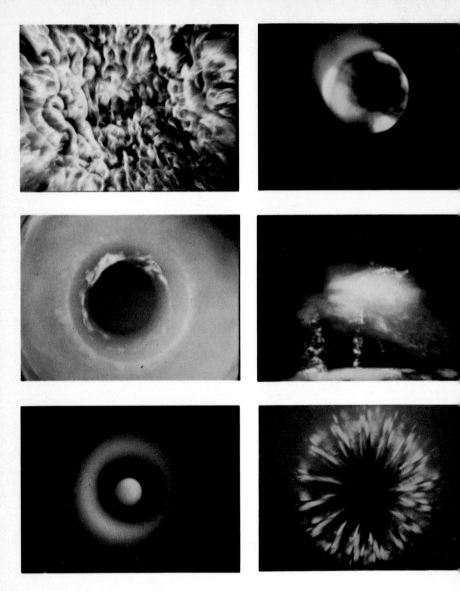

Jordan Belson: (*Left column*) *Samadhi*. 1967.
16mm. Color. 6 min. (*Right column*) *Momentum*.
16mm. Color. 6 min. "I first have to see
the images somewhere: within or without or
somewhere. I mean I don't make them up  . . .
in a sense everything I've learned in life
has been through my efforts to find out what
these things mean." (See pages 171, 176.)

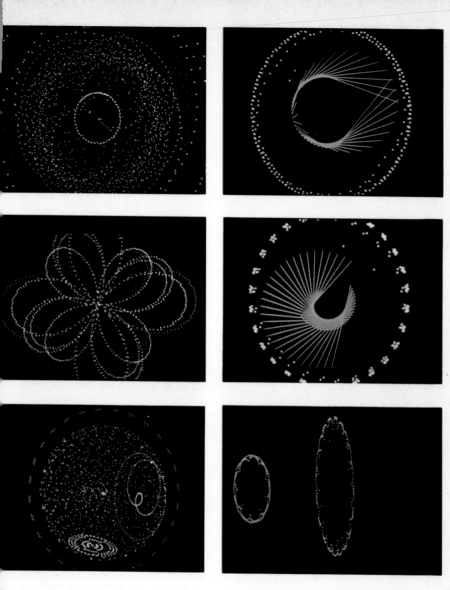

John Whitney: *Permutations.* 1967. 16mm. Color. 8 min. "The parallel is with counterpoint or polyphonic musical phenomena. Should it be called polygraphic phenomena?" (See page 215.)

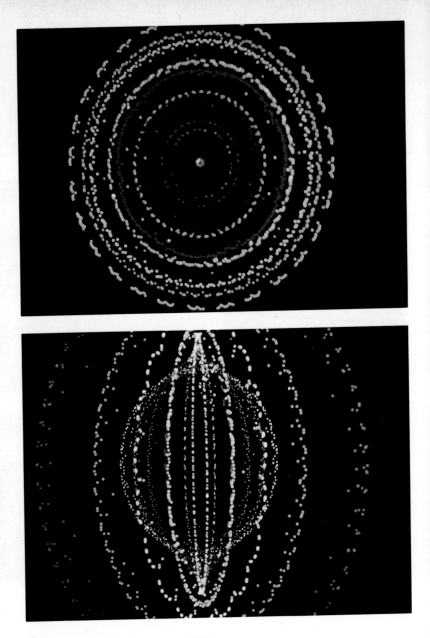

John Whitney: Permutations. 1967.
16mm. Color. 8 min. "So I ask myself
what can be essentially the image of
time for the eye to perceive?" (See
page 215.)

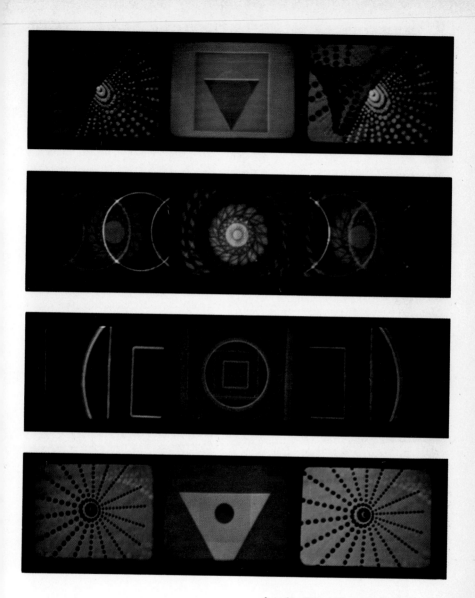

A selection of images from John Whitney, Jr.'s, triple-projection computer film. 1967. 16mm. Color. 17 min. (See page 231.)

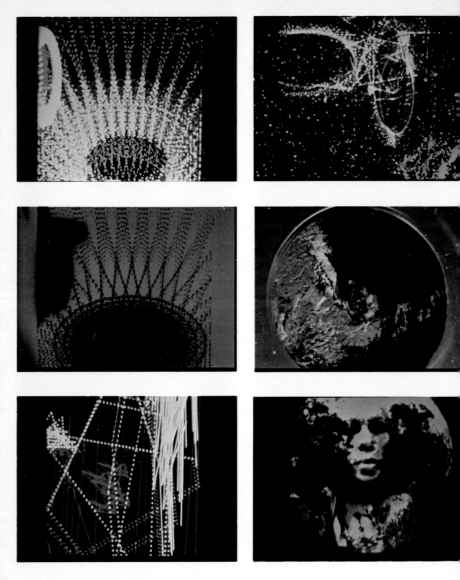

John Stehura: *Cybernetik 5.3*. 1965–69.
16mm. Color. 8 min. "It creates an
overwhelming atmosphere of some
mysterious transcendental intelligence
at work in the universe . . . as though
one were peering into a new dimension
of existence." (See page 239.)

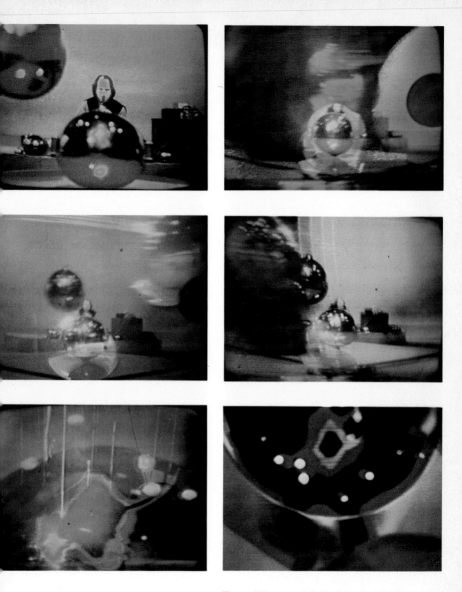

Terry Riley and Arlo Acton: *Music With Balls.* 1969. Hi-Band Color VTR. 15 ips. 23 min. "A rich mantra of color, sound, and motion . . . phantasmagoric convolutions of spatial dimensions." (See page 293.)

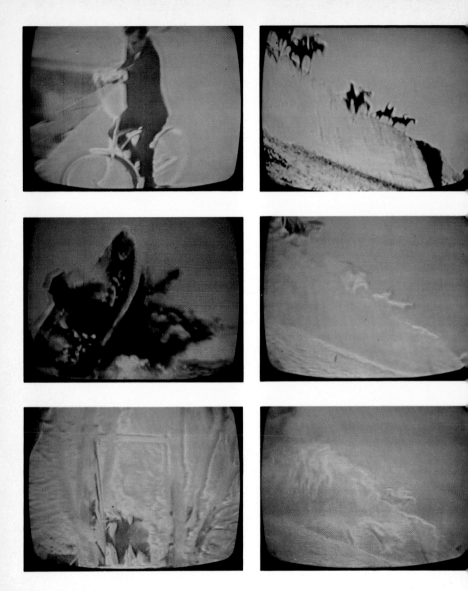

Philip Makanna: *The Empire of Things.* 1969. Hi-Band Color VTR. 15 ips. 20 min. "Haikuesque impressions of things observed, events remembered, nightmares experienced . . . the sky bursts in spectral madness." (See page 295.)

James Seawright: *Capriccio for TV*. 1969. Hi-Band Color VTR. 15 ips. 5 min. "It was possible to see two images of the same figure performing the same action at different stages in different colors." (See page 301.)

Three experiments with the color cathode tube by Korean artist Nam June Paik. "It's so cool," he says. "It's like going to the moon." Photos: Paul Wilson. (See page 303.)

Scott Bartlett: *OFFON*. 1967. VTR/
16mm. film. Color. 10 min. Spectral
breakdown and videographic
metamorphosis. (See page 318.)

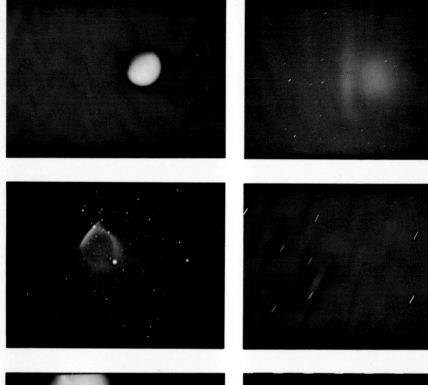

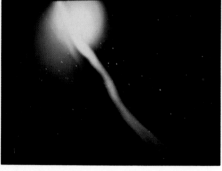

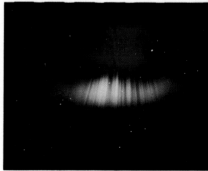

Clouds of barium atoms released by rockets at high altitudes are ionized by solar radiation. They then interact with electromagnetic force fields around the earth. Several artists have proposed similar projects to generate hemispherical lumia displays. Photo: courtesy of the Max Planck Institute for Physics and Astrophysics, Munich, West Germany. (See page 348.)

# PART FIVE:
# TELEVISION AS A CREATIVE MEDIUM

"Art has operated in the gap between what we know and what we dream. The gap is closing quickly: what we dream is often what we see. Television will serve to bridge the gap and to guide the way toward a more successful environment. The eyes replace the me's and we arrive at a condition where what we show becomes what we say."

EDWIN SCHLOSSBERG

On July 20, 1969, approximately 400 million world people watched the same Warhol movie at the same time. As iconographic imagery goes there's no appreciable difference between four hours of *Empire* and four hours of *LM*. There even were similar hallucinations of redundancy in our sustained hot cognition of NASA's primary structure. The bit-capacity of that Minimal hard-edge picture plane without gray scale was really amazing. We were getting a lot of information in dragtime across space-time. And they called it *Tranquillity*.

The first moon landing was the first global holiday in history. They even mounted the camera at an Orson Welles heroic low angle to catch Beautiful Buzz Armstrong the Archetypal Spaceman coming down the ladder to recite his historical speech: ". . . one giant step for mankind." But few commentators remarked, then or later, that mankind hadn't moved an inch. No one said how really convenient it was to sit there in your home, looking directly at the moon dust, listening simultaneously to four or five conversations separated by a quarter-million miles, getting metabolic information about the Buzz Armstrongs in a closed-circuit loop that extended humanity's total brain-eye out around the moon and back. Who needs telepathy?

The growth of television has been phenomenal. In 1948 approximately 200,000 American homes had television sets and 15 television stations were broadcasting regularly. In 1958 there were 520 stations broadcasting to sets in 42 million homes. Today there are tens of

thousands of broadcasters, and approximately 100 million homes have television sets. There are 14 million color sets alone in this country. In fact, there are more television sets in American homes today than telephones, bathtubs, or refrigerators. Television antennas bristle from the rooftops of ghetto shacks that don't even have plumbing. An estimated quarter-billion television receivers are in use around the world. Yet, because of political sovereignties and profit-motive selfishness, more than one-third of humanity is illiterate.

Television, like the computer, is a sleeping giant. But those who are beginning to use it in revolutionary new ways are very much awake. The first generation of television babies has reached maturity having watched an average of 15,000 hours of television while completing only 10,000 hours of formal education through high school. Yet television itself still has not left the breast of commercial sponsorship. Just as cinema has imitated theatre for seventy years, television has imitated cinema imitating theatre for twenty-five years. But the new generation with its transnational interplanetary video consciousness will not tolerate the miniaturized vaudeville that is television as presently employed.

At London's Slade School, the German-born video artist Lutz Becker observes: "This purely electronic medium with its completely abstract rules does not have its own art form which should develop within the scope of new technologies and their almost chaotic wealth of possibilities. A new art form is not only the result of new technologies, but also the result of new thinking and the discovery of new orders."

But no new orders are to be found in the economic society's use of the medium it created. "A country that is chiefly interested in turning out consumers and producers," wrote Robert M. Hutchins, "is not likely to be much concerned with setting minds free; for the connection between selling, manufacturing, and free minds cannot be established. Such a country will transform new opportunities for education into means of turning out producers and consumers. This has been the fate of television in the United States. It could have been used for educational purposes, but not in a commercial culture. The use of television, as it was employed in the United States in the 1960's, can be put in its proper light by supposing that

Gutenberg's great invention had been directed almost entirely to the publication of comic books."[1]

A major portion of America's creative energy is siphoned off into television's exploitation of the profit motive: "Few messages are as carefully designed and as clearly communicated as the thirty-second television commerical. . . . Few teachers spend in their entire careers as much time or thought on preparing their classes as is invested in the many months of writing, drawing, acting, filming, and editing of one thirty-second television commercial."[2]

[1] Robert M. Hutchins, *The Learning Society* (New York: Praeger, 1968), p. 127.

[2] Peter F. Drucker quoted in: Gerald O'Grady, "The Preparation of Teachers of Media," *Journal of Aesthetic Education* (July, 1969).

# The Videosphere

I have found the term "videosphere" valuable as a conceptual tool to indicate the vast scope and influence of television on a global scale in many simultaneous fields of sense-extension. Like the computer, television is a powerful extension of man's central nervous system. Just as the human nervous system is the analogue of the brain, television in symbiosis with the computer becomes the analogue of the total brain of world man. It extends our vision to the farthest star and the bottom of the sea. It allows us to see ourselves and, through fiber optics, to see inside ourselves. The videosphere transcends telepathy.

Broadcasters now speak of "narrowcasting," "deepcasting," "minicasting," and other terms to indicate the increasing decentralization and fragmentation of the videosphere: regular Very High Frequency programming (VHF); Ultra High Frequency special-interest programming such as educational television or foreign-language stations (UHF); Community Antenna Television (CATV); Closed-Circuit Television (CCTV); Videotape Recording (VTR); Videotape Cartridges (VTC); Electronic Video Recording (EVR); Satellite Television (COMSAT, INTELSAT)—all of which amount to a synergetic noospherical metaphysical technology that drastically alters the nature of communication on earth.

Although the emphasis now is on the EVR cartridge and video-tape cassette as being revolutionary developments in communication, the more likely possibility is that CATV and the videophone will provide unparalleled freedom for the artist as well as the citizen. In addition to regular broadcast programming, CATV operators may establish subscription systems through which customers might receive as many as eighty channels of color programming not available to the VHF or UHF audience. Much of this programming obviously will constitute the kind of personal aesthetic work to be discussed in this book. CATV subscribers may lease receivers with high-resolution 1,000-scan-line pictures, compared with broadcast

TV's 525 scan-lines.[3] In addition to providing videofax newspapers, magazines, and books, CATV will allow "visits" to friends, shops, banks, and doctors' offices without ever leaving the comfort of one's home. CATV systems are now being developed to transmit programs to home VTRs while a family is sleeping or away from the house, to be replayed later.

It is estimated that ninety percent of American homes will be wired for CATV by 1980, primarily because "demand TV" or "telecommand" systems are expected by about 1978. By this process one will telephone regional video-library switchboards, ordering programs from among thousands listed in catalogues. The programs will be transmitted immediately by cable, and of course could be stored in the home VTR if repeated viewings are desired. The videophone will be included in a central home communications console that will incorporate various modes of digital audio-visual and Xerographic storage and retrieval systems. New developments in videotape recording will be crucial in this area.

There are two key phases in information storage: recording and retrieval. Retrieval is perhaps more important than recording, at least at this early stage. Retrieval systems are more difficult to perfect than recording devices. Nam June Paik has illustrated this problem with the difference between the English alphabet and Chinese characters. "Retrieval is much quicker with Chinese characters," he explains. "You can record (write) quicker in English but you can retrieve (read) quicker in Chinese. One is retrieval-oriented, the other is recording-oriented—but you read more than you write." Thus it is quite likely that video-computer systems will be available for home use with one-inch videotape, half devoted to video information, half to digital storage codes.

After some twenty-five years of public television, we are just now developing a sense of global unity that is destined to affect directly the life of each individual before this decade is past. We have seen that technology already is fragmenting and decentralizing broadcast

---

[3] Electron beams in camera-tubes and picture-tubes scan the screen in 525 horizontal lines from top to bottom. This is standard in the United States. Associated with this is what are called "lines of resolution." Since microwave broadcasting tends to dissipate the coherence of a signal, it is composed of only approximately 320 lines of resolution by the time it reaches home receivers.

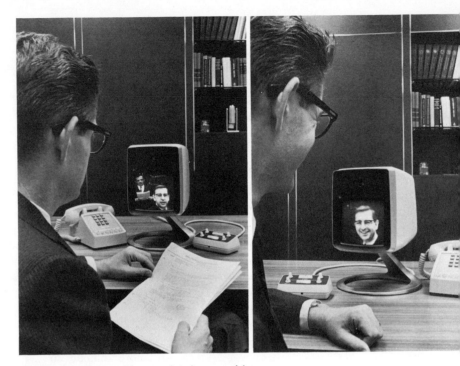

The Picturephone: "A completely new video environment and life-style." Photo: Bell Telephone Laboratories.

television. Soon entertainment and localized functions of the videosphere will be handled by CATV and videotape cartridges, leaving broadcast television free to perform vital new tasks. Large communications conglomerates such as RCA, CBS, ABC, CBC, BBC, Eurovision, Bell Telephone, AT&T, and COMSAT are now planning networks of planet analysis that will result in television as a constant source of global metabolic and homeostatic information.

Direct satellite-to-home television has been technically feasible for some time. Scientists at Bell Telephone and COMSAT anticipate fifty domestic communications satellites in orbit by 1977. The total system will be capable of 100,000,000 voice channels and 100,000 television channels.[4] Hughes Aircraft engineers estimate that within

[4] *Videa 1000 Newsletter,* Vol. 3, No. 3 (New York: Videa International, January, 1969).

the decade individual roof-top antennas will pick up twenty-five to thirty channels from "local" satellites in addition to whatever video information the home may be receiving from CATV and videotape cartridges.[5]

Existing satellites now deliver photographs and video images with such high resolution that "COMSAT typesetting" is possible. A CBS satellite system employed by the military to flash reconnaissance photos from Vietnam to Washington reportedly resulted in color qualities "as good or better than *National Geographic*." In 1969, RCA engineers began work on video cameras and receivers capable of 10,000- and possibly 12,000-scan-line resolution. Also in that year, RCA officials proposed that NASA's TIROS M meteorological satellite could be converted into an "earth resources" vehicle to help overcome food shortages and combat pollution problems. Equipped with special high-resolution 5,000-scan-line cameras in a 500-mile orbit, the satellite would yield picture resolution equivalent to 100 feet above ground. Higher resolution would be possible, officials announced, but some countries would complain of "invasion of privacy."

On the receiving end, the next few years will see the development of transistorized sets with 500-hour rechargeable batteries; TV sets that can screen 16mm. movies through the color cathode tube by using built-in telecine systems; so-called spectral color 3-D television without polaroid glasses; four-by-six-foot cathode tubes only one foot thick; self-correcting color receivers that will correct even broadcast errors; one-gun color sets that will eliminate three-gun registration problems; stereo TV; new color TV projection systems that will project six-foot color images with brightness and registration equal to studio monitor equipment; two-dimensional laser color TV; tubeless TV cameras smaller than a man's hand, coupled with TV receiving tubes the size of a quarter. And it is estimated that the flat wall-size plasma crystal screen will be distributed commercially by 1978.

Individual personal expression through videotape has begun only recently, and the artist who works with videotape as his own personal medium of expression is still quite rare. However, new developments in small inexpensive portable videotape recording

[5] *Ibid.*

systems will completely revolutionize this mode of artistic freedom. As early as 1968 several firms demonstrated prototype low-cost home VTR systems in the thousand dollar price range. It is expected that by 1973 one will be able to purchase a color TV camera, color VTR unit, and color display console for less than $1,000. By comparison, similar equipment in 1970 ranged from $11,000 (Sony) to $50,000 (Ampex).

However, within the next few years we'll witness the growth of video cartridges and cassettes into a market greater than that presently enjoyed by books and records. The potentials are so impressive that Jean-Luc Godard, possibly in a moment of passion, once vowed to abandon his feature-film career to make "instant newsreels" via portable videotape equipment. The first serious competitor to Columbia's EVR system will be Sony's videotape cassettes for home VTRs, to be marketed by 1973. At approximately the same time RCA will introduce its "SelectaVision" unit, which will play pre-recorded tapes through any TV set using a safe low-power laser beam and special scratch-proof vinyl tape. Virtually all video hardware manufacturers are developing their own versions of the videotape cartridge storage-and-retrieval system.

Meanwhile a whole new area of feature film cartridge projection systems has developed to compete with the video cassette market. Kodak, Bell & Howell, Fairchild, and Technicolor have demonstrated cartridge projection systems for home viewing. Zeiss-Ikon has developed a compact textbook-size cartridge projector for 300-foot cassettes of 70mm. film divided into twelve separate image tracks to produce two hours of color sound movies in stop-motion, slow motion, and reverse, using a capstan drive instead of sprockets.

It is now obvious that we are entering a completely new video environment and image-exchange life-style. The videosphere will alter the minds of men and the architecture of their dwellings. "There's a whole new story to be told," says video artist Scott Bartlett, "thanks to the new techniques. We must find out what we have to say because of our new technologies."

# Cathode-Ray Tube Videotronics

The underlying principle in creative use of videotronic hardware might be called "video synthesizing," just as we speak of sound synthesizing in the Moog process. There are no special restrictions inherent in the video signal as opposed to the audio signal. Anything that can be done with sound can be done with video if the proper hardware is available. The basic ingredient of alternating current is identical in both processes, and represents potential for as many variations as the equipment will allow. Just as the new filmmaker seeks to synthesize all the elements of his technology, so the video artist attempts to synthesize the possibilities of his medium in the creation of electron synaesthetics.

Since present television studio equipment was not made for the purpose of aesthetic experimentation, artists have been forced to work within parameters that amount to video imitation of cinematic techniques: electronic equivalents of cinematic wipes, fades, superimpositions, and traveling mattes. There are, however, certain advantages in working with video systems to achieve variations of these effects quite unlike their cinematic counterparts, and with considerably less expenditure of time and effort.

## The Television Camera

In standard photography a photosensitive emulsion on a strip of acetate is exposed to lens-focused rays of light that form an image in the emulsion. A similar principle is involved in television except that the image is translated into coded electronic-signal information and is then "erased" to make way for another image. Inside every TV camera, instead of film, is a photoconductive camera tube. These tubes are called variously Image Orthicon, Vidicon, Staticon, and Plumbicon, depending on the chemical makeup of the tube's photosensitive surface, which is called the photocathode screen. For many years the Image Orthicon was the standard camera tube. Recently, however, the Plumbicon, whose photosensitive surface is composed of lead oxide, has become the popular camera tube.

According to how much light is focused onto the surface of the

photocathode screen, each tiny photosensitive element becomes electrically charged, building up a "charge pattern" across the screen proportional to the lights and darks of the televised scene. This charge pattern is swept across, or "read," by a beam of electrons emitted from a cathode gun in the camera tube. The beam neutralizes each picture element on the photocathode screen as it sweeps across, producing a varying electric current that corresponds to the pattern of light and shade in the televised scene.

As each photoconductive element on the screen is scanned by the electron beam and relinquishes its information, it is said to be "wiped clean" and can therefore respond to any new light image it may receive through the camera lens. This charge-forming and systematic "reading" is a rapid, continuous process with the entire photocathode screen being charged, scanned, and recharged thirty times per second to produce a constant scan-line pattern of 525 lines resolution, the standard in the United States.[6]

## The Television Receiver

The video picture signal thus produced is subsequently amplified and cabled through a video switcher/mixer console in the studio control room where it is transformed back into a picture on monitors that operate like home television receivers. Cathode-ray tubes in television receivers are called "kinescopes." In them, a cathode gun like the one in the camera tube sprays the phosphor-coated screen with a beam of electrons synchronized with the exploratory beam in the studio camera. The phosphor coating glows in the path of the beam as it scans the picture tube. Horizontal and vertical "sync pulses" keep the two beams in step.

A beam of constant strength would produce a white rectangle of fine horizontal lines, which is called a "raster" and is the basic field of the picture. But if the beam's strength is varied, the trace-point brightness is varied also. When the video signal is made to regulate the picture tube's beam, a pattern of light and shade can be built up on the screen's phosphor corresponding to the distribution of lights and darks focused through the camera lens—thus a duplication of

---

[6] Gerald Millerson, *The Technique of Television Production* (New York: Hastings House, 1961) and Howard A. Chinn, *Television Broadcasting* (New York: McGraw-Hill, 1953).

the televised scene. This picture fades and is continually replenished by the rapidly-scanning beam so that we see a clear, complete image. In relatively low-resolution systems such as the 525-line U.S. standard, a so-called rolling effect of the scan-lines can be detected on the picture tube. In high-resolution systems of 1,000 to 5,000 lines, however, the resulting image is unflickering and extremely clear.

The same principles are involved in color television except that four camera tubes are incorporated inside each camera: one each for the basic colors red, blue, and green, and one black-and-white tube for use in aligning and resolving the three colors. In color television receivers, three cathode guns instead of one are used to scan the phosphor screen, electronically "mixing" the palette according to the distribution of hues in the televised scene.

## De-Beaming

The electron beam scanning the photocathode screen in the television camera requires a certain strength, a certain amount of electric current, in order to reproduce the image completely with sharp definition and contrast. Controls on the camera called "gain control clippers" are provided to assure that the beam is receiving proper energy to reproduce the image. By deliberately starving the electron beam of its required current, highlight details are washed out of the picture, causing the image to be retained or smeared in the camera tube. Any motion occurring in the brighter areas of the televised scene will produce a lingering smear of the image similar to the phenomenon of retinal persistence in human vision, but slower and longer lasting. Accidental beam-starving often is noticeable in musical programs when brass instruments develop flaring jelly-like trails as they move. Deliberately causing and exaggerating this effect is known as "de-beaming" or "rolling off the beam."

In color television, beam energies can be controlled in any of the three primary color tubes inside the camera simultaneously or separately. This means that the smear will be in one or all of the three colors and their combinations. Thus a human face or figure can be made to have brightly-colored outlines or ghost images that seem to stick to the screen as the figure moves. In addition, the three color tubes can be deliberately de-aligned from the coordinating black-and-white tube, producing three separate color images

moving together in time but spatially differentiated, as sometimes occurs accidentally in offset color lithography.

## Keying and Chroma-Keying

The video equivalent of cinematic matting is called "keying." As in cinematography, the purpose is to cause one image to be inserted into another image so that the background image is effectively obscured by the insertion. Cinematic matting is mechanical whereas video keying is electronic. There are two basic methods of keying: "inlay keyed insertion" (static mattes and wipes), and "overlay keyed insertion" (traveling mattes). Inlay keying involves a picture tube displaying a plain white raster on its screen, which is seen through a transparent masking plate (or "cel") by a lens focused onto a photo-tube that triggers a switching circuit. We select part of Camera One's picture to be matted out and make an opaque mask (cardboard, etc.) to cover the corresponding area on the cel over the inlay tube's raster. The switching circuit automatically blanks out that area in Camera One's picture, allowing the rest to show through wherever the circuit "sees" the inlay tube's raster. Camera Two's picture is automatically inserted into the matted area. Numerous wipes are possible simply by moving a mask over the inlay tube's raster. These wipe masks may be manually or electronically operated. Or they can be photographed on motion-picture film, which is then run through a telecine projector whose video signal triggers the switching circuit.

In overlay (traveling matte) keying, the switching circuit senses the scale of grays in a televised scene. Clipper controls on Camera One are adjusted to select the particular gray-scale level at which a keyed insertion from Camera Two is desired. This level of luminosity is known as the "switching tone." If a white switching tone is selected, Camera Two's picture will be inserted into Camera One's picture wherever the circuit "sees" the switching tone or a lighter one. If a dark tone is selected, the insertion will be made wherever the circuit "sees" that tone or a darker one. The shape of the insertion is determined by the shape of the switching tone areas in the scene. There must be a marked tonal difference between the inserted subject and its surroundings for the switching circuit to operate effectively. For example: Camera One shoots a dancer in

black leotards against a white backdrop; Camera Two shoots a striped pattern. If a white switching tone is used, the dancer will be seen against a striped background. If a black tone is used, the dancer's body will be filled with stripes and the background will remain white.

Ordinary use of keying as described here usually results in the same sort of unconvincing, tacky visual effects as are generally produced by traveling mattes in movies: that is, a scene in which two images are trying unsuccessfully to be one. The problem lies in general insistence on "clean" mattes. Tonal differences of at least fifty percent on the gray scale must exist between the subject and surroundings, otherwise the switching circuit reaches points where it cannot distinguish between forms. This results in image-break-through and ragged "fringing" of matted edges, destroying the desired illusion of "objectivity." In synaesthetic videographics, however, keying is employed purely for its graphic potential in design information. Since there's no attempt to create the illusion of a "foreground" figure being inserted into a "background" field, image-breakthrough and edge-fringing are no longer a problem. In fact, they are deliberately induced through a technique called "tearing the key."

If there is no second video source, all areas of a scene above a white switching-tone turn black and all areas below a black tone turn white. If the scene contains a wide range of gray-scale tones with little contrast a great deal of image-breakthrough and edge-fringing will occur to the point where one cannot distinguish between the two. Electronic metamorphosis has occurred. If the scene is a medium close-up of faces in low contrast and a white tone is used, all facial highlights will turn black while all lower gray-scale values will remain normal. If a black tone is used, facial shadows will flash white while lighter values reproduce normally.

If the clipper, or sensor of the gray-scale level, is adjusted up and down the scale instead of being left at one level, the result is a constantly "bleeding" or randomly flaking and tearing image. This is called "tearing the key." In the scene just described, this would result in a constant reversal of dark and light tones and a general disintegration and reappearance of the image. If a second video source is used, which happens to be the same image we're seeing,

except through another camera, the result is a bizarre solarization effect of flashing outlines and surfaces, or a composite in which an image appears to be inside of itself.

Gray-scale keying is possible also in color television, flaring and intermixing colors based on their gray-scale luminosity. However, Chroma-Key, although limited in some ways, provides certain advantages in color video work. Chroma-Key does not sense gray-scale luminosity but rather color hues. Any combination of the red, blue, and green primary tubes can be selected as the keying hue. Whenever a background is a particular hue, it will be keyed out and a second video source will be inserted. Any combination of colors in the spectrum can be used, but blue is normally employed because it is most opposite to skin tones and therefore provides the widest margin for "clean" mattes. If a blue-eyed girl is in front of a blue background and the Chroma-Key is set for blue, "holes" will appear in her eyes into which any other video source—including another image of herself—can be inserted.

In July, 1968, WCBS-TV in New York featured the Alwin Nikolais Dance Company as part of its Repertoire Workshop series. The dance composition, *Limbo*, was designed especially for Chroma-Key effects and thus provides an excellent example of a certain approach to this technique. In one scene of *Limbo* a man is threatened by disembodied hands and arms. He is tossed aloft by them and, according to the program description, "all of life's little problems are thrown at him." To achieve this effect the principal dancer and the chorus were positioned in front of a blue backdrop, all on the same camera. The chorus members were dressed completely in blue except for their hands and arms. Using a blue Chroma-Key, this meant that wherever there was blue in the picture, the background camera shooting smoke would show through. Thus the hands and the principal dancer appeared to be floating through smoke clouds. At one point, the hands appeared to pull confetti and streamers out of nowhere and throw them in the air. The colored confetti was concealed with blue confetti covering the top of the pile. It was invisible until it was pulled out in the open.

In another segment, serial rows of running dancers were suspended in green space. The inside of the dancers' bodies was a

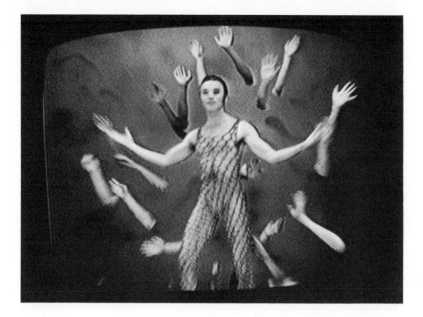

Chroma-Key video matting makes
arms of Alwin Nikolais dancers seem
to float in space. Photo: WCBS-TV.

series of wavy stripes that moved from right to left to accentuate the
effect of motion. Two cameras and three videotape recorders were
used. In this way, three separate "takes" of one row of dancers were
combined in the final image. On take 1 the camera framed the
dancers at the top of the screen. The dancers were placed against a
large blue canvas backdrop that curved down to the floor, permit-
ting even lighting so that the dancers' full figures could be matted.
The background was a green slide that appeared wherever there
was blue in the picture. The outlines of the dancers cut the "hole" in
the matted green slide, and these "holes" were filled by another
camera shooting a revolving drum with painted stripes on it. This
was recorded on videotape 1 (VT-1). This was played back to the
studio where a wipe was used to combine the first level of dancers
on tape with a second level of dancers now being framed live in the
center of the camera. The resulting composite of two rows of striped
dancers was then recorded on VT-2. This was played back to be

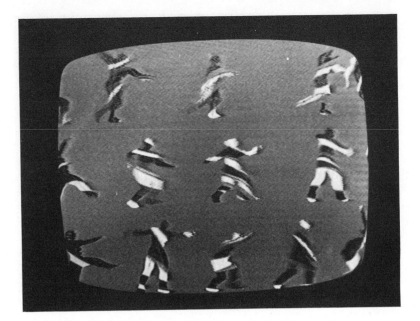

Two cameras and three VTRs were
used to suspend candy-striped dancers
in green space. Photo: WCBS-TV.

combined with the third level of dancers using the same process.
The total effect was recorded on VT-3.

In another vignette the dancers were to represent the torments of
everyday living, from crawling sensations to jangling nerves. The
final effect was of two lines of dancers, toe to toe, lying side by side
on clouds and water, holding long tapes above their head to repre-
sent nerve endings. The outlines of bodies and tapes were filled
with red. The segment was done in two takes. The first take was
tape-recorded with the dancers lined up on the right side of the
screen. On the second take, the dancers moved to the left side of the
screen. The tape was played back and combined with the live action
using a vertical wipe. Later this effect, plus goldfish and crawling
ants, was inserted inside the body of the principal dancer.[7]

[7] Technical descriptions of the *Limbo* program were provided by Herb
Gardener, WCBS-TV Studio Operations Engineer, in *How We Did It,* a pub-
lication of the WCBS-TV Repertoire Workshop, New York.

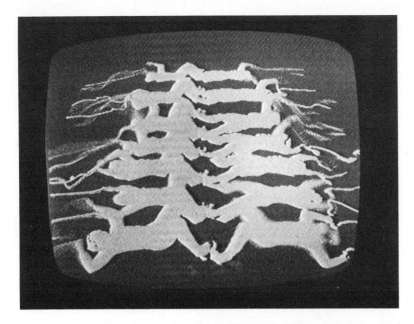

Two VTRs were wiped together in this composite scene from the *Limbo* program. Photo: WCBS-TV.

While demonstrating the nature of Chroma-Key, these examples also clearly show how a purely electronic medium with an unexplored range of possibilities has been used to imitate the older discipline of cinema, and to express an archaic intelligence that insists upon "objectivity" and linear development in graphic forms. The rigid adherence to "clean" matting implies disdain toward what is obviously the unique property of video keying: "metamorphosis," not overlay or insertion. The new consciousness seeks the transformation of realities whereas the old consciousness ventures no further than a timid juxtaposition of "objective" realities that retain their traditional identity. The fact is that there exists no cinematic equivalent of video keying. Tearing a key in grays or colors produces graphic designs of unique character, blending form and color in a manner virtually impossible in any other medium. Video keying is inherently synaesthetic; such a claim can be made for no other aesthetic medium.

## Feedback

If a microphone is placed too close to its amplifier it squeals. If a television camera is positioned too close to its monitor it squeals also, but it squeals visually. This visual noise, like audio noise, is called "feedback." Video feedback may be intentionally induced and carefully controlled to produce graphic effects possible only through this technique. The most common effect is the infinitely-repeated image similar to the infinity effect of fun house mirror chambers. This can be done with one, two, or three cameras shooting into the same monitor that displays their output. One or two cameras can shoot into a monitor that displays their output in addition to an image from a third camera. There are a number of combinations based on the principle of the squealing camera.

## Telecine Projection

Because it is the video equivalent of a cinematic optical printer, the "telecine projector," commonly known as the "film chain," plays an important role in the production of synaesthetic videotapes or videographic films. It is a device that projects slides or films directly into television cameras whose signals are sent through a switching/mixing console and then are broadcast or videotaped. Telecine movie projectors are modified to project at the video rate of 30 fps instead of the cinematic rate of 24 fps. (A video "frame" is the amount of signal information produced in the thirtieth of a second required for the camera-tube electron beam to scan the photocathode screen one time.)

Since certain limitations are inherent in the physical and technical characteristics of a live studio setup, the film chain offers many advantages in the production of videographics where image control and graphic integrity are extremely important. The video signal from a film chain is "live" in the sense that a slide or movie is being re-recorded live. Thus it is possible to televise scenes that have been prestylized and could not exist live in front of a studio camera. These may then be combined on videotape with normal studio scenes.

Most film-chain cameras employ Vidicon tubes, which can be controlled just the same as studio floor cameras. In fact, film-chain

Vidicons often are more flexible to work with, since studio cameras are fine-tuned and one frequently is forbidden to alter their adjustments. De-beaming and keying film-chain cameras produces a very different effect, a more subtle effect than the same techniques in live studio cameras, for the simple reason that film loops can be fed through the system. Film loops allow one to rehearse, as it were, the precise moments at which a certain effect is desired. Endless takes can be made with the same image, an advantage not possible in studio situations. For tape-mixing purposes, monitors show which film-chain images are upcoming, and several film chains can be synchronized for mixing onto one tape.

Slightly different procedures are involved in using film chains for the production of videotapes as opposed to videographic films. The primary difference is in the ability to manipulate colors. In film-making, the usual procedure is as follows: Original footage is shot on 16mm. or 35mm. high-contrast stock from which a workprint is made. This print may then be edited in the usual fashion or fed directly into a video system through the film chain. High-contrast stock is used to overcome the image-breakdown effect of video scan-lines, and to retain image quality as much as possible through the three separate stages of videographic filmmaking: original footage, videotape, and kinescope (videotape images recorded on movie film). This process would tend to obliterate the subtle shadings of slower, more sensitive film stocks.

Once the high-contrast work print is formed into loops and fitted into the film chain, it can be processed through the video mixing/switching system, augmented by de-beaming, keying, wipes, and compounded with other video sources, either live-action, tapes, films, or slides. The final master tape may be edited before a kinescope is made. Assuming that the imagery has already undergone three edits—first as original footage, then in film-chain mixing, then as a master tape—a fourth edit may be performed on the kinescope footage. This is then processed through an optical printing system where color is added.

Since video colors reproduce poorly onto film, most videographic films are shot in black-and-white with color added optically after video processing is completed. However, as in the case of Scott Bartlett's *OFFON* and *Moon,* color can be added to black-and-

white film by running it through a three-gun, color film chain. The color is induced electronically through the video circuit and appears on tape. The same reproduction problem remains when a kinescope is made of this color tape, and the final color print must be augmented in optical printing. Videotronically-induced colors are desirable for their unique qualities of electron luminescence, which cannot be duplicated in chemical photography.

Since synaesthetic videotapes are made with no intention of transferring them onto film, color reproduction is no problem. Tapes may be composed entirely through the film chain from looped film information, or composites of film, live action, slides, and other tapes. Color or black-and-white film stocks may be used since videotape color in a closed-circuit playback situation is always superior to the incident-reflected light of movie projection.

### Videotronic Mixing, Switching, and Editing

The television switching/mixing console, described by Stan Van-DerBeek as "the world's most expensive optical bench," is an array of monitors and switching circuits by which different sources of video information are selected, mixed, and routed in various ways. Within its basic ingredient—alternating current—exists the potential for an art of image-synthesizing that could exceed the boldest dreams of the most inspired visionary. Yet, because the equipment was neither conceived nor constructed for aesthetic purposes this potential has remained tantalizingly inaccessible. Traditional use of the video system to imitate cinema is, in the words of one artist, "like hooking a horse to a rocket." Still most artists are quick to admit that even this limited potential of the television medium has not been fully explored.

Most video systems are capable of handling only three image sources at once. Although any number of sources may be available—most larger systems accommodate approximately twenty-four—the maximum capacity for viewing is any combination of any three of those sources. This is an absolutely arbitrary limitation based only on the intended commercial use of the equipment, for which three video sources are perfectly adequate. A few systems can accommodate four video sources at one time. Still fewer, called "routing switchers" or "delegation switchers," have five available

sources, each of whose five input terminals is fed by five more so that the image potential becomes any combination of any five-times-five video sources. This is a positive step in the direction of video synthesizing.

Compounding this image limitation is the cumbersome and unwieldy physical layout of the switching console itself. The primary reason is that video hardware has been design-oriented around the literary narrative mode of the cinema it imitates. It is built to accommodate a literary instructional form in which the elements are relatively simple and linear. In reality, the unique capabilities of video are perhaps even further from the narrative mode than cinema. No amount of written instruction could communicate the complexity of technical and intuitive maneuvers involved in the synaesthetic videographics we are about to discuss; and even if that were possible, no engineer could spend the time required to read and carry out those instructions: the program would never reach the air. Video hardware has been designed around a depersonalized instructional motive whereas it clearly should have been designed to accommodate personal aesthetic motives since all technology is moving inexorably in the direction of closer man/machine interaction and always has been.

The result of this traditional perversion of the medium is that any attempt at creativity becomes extremely complex and often flatly impossible. Even relatively simple effects used commonly in movies —such as dissolving from one matted title to another matted title— are not possible with normal switchers. The desired effect is a background scene over which title credits, either static or in motion, dissolve from one set of words into another set of words without changing the background. In video this requires a very elaborate device called a "double reentry switcher" with six rows of push buttons for each video source. Combinations of any of two- or three-times-six buttons must be used in order to get the effect on the screen.

Assume that one wishes a video image in which colors are automatically reversed while blacks and whites remain the same; or reversing the blacks and whites while colors remain unchanged; draining a picture of all colors but one or two; enhancing only one or two colors so that they become vivid while other hues in the

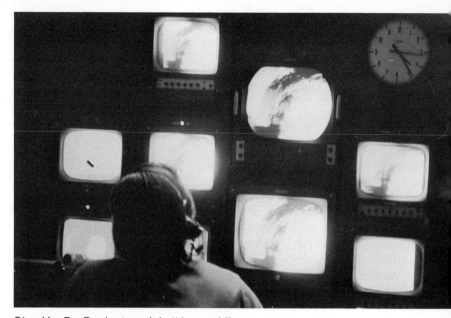

Stan VanDerBeek at work in "the world's
most expensive optical bench," the mixing/
switching control room at WGBH-TV,
Boston, Massachusetts. Photo: Gene Youngblood.

scene remain stable; warbling a picture so that it looks like shim-
mering water; composite wipes, so that the edge of the wipe moving
across the picture is not a hard edge but rather modulated by the
audio or modulated by gray scales or colors; numerical camera
controls that would cause one portion of a scene to grow larger or
smaller according to the control setting. All of these things are
possible in existing video technology, yet are not available to the
artist in the form of a mixing/switching console. Moreover, they are
potentially possible in a totally random and instantaneous fashion,
whereas much labor and many hours are required to achieve the
same effects in the cinema.

In addition, there is no reason that video switching must be push-
button controlled so that the operator of a common master-control
switcher must select combinations of approximately one hundred
and twenty buttons. Effects could easily be tone- or voice-actuated,
or controlled by hand capacitors, photoelectric cells, or correspond-

ing pairs of voltages for transition effects. All of this could be real-
ized in integrated circuitry, reducing the mammoth proportions of
existing switchers by many times. Delegation or routing switchers
could accomplish with twelve buttons what now requires more than
a hundred.

The potentials of a video system are so vast that it becomes
physically impossible for one person to have them accessible to him
in a workable manner. This is where video-computer symbiosis
becomes necessary. Virtually every possible alternative can be pro-
grammed into a computer, which then can employ them in a specific
programmed order, or within random or semirandom parameters.
Computer-controlled switchers can and will be designed that allow
simultaneous processing of the video source by computer program,
audio modulation, and manual override. In this way all desirable
features of synergetic technology would be available: the random-
ness of a computer, which can be infinitely more "random" than any
human; the video being semicontrolled by its own audio; and finally
the artist manually overriding the whole system. Thus it would be
possible to preset all conceivable combinations of alternatives for
one video source, which could be actuated by one button or one
audio tone. These capabilities not only exist within the scope of
existing video technology, they are virtually inherent in the nature
of the medium.

Until recently the one major advantage of cinema over video was
sprocket holes and frames: that is, the ability to do stop-frame
animation. For many years the closest that video could come to this
was the digital method of videotape editing such as the Ampex
Editec system or the EECO system. These methods involved the
digital timing of the videotape cue track in hours, minutes, seconds,
and frames. Thus it was possible to pre-edit a videotape session by
setting a dial, or to do post-editing and single-frame animation,
though extremely time consuming and lacking precision. Remarks
video artist Loren Sears:

One of the hardest things to do is stop the recorders and try to sync them
up again. So the goal is to go from start to finish in planned lengths but
still keeping the tape recorders running. So I tried doing some animation
with an Editec system. You can animate by presetting anything from
one to thirty-six frames, and there's a manual override that keeps repeat-

ing the same frame as long as you hold it down. You lay down a cue track and set the machine going in an automatic mode. It has a seventeen-second cycle time in which it rolls to a stop, backs up and lays down a pulse where it's to pick up next time. It took about four hours to do twenty or thirty seconds of animation, whereas in film that's all instant with the single-frame button. This is exactly the reverse of other aspects of video-versus-film, in which video is much more expedient. It's an extreme example, but it's something that film can do easily and there's no advantage of doing it in television; you waste time, and you can be more creative in film.

However, greater animation control and simplicity is now possible in video through computer-controlled color disk recording such as the Ampex HS-200 system. It provides all of the editing freedom that previously was possible only with film, plus the ability to pre-program the insertion of cuts, wipes, dissolves, and other effects exclusive to video—all instantaneously, with the push of a button. Digital identification and retrieval of any frame within four seconds allows skip-framing and stop-motion at normal, fast, and slow speeds in both forward and reverse modes. Apart from this positive note, I have stressed the limitations of the video system as an aesthetic medium because they need to be emphasized, and because the many positive aspects of videographic art will be quite clear in the pages that follow.

# Synaesthetic Videotapes

## VT Is Not TV

It is essential to remember that VT is not TV: videotape is not television though it is processed through the same system. The teleportation of audio-visual information is not a central issue in the production of synaesthetic videotapes; rather, the unique properties of VTR are explored purely for their graphic potential. An important distinction must also be made between synaesthetic videotapes and videographic cinema: the videotape artist has no intention of transforming his work into film.

"I've come to find out that there's a lot of difference between seeing something on a TV screen and seeing it projected," explains Loren Sears. "The two-dimensionality of the movie screen as simply a surface for reflecting a shadow is quite obviously incident light. Television doesn't have that two-dimensional quality at all; it doesn't strike you as a surface on which something is being projected, but as a source. It comes as light through a thing."

It is perhaps not surprising that the most important work in synaesthetic videotape has been done through affiliates of the National Educational Television network (NET). In 1967 an experimental video workshop was established at NET's San Francisco outlet, KQED, with funds from the Rockefeller Foundation and the National Endowment for the Arts. Two years later the workshop had become the National Center for Experiments in Television, with a grant from the National Corporation for Public Broadcasting.

In 1968 KQED became involved in a third project. In collaboration with San Francisco's Dilexi Foundation, the station provided facilities and assistance to artists commissioned to work in the video medium. Some of the most impressive videotapes to be seen anywhere resulted from this project, notably Terry Riley's *Music With Balls* and Phil Makanna's *The Empire of Things*.

Meanwhile, that same year, NET's Public Broadcasting Laboratory (PBL) produced a program of video experiments by six artists including Allan Kaprow, Nam June Paik, and Otto Piene. The show, called "The Medium Is the Medium," was produced at WGBH-TV in

Boston, where later in 1969 Stan VanDerBeek became the first of several artists to take up residence under a three-year Rockefeller grant. He was followed by Nam June Paik.

A new breed of television management is evolving as teledynamic video consciousness saturates the noosphere. Since the fundamental art of television rests in the hands of the broadcaster—the ability to move information through time and space—his attitude toward the medium is a matter of cardinal importance. We know what most broadcasters think of the medium; in the following pages, in addition to discussing artists and their work, I hope to present a new attitude from a new generation of TV management. Until videotronic hardware becomes inexpensive enough for individual use it is the producers, directors, and station managers who make today's video art possible. Brice Howard of the National Center, John Coney of the KQED/Dilexi programs, and Fred Barzyk of WGBH are exemplary of the new vision in television.

## Videospace: The KQED Experimental Project

With few exceptions, most of the work produced during the first year in the experimental workshop was black-and-white videotape. The approach seemed balanced between use of the medium for its kinaesthetic design potential, and the medium as vehicle or environment for some other aesthetic content. Artists in residence included a composer, Richard Feliciano; a poet, Joanne Kyger; a novelist, William Brown; a painter-sculptor, William Allen; and a filmmaker, Loren Sears.

In addition, various guests were brought in throughout the year, participating from one week to three weeks. These included Ellen Stewart of the Cafe La Mama theatre troupe; Paul Foster, one of the playwrights who had come out of that workshop; Eugene Aleinakopf, an expert in television law; Maurice Freidman, a theological philosopher, particularly known in the United States for his English translations of Martin Buber; Robert Creeley and Charles Olson, poets; and Joel Katz, a New York psychiatrist.

The two most vital functions were performed by Robert Zagone who was resident director of the actual videotaping sessions, and Brice Howard, organizer and administrator of the project. I asked him what answers had been found to the project's two questions:

What is the nature of the medium? Can an artist work in it?

BRICE: Yes, the artist can work in television. Of course it's quite a different system from that of the artist. Artists generally are one-to-one people. They and their medium are in direct contact. But the television system engages a great many people; any product of that system is the product of a number of people. No single human being can make anything in television. And of course television equipment is not easily available to the artist either.

GENE: One possibility is working through the medium of the cassette videotape cartridge rather than a broadcast system.

BRICE: No question about it. But it's a long way off, not so much technologically and commercially, but philosophically. The kind of work going into the EVR cartridge now is institutional. The artist will be the last to participate.

GENE: And what have you discovered about the nature of the medium?

BRICE: Where I'm having the greatest difficulty in reporting this occurrence is in discovering ways of separating the medium from its broadcast, distribution characteristics. Television has been a broadcast system, and for that reason its technology and its practice grow essentially from that logic, the logic of distribution. We accepted the inference that we were not obligated to produce anything. And because of that, all kinds of things happened. If we had started out by saying "let's make a program" it would have been a pretty redundant or repetitious thing.

GENE: In your estimation the technology is separate from the practice?

BRICE: The emphasis so often gets centered in the technological. I want to take it away from the technology because it really is not that. So frequently I find myself saying, when confronted with technical questions, "It is not technology; it is *attitude shift* that is making this happen." Indeed, there is no technology in any of the experiences we've had that is greater than that which exists in any standard television studio. We went after our goal from a different place. For instance, you can experience some of our material and feel that you're discovering an enormously rich technical breakthrough, when as a matter of fact what you're experiencing

is process. And the same process would be with clay, paint—anything. In this case the material just happens to be the electron. All the tapes have no post-editing, are records of process, records of discovery, untouched, nonobjective, nonprogrammatic. Very often the most meaningful moments were those in which some incredibly remarkable, mercurial connection was occurring among a number of people, and the process was constantly feeding back upon it.

GENE: Were certain visual effects deliberately sought?

BRICE: When you describe a particular visual effect achieved in our work it must be remembered that there are so many other elements involved. Television has been fed by four currents of recent history, and one not so recent: cinema, radio, journalism, and theatre. And the characteristics of these histories affected the making process. You mention a specific effect and I might tell you that keying is the technical means by which you acquire that effect. But in order for that effect to be genuinely valuable we have to add theatre's part, journalism's part, radio's part, and film's part. Then keying becomes something meaningful.

GENE: What effect does radio have on keying?

BRICE: It has to do with the architectural space in which the experience occurred. You see, the fascinating character of the space in which some of the sources of the mix are acquired is that it's a space of a different order. The television studio is affected architecturally by the influences of theatre and radio. For example, the audiometrics—the acoustical character of that situation—is very much influenced by microphones which preceded television. And how sound pickup sources affect the order of masses, planes, volumes, compositions, so on. Very frequently the imposition of that technology, which has nothing to do with the experience you're seeking at the moment, is there nonetheless and has to be taken into consideration, forcing certain kinds of compromises. For example there's no reason that an omni-directional acoustical transducer cannot be devised to pick up all the sound in all the 360-degrees of cubic space within the studio. But there isn't one. And that's partly a factor of radio and partly a factor of film.

The architectural space itself is very close to theatre, from which film derived its basis, etcetra, etcetera. And indeed in a

conventional studio, ask a so-called set designer, stage designer, television art director (all those terms apply to the same man in television; all those terms are used in television), you ask that man to fix you an environment and more frequently than not he'll fix you an environment that looks like it's on a stage. Indeed you can almost see the proscenium arch. Now the cubic space with which you are dealing in this newer mode of television is of a different order entirely. The only space which is valid is the space on the surface of that monitor. Whether or not one wants to argue about the word "space" is irrelevant as long as you understand the intent. I'm saying that it isn't in the studio, it's in the monitor. Now, the monitor screen has some remarkable characteristics. Among other things, it itself is information irrespective of anything you put in it—sign, symbol, rhythm, duration, or anything. It is delicious all by itself, if you want to enjoy it, though its matter is apparently of a totally random character. It is different, for example, from the reflective surface, which is a movie screen, off which light bounces with the image intact. But television is an electronic surface whose very motion is affecting the motion that you're putting into it. And what is really the richest part of television, less its technology, less its cubist nature, less its incredible colorations and shapes and motions and excitements—it's *now*, it's capturing the damned *actual* with all of its aberrations. Television will help us become more human. It will lead us closer to ourselves.

## Robert Zagone: The Music of Electrons

Virtually all of the project's black-and-white tapes, plus a one-hour segment of a regular KQED color program called *West Pole,* were directed by Robert Zagone, one of an increasing number of video artists who approach the medium from the side of the new consciousness. ("I *mixed* the programs," Zagone said. "We don't use the term 'director' any more.") Out of more than forty hours of tape approximately fifteen hours were considered relevant. Of these I have selected two for discussion here.

The first is a brief but devastating exercise in feedback techniques, which was among many effects accompanying a poetry recital by Robert Creeley. This particular episode involves the

Multiple-camera feedback techniques
produced this disintegration of form
in *Videospace* at the KQED Experi-
mental project.

gradual disintegration of the poet's profile in silhouette. In addition to the figure, other image sources included multiple translucent plastic surfaces being fed into a monitor that was taking images from still another source. At one point all three cameras shot the same monitor that displayed their images.

The result is an almost visceral, physical quality to the image as endless waves of flaking matter peel away from the silhouette, slowly at first, then faster and more chaotically, with ever-increasing convolutions of geometrical patterns. A kind of serial nightmare, like a magnetic field suddenly rendered visible, the reverberations of chiaroscuro flip hectically in giant sweeping flak bursts of light until a shimmering white glow is all that remains of the image of a man. "It's really a matter of where your head is at with respect to the technique," said Zagone. "I would say that it would take eight months to achieve in film the same effects that took us one minute and forty-five seconds with Robert Creeley's recital. And even then the texture would never be the same."

Like most videographics, the immediate impression is of seeing something that one has never encountered before, except perhaps in dreams. This was even more pronounced in Zagone's interpretation of a solo dance sequence involving a male dancer in six levels of delayed tape superimpositions of de-beamed positive and negative images. Three cameras taped the dance simultaneously as Zagone mixed. At first the dancer is silhouetted in black against a white field. A second and then a third image of himself, delayed and slightly staggered with each superimposition, appear like ghosts who follow him through his routine. Suddenly the background becomes dark and the dancer develops a glowing white outline or halo; his facial characteristics become ominous with huge white eyes and exaggerated features. Still more delayed images appear until there are six figures of the same dancer seen simultaneously at various points in time, like visual echoes. The richness of the image was varied with each superimposition, causing some images to stand out while others fade almost into nothingness. Finally, as though trapped in some video world where space and time are out of register, the dancer looms large and close, peering into (out of) the camera (monitor) as though to examine the "real" world of men.

Six levels of delayed videotape super-
impositions of de-beamed positive
and negative images were combined
in this experiment at KQED.

"The technique is satisfactory," said Zagone, "but requires immense sophistication on the part of the user. You must constantly be thinking in advance—where will you be five superimpositions from now? How will you deal with the tape at that point with respect to the images you're creating now? We had no plan for that sequence ten minutes before it began. The conceiving of it took place as it happened in the cathode tube. It's all in the electrons. The effects exist nowhere but where you see them. It's not in clipper levels or blanking pulses or blacks and whites—that's not where it's at. The most successful moments occurred when we had absolutely no preconceived notion of what would happen."

In May, 1968, Bob Zagone directed two half-hour segments of KQED's *West Pole*, featuring a rock concert by The Sons of Champlin. Even for young filmmakers of the San Francisco/Berkeley area, where synaesthetic cinema is part of the life-style, this initial exposure to pure video amounted to a revelation. An article in the rock newspaper *Rolling Stone* described the show as "more psychedelic than underground movies." The realization that something so common and "public" as a television set could be the source of virtually unprecedented visual experiences was the beginning of a new socio-technical awareness that is now common, as are the *West Pole* techniques. Colors bloomed, flared, and melted; shapes disintegrated and intermixed; the picture-plane was demolished in a cascade of spectral brilliance—the *Bonanza* fan, who knew that television was capable of something more, finally saw that potential in all of its phosphorescent shimmering beauty.

GENE: What were you reaching for in the *West Pole* work?

BOB: I just wanted to fuse the electronic music with electrons. Video is very close to music and rock music is very close to video.

GENE: What effects were you particularly pleased with?

BOB: Tape delays and de-beaming, primarily. We had been working with refinements of those techniques regularly for six months.

GENE: There's a fabulous scene where the fellow is singing: green gaseous clouds move across his mouth, and when he opens his mouth to sing, the inside is intense red.

BOB: That's a combination of tape delay, feedback, de-beaming, tearing the key, and the black-burst generator which suffuses any color with black.

Loren Sears: *Sorcery.* 1968. VTR.
Black and white. 30 min. "I wanted to
express a feeling of entrapment in the
electronic environment."

## Loren Sears: The Sorcery of Neuro-Aesthetics

Loren Sears regards television as an extension of the central nervous system, and thus employs the term "neuro-aesthetics" to indicate the unique character of videographic art. Sears produced seventy-five minutes of experimental videotapes as an artist in residence at KQED in 1968. The best was called *Sorcery*, which he codirected with Bob Zagone. "Every medium," Sears explained,

has a fundamental means of operation. In film it's sprocket holes, registration, optics, frames. The characteristics of television are different. In both cases, however, there's a strategic way of using the medium effortlessly. *Sorcery* was an attempt to go right through the medium using what it can do easily.

It occurred to me that if media are extensions of the central nervous system, it's like you're taking on an extra load. There's more of yourself to deal with, because while you're putting things out of it, you're also taking them back in. So I'm certain there are hallucinations which occur entirely within this realm. It has its own ability to create, its own importance, its own way of seeing things. It shapes the world-view information that's put in and taken out of it. So I wanted to do a very intuitive piece that would express a sense of the video mode of operation. I wanted it to evolve without a script simply from camera techniques, mixing techniques, a set, two people clothed in an odd fashion, some props like death's heads. So I put Joanne Kyger and Chuck Wiley, with his violin, in front of a rear-projection screen for slides.

I wanted to express a feeling of entrapment in the electronic environment. You watch television and all you know is what's going on in television. That's all you really find out. There's no way to tell if that's really what's going on in actuality. It was pretty difficult to think of a way to suggest that, so I just told Chuck and Joanne that they were totally trapped in this milieu and their problem was to try to get through it somehow to outside reality through some kind of divination. They were left alone in the studio with these instructions and two cameramen who had been given shooting patterns to follow. They ad-libbed their way through it. Chuck played his violin. And what happened was that they began to feel it. It began to work on them.

Through de-beaming and keying of one camera while a second camera was on tape-delay, an ominous sense of the video environment was generated through most of *Sorcery*. Relatively representa-

tional images slowly disintegrated into swirling diaphanous lines and clouds of light. The death's head melts into vague outlines through which are seen smoky crumbling faces and ghostly super-impositions. Long sections of the half-hour tape are composed of swirling lines as sounds and voices are heard as though from another world. Humans interact with clouds of electrons, which seem finally to engulf them.

"Any medium can be transformed by the user," Sears said. "The paradigm for it all is music. There's the music of the medium, which means it also has a muse. We can learn from it. Television has been used as an attraction, a come-on, an effect. Nothing used for effect is an art." Just as in his synaesthetic cinema, Sears merged aesthetic and technique. There are no effects when form and content are one.

## Conceptual Gallery for Conceptual Art

The traditional triangle of studio-gallery-collector in which art historically has thrived is slowly being transformed. The psychological effect of television's totally immaterial nature may be largely responsible for the contemporary artist's awareness of concept over icon. For several years Gerry Schum has operated a unique "television gallery" (*Fernsehgalerie*) at a station in Düsseldorf, West Germany. "In art," he explains, "there is a general change from the possession of objects to the publication of projects or ideas. This of course demands a fundamental change in artistic commerce. One of the results of this change is the TV gallery, more or less a conceptual institution which comes into existence only in the moment of transmission. After the broadcast there is nothing left but a reel of film or videotape. There's no object that can be seen 'in reality' or be sold as an object."

Somewhat similar ideas inspired San Francisco art dealer James Newman to transform his Dilexi Gallery into the Dilexi Foundation in December, 1968, with the purpose of "allowing more freedom for the artist, reaching a general audience and making art an organic part of day-to-day life." Newman was among the few gallery owners to recognize television's potential as the most influential gallery in the history of art. He engaged in a joint project with KQED-TV to

establish a regular series of programs in the form of an "open gallery," not to sell objects but to move information—the experiential information of aesthetic design and concept.

Newman commissioned works by Robert Frank, Ken Dewey, Walter de Maria, Yvonne Rainer, Ann Halprin, Julian Beck and the Living Theatre, Robert Nelson, Frank Zappa, Edwin Schlossberg, Terry Riley, and Philip Makanna. The first pieces, televised in the spring and summer of 1969, were unanimously acclaimed. Chiefly responsible for this success was KQED producer-director John Coney, who coordinated, produced, and codirected many of the video projects, working closely with the artists.

## Terry Riley: *Music With Balls*

Rarely has the multiplex structure of any film or videotape been so totally integrated as in the transcendental composition *Music With Balls* (see color plates), conceived by Terry Riley and commissioned by the Dilexi Foundation in 1968. It was the work of three men whose separate disciplines meshed in synaesthetic alloy: Terry Riley, composer; Arlo Acton, sculptor; John Coney, video mixer. *Music With Balls* is a dialectical synthesis of nonverbal energies that strikes deep into the inarticulate conscious. It inundates the beholder in megabits of experiential design information, aural, visual, and kinetic. To understand it we must understand its four elements: music, sculpture, cinema, and video.

Riley's music is strongly influenced by the work of LaMonte Young, with whom he is closely associated. Yet it can be said that Riley's music is unique in itself and represents, with the exception of Young, the most vital and refreshing American musical composition of the late twentieth century. While he is seriously involved with the "row" and "stasis" techniques that inform Young's work at a fundamental level, Riley is able to subsume a wide range of musical structure, combining the climax and directionality of Western music with the stasis of Eastern modalities. The result is cyclic precision and a buoyant mathematical randomness.

For *Music With Balls*, Riley pre-recorded four tracks of fourteen-cycle beats with a tenor saxophone and a Vox electric organ. Each beat was assigned a pitch, thus forming a tonal "row" that he played

back through oscillators. Various levels of tape delay were possible by starting and stopping one or more of the tracks randomly. In the studio Riley sat behind a bright red table, flanked by his tape equipment. Against the recorded, delayed, and oscillated time cycles he played rhythmic variations on his saxophone, effectively generating a static yet melodious macrostructure of cycles containing epicycles within epicycles. The music was alternately tense and relaxing, a shimmering trilling universe of aural bubbles penetrated randomly by syncopated wailing crescendi and diminuendi. The overall effect was magical, soothing, hypnotic.

Two stereo speakers were fitted into two of Arlo Acton's giant black spheres that were swung from the studio ceiling on long wires and revolved around the set in diminishing circles, pushed periodically by black-clad girls at either side. Thus the amplification of the cyclic music was itself heard in a physically cyclic fashion as it swirled about the empty space. A smaller chromed sphere was set in pendular motion, like a giant metronome, just above Riley's head. This had a calming, centering effect.

This auditory/tactile/kinetic environment was then processed through cinema and video on several levels, all corresponding to the cycle/epicycle mode. Tiny ball bearings suspended from threads were filmed in ultraslow motion with a high-speed camera to make them seem heavy. The resulting film of swinging spheres was made into twelve loops that were then superimposed over one another in all the various combinations and as many levels of multiple-exposure as possible on one master print that had been cut into a strip as long as the entire program, twenty-six minutes. This was fed through a film chain as one possible video source.

Two floor cameras shot Riley in wide-angle and close-up, and also focused alternately into a color monitor and a concave mirror. "The mirror gave the entire image a curvature which corresponded to the cyclic nature of the whole piece," Coney explained. "Also it broke the repetition of the circular orbits by making them elliptical. Shooting the color monitor was not done for feedback but simply to achieve an electronified or subaqueous visual patina. A rather blue cast. Also it accentuates the scan-lines which are appropriate to TV, and we used them as a design element. In addition it gave us the

ability to have the same picture running synchronously on two different scales. Seeing the image a bit larger on one camera than the other. That produced a very interesting cycle effect, particularly when we dissolved to another image."

The master tape of *Music With Balls* is a fabulously rich mantra of color, sound, and motion. Huge spheres sweep majestically across the screen trailing comets of shimmering ruby, emerald, and amber. Contrapuntal trajectories intersect, pierce, and collide. Keying, de-beaming, wipes, and dissolves result in phantasmagoric convolutions of spatial dimensions as Riley is seen in several perspectives at once, in several colors, alternately obscured and revealed on various planes with each pass of a pendulum. The composition builds from placid serenity to chaotic cacophany to bubbly melodiousness with a mad yet purposive grace. Acoustical space, physical space, and video space become one electronic experience unlike anything the cinema has ever known.

## Philip Makanna: *The Empire of Things*

"I'm supposedly a sculptor," remarks Phil Makanna, "but there's something strange and maybe decaying about making things—*things*—peopling the overpeopled world with more junk, not really touching anyone. More than anything I feel the frustration, desperation, of wanting to be able to reach out and hold your heart." With the startling beauty of his synaesthetic composition *The Empire of Things* (see color plates), Makanna reached out through the videosphere and held the hearts of thousands.

A combination of sculptor, writer, filmmaker, and electronic engineer, Makanna was conducting a creative television course at the California College of Arts and Crafts in Oakland when he was commissioned by the Dilexi Foundation in 1968. At the college, Makanna focused on TV as a medium specifically for such "fine" artists as sculptors and painters. His approach followed two directions simultaneously: videotape as a self-contained aesthetic experience, and closed-circuit television as an environment for live events of a theatrical nature. These included a collaborative effort with the Mills College Electronic Tape Music Center, involving live performers, eight television cameras, twenty monitors, and eight audio

recorders functioning simultaneously. In another project, three and four acts of *King Lear* were presented simultaneously in several modes: actors seen in rear-projected movies, actors in video projections, actors seen through several closed-circuit monitors, and "live" actors on a stage.

But it remained for the medium of broadcast television, and *The Empire of Things,* to reveal to Makanna a means of reaching out to the hearts of the public. "He has such a powerful conceptual mind," recalls John Coney, "that all I did was guide him into a general technical format, offered suggestions that he could use as a matrix, and explained the capabilities of the color-film chain in painting video color. We processed *The Empire of Things* entirely by de-beaming the guns of the film chain. We formed the film into loops and practiced over and over again until the balance between form and content was perfect. We had a couple of engineers—Larry Bentley and Wayne McDonald—who were very interested in that piece of equipment as an electronic painting palette."

While *Music With Balls* is wholly nonverbal and concrete, *The Empire of Things* is that rare combination of words and images often sought but seldom achieved. Makanna miraculously manages to contrast the abstraction of words with the concreteness of images, clarity with ambiguity, alternating between evocation and exposition to produce an overwhelming emotional environment of evocative powers. The title of the piece is the title of a short story by H. L. Mountzoures that appeared in the *New Yorker* magazine. An offscreen narrator reads the entire story aloud while we see a collection of images shot by Makanna specifically for this purpose, combined with stock footage from old movies, newsreels, and TV commercials.

Mountzoures' story is itself a masterpiece of imagist prose, often indistinguishable from poetry and only occasionally linear in structure. A parable of war in surrealistic and extra-objective terms, it consists of alternating *haiku*esque impressions of things observed, events remembered, nightmares experienced, and realities confused in the first-person consciousness of the narrator. One is completely caught up in this strangely beautiful story as it unfolds with a masterly richness of language. At the same time, however, the images are generating their own, quite separate, world of impres-

sions. One is caught in a sensorium of contrasts, a dialogue between visual and aural absolutes from which arises a pervasive sense of abstraction. One is made keenly aware of nuances seldom expressed with such clarity in any art form. The synthesis of harmonic opposites is raised to perfection.

Word-and-image connections are tangential at best, and often starkly antithetical in conceptual content. The narrator might be speaking of old belongings in an attic trunk, for example, while we see a line of men on horseback at the rim of a steep cliff. As the horses plunge down the incline, video de-beaming turns the sky orange and sends mint-green flames streaking behind them. The scene becomes an Expressionist painting of green shadows and purple highlights quivering in a liquid mosaic of hues. This almost Daliesque image of rainbow horses melts into an Impressionist vision of sun-dappled woods. A horse and rider move slowly through trees whose colors suddenly detach and float in midair. Images merge until all that is left of the horseman is a cloud of electronic pigment moving nebulously through a spangled field of Seurat-like pointillist fragments. Elsewhere a man rides a bicycle that melts beneath him; he performs a strange dance ritual on a deserted beach as the sky seems to burst in spectral madness. Never have conceptual information and design information been so poetically fused as in *The Empire of Things*.

We haven't even begun to explore the potentials of the medium [Coney remarked]. Part of it lies beyond our reach because of stringent union regulations as to who can use the equipment and who can't. Part of it lies beyond the reach of the technicians who *are* authorized to use it. Videotronics will never come of age, will never be useful for creative purposes, until the knobs are put in the hands of the artist. We haven't even begun, for example, to work with really controlled color design. One built-in characteristic of television is the ability to manipulate spectral colors. There's a tremendous amount that can be done with muted and controlled colors that we haven't even started to do.

Television's biggest problem today is learning how to let go. Essentially that's what I'm trying to do; I want to let go of control without creating a disaster on the set. I want to open television to the extent that film is open. You see a multiplicity of voices and ideas in film on a number of levels of intent, interest, and seriousness. It doesn't always have to be "professional" to be true. And truth is what we're after.

## WGBH-TV, Boston: "The Medium Is the Medium"

"The reason we're experimenting," explained Fred Barzyk, "is that a large portion of the public is really ahead of television. They can accept more images and ideas at once. They're watching underground films; they're commercial buffs who are fascinated by how many cuts there are in a Pepsi-Cola ad. These are the people who could easily be turned on to educational television if it had the proper ingredients." With young producer-directors like Barzyk taking an interest in television as an educational experience, the ingredients are certain to be there sooner or later.

It was at WGBH, for example, that the program "What's Happening Mr. Silver?" was originated. A regular experimental feature on pop culture, the program proved so successful that it was carried also by most other ETV stations except KQED in San Francisco, where it was found to be "technically innovative but slightly sick." In 1967 the program's host, David Silver, conducted his weekly show from a bed in the center of the studio floor, in which he reclined naked with an equally nude young lady.

We wanted to experiment with every possible aspect of the medium [Barzyk explained] and intimate behavior in the form of nudity became one factor. We tried to create new problems in the broadcast system so that we could break down the system as it existed. We adopted some of John Cage's theories: many times we'd have as many as thirty video sources available at once; there would be twenty people in the control room—whenever anyone got bored they'd just switch to something else without rhyme or reason.

"The Medium Is the Medium" came out of this show in one sense, because after two years of "What's Happening Mr. Silver" we had so totally bombarded the engineering staff with experimentation. We took the attitude that the engineers would have to change their normal functions. In most of the television industry a video man is a video man, an audio man is an audio man, a cameraman is a cameraman; they never step over each other's bounds. We created a situation in which each one of them was asked constantly what he could do for the station. We told them they were artists. We said each week, "We don't know what we're going to do, here's our raw material, let's see what we can do with it." So out of this the audio man had his sources running, the cameraman had his sources running, and so on.

Initially there was a great deal of resistance from the engineering staff,

as might be expected when you change someone's job conditions. We deprived them of their security. I mean, you know what a "good picture" is: flesh tones, lighting, so on. But we deprived them of that. We said on our shows it doesn't really matter. One engineer turned off his machine. He didn't think it was right. A year later he came up to me with three new ideas that we might be able to use. So the pressure is reversed to bring creativity out instead of repressing it; we have the most production-oriented engineers in the whole country, I'd say. In effect we tell them the station is experimenting and we ask them not to be engineers.

It was in this environment that the experimental program "The Medium Is the Medium" took form in the winter of 1968–69. The contributions of Allan Kaprow, Nam June Paik, and Aldo Tambellini are discussed elsewhere in this chapter; Otto Piene and James Seawright were also among the six artists who participated in the project.

## Otto Piene: *Electronic Light Ballet*

Otto Piene's work with luminescence, pneumatics, and lighter-than-air environments is among the most elegant examples of aesthetic applications of technology. The artist's exquisitely delicate sense of proportion and balance, as demonstrated in his *Light Planets,* for example, is always stunning to behold. His synaesthetic videotape *Electronic Light Ballet* was no exception.

Typical of Piene's austere sensibility, only two image sources were used in this piece: a grid of colored dots that melted in rainbow colors across the screen; and a videotape of Piene's *Manned Helium Sculpture,* one of a series of experiments with lift and equilibrium that the artist conducted as a Fellow at M.I.T.'s Center for Advanced Visual Studies. The helium sculpture involved 800 feet of transparent polyethylene tubing in seven loops, inflated with approximately 4,000 cubic feet of helium, attached with ropes and parachute harness to a ninety-five-pound girl for a thirty-minute ascension into the air, controlled from the ground by ropes attached to the balloons and harness.

The ascension was staged at night in the parking lot of WGBH, which was illuminated by colored floodlights. Over this slow, buoyant, ethereal, surrealistic scene Piene superimposed a geometrical grid of regularly-spaced colored dots similar in effect to the multiple-

Otto Piene: *Electronic Light Ballet.* 1969.
Hi-Band Color VTR. 15 ips. 5 min.
Lighter-than-air space contrasted with vivid
videospace in Piene's usual elegant fashion.

bulb brilliance of his light sculptures. In exquisite counterpoint to the balloon scene the dots flared brightly, became liquid, developed spermlike tails, and finally dripped oozing globlets of color across the screen. The technique was deceptively simple: de-beaming the separate guns of the color camera with a strong hot light source shining through multiply-perforated stencils. Both the stencils and the camera were moved, causing a sperm-shaped burn-in of intense colors. If a dot appeared originally as yellow and was moved, the de-beamed "tail" would remain yellow but the "head" of the comet-shaped light would suddenly turn red or green. The effect, as in all of Piene's work, was quietly elegant, revealing the potentials of the medium in the hands of a true artist.

## James Seawright: *Capriccio for TV*

James Seawright, then technical supervisor of the Electronic Music Center of Columbia and Princeton Universities, was best known for kinetic/electronic sculptures. In fact, *Capriccio for TV* (see color plates) was Seawright's first experience with video as a creative medium. Whereas Piene's effort was a ballet of light and air, Seawright processed an actual ballet *pas de deux* through the videotronic medium to produce an inspired dance of form and color.

In contrast to the elaborate yet unimaginative convolutions of the CBS "Limbo" program, Seawright's piece was simple and effective. He televised two dancers—his wife Mimi Garrard and Virginia Laidlaw—against a score of electronic music by Bulent Arel. In the first two "movements" the dancers were shot in negative color and were superimposed over reversed images of themselves, producing a Rorschach-like mirror effect similar to bas-relief "flopping" in the cinema. In the concluding section Seawright televised the scene with three cameras that recorded only one of the three basic colors each onto three separate tapes. In addition, one camera was on tape delay so that a second dimension of abstraction was added. It was therefore possible to see two images of the same figure performing the same action at different stages in different colors, whereas the other figure was equally abstract in other colors. The image took on a ghostly quality, suggesting colored X rays or dream sequences in the mind's eye. Space, time, form, and color were brought into concert in an unforgettable video experience.

## Nam June Paik: Cathode Karma

"Cybernetics, the art of pure relations, has its origins in karma. The Buddhists say karma is sangsara, relationship is metempsychosis. Cybernated art is important, but art for cybernated life is more important, and the latter need not by cybernated."

"My experimental television is not always interesting," admits Nam June Paik, "but not always uninteresting: like nature, which is beautiful not because it changes beautifully, but simply because it changes." Paik is the embodiment of East and West, design scientist of the electron gun, pioneer ecologist of the videosphere. He is to television what John Whitney is to the computer; he does with TV sets what David Tudor does with pianos. "Television has been attacking us all our lives," he says, "now we can attack it back."

This Korean-born genius has been attacking it back longer than anyone, and in his own inimitable fashion. The bloody head of an ox was hung over the door to his first video exhibit in Wuppertal, Germany, in 1963, as a shock device "to get the audience into a oneness of consciousness so they could perceive more"—as in Zen, the master would strike the pupil. Although he never really harmed anyone, Paik was for several years a cultural terrorist, a kind of *deus ex machina* of the Orient, who left in his wake a series of demolished pianos, clipped neckties, bizarre junkyard robots, and scandalized audiences from Holland to Iceland. John Cage once remarked that "Paik's work, performances, and daily doings never cease by turn to amaze, delight, shock, and sometimes terrify me."

In recent years Paik has abandoned his mixed-media environmental Happenings to concentrate exclusively on television as an aesthetic and communicative instrument. Independently, in collaboration with scientists, and in a special research and development program with the State University of New York, he has explored nearly every facet of the medium, paving the way for a new generation of video artists. His work has followed four simultaneous directions: synaesthetic videotapes; videotronic distortions of the received signal; closed-circuit teledynamic environments; and sculptural pieces, usually of a satirical nature.

There are approximately four million individual phosphor tracepoints on the face of a 21-inch television screen at any given

moment. Paik's canvas is the electromagnetic field that controls the distribution of these trace-points in horizontal and vertical polar coordinates at 525 lines per second. By interfering, warping, and otherwise controlling the cathode's magnetic field, he controls the four million glowing traces. "It creates the possibility of electron-drawing," he says. "It's better than drawing on a CRT with a light pen because it's multicolored and provides interaction with the air program." (See color plates.)

Although he is continually developing new parameters of control and interaction with television, most of Paik's basic techniques were developed in the period 1963–64 in collaboration with Hideo Uchida, president of Uchida Radio Research Institute in Tokyo, and with Shuya Abe, an electronics engineer who, according to Paik, "knows that science is more beauty than logic." Paik has outlined three general areas of variability with these techniques. ("Indeterminism and variability are underdeveloped parameters in the optical arts," he says, "though they have been the central problem in music for the last two decades. Conversely, the parameter of sex has been underdeveloped in music as opposed to literature and the visual arts.")

The first level of variability is the live transmission of the normal broadcast program, "which is the most variable optical and semantical event of our times . . . the beauty of distorted Nixon is different from the beauty of distorted football hero, or not always pretty but always stupid female announcer." Paik estimates that he can create at least five hundred different variations from one normal broadcast program.

The second level of variability involves the unique characteristics of circuitry in each individual television receiver. Paik has resurrected several dozen discarded sets from junkyards and brought them back to wilder life than ever before in their previous circuits. "I am proud to say that thirteen sets suffer thirteen different varieties of distortion," Paik once announced, and then added: "1957 model RCA sets are the best." By altering the circuitry of his receivers with resistors, interceptors, oscillators, grids, etc., Paik creates "prepared televisions" that are equivalent in concept to David Tudor's prepared pianos.

The third level of variability is the manipulation of these pre-

pared TVs with wave-form generators, amplifiers, and tape recorders to produce various random, semirandom, or completely controlled effects, examples of which are: (a) the picture is changeable in three ways using hand switches: upside-down, right-left, positive-negative; (b) the picture can become smaller or larger in vertical or horizontal dimensions separately, according to the amplitude of the tape recorder; (c) the horizontal and vertical electron-beam deflection of normal TV is changed into a spiral deflection using a yoke oscillator-amplifier, causing an average rectangular picture to become fanlike; (d) the picture can be "dissipated" by a strong demagnetizer whose location and rhythm contribute variety; (e) amplitude levels from radios or tape recorders can be made to intercept a relay signal at the grid of the output tube so that the picture is visible only when the amplitude changes; (f) asymmetrical sparks flash across the screen when a relay is intercepted at the AC 110-volt input and fed by a 25-watt amplifier without rectifier; (g) a 10-megohm resistor is placed at the vertical grid of the output tube and interacts with a sine wave to modulate the picture; (h) wave forms from a tape recorder are fed to the horizontal grid of the output tube, causing the horizontal lines to be warped according to the frequency and amplitude.

Once a set has been thus prepared, the simple flick of a switch results in breathtakingly beautiful imagery, from delicate Lissajous figures to spiraling phantasmagoric designs of surreal impact and dazzling brilliance. Tubular horizontal bands of color roll languidly toward the viewer like cresting waves; flaccid faces melt, twitch, and curl, ears replacing eyes; globs of iridescent colors flutter out of place. When videotape playback systems are used as image sources instead of broadcast programs, the extent of control is multiplied and the visual results are astounding.

However, technical descriptions tend to underplay the sheer intuitive genius of Paik's video art. His techniques are hardly exclusive and are far from sophisticated (engineers say he does everything he shouldn't), and his cluttered loft on New York's Canal Street is scientifically unorthodox to say the least. Yet out of this tangle of wires and boxes comes some of the most exquisite kinaesthetic imagery in all of electronic art. "My experimental color television has instructional resource value," he suggests. "Kinder-

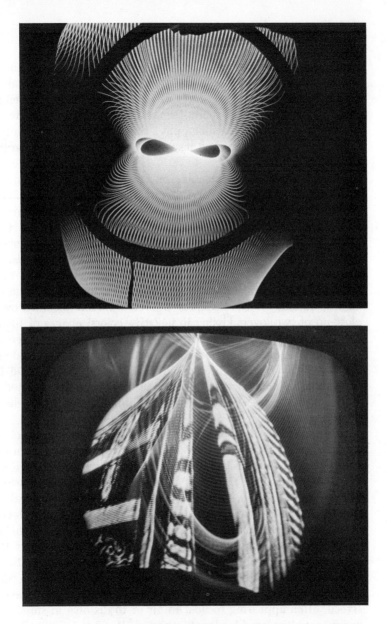

Electromagnetic distortions of the video image by Nam June Paik. "Out of this tangle of wires and boxes comes some of the most exquisite kinaesthetic imagery in all of electronic art." Photos: Peter Moore.

garten and elementary school children should be exposed to electronic situations as early as possible. My experimental TV demonstrates various basic facts of physics and electronics empirically, such as amplitude modulation, radar, scanning, cathode rays, shadow mask tubes, oscillography, the ohm principle, overtone, magnetic character, etc. And it's a very pleasant way to learn these things."

Perhaps the most spectacular of Paik's videotape compositions was made early in 1969 for the PBL show "The Medium Is the Medium" at WGBH-TV in Boston, where later he became artist in residence. Paik brought a dozen of his prepared TVs into the studio; using three color cameras he mixed these images with two nude dancers, tape delays, and positive-negative image reversals. The nude slow-motion dancers in multiple levels of delayed action suddenly burst into dazzling silver sparks against emerald gaseous clouds; rainbow-hued Lissajous figures revolved placidly over a close-up of two lovers kissing in negative colors; images of Richard Nixon and other personalities in warped perspectives alternated with equally warped hippies. All this was set against a recording of the *Moonlight Sonata,* interrupted periodically by a laconic Paik who yawned, announced that life was boring, and instructed the viewer to close his eyes just as some fabulous visual miracle was about to burst across the screen.

Later in 1969, Paik produced an impressive teledynamic environment called *Participation TV.* The first version was shown in an exhibit called "Television as a Creative Medium" at the Howard Wise Gallery in New York City; it was then modified into *Participation TV No. 2* for the "Cybernetic Serendipity" exhibit in Washington, D.C. The principle of the piece involves three television cameras whose signals are displayed on one screen by the red, green, and blue cathode guns respectively; the tube shows three different images in three different colors at once. Color brightness is controlled by amplitudes from three tape recorders at reverse phase. Thus the viewer sees himself three times in three colors on the same screen, often appearing to float in air or to dissolve in shimmering water as multicolored feedback echoes shatter into infinity. This was repeated on three and four different TV sets arranged around the environment.

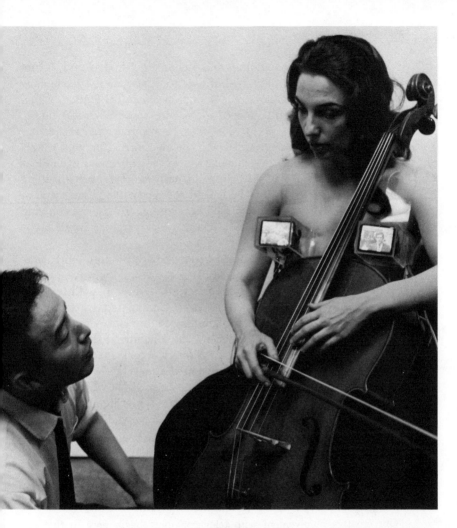

"Television has not yet left the breast":
Nam June Paik with Charlotte Moorman in
*TV Bra for Living Sculpture.* Howard Wise
Gallery, New York, 1969. Images are
modulated by musical tones played on the
cello. Photo: Peter Moore.

"The real issue implied in art and technology," he has said, "is not to make another scientific toy, but how to *humanize* the technology and the electronic medium. . . . I suggest *Silent TV Station,* which transmits only beautiful 'mood art' in the sense of mood music. What I'm aiming at with my Lissajous figures and other distortions is a television equivalent of Vivaldi, or electronic Compoz. Lumia art will then become a permanent asset in the collections of millions of people. The *Silent TV Station* will simply be *there,* not intruding on other activities, and will be looked at exactly like a landscape or a beautiful bathing nude of Renoir. Normal TV bores you and makes you nervous; this soothes you. It's like a tranquilizer. Maybe you could call it video-soma."

Paik's exquisite sense of satirical irony comes through most effectively in his video sculpture pieces. In *TV Bra for Living Sculpture,* Paik covered cellist Charlotte Moorman's bare breasts with two tiny three-inch TV sets whose images were modulated by the notes played on her cello. "Another attempt to humanize technology," Paik explained. For an exhibit titled "The Machine at the End of the Machine Age" at the Museum of Modern Art, Paik contributed a chair with a built-in TV set in place of the seat: one was able to sit on the program of one's choice. For an exhibit at New York's Bonino Gallery he constructed a video crucifix of glaring and ominous proportions; and in the privacy of his studio loft there sits a box containing a TV set that peeps through the vaginal opening of a photographed vulva. "Art," he says, "is all activities, desires, phenomena, that one cannot explain."

## Aldo Tambellini: *Black TV*

"Our creative involvement with television must begin now so that the electronic energy of communication can give birth to new visions: we will face the realities which astronauts and scientists know to be part of life."

Intermedia artist and filmmaker Aldo Tambellini has worked creatively with television in many ways for several years. He has produced synaesthetic videotapes, videographic films, and closed-circuit teledynamic environments. All of his work, in whatever medium, is concerned with the theme of "black," both as idea and

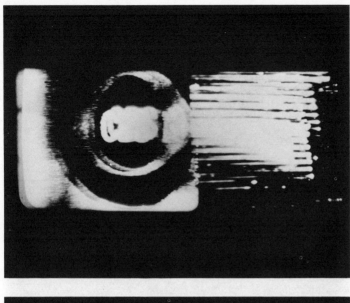

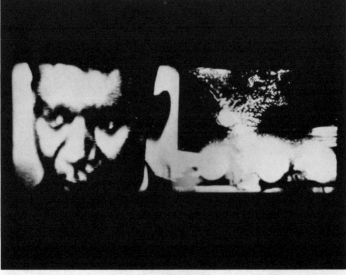

Aldo Tambellini: *Black TV*. 1964–68. 16mm.
Black and white. 9½ min. Two years of TV
news compressed into a staccato barrage
of sight and sound.

Aldo Tambellini: *Black Video Two*. 1968. VTR. Black
and white. Both image and sound were generated
electronically. Made in collaboration
with engineer Ken Wise. Photos: Peter Moore.

experience. For Tambellini, black is the womb and the cosmos, the color of skin and the color of the new consciousness. "Black is the beginning," he says. "It is birth, the oneness of all, the expansion of consciousness in all directions."

Tambellini began working with videotape in 1966–67 as part of his intermedia presentations. This work was subsequently expanded into live, closed-circuit, and broadcast video experiments. In the spring of 1969, Tambellini became the recipient of a grant from the New York State Council on the Arts in a project to develop relationships between artists and television engineers. He worked with technologists at five educational TV stations throughout New York, producing several experimental programs.

Also in 1969 he was one of six artists participating in the PBL program "The Medium Is the Medium" at WGBH-TV in Boston. The videotape produced for the project, called *Black*, involved one thousand slides, seven 16mm. film projections, thirty black children, and three live TV cameras that taped the interplay of sound and image. The black-and-white tape is extremely dense in kinetic and synaesthetic information, assaulting the senses in a subliminal barrage of sight and sound events. The slides and films were projected on and around the children in the studio, creating an overwhelming sense of the black man's life in contemporary America. Images from all three cameras were superimposed on one tape, resulting in a multidimensional presentation of an ethnological attitude. There was a strong sense of furious energy, both Tambellini's and the blacks', communicated through the space/time manipulations of the medium.

*Black TV* is the title of Tambellini's best-known videographic film, which is part of a large intermedia project about American television. Compiled from filmed television news programs and personal experimental videotapes, *Black TV* has been seen in many versions during the four-year period in which Tambellini constantly re-edited it. "Since my interest is in multimedia and mixed-media live events, and in experimental television, I think of film as a material to work with, part of the communications media rather than an end in itself. In the future we will be communicating through electronically transmitted images; *Black TV* is about the future, the contemporary American, the media, the injustice, the

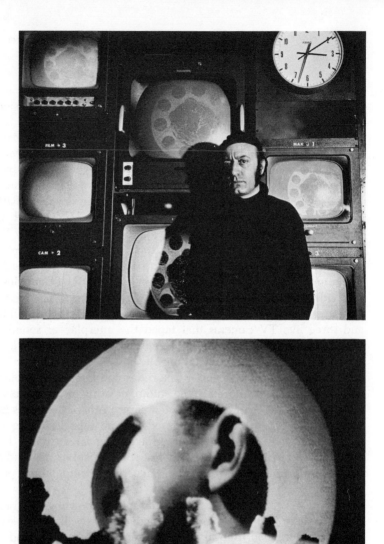

Aldo Tambellini in control room of WGBH-TV, Boston.
*Below,* a scene from *Black* (1969), an experimental videotape
he produced at the station with 1,000 slides, seven 16mm.
projectors, thirty black children, and three TV cameras.

witnessing of events, and the expansion of the senses. The act of communication and the experience is the essential."

As Tambellini's remarks indicate, *Black TV* is about perception in the intermedia network. It generates a pervasive atmosphere of the process-level perception by which most of us experience the contemporary environment. Since it involves the use of multiple monitors and various levels of video distortion, there is a sense of the massive simultaneity inherent in the nature of electronic media communication. *Black TV* is one of the first aesthetic statements on the subject of the intermedia network as nature, possibly the only such statement in film form.

*Black Video One* and *Two* are representative of the techniques and approaches involved in Tambellini's videotape compositions. He calls them "video constructions" to emphasize that they are self-contained image- and sound-generating units, which do not take image material either from broadcast programs or closed-circuit cameras. Instead, special circuitry is devised to generate both image and sound electronically on two monitors. These completely synthetic videographics can be juxtaposed with other image material to create a sense of convergence between different worlds. As in most of Tambellini's work, archetypal white globes, spheres, or expanding coils are seen suspended in a black video void. Various forms of video noise are generated to accentuate the purely kinetic aspect of the tapes. Most of this work was first produced in 1967–68, and has been incorporated into Tambellini's intermedia presentations and films.

*Black Video Two* was exhibited at the Howard Wise Gallery in New York in 1967. Two years later, Wise commissioned Tambellini and two engineers from Bell Telephone Laboratories to produce a work for his exhibit "Television as a Creative Medium." Tambellini and the engineers, Tracy Kinsel and Hank Reinbold, came up with *Black Spiral*, a beautiful example of aesthetically manipulated video circuitry. The normal rectangular raster of the TV picture was transformed into a circular raster by modification of the circuitry from an *xy* coordinate system to a polar coordinate system. As a result, the broadcast picture appeared as a flowing spiral; any movement in the picture caused the spiral to swoop and explode in giant gaseous curls of glowing phosphors. "Television is not an

object," Tambellini said. "It's a live communication media. *Black Spiral* brings you live information. One day we will look at nature as the floating astronauts do in a spiral or circular form where no up or down or gravity exists." The sound was transformed by modulating normal audio signals from the television station with a random audio signal.

"The artist will have to get to this medium and begin to explore all possibilities," Tambellini urges. "After all, television is actually an image made of light which travels through time and space. I'm interested in getting to that particular point to actually show that light is a constantly moving and ever-changing form, that light is energy, and the same energy which moves through us is the energy which moves through the universe. It is the same energy we have discovered in the atom. When creative people begin to get involved with this idea of energy rather than making objects for someone, they will be exploring possibilities for everybody, art will be an exploration for all of mankind."

## Eric Siegel: Video Color Synthesizer

"I see television as bringing psychology into the cybernetic twenty-first century. I see television as a psychic healing medium creating mass cosmic consciousness, awakening higher levels of the mind, bringing awareness of the soul."

In 1960, as a high school student of fifteen, Eric Siegel won second prize in the New York City Science Fair for a home-made, closed-circuit television system he constructed from second-hand tubes, a microscope lens, and junk parts. The following year he won another prize in the same competition for a home-made system called "Color Through Black-and-White TV." Although highly successful as a technician, he was virtually unknown as an artist until his spectacular "Video Color Synthesizer" was exhibited at New York's Howard Wise Gallery in May, 1969. It was clear the television generation had produced another genius.

The synaesthetic videotape *Psychedelevision in Color,* made by Siegel on his own home-made equipment, was at least as creative as works by more established artists represented in the exhibit, and according to some critics was the outstanding work of the entire

Eric Siegel: *Psychedelevision*. 1968–69.
Synthesized VTR. "Great waves of curling
clouds sweep under and over the viewer
in turbulent fury."

show. "A work of genius," wrote video artist Peter Sorensen in a
rave review devoted entirely to Siegel's tape. A reviewer for *Time*
found *Psychedelevision* ". . . closer to Kubrick's *2001* than to Dis-
ney's *Fantasia* . . . a glowing visual abstraction."

Siegel's synthesizer is a device that converts the gray scale of a
video signal (in this case from a portable videotape recorder play-
back unit) into changes in hue on the screen of a color TV set. The
results are, according to Siegel, "electronic Rorschach patterns in the
context of a metaphysical statement." The statement is the tape he
prepared for processing through the synthesizer, and this tape itself
was recorded through special equipment that the young artist,
characteristically, calls his "magic box." This device, more aptly de-
scribed as a "video effects generator," processes images from a
portable TV camera during the actual taping: the images are trans-
formed during the process of moving from the camera to the
videotape recorder.

One segment of *Psychedelevision* involves variations on a portrait of Albert Einstein as recorded through the effects generator and tinted through the color synthesizer. Einstein's face is seen in infinitely-repeated multiples, then implodes, bursting into a shower of fiery sparks, reforms again from the fragments only to melt into Daliesque puddles.

Because of the peculiar nature of the color synthesizer, the colors of *Psychedelevision* are unlike most other video hues: now organic in appearance, now like shimmering metal or mercury, glowing with an unearthly light, trembling in fierce brilliance, like the colors on the inside of the retina. But in the best kinetic art it's form as well as color that determines the kinaesthetic effectiveness of the piece. Siegel's forms are virtually indescribable: great waves of curling clouds sweep under and over the viewer in turbulent fury, quite reminiscent of the Stargate Corridor in *2001*. Random fire bursts of phosphorescent crimson flash across this eerie landscape. Suddenly the forms become bilaterally symmetrical, with shapes and colors streaming wildly from the center of the screen.

"*Psychedelevision* is my attempt at video mind expansion," Siegel explained. "A new science must be created which can reach the inner core of human beings. One of the most important tools of this new science will be television. I've been thinking of a television system which would take impulses from a human being through electrodes in a positive feedback loop: the person would be able to watch his own neurological reactions to the video patterns and video information generators activated by himself. The American Dream no longer is evolving. It's in a state of decay. Television must be liberated."

# Videographic Cinema

"We use video technology in filmmaking," explains Loren Sears, "exclusively for its graphic potentials. You can't really 'represent' or carry over satisfactorily into film the electronic viewing experience of watching television. You can carry the graphics over, but not the actual electronic experience." In the best videographic cinema, which we are about to discuss, the artist is at least able to approximate or suggest the luminescent atomic world of video imagery. As Sears indicates, however, the motivation is more toward the graphic characteristics exclusive to television, which simply cannot be duplicated by cinema alone.

"Metamorphosis is the main thing you can do with video that you can't do with film," says Scott Bartlett. "But video plus computers could do it even better." As it turns out, the optical effects of many Hollywood films have for several years been done on high-resolution videotape since that medium is less expensive to edit than film. But the fantastic capabilities inherent in videotape are not used; it is employed only as an imitation of cinema.

In the work discussed here, film and video technologies have been synthesized together, often through many generations of processing, to achieve graphic character unique in the world of film. Since one automatically thinks of any movie image as having been photographed by a camera, videographic films are quite startling on first encounter. Nothing in one's experience with movies can explain how such visions were captured on film—and indeed they were not: videographic cinema might succinctly be described as a film of videotaped film. "Color is the biggest problem," Bartlett admits. "It's very difficult to control. But more stable circuits are being developed all the time. The possible range of video color is as great as the range of color in any other medium. And because you're right there watching it happen you can deal with the psychological nuances of color and form."

## Scott Bartlett: Tribal Television

"There's a pattern in my film work that could be the pattern of a hundred-

thousand movies. It simply is repeat and purify, repeat and synthesize, abstract, abstract, abstract."

With his first film, *Metanomen*, made at San Francisco State College in 1966, Scott Bartlett went practically as far as possible within the structural limitations of black-and-white film and conventional cinema technology. Winner of the 1966 National Student Film Competition, *Metanomen* was a stunning kinaesthetic experience in which form and content merged in synaesthetic alloy. It became immediately obvious that with more elegant structural technologies Bartlett could raise this form/content metamorphosis to higher levels of graphic integrity. Like the best synaesthetic cinema Bartlett's films are not *about* an experience: they *are* the experience. Here we find kinetic empathy soaring to poetic heights.

Early in 1967, as Bartlett recalls, "television sort of found me. I had been superficially exposed to it, as my friend Tom DeWitt was in the TV department at school. That summer another friend, Michael MacNamee of Washington State University, said he could set up a TV studio situation for me at a station in Sacramento. I didn't know what would come of it, but *OFFON* came of it. And now *Moon* has come of that. Going into television doesn't mean I've abandoned cinema. It's a matter of expanding my technical vocabulary. I'm still doing *Metanomen* things, and I'm still doing *OFFON* things. But it's all adding up; I'm creating a new vocabulary."

Winner of many international awards, *OFFON* (see color plates) was the first videographic film whose existence was equally the result of cinema and video disciplines. Like all true videographic cinema, *OFFON* is not filmed TV, in the way that most movies are filmed theatre. Rather, it's a metamorphosis of technologies. "That's becoming a kind of aesthetic common denominator," says Bartlett. "Marrying techniques so the techniques don't show up separately from the whole. It's crossbreeding information. That's what a computer does, too. Having several aesthetics force each other into their separate molds and then sort of seeing what happens."

What happens in *OFFON* is extraordinary. The basic source of video information was in the form of twenty film loops that Bartlett and DeWitt had culled from more than two-hundred loops they had

made for a multiprojection light concert called *Timecycle,* described as a "two-hour moviemural." The iconographic character of the *Timecycle* imagery was clean and simple since it was intended for use in addition to other image projections. These loops were superimposed over one another to a depth of as many as eleven print generations for one strip of film, separating images from background, positives from negatives, adding colors to separate strips, and then recombining them optically.

Black-and-white loops were fed through a color film chain in the television control room, adding videotronic phosphor-texture to the cinematic graphics. Simultaneously, other loops and portions of Glen McKay's light show were rear-projected onto a screen on the studio floor, which was televised as a second video source. Both video sources were routed into one monitor: two images riding between two incoming channels, each pattern competing for exhibition on the monitor, generating a cross-circuited electronic feedback loop ". . . to the point where white information in competition with itself breaks down into colors: spectral breakdown." A second TV camera televised the monitor, feeding the signal to a videotape recorder. This master tape was again processed through the switching/mixing system. Instead of being recorded back onto film in the usual kinescope process, a special camera was set up in front of a monitor that filmed at the video rate of 30 fps instead of the movie rate of 24 fps.

"The entire process took three hours," said Bartlett. "The advantage I had was that all the material was on loops and I could just keep adjusting knobs and arranging appliances, cameras and such, until I had what I wanted, and then just film a burst of it." This videographic imagery was again processed through an ordinary cinematic optical printing system in Bartlett's studio. "The video colors were pale, but they were for that special texture that you can't get any other way. After I had that, I separated the film into AB rolls and dyed the strips with food color. One roll was dyed one color, another roll was dyed a different color. I built a trough and filled it full of dye and rolled the film from one reel through the trough and up along banks of heaters. I sat atop a ladder and very slowly rolled the film through this assemblage at a rate of about five or six inches a minute. Took me all night. A yoga dedication."

It was well worth the dedication. *OFFON* begins with a close-up

of a huge blue-red eyeball that pulsates with the sound of a heart-beat. The eye is both human and video: suddenly it bursts into an electromagnetic field of vibrations and becomes a slowly-expanding force field, a tight ring of bright red in a pale blue universe. The red ring blossoms into a constellation of scattering sparks and suddenly we see the image of a mirror-doubled dancer throwing out multiple layers of arms like a human flower in bloom. "The multiplication of arms was done in cinematic optical printing," Bartlett explained. "But the multiplication of the multiplications was done in video: the halos around the arms were created by video feedback."

Pink and blue sea gulls wheel languidly around the disintegrating dancer, whose image slowly melts into an infinity of geometrical echoes. This evolves into a close-up of a girl's face that seems to be streaking off, disintegrating but somehow holding together. "That's a good example of hiding one technique inside another," said Bart-lett, "by doing essentially the same thing with both systems and just compounding one action. Two pieces of film of the same shot were flipped over so that the left became the right. This was printed back onto the left, except out of register so that it staggered behind, apparently trying to catch up with the right. And the shot itself initially was a very slow zoom, rocking the camera back and forth while zooming in on the girl's face, who was herself rocking back and forth. When that was fed through the monitor it was refilmed by a zoom lens which was also rocking and swaying."

*OFFON* moves with dynamic thrust through a succession of images that never seem separate from one another, each evolving into videographic metamorphosis, exploding, glowing, disintegrating, cracking into infinity until it all ends with a final burst of kinetic energy. Later in 1968, Bartlett made a second videographic film, this time in black-and-white, called *A Trip to the Moon*. It involved a live panel discussion between Bartlett and friends on the subject of the new consciousness, cosmic unity, and metamorphosis. Films and slides of the moon and rockets were keyed into the scene randomly and certain interesting effects were achieved by associating audio and video feedback techniques. However, the film was too long (approximately half an hour) and not varied enough to support its length.

In the spring of 1969 Bartlett set about remaking *A Trip to the*

*Moon,* but the film that resulted, simply titled *Moon,* became a wholly new work with only a few seconds of original footage remaining. *Moon* proved to be his most satisfying work, more impressive even than *OFFON,* because in addition to spectacular videographics it also was constructed around a substantial conceptual content. It was completed less than two months before the first moon landing, yet is more effective in its metaphysical evocative power than many of the films of the same thematic content made since then.

*Moon* begins in a black void as we hear a recording of the Apollo Eight astronauts reading from Genesis. Under this is a rather spacey track from the Steve Miller album, *Sailor.* Suddenly the black void is recognized as a night sky as we approach a distant airport whose lights seem to float in deep space. The image is flopped; the runway lights become a starry corridor similar to the slit-scan corridor of *2001.* This gives way to stop-frame, optically distorted footage of astronauts boarding their craft before takeoff. The pale colors and unearthly motions lend a kind of dreamlike *déjà-vu* quality to the scene as these hooded creatures lumber slowly toward the giant rocket.

We see the ocean and a dawning sky. As though from another time and place, we hear reverberating voices speaking of the Universal One, cosmic unity, the *I Ching.* A purple face appears in the sky and is fragmented into infinity. Waves of the ocean—obeying lunar gravity—crash in slow motion, and over this we see skip-frame video-distorted scenes of the lunar module simulator spinning and maneuvering in space.

Now we're inside a television control room with several monitors reflecting the faces of men whose words seem far away. The control center appears like some window onto a video space of another dimension. A roaring wind takes us soaring through towering clouds, an ethereal atmosphere similar to the opening sequence of *8½.* Aqueous fingers of de-beamed video phosphors stretch across the sky like phantom visitors from another galaxy. A spaceman whirls through the clouds, flashing and sparkling like an asteroid. The graphic tempo increases with flashes of light and a tremendous roar until the final crescendo. The last image we see is the ocean receding from a beach.

Scott Barlett: *Moon.* 1969. VTR/16mm. film.
Color. 8 min. ". . . A purple face appears
in the sky and is fragmented into infinity . . ."

*Moon* is a beautiful, eerie, haunting film, a product of the New Surrealism, all the more wonderful for the fact that we do not actually see the moon: only the manifestation of its power here on earth: the ebb and flow of the waters that cover three-quarters of our planet. The film contains some of the most spectacular manipulations of video techniques Bartlett has yet achieved, sending fiery rainbows into a cloudy sky, transforming men and rockets into shattering crystals, creating a portrait of the cosmos in continual metamorphosis.

The magic of the film [said Bartlett] is its totally undefined meaning, the purely visceral message. The message could be called a code that we're trying to learn about, a code for connections to new space and new consciousness, a code for making it to the moon metaphysically, paths for your mind to get out where you can reach anything. In some ways technique equals meaning: the stop-frame action means mechanically defined space and time and the feedback layers are like accordion time—all the times stacking up on top of one another.

Commercial filmmakers use certain images or techniques as standard recognizable givens. Like the way a dissolve for them means the passage of time. But for us dissolve means "blend." Not so much one, not so much the other, but something in between the two, getting from one to another. It's valuable to hang somewhere between two different realities as a dramatic element. Dali does that. You see a face but then you realize the face is made up of a woman's ass and a cow and a flagpole or something. Your mind goes from one understood state to another understood state and you realize that you've voyaged in that process.

The understood state toward which Bartlett was headed in the latter part of 1969 was a "tribal television network" linking thirty or forty experimental video centers on the West Coast, some of them sponsored by rock groups such as the Jefferson Airplane and the Grateful Dead. "It will be a family of production centers cabled together and co-broadcasting with an FM radio station," Bartlett explained. "The FM radio would provide the mainstream programming and the disk jockey would be televised and would switch on visuals during records which would be electronically synthesized interpretations of the sounds. The production centers would make specials which would always supercede the main entertainment. The television station would be a voice: a natural accelerating pace

for more people sharing more knowledge. The tribal television would allow art and science to wed in a media marriage free from commercial concerns, free for pure experiment."

## Tom DeWitt: *The Leap*

"I look at the medium through its manipulation of time and space. Man's ability to manipulate space is very limited. Actually a space change is almost inconceivable. The same with our control of time. We're contained in clock time. But the medium at least *seems* to control space within completely malleable time."

After his collaboration with Scott Bartlett in the making of *OFFON*, Tom DeWitt made his own extraordinary videographic film, *The Leap*, completed late in 1968. Although the two films were born at approximately the same time and place in San Francisco, they are dramatically different in almost every respect: evidence not only of two strongly individualistic personalities, but of the latitude for personal expression possible in the videotronic medium.

"I turned to cinema as a vehicle for expressing my intuition," DeWitt explained. "I find myself only at the threshold and I can see no horizons. I try to use technology flexibly to realize dream images, but I would hardly call my work more than the first crude stage of image-manipulation through modern technology. I've been trying to learn enough about image technologies so that if I ever make a dramatic statement I'll know that it's being communicated through the essence of the medium. There was a time when I had my copy of Fortran and began to learn it—I saw computer art as a potentially limitless field—but I decided to explore what I could contribute through videographic cinema."

The leap of the film's title might be interpreted in several ways, all of them appropriate: a leap of consciousness from one reality to another; a leap in image technology from cinema to video; a leap to escape the suffocating boundaries of metropolitan life (in this respect *The Leap* is a continuation of the theme of DeWitt's first film, *Atmosfear*); and finally it might be seen as a leap to escape the purely videotronic world of the film's imagery. However one chooses to view it, *The Leap* unquestionably accomplished DeWitt's motivation: "I wasn't satisfied with the film until I felt that without

Tom DeWitt: *The Leap.* 1968. VTR/
16mm. film. Color. 6 min. "A man
seems to interact physically with
videographic apparitions . . .
androgynous symbols and arcane
electronic voodoo . . ."

any verbal references it would take you on an emotional trip, reacting purely to the essence of cinema and television."

Whereas *OFFON* is composed entirely of iconographic, geometric concrete imagery—organic figures processed through the medium until only a fundamental primary structure is left—*The Leap* is impressive for its mixture of pure video space with representational filmic space. Thus an ordinary man seems to interact physically with videographic apparitions, moving in and out of different space/time realities, fluctuating between the physical and the metaphysical with each stride of his leap toward freedom.

We see a man jumping across rooftops and racing up a grassy hillside. He dodges through a jungle of billboards, ominous structures, and forests of barbed wire. This is the basic vocabulary: a man running through an industrial landscape in search of nature. But through the video system this simple footage was transformed into a breathtaking constellation of exploding perspectives, shimmering masses of color, androgynous symbols, and vast realms of arcane electronic voodoo. There are endless zooms into quivering video centers, rectangles within rectangles of vanishing imagery. In mid air the man's body becomes a videotronic ghost filled with vibrating silvery shock waves. A simple motion is shattered into a thousand mirror images reverberating into infinity. Intersecting space grids completely demolish perspectival logic. Positive becomes negative, up becomes down, inside is out and outside is in.

In making *The Leap*, DeWitt first shot approximately one-hundred and fifty feet of high contrast, black-and-white film that was processed through a video system. "By compounding the imagery through the video mixing panel I expanded the image material into about eight-hundred feet," he said. "While the film was running through the system, I added effects by keying, wiping, and debeaming, inserting images into each other. One of the film-chain monitors had a camera on it, so whenever I switched to that camera I got a feedback. That studio had only two monitors for four film projectors and two slide projectors, so some of the calls were blind, based on what I thought was back on the film chain. I could see the final mix on monitors, plus one of the two sources coming in from film chains, plus images coming in from a videotape recorder we started to use after the first session. So at about three layers deep it

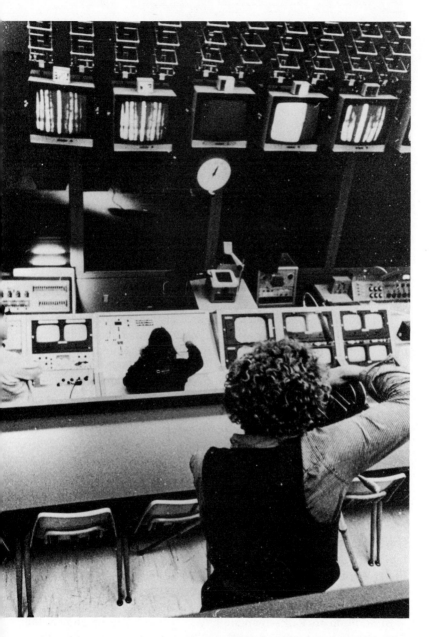

Scott Bartlett filming Tom DeWitt at work in television control room. Photo: William Bishop.

got pretty complex. I was very happy because I was penetrating an area that was completely new to me; but if I were doing it over again I'd want more control. I'd want to see all the images feeding in; I'd want synchronization between the images, and I'd master roll the images before I put them in."

During fifteen hours of studio time DeWitt was assisted by an engineer who operated the videotape machines, an engineer operating the two film chains, and a man on the feedback camera. DeWitt made all aesthetic decisions at the master control panel. "One of the main things I like about video," he explains, "is the immediacy of seeing what you're doing, which is a tremendous balancing effect because you can make decisions on the spot which feed back into the work you're creating. It's much more spontaneous than working in film, where you're never really sure what the results will be until you get the film back. Plus the effects built into television which are very difficult to get in film, particularly keying and wipes."

The master tape was re-edited as a whole before a kinescope was made. The kinescope was edited through conventional film techniques, and color was added on DeWitt's home-made optical printer. This footage was edited once again, and finally an electronic sound track was made by Manny Meyer, who composed the track for *OFFON*. "I wanted to express an emotion," DeWitt said. "Certainly you're triggering something in the unconscious when you start playing with space/time alterations."

## Jud Yalkut: *Paikpieces*

Recognized as one of the leading intermedia artists and filmmakers in the United States, Jud Yalkut has collaborated with Nam June Paik since 1966 in a series of films that incorporate Paik's television pieces as basic image material. Yalkut's work differs from most videographic cinema because the original material is videotape, not film. They might be considered filmed TV; yet in each case the video material is selected, edited, and prepared specifically for filming, and a great deal of cinematic post-stylization is done after the videographics have been recorded.

In addition to Paik's own slightly demonic sense of humor, the films are imbued with Yalkut's subtle kinaesthetic sensibility, an ultrasensitive manipulation of formal elements in space and time.

Jud Yalkut: *Paikpieces. (Left column)*
*Beatles Electroniques.* 1967. VTR/
16mm. film. Black and white. 3 min.
*(Right column) Videotape Study No. 3.*
1968. VTR/16mm. film. Black and
white. 5 min.

Paik's electro-madness combined with Yalkut's delicate kinetic consciousness result in a filmic experience balanced between video and cinema in a Third World reality.

The two films illustrated here—*Beatles Electroniques* and *Videotape Study No. 3*—are part of a forty-five-minute program of films by Yalkut and Paik, concerning various aspects of Paik's activities. The other films include $P+A-I=(K)$, a three-part homage to the Korean artist, featuring his concert Happening performances with Charlotte Moorman, Kosugi, and Wolf Vostell; his robot *K-456* walking on Canal Street in New York; and his color television abstractions. Other films in the *Paikpieces* program are *Cinema Metaphysique,* a nontelevision film in which the screen is divided in various ways: the image appears on a thin band on the left side, or along the bottom edge, or split-screen and quarter-screen; and two other films of Paik's video distortions, *Electronic Yoga* and *Electronic Moon,* shown at various intermedia performances with Paik and Miss Moorman.

*Beatles Electroniques* was shot in black-and-white from live broadcasts of the Beatles while Paik electromagnetically improvised distortions on the receiver, and also from videotaped material produced during a series of experiments with filming off the monitor of a Sony videotape recorder. The film is three minutes long and is accompanied by an electronic sound track by composer Ken Werner, called *Four Loops,* derived from four electronically altered loops of Beatles sound material. The result is an eerie portrait of the Beatles not as pop stars but rather as entities that exist solely in the world of electronic media.

*Videotape Study No. 3* was shot completely off the monitor of the videotape recorder from previously collected material. There are two sections: the first shows an LBJ press conference in which the tape was halted in various positions to freeze the face in devastating grimaces; the second section shows Mayor John Lindsay of New York during a press conference, asking someone to "please sit down," altered electronically and manually by stopping the tape and moving in slow motion, and by repeating actions. The sound track is a political speech composition by David Behrman. In his editing of these films, Yalkut has managed to create an enduring image of the metaphysical nature of video and its process of perception.

## Ture Sjölander, Lars Weck, Sven Höglund:
## Video Monument in Sweden

In the fall of 1967, intermedia artists Ture Sjölander and Lars Weck collaborated with Bengt Modin, video engineer of the Swedish Broadcasting Corporation in Stockholm, to produce an experimental program called *Monument*. It was broadcast in January, 1968, and subsequently has been seen throughout Europe, Asia, and the United States. Apart from the technical aspect of the project, their intention was to develop a widened consciousness of the communicative process inherent in visual images. They selected as source material the "monuments" of world culture—images of famous persons and paintings.

The program was created in the form of a black-and-white videographic film, made with the telecine projector from other film clippings and slides. The films and slides first were recorded on videotape and then back onto film for further processing. Image distortions occurred in the telecine process of recording film on videotape. The basic principle involved was the modulation of the deflection voltage in a flying-spot telecine, using sine and square impulses from a wave-form generator. With the flying-spot method used by Swedish television, the photographic image is transformed into electrical signals when the film is projected toward a photocell with a scanned raster as the source of light. The deflection voltage regulates the movement of the point of light that scans the screen fifty times per second.

In the production of *Monument*, the frequency and amplitude of the flying-spot deflection was controlled by applying tones from the wave-form generators. Thus image distortions occurred during the actual process of transforming original image material into video signals, since the scan that produces the signals was electromagnetically altered. In principle this process is similar to methods used by Nam June Paik and others, except that the Swedish group applied the techniques at an early stage in the video process, before signal or videotape information existed.

After the videotape was completed from various film clips, a kinescope was made, which was edited by Sjölander and Weck into its final form. The result is an oddly beautiful collection of image

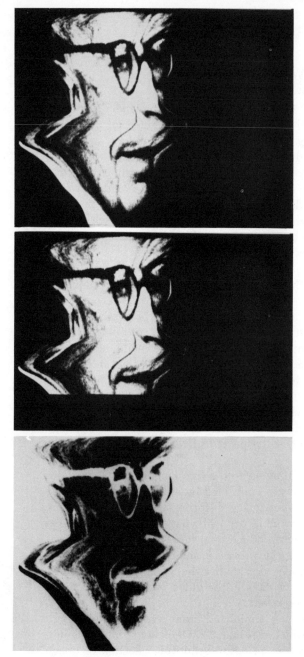

The King of Sweden as seen in videographic film *Monument* (1967), by Ture Sjölander and Lars Weck.

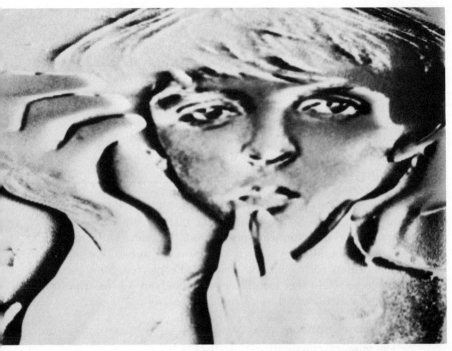

Paul McCartney in *Monument*.

sequences unlike any other video art. We see the Beatles, Charlie Chaplin, Picasso, the *Mona Lisa*, the King of Sweden, and other famous figures distorted with a kind of insane electronic disease. Images undergo transformations at first subtle, like respiration, then increasingly violent until little remains of the original icon. In this process, the images pass through thousands of stages of semicohesion, making the viewer constantly aware of his orientation to the picture. The transformations occur slowly and with great speed, erasing perspectives, crossing psychological barriers. A figure might stretch like Silly Putty or become rippled in a liquid universe. Harsh bas-relief effects accentuate physical dimensions with great subtlety, so that one eye or one ear might appear slightly unnatural. And finally the image disintegrates into a constellation of shimmering video phosphors.

More than an experiment in image-making technologies, *Monument* became an experiment in communication. *Monument* became an image-generator: newspapers, magazines, posters, record

albums, and even textile factories began using images from the videographic film. Sven Höglund, a well-known Swedish painter, entered the project after the film was completed. He made oil paintings based on the *Monument* images because he found them "parallel to my own creative intentions; I had for a long time been working on problems concerning transformations of forms. My painted versions of the images became another phase of the experiment in communication called *Monument*.

"Other phases were silk-screen prints, illustrated magazine articles, posters, giant advertisements. In each phase *Monument* experiments with pictures in their relation to spectators. The common denominator is the mass-media picture, especially the most commonly seen pictorial representation, the television picture. The pictures in the film are so well known to the public that they have been invested with symbolic meaning. People recognize them and are able to retain this identification throughout all the transformations and variations of the electronic image."

## Lutz Becker: *Horizon*

The young German artist Lutz Becker began experimenting with video feedback techniques in 1965 at the age of twenty-four. In the period 1967–68 he produced three films of these experiments as a student in the film department of the Slade School of Fine Art, London, in collaboration with the BBC. *Experiment 5, Cosmos,* and *Horizon* are little more than documents of the cathode-ray tube experiments and thus are not particularly significant as examples of videographic cinema per se. They do, however, clearly demonstrate the degree of control and precision that is possible in this technique, and will serve to illuminate our conception of it.

In cooperation with BBC engineer A. B. Palmer, Becker began his experiments by focusing a TV camera on the blank white raster of its own monitor—the pictureless glowing rectangle produced by a constant strength of electrons. A point of light appearing momentarily on the monitor as a result of unavoidable "camera noise" will be picked up by the camera and reproduced again on the screen. If the monitor raster and camera raster are suitably registered, the reproduced point will coincide in position with the original and will be sustained as the cycle repeats. Depending on the total *gain*

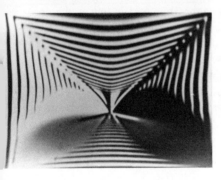

Lutz Becker: *Horizon.* 1968. Video
feedback. 16mm. Color. 5 min. Tightly
controlled phasing between a TV
camera and its own output monitor.

around the feedback loop—that is, the video signal's tendency to exceed the electrical limits of the equipment—the point brightness will either increase until limited in some way, or decrease to extinction.

If the two rasters are deliberately placed slightly out of register, the reproduced point then appears alongside the original, the next alongside that, and so on. The visible effect is that the point of light moves across the picture as the positional errors are integrated. The direction and velocity of the movement depend on the direction and degree of misregistration. The point can be made to move horizontally or vertically by shifting the registration between the two rasters in horizontal or vertical modes. Changes of raster amplitude (adjusting the strength of the picture signals) produce either a convergent or divergent motion in the picture. If one raster is tilted relative to the other, the movement becomes circular.

By combining these raster-misregistration feedback techniques with careful adjustment of camera controls Becker achieved a wide variety of concrete motion graphics, which he describes as "sustained oscillations in two dimensions." Further effects were realized by reversing the magnetic field of one raster scan. Original signals on the left were reproduced on the right, then on the left, and so on. The pattern thus achieved is symmetrical around a central vertical line. Further convolutions were obtained by combining scan reversals with raster misregistrations. These are some of the feedback possibilities employing only a blank scanned raster and attendant noise patterns. An entirely different range of effects can be obtained if a second and a third video source are introduced into the feedback loop.

# Closed-Circuit Television
## and Teledynamic Environments

"Television can't be used as an art medium," claims Les Levine, "because it already *is* art. CBS, NBC, and ABC are among the greatest art producers in the world." The art of which he speaks is the art of communication. And, after all, art always has been communication in its most eloquent form. But until television, artists have been inventors first and communicators second. Artists have created things to be communicated: they have not created communication. But television is neither an object nor a "content." Television is the art of communication itself, irrespective of message. Television exists in its purest form between the sender and the receiver. A number of contemporary artists have realized that television, for the first time in history, provides the means by which one can control the movement of information throughout the environment.

In this respect television is not fundamentally an aesthetic medium, at least not as we've traditionally understood the term. It's an instrument whose unique ability is, as its name implies, to transport audio-visual information in real time through actual space, allowing face-to-face communication between humans or events physically separated by continents and even planets. The self-feeding, self-imaging, and environmental surveillance capabilities of closed-circuit television provide for some artists a means of engaging the phenomenon of communication and perception in a truly empirical fashion similar to scientific experimentation.

This approach to the medium may in fact constitute the only pure television art, since the teleportation of encoded electronic-signal information is central to its aesthetic. The actual transmission of information across space/time is not an issue when video equipment is used only for aesthetic manipulation of graphic images as in synaesthetic videotapes and videographic films. I use the term teledynamic environment to indicate that the artist works directly with the dynamics of the movement of information within physical and temporal parameters. The physical environment is determined

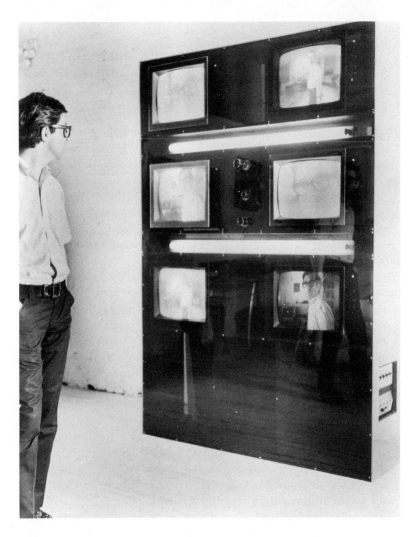

Les Levine with *Iris.* 1968. Three TV
cameras and six monitors in an eight-by-five
console. Collection of Mr. and Mrs. Robert
Kardon, Philadelphia, Pennsylvania.

by the characteristics of the closed-circuit video system. The artist is concerned not so much with what is being communicated as with *how* it's communicated and the awareness of this process. Thus television becomes the world's first inherently objective art form.

## Les Levine: *Iris*

"Machines that show the human organism itself as a working model," says Les Levine, "may eventually destroy the need for psychology as we know it today." Essentially an intermedia artist who works in plastics, alloys, and disposables, Levine was among the first conceptual artists on the New York scene focusing more on idea than icon. Naturally he turned to television, the most conceptual of all creative media. As a video artist Levine is best known for two closed-circuit teledynamic systems, *Iris* (1968) and *Contact: A Cybernetic Sculpture* (1969).

In both works the motivation is somewhat psychological: Levine is fascinated by the implications of self-awareness through the technologically-extended superego of the closed-circuit TV. "I don't tend to think of my work purely in psychological terms," he explains, "but one must assume some psychological effect of seeing oneself on TV all the time. Through my systems the viewer sees himself as an image, the way other people would see him were he on television. In seeing himself this way he becomes more aware of what he looks like. All of television, even broadcast television, is to some degree showing the human race to itself as a working model. It's a reflection of society, and it shows society what society looks like. It renders the social and psychological condition of the environment visible to that environment."

In *Iris*, three concealed cameras focus on an environment (one's living room, for example) in close-up, middle-distance, and wide-angle. These images are displayed on six black-and-white TV tubes mounted in an eight-foot console that also houses the cameras. Combinations and distortions of images interact from screen to screen in a kind of videotronic mix of the physical and metaphysical elements of the environment. Seeing three different views of oneself in combination with three others is a unique experience.

"Looking at *Iris*," he remarked, "many people are greatly surprised at the way they actually look. They see themselves the way

they usually see other people on television, and they have to make some kind of judgment about themselves in terms of themselves as a piece of information. That's what *Iris* does most of all, it turns the viewer into information. The viewer has to reconsider what he thought about himself before. He must think about himself in terms of information. You notice people in front of *Iris* begin to adjust their appearance. They adjust their hair, tie, spectacles. They become aware of aspects of themselves which do not conform to the image they previously had of themselves."

*Contact: A Cybernetic Sculpture* continues the principles of *Iris* on a somewhat expanded scale. It involves eighteen monitors and eight cameras mounted in a sleek eight-foot stainless steel console, nine monitors and four cameras on each side beneath plastic bubble shields. As in *Iris,* the cameras produce close-ups, mid-range and wide-angle views as images shift from screen to screen every few seconds. Each monitor screen is covered with a colored acrylic gel so that a given image may be seen in nine different colors as it swirls through the closed-circuit system.

"*Contact* is a system that synthesizes man with his technology," Levine states. "In this system, the people are the software. It relies totally on the image and sensibility of the viewer for its life. It is a responsive mechanism and its personality reflects the attitudes of its viewers. If they are angry, the piece looks angry. Contact is made not only between you and your image, but how you feel about your image, and how you feel about that image in relationship to the things around you. The circuit is open."

Levine is rather indifferent to the physical structure of the consoles that house his video systems. "I don't tend to consider my work in aesthetic terms," he says. "I don't make a work with any aesthetic principles in mind. If it happens to be a nice object to look at, that's fine. What a TV set looks like is only of value in terms of iconic imagery. However, what comes on the TV set is the real intelligence of the object, which has no intelligence until the software is injected into it. People don't look at the TV set, they look at the tube and the tube is always pretty much the same shape. But television is constantly re-wiping itself and printing over all the time, so that depending on what information is available at any given moment the image will be different. So there's really no

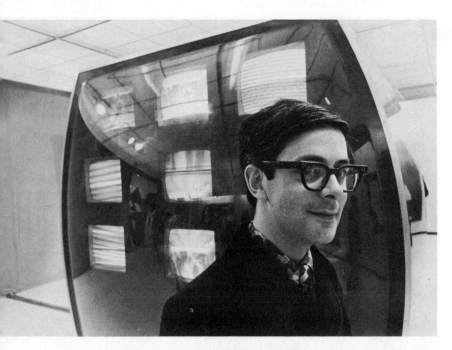

Les Levine with *Contact: A Cybernetic Sculpture.*
1969. Photo: courtesy of Museum of
Contemporary Art, Chicago, Illinois.

image, no definite image. One could equate it, because of its flexibility, with looking at a person sitting in a chair: he looks as he always looks except that his behavior changes your image of him. Television has this quality: it always somehow looks the same, but it's always doing something different."

### Frank Gillette, Ira Schneider: *Wipe Cycle*

Unlike Levine's work, the effect of *Wipe Cycle,* by the young New York artists Frank Gillette and Ira Schneider, was to integrate the viewer and his local environment into the larger macrosystem of information transmission. *Wipe Cycle* was first exhibited at the Howard Wise Gallery in New York in 1969. It consisted of nine monitors whose displays were controlled by synchronized cycle patterns of live and delayed feedback, broadcast television, and taped programming shot by Gillette and Schneider with portable

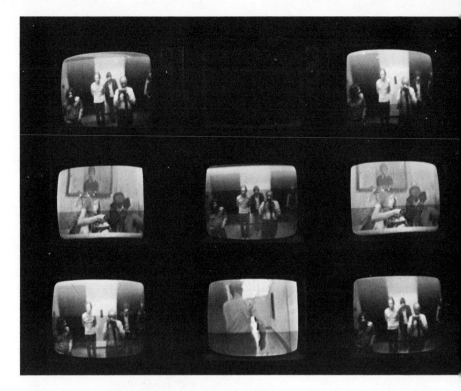

Frank Gillette and Ira Schneider: *Wipe Cycle.*
1969. TV camera, closed-circuit system,
nine monitors, tapes, broadcasting. Photo: courtesy
of Howard Wise Gallery, New York.

equipment. These were displayed through alternations of four pro-
grammed pulse signals every two, four, eight, and sixteen seconds.
Separately, each of the cycles acted as a layer of video information,
while all four levels in concert determined the overall composition
of the work at any given moment.

"The most important function of *Wipe Cycle,*" Schneider ex-
plained, "was to integrate the audience into the information. It was
a live feedback system which enabled the viewer standing within its
environment to see himself not only now in time and space, but also
eight seconds ago and sixteen seconds ago. In addition he saw
standard broadcast images alternating with his own delayed/live
image. And also two collage-type programmed tapes, ranging from

a shot of the earth, to outer space, to cows grazing, and a 'skin flick' bathtub scene."

"It was an attempt," Gillette added, "to demonstrate that you're as much a piece of information as tomorrow morning's headlines— as a viewer you take a satellite relationship to the information. And the satellite which is you is incorporated into the thing which is being sent back to the satellite. In other words, rearranging one's experience of information reception."[8] Thus in *Wipe Cycle* several levels of time and space were synthesized into one audio-visual experience on many simultaneous frequencies of perception. What is, what has been, and what could be, were merged into one engrossing teledynamic continuum and the process of communication was brought into focus.

## Allan Kaprow: *Hello*

The elements of randomness and chance, which Allan Kaprow has explored so successfully in his Happenings and environmental events, were brought into play in a television experiment conducted by Kaprow with the unique facilities of WGBH-TV in Boston for "The Medium Is the Medium." The station has direct closed-circuit inputs from a number of locations in the Boston-Cambridge area: a line to M.I.T., another to a hospital, another to an educational videotape library, and a fourth to Boston Airport. These were interconnected with five TV cameras and twenty-seven monitors that Kaprow utilized as a sort of sociological conduit, demonstrating the possibilities of creativity in the act of videotronic communication, including obstacles to communication.

Groups of people were dispatched to the various locations with instructions as to what they would say on camera, such as "Hello, I see you," when acknowledging their own image or that of a friend. Kaprow functioned as "director" in the studio control room, ordering channels opened and closed randomly. If someone at the airport were talking to someone at M.I.T., the picture might suddenly switch and one would be talking to doctors at the hospital. Thus not only the process of communication was involved, but the elements of choice and decision-making as well. Kaprow has suggested a

[8] From an interview with Frank Gillette and Ira Schneider by Jud Yalkut in "Film," *East Village Other*, August 6, 1969.

global form of *Hello*, interconnecting continents, languages, and cultures in one huge sociological mix. The information transmitted in *Hello*, he emphasized, was not a newscast or lecture but the most important message of all: "Oneself in connection with someone else."

"Shall we . . . use the new art as a vehicle for a new message and express the human longing which light has always symbolized, a longing for greater reality, a cosmic consciousness, a balance between the human entity and the great common denominator, the universal rhythmic flow?"

THOMAS WILFRED

# The Artist as Ecologist

For some years now the activity of the artist in our society has been trending more toward the function of the ecologist: one who deals with environmental relationships. Ecology is defined as the totality or pattern of relations between organisms and their environment. Thus the act of creation for the new artist is not so much the invention of new objects as the revelation of previously unrecognized relationships between existing phenomena, both physical and metaphysical. So we find that ecology is art in the most fundamental and pragmatic sense, expanding our apprehension of reality.

Artists and scientists rearrange the environment to the advantage of society. Moreover, we find that all the arts and sciences have moved along an evolutionary path whose milestones are Form, Structure, and Place. In fact, man's total development as a sentient being can be said to follow from initial concerns with Form or surface appearances, to an examination of the Structure of forms, and finally to a desire to comprehend the totality of relationships between forms, that is, Places. Since it generally is thought that art represents the avant-garde of human insight, it is interesting to note that science itself has evolved through Form, Structure, and Place appreciably in advance of the arts.

The conception of the principle of the atom by the Epicureans in Greece approximately 2,000 years ago began that stage of science chiefly concerned with Form, which included the contributions of Euclid, Descartes, Copernicus, and Kepler. The Structural phase of science might be epitomized by Newton and Clerk Maxwell, although we must leap forward in time and include Rutherford and Bohr, who found a structural model for the atom in the planetary system. The stage of science that I've designated as Place is represented by Einstein and Max Planck, and has to do with space/time, synergy, and entropy, all of which subsume both Form and Structure.

If further evidence is desired, one need only examine the technology of the respective scientific eras. As Bronowski has pointed out, a characteristic invention of the Scientific Revolution was the

telescope, which Galileo demonstrated in 1609, a tool for perceiving form. A characteristic invention of the Industrial Revolution was the power machine to perform the routine work of the human muscle, thus a structural tool. And the characteristic invention of the Cybernetic Revolution into which we are moving is the digital computer, which does the routine work of the human brain: the cerebral realm is the "Place" in which all experience resides.

It is interesting to note that the terms *economy, ecumenical,* and *ecology* share a common Greek root: *oikos,* a house. Following a period of Karmic Illusions (pre-Space Age history), the Renaissance Man emerges from his cocoon with difficulty (the generation gap) to find himself the master of a whole house and attendant guest cottage (the moon), and with nothing to do—the Leisure Problem. So the artist, not the politician, finally is accepted as the true legislator of mankind. Today's artists work empirically with problems of leisure and decision-making. Men like Robert Rauschenberg, Robert Morris, and Robert Whitman are concerned more with the personal responsibility of their audience than with creating objects to be "owned," since ownership is seen as an irresponsible concept when the obvious need is for global synergy. So we see that Duchamp's penetrating description of art as "defined by context and completed by the spectator's response" anticipated the present symbiosis of artist and ecologist.

That description also anticipated the burgeoning of intermedia art as one of the most significant developments of twentieth-century society. Buckminster Fuller has differentiated *mind* from *brain* by demonstrating that the brain performs "special case" functions on individual, discrete bits of information, whereas mind is concerned with "general case" metaphysical relationships and implications. In our discussion of intermedia art I intend to present the general case. This approach begins with the word itself: I might have used *mixed media,* certainly a more common and identifiable term; but an environment in which the organisms are merely mixed is not the same as an environment whose elements are suffused in metamorphosis.

During the 1960's a group of artists and engineers, working under the name USCO, pioneered in the development of multimedia performances and kinaesthetic events throughout the United States, Canada, and Europe. More recently, Gerd Stern and other members

of USCO have joined with a group of behavioral scientists from Harvard University to form the Intermedia Systems Corporation, whose purpose is to ". . . explore multi-channel audio-visual techniques and design of facilities, hardware and software" primarily for use in education, but with a view toward entertainment *as* education. Since education is the obvious direction in which virtually all communication is trending, perhaps this group's definition of the word intermedia would be most appropriate here: "Intermedia refers to the simultaneous use of various media to create a total environmental experience for the audience. Meaning is communicated not by coding ideas into abstract literary language, but by creating an emotionally real experience through the use of audio-visual technology. Originally conceived in the realm of art rather than in science or engineering, the principles on which intermedia is based are grounded in the fields of psychology, information theory, and communication engineering."

For some time now it has been clear that intermedia art is trending toward that point at which all the phenomena of life on earth will constitute the artist's palette. It is the purpose of this chapter to illuminate the direction of that trend and to cite a few pertinent examples. As with all other Paleocybernetic phenomena, the direction is simultaneously toward inner and outer space, the microcosm and the macrocosm. On the one hand, intermedia environments turn the participant inward upon himself, providing a matrix for psychic exploration, perceptual, sensorial, and intellectual awareness; on the other hand technology has advanced to the point at which the whole earth itself becomes the "content" of aesthetic activity. The term "light show" must now be expanded virtually to include the aurora borealis, since hemispherical lumia displays are possible in the creation of artificial plasma clouds in space (see color plates), the launching of rockets to generate atmospherical events, or urban environmental generators such as Nicholas Schoffer's monumental *Cybernetic Light Tower,* which transforms the skies of Paris into panoramic fantasias of color.

Implicit in this trend is another facet of the new Romantic Age. The new consciousness doesn't want to dream its fantasies, it wants to *live* them. The child of the Paleocybernetic Age intuits that his life could be a process of nonordinary realities if the energies of the

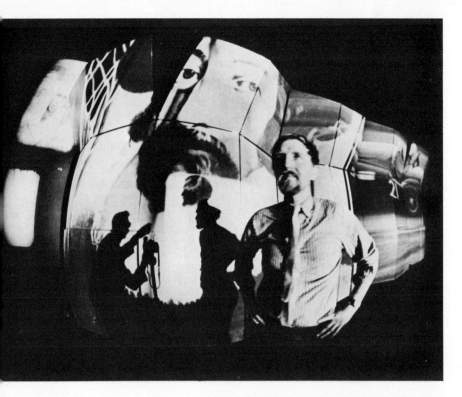

Stan VanDerBeek with multifaceted surface for multiple-projection intermedia environment. Photo: Richard Raderman.

globe were properly distributed. We're developing all these fabulous hardware systems that soon will make life a process of continual myth-generation for the individual as well as the collective ego.

"We're just fooling around on the outer edges of our own sensibilities," says Stan VanDerBeek.

Unconsciously we're developing memory storage and transfer systems that deal with millions of thoughts simultaneously. Sooner than we think we'll be communicating on very high psychic levels of neurological referencing. It's becoming extremely rich. This business of being artist in residence at some corporation is only part of the story; what we really want to be is artist in residence of the world, but we don't know where to apply. Major

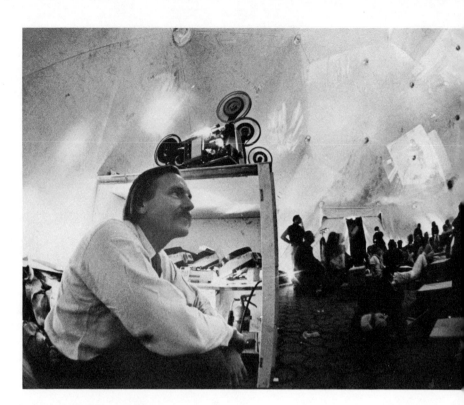

Stan VanDerBeek presides over intermedia
presentation at his Movie Drome in Stony
Point, N.Y. Photo: Bob Hanson.

internationalizing by artists is going to become very important, and so will
the myth-making process. What we're looking for in some sociologically
appropriate way is a third side to each confrontation: a way to deal with
each other through a medium.

All media, like the automobile and telephone, are essentially a third
party which relates us to whatever else it is we're doing. I think the
student riots are a manifestation of a deep-seated awareness of this prob-
lem. There's such a contagiousness now with rioting; I think we realize
that rarely do we directly deal with issues, personally, physically, inti-
mately, with real body contact. That could easily be the cause, or at least
partial cause, of the riots. We suddenly realize that riots may be the only
real form of theatre left in which we're not just an audience.

But, you see, being an audience is necessary. A major factor in living
in an overpopulated world is that we really *cannot* deal with each other

directly. As the Japanese do, for example. They've spent thousands of years cultivating this idea that they're there but they're not there. Because they've been jammed together for a long time, they've learned how to do it. Now our culture is moving in that direction also. That's one reason for all these transfer systems—photo-reality, mock-reality, artificial intelligence, whatever term you choose—are spontaneously and unconsciously evolving. It's a tremendous urgent unconscious need to realize that we can't really see each other face to face. We only see each other through the subconsciousness of some other system. Cybernetics and the looping-around of the man/machine synergy are what we've been after all along. Who knows, but certainly for the last thousand years man has been inching toward that point, and now we're running full speed. And, of course, the machines we're running toward can trip us up as easily as not. We really can't be certain. But movies are the ultimate illusionistic system. I'm working more and more with tools that show it can go far beyond its present form. Holograms obviously are a key direction to go into: where things are stored on a molecular level.

# World Expositions and Nonordinary Reality

In this forthcoming global activity of continual myth-generation, dramatic-fiction cinema will find a new and vital role to play. Although obsolete in one respect it will become enriched in another. While videotape cartridges and cable television will bring conventional cinema into the home on an individual level, society will seek its communal mythic experiences in elaborate intermedia environments found today only at world expositions where the average citizen is able to experience, for a limited time, the wealth and inventiveness that is kept from him in everyday existence.

"There's a basic human need for a communal experience of vision," observes Roman Kroitor, who developed the spectacular *Labyrinthe* for Expo '67 at Montreal. Kroitor's Canadian firm, Multiscreen Limited, has perfected a revolutionary projection system to be included in a chain of local theatres with screens seven stories high. The process, originally called Multivision, was developed for Expo '70 in Osaka. It involves 70mm. film projected horizontally rather than vertically. Through what is known as the "rolling loop" or "loop-wave" method of film transport, the Multivision projector throws an image as high as the ordinary 70mm. frame is wide (each frame of Kroitor's film is the size of a postal card and has fifteen sprocket-hole perforations). The rolling-loop system removes virtually all tension from the film during transport through the projector at 336 feet per minute, stopping and starting every twenty-fourth of a second. Thus it is possible to project a seven-story image of perfect steadiness and crystal clarity.

As the name Multivision implies, the movie contains from three to several dozen independently-moving images on the screen simultaneously, thus approaching on an environmental scale what had existed in 16mm. synaesthetic cinema for decades. Here, however, the synaesthetic experience is three times the size of Cinerama and encompasses a ninety-degree span of vision from any location in the theatre. "New kinds of storytelling and new audience tastes will result from this technology," Kroitor said. "People are tired of the standard plot structure. New film experiences will result, in

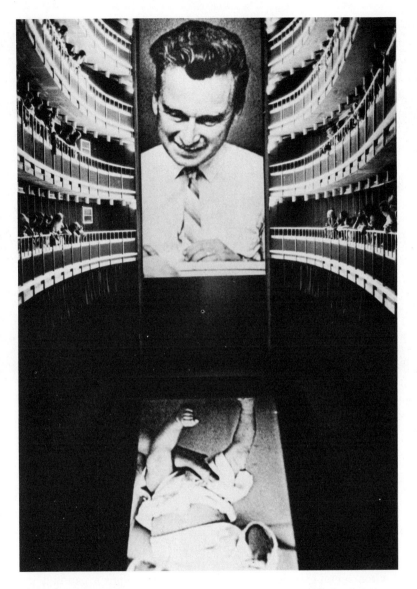

Chamber One of Roman Kroitor's *Labyrinthe* at Expo '67, Montreal, Canada. From eight balconies on four levels on either side of the space, the audience could see a huge screen on the floor and another perpendicular to it. Both screens were approximately forty feet long. Some 288 speakers surrounded the audience. Photo: courtesy of the National Film Board of Canada.

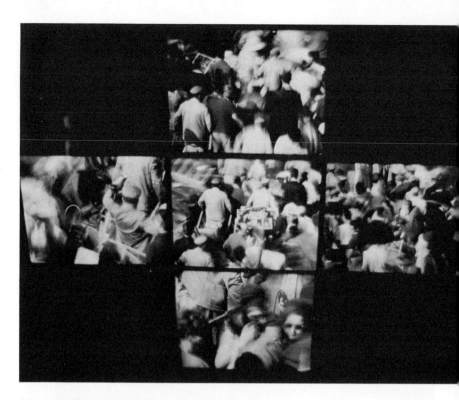

Chamber Three of *Labyrinthe,* in a five-screen
cruciform arrangement. Photo: courtesy
of the National Film Board of Canada.

which there'll be a tight relationship between the movie and the architecture in which it's housed. We took a step in that direction with *Labyrinthe.* A new language is going to develop. There are ways in which shaping the relationships of images cuts through the superficial realities and reaches for something deeper."

Francis Thompson, a pioneer in large-scale multi-image film techniques, currently is working toward both micro- and macro-environmental experiences. "We're interested in films expanding and swallowing a huge audience," he said, "but we're also interested in pictures the size of a wristwatch. We would like to make the world's smallest motion picture as well as the largest. As regards the idea of expanded cinema, I would like to make a theatre that would be a huge sphere, as big as Radio City Music Hall or larger, and seat the

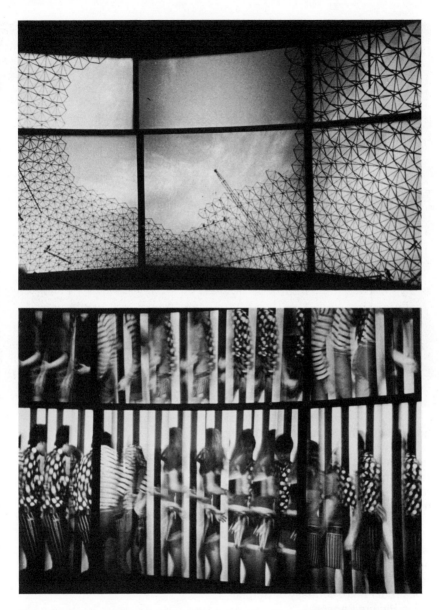

Two scenes from Francis Thompson's *We Are Young* for the Canadian Pacific–Cominco Pavilion at Expo '67. The six-screen arrangement covered a total area of 2,952 square feet. By comparison, normal commercial theatre screens average 450 square feet.

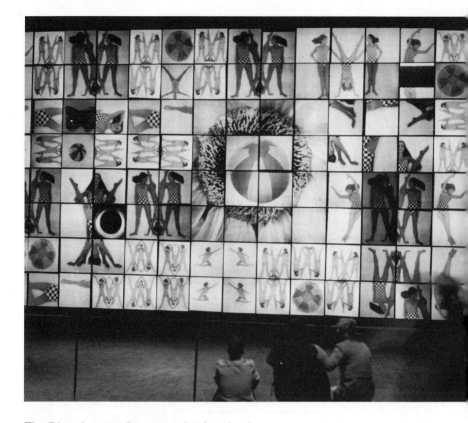

The Diapolyceran Screen at the Czechoslo-
vakian Pavilion at Expo '67. The 32 by 20
foot screen was composed of 112 rear-
projection cubes containing two slide
projectors each. In turn, each slide
projector was equipped with a tray of eighty
slides that could be changed in half a
second. Thus each cube was capable of
displaying 160 images in eighty seconds.
The entire wall could be one picture, or
sections of it could be delayed or speeded
as desired. Photo: courtesy of Bergen
Motion Picture Service.

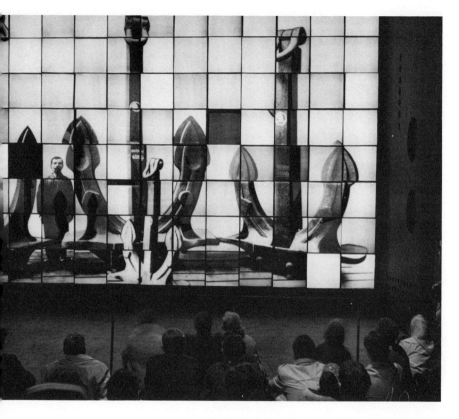

The Diapolyceran Screen, Expo '67. Photo:
courtesy of Bergen Motion Picture Service.

audience around one side of it: a series of balconies so everybody's in the front row. The audience would become part of the sphere. The picture comes around as far as you can see, and beneath you too.

"What I would like to see is a theatre with so great an area that you no longer think in terms of a screen: it's the *area* you're projecting on. Your images should come out of this great, completely-surrounding area and hit you in the eye or go off into infinity. So you're no longer working with a flat surface but rather an infinite volume."

Thompson's other major interest is the earphone/eyephone concept similar to the hoodlike training devices used in aircraft and aerospace navigation schools. A *mini-dome* or individual sphere is lowered over the head of the viewer. "You have images that completely fill your field of vision and sound that would fill your entire range of hearing." Thompson also finds in expanded cinema the potential for a new consciousness and life style. "Through formal relationships of images, most carefully planned, you can produce the most powerful kind of communication. With a great sphere you're introducing people into a whole new visual world which would be emotionally, physically, and intellectually overwhelming."

# Cerebrum: Intermedia and the Human Sensorium

The technology to produce such environments as Kroitor and Thompson describe has existed for some time; what has not been available is the necessary consciousness. Man has been so busy proving his right to live that he has not learned *how* to live. Thus we exist in an environment almost totally bereft of aesthetic sensibilities; we are conditioned by architecture of the most vulgar design; our entertainment is of the lowest level of conditioned response to formulas; our traditional mode of interpersonal relationships is practically bankrupt of integrity; the economic system forces us to act for "profit" rather than use; there is hypocrisy and violence everywhere. Disneyland is this culture's idea of a sensorium.

Yet the evolution of intermedia, from the primitive shadow show to Wilfred's color organs to the cybernetic phantasmagorias of contemporary world expositions, indicates an increasing human capacity to assimilate and comprehend more complex environmental stimuli. The existence of something like New York's "Cerebrum," therefore, is hardly surprising: it's one of many current phenomena that constitute a pattern-event toward the eupsychia that is implicit in the intermedia experience as a kind of sensory-stimulation laboratory.

Cerebrum is among the first indications of an imminent trend that simultaneously will transform and unite those disparate social experiences characterized by "nightclubs" on the one hand and "art galleries" on the other. Cerebrum is neither. There's nothing for sale at Cerebrum except time. And although certain synthetic events do occur, they are such that one's relative participation determines their effectiveness. So one could say that Cerebrum not only isn't an object, it doesn't even lay claim to an identifiable, marketable experience; that's because Cerebrum (the place) exists in cerebrum (the mind). Fundamentally, one purchases three hours of time in which to practice leisure, decision-making, interpersonal responsibility, body awareness, and sensory perception; Cerebrum's "guides" supply the necessary intermedia environment.

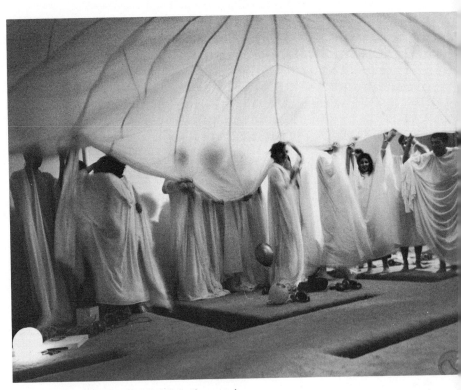

Sensory-kinetic multimedia experience at
Cerebrum in New York. Photo:
Ferdinand Boesch.

An evening at Cerebrum follows from Form to Structure to Place.
You get out of the cab in a sleazy slum neighborhood and ring a
buzzer. The door opens automatically and closes behind you, lock-
ing. You find yourself in a small black cubicle about four feet
square. A hidden speaker asks your name, and after a few minutes
one of the walls opens. You are led to an anteroom where you are
asked to remove your shoes. A boy and a girl, obviously nude
beneath diaphanous flowing gowns, lead you down a narrow cor-
ridor to a large white rectangular space.

This is the Form level: from a dark closet to a larger room, down
a narrow hallway to an open space. Next comes the Structural
experience: the floor actually is a raised, carpeted platform sec-
tioned into geometrical islands inset with electronic control panels.

These islands are approximately three feet above the real floor, and you are forced to pay close attention to where you step.

The guides lead you to a particular island (there are about ten of them, each accommodating four persons). You are instructed to put on a gown, and are invited to remove beneath it as much of your clothing as you desire. Glancing around, it becomes obvious that nearly everyone is nude beneath his gown, so you strip. The sensation is delicious, especially for men, who are not accustomed to being naked beneath a long silk gown. One is immediately self-conscious, but not embarrassed; one simply becomes fascinated with the feel of one's own body in its silken envelope.

The first half-hour of the three-hour "session" is spent adjusting to the environment, staring at bodies as they pass in silhouette, wondering what to do with yourself, and finally venturing off your island to walk among the other guests, feeling the air on your skin: this is the Place experience. A noticeably eclectic selection of music (from polkas to swing-era ballads, ragas, rock, symphonies) seems to come from nowhere in particular, and a cool passive light show plays ambiently across the walls and ceiling. Eventually, the guides pass around tambourines, gongs, triangles, and flutes, encouraging everyone to play along with the Muzak.

During this time I began to notice what for me was the most interesting aspect of the experience. People began to act out their fantasies, get into their own realities, perform anonymous little psychodramas. One refined-looking, silver-haired, middle-aged gentleman knelt and gazed lovingly at his matronly wife as she danced before him like Scheherazade, palms pressed together over her head, hips swaying in silhouette. It was, perhaps, a fantasy they had never realized in the privacy of their own bedroom. Elsewhere, a beautiful young girl who wouldn't remove her panties was "raped" by her husband, who peeled them off beneath her gown as his friend held her arms. She squealed in mock anger and false modesty, but an hour later could be seen twirling about the room like a ballerina, her gown flying far above her shapely hips.

Thus, for some, Cerebrum becomes an excuse to do and say things they might not otherwise attempt. The two examples I've cited occurred rather anonymously, and probably went unnoticed

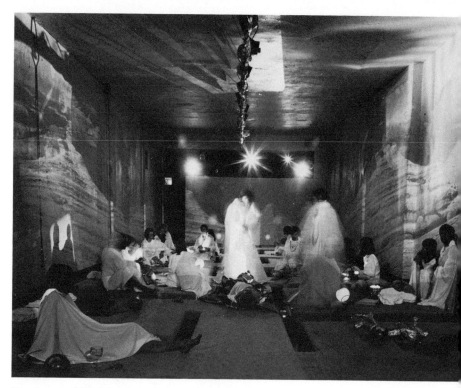

Cerebrum: "All the senses were stimulated in various subtle ways." Photo: Ferdinand Boesch.

by most of the guests. The nature of Cerebrum is such that it would be difficult to create an unpleasant scene.

I found the unisex effect of the gowns quite stimulating. At one point male guides came around with mint-flavored menthol ice that they smeared on our lips with their fingertips. "What does it taste like?" they inquired softly, as though not expecting an answer. This intimate contact with a complete stranger in a relatively "public" setting was a challenging experience, particularly for men, who are not as disposed as women to physical intimacies in public. The young men were followed by girls who daubed our foreheads with a similar skin-tingling substance. These sensual encounters had an ethereal, gentle, transcendental effect. One appreciates the delicacy and poise necessary to accomplish them without embarrassment.

Then the guides began collecting guests together in groups of six. They instructed us to form circles and clasp hands in the center, like spokes of a wheel. They squirted hand cream into the tangle of fingers as we closed our eyes and felt our hands melt into others, rubbing and squeezing anonymous flesh. We then lay on our backs, feet touching in the center of the circle, and wiggled our toes against one another as the guide squirted them with the slippery cream. The effect was extraordinarily erotic.

At one point a scented fog was released from beneath the platforms, filling the space with an eerie haze through which one could see ghostly figures moving and dancing. Needles of light from a mirror-globe cut through the fog like electrons in a cloud chamber; it was beautiful. Next a huge parachute was spread out; half of the guests lay on the floor beneath the parachute as the other half stood around its circumference, raising and lowering it to form a suction that lifted gowns, and exposed bodies, but no one cared; we just closed our eyes and enjoyed the sensation, rather like dreaming that one's bed is flying away.

All the senses were stimulated in various subtle ways: the touch and taste of the camphor ice on the lips, the slippery intermingling of hands and feet, the scent of the vapors, the kinetic stimulation of the light show and parachute, the visual alterations in the general level of luminosity that also affected one's perception of forms and distances. Bits of melon and fruit were passed around, as well as a communal mug of Coke. There was no sensation-numbing alcohol.

A kind of hypnotic centering took place when a giant balloon, anchored to an outlet in the center of the floor, began inflating slowly with a loud steady hiss. The balloon was illuminated from a spotlight on the floor beneath it and glowed eerily as the houselights were dimmed. Everyone sat in the lotus position and gazed as the luminescent sphere loomed above our heads. Then it was deflated just as slowly. A simple but effective experience.

At Cerebrum one is voyeur, exhibitionist, and participant. One is both male and female. One is a walking sensorium. Surely we can foresee that not-too-distant day when "nightclubs" will be operated by art dealers who commission artist-guides to create ecological-

experience places that will resemble Cerebrum in many respects. In other ways, however, the intermedia palaces of the near future will embrace bold new vistas of human experience. "I can envision a world in which people's lives are recorded," says intermedia artist Tom DeWitt, "and a massive amount of material is accumulated, vast libraries, and people who never meet other people but just spend their lives editing audio-visual records of their own existence. When you look at a mixed-media show there's an awful lot of information; it's beyond the comprehension capabilities of most people. But if it were an intermedia show made for an individual whose life was being portrayed, he could relate to it. I can imagine people having traumatic experiences in such an environment and coming to some idea of who they really are." In the pages that follow I hope to demonstrate that intermedia art is but another path in man's ancient search for himself.

# Intermedia Theatre

Susan Sontag once defined the "two principal radical positions" in contemporary art as that which recommends the breaking down of distinctions between genres, and that which maintains or upholds those distinctions: on the one hand seeking a "vast behavioral magma or synaesthesis"; on the other hand pursuing "the intensification of what each art distinctively is." She concluded that the two positions are essentially irreconcilable except that "both are invoked to support a perennial modern quest—the quest for the definitive art form."[1]

Surely the definitive art form is not anti-environmental, as art must be when viewed in terms of genres: to isolate a "subject" from its environs by giving it a "form" that is art denies the natural synaesthetic habitat of that subject, physical or metaphysical, icon or idea. In the progression of art history through Form, Structure, and Place, the idea of art as anti-environment has long been surpassed. This is not to say that any activity that seeks to discover the essence of a medium is somehow disreputable; on the contrary, the exclusive properties of a given medium are always brought into sharper focus when juxtaposed with those of another.

Thus, in intermedia theatre, the traditional distinctions between what is genuinely "theatrical" as opposed to what is purely "cinematic" are no longer of concern. Although intermedia theatre draws individually from theatre and cinema, in the final analysis it is neither. Whatever divisions may exist between the two media are not necessarily "bridged," but rather are orchestrated as harmonic opposites in an overall synaesthetic experience. Intermedia theatre is not a "play" or a "movie"; and although it contains elements of both, even those elements are not representative of the respective traditional genres: the film experience, for example, is not necessarily a projection of light and shadow on a screen at the end of a room, nor is the theatrical experience contained on a proscenium stage, or even dependent upon "actors" playing to an "audience."

[1] Susan Sontag, "Film and Theatre," *Tulane Drama Review* (Fall, 1966), pp. 24–37.

## Carolee Schneemann: Kinetic Theatre

Pioneer intermedia artist Carolee Schneemann describes Kinetic Theatre as "my particular development of the Happening, which admits literal dimensionality and varied media in radical juxtaposition." She works with untrained personnel and various materials and media to realize images that range from the banal to the fantastic, images which, in her words, "dislocate, disassociate, compound, and engage our senses to allow our senses to expand into primary feelings, as well as the sensitive relatedness among persons and things." Through these methods she seeks "an immediate, sensuous environment on which a shifting scale of tactile, plastic, physical encounters can be realized. The nature of these encounters exposes and frees us from a range of aesthetic and cultural conventions."

Since 1956 Miss Schneemann has continually redefined the meaning of theatre. Though New York is her home, she has staged radical intermedia events throughout the United States, Canada, and Europe. Her best-known works include *Snows*, presented as part of New York's Angry Arts Festival in 1967; *Night Crawlers*, staged at *Expo '67* in Montreal; *Illinois Central* (1968); and the film *Fuses*. I asked what directions she will follow in future intermedia work.

CAROLEE: I'm moving more into technology and electronics. My long-range project is completely activated by the spectators. I'll sensitize the audience through a performance situation in which detailed film images are set off by the audience as they move into the performance environment. They'll activate overlapping timed projectors. If they want a film to be shown again they'll have to figure out what they did to make it start in the first place. These films will show detailed aspects of performance situations: touching, handling, moving. Then as the participants move in other directions the actual materials shown in the films will be introduced. They'll fall from the ceiling or be tossed out of boxes.

GENE: I take it you find film/actuality interactions effective in involving the audience.

CAROLEE: *Night Crawlers*, which I did at Expo '67, was very successful in this manner. I juxtaposed my Vietnam film with a

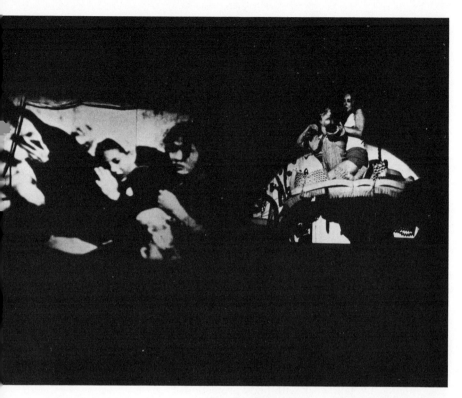

Carolee Schneemann: *Night Crawlers*. Expo '67. Live performers (*right*) contrasted with film projection.

little Volkswagen that drove in front of the film and stopped. It was stuffed with foam rubber. My partner and I performed a complex of physical handling on top of, and inside the VW while another person was pulling all the foam out. It was a very intimate and humorous event in front of this horrifying Vietnam film. Before it began, a girl and I went through the audience and stepped on their shoulders and knees and gave each person candy and cake. We spoke to them. They got very turned on by the whole thing. At the end we brought them into the performance area and played lights and sound around them. They found elements of the environment that they could start to tear down. They began rather hesitantly, but after they ripped a couple of

layers of paper there'd be a message greeting them, saying proceed, or directing them to paint cans. The point seems to be to let people work out of impulses that are blocked. If the situation is obvious they tend to be destructive. They're working in daily life with outmoded kinds of repressions and resistances. They tend to get violent. So we try to open up an empathy between them and what we're doing that they're not consciously anticipating.

GENE: Do you always use film in your theatre pieces?

CAROLEE: Yes, I tend always to use it in some aspect of an environmental performance situation, primarily because of the intensification of information it gives, which may just be sensory information. And I use it to transform the environment. I tend to use film very formally. Every element that goes into the environment I'm working with is very carefully shaped in terms of scale, time duration, what's going on in juxtaposition to a film. In *Illinois Central* there was a three hundred and sixty-degree visual environment that was changing and shifting all the time, composed of films and slides. And I like using slides against films because I can start and stop, overlap, black out, manipulate. I've been working with portable projectors so that the image can be shifted in space.

GENE: Do you work with body projections?

CAROLEE: Yes, and I find it always satisfying. I do a lot of performing just in the light of film projectors. So that it's a very compacted image and there are no peripheral distractions. It becomes central to the environment without your really having the sense of film, because the bodies or forms of people are quite embedded in it.

GENE: Do you make your own films or work with found images?

CAROLEE: I animated the Vietnam film, shot it from stills with various lenses so that it seems as if it's really moving. The images in that film were central to the development of *Snows*. My *Snows* movie begins with a very beautiful 1947 newsreel, a snowstorm, a fall of confetti during a parade, and ends with a car exploding and bursting into flames, then the Pope blessing people. One little horrific element after another: volcanic eruptions, ships going down . . . For my film *Viet Flakes* I shot a still of a Nationalist soldier shooting a Communist worker. It's in three sections: he

raises his gun, he leans forward, and the victim is lying there with a dark spot under his head. Then I got two newsreels of winter sports in Zürich during World War II while all hell was breaking loose everywhere else in the world. Then I made a little 8mm. film that played on our bodies, showed a New York blizzard and a car driving through the city. The projectors were either carried by hand or mounted on revolving stools.

GENE: How did you work with film for *Illinois Central?*

CAROLEE: I went out in advance and shot footage of empty horizons. Very slow, attenuated, linear footage. Then I borrowed about five hundred slides of the same landscape, this absence of form. And I used the slides stretched out against the film; while the film would have a certain kind of horizon line, I'd have six duplications of one slide horizon feeding into the film from all around the room. And then as the film shifted, slide images would shift. It wasn't decorative. I use films and slides as compacted metaphors. It compounds the basic range of emotive material. It concretizes the event, girds it in. While the live physical movements are ambiguous and emotional, the films lend a banal insistence.

GENE: How do you think of your work in terms of their objective and subjective aspects, actuality versus illusion?

CAROLEE: I've always thought that I'm creating a sensory arena, and what you describe as kinetic empathy is very basic to the process. Because the information, in terms of what we're able to feel, how much the audience is able to open up, be moved and touched—it's all completely of the moment. There's this strange sort of fulcrum of the individual sitting there without narrative or literary preparation to help him follow the action. It's all involved in sensory receptivity. And I'm bombarding them, I'm giving them more than they can possibly assimilate at any one point. Unlike painting, which used to be my medium, where you could take a great deal of time. And the thing is, with a static element, the audience is actually being more active. You choose the time duration and manner in which you experience the object. But my theatre pieces call forth a whole other range of response areas. At the end of *Snows* many people in the audience are crying, and they don't really know why, because it all happens with an incredible immediate speed and it's overwhelming.

GENE: Some critics feel that many of the arts explore sensory aware-
ness or perception well enough, but that one doesn't come away
with a knowledge of a subject having been learned.

CAROLEE: I know that criticism, but it doesn't bother me because it's
not a real criticism anymore. What I'm going more toward is not
merely a sensory or perceptual activation of the audience but an
actual physical involvement. There no longer can even be the
situation of performers who prompt or provoke the audience; we
must deal directly with the audience itself as performers. As
much as we so-called actors need to be performers, so they need
to become performers, they need to enact that situation them-
selves. They must give over a kind of trust in the situation and go
into it. I approach the audience with a great deal of care and
tenderness, never being physically aggressive. The media infor-
mation may be aggressive, but it's going to stimulate them in
ways that I have to be responsible for. So in terms of what that
media might provoke, I have to oversee it.

GENE: So in a sense one goes to the theatre for completely different
reasons than one used to; I hesitate to use the term "therapy," but
it seems to approximate something like that.

CAROLEE: We go to the theatre in search of inner realities because of
the bankruptcy of the myths and conventions we're used to deal-
ing with in everyday life.

GENE: Perhaps in the near future, the whole process of living will be
in this active seeking out of experiences.

CAROLEE: Right. What people really want is tactile confirmation, to
be in touch with their physicality, to be able to communicate, and
to grow, to touch one another and be touched. To get away from
the somnambulism of contemporary life. We get all this informa-
tion and there's absolutely no way to react. You're reading some
horror in your newspaper while eating your doughnut. And if you
were a natural animal you'd at least scream for fifteen minutes or
chop the sofa into bits—assuming that you can't go and change
the thing that the media tells you is an outrage. So we're trapped
with all these fears of real impotence.

GENE: What other kinds of environmental projections have you
done?

CAROLEE: Smoke, balloons, and buildings. In Montreal I did an

outdoor event in which we carried the projectors and moved films across buildings at night, the images breaking into planes and fragments. The basic condition for my work is that whenever I find out how something works, what makes it go, say in regard to technology or any kind of element—even a human being—then I want to change it. As soon as I saw what a frame was for film I wanted to break it. I didn't want to be stuck with that same rectangle.

## Milton Cohen: Space Theatre

Milton Cohen, primary creative force behind the famous ONCE group of Ann Arbor, Michigan, has, since 1958, been developing what he calls "Space Theatre," a highly original and effective environmental projection system for intermedia events. In fact Space Theatre is more concept than system, for Cohen continually modifies the hardware and architectural parameters of the theatre he has constructed in his studio. Yet the motive remains, as always, "to free film from its flat and frontal orientation and to present it within an ambience of total space."

The core of Space Theatre is a rotating assembly of mirrors and prisms adjustably mounted to a flywheel, around which is arranged a battery of light, film, and slide projectors. The movement of the mirror/prism flywheel assembly determines image trajectories as the projections are scattered throughout the performance environment. In the past, Cohen has positioned rectangular and triangular panels about the space, to serve both as screens and as strategic points for image interaction with live performers. Often these panels have also been mobile—revolving, folding, or tilting—operated mechanically or by hand in a manner responsive to the image being projected.

Cohen's most recent presentation was *Centers: A Ritual of Alignments*. Here the projection surface was a translucent circular core from which eight triangular screens radiated. Behind each screen was a photoelectric cell that activated sound and strobe-light events at various positions in the performance area. (Cohen often employs the amplified sound of the projection equipment itself as the aural complement of the imagery.) Behind the core, also described as the "target" area, was a slide projector.

Film imagery was basic to the performance. Cohen adapted pro-

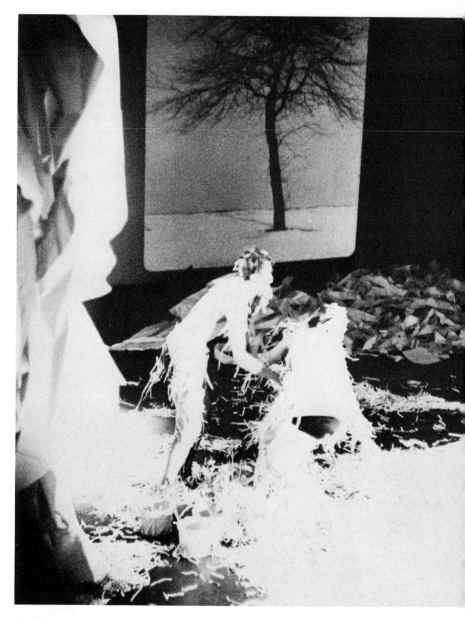

Carolee Schneemann: *Illinois Central*. 1968. "I've always thought
that I'm creating a sensory arena . . . we must deal directly
with the audience itself as performers." Photo: Peter Holbrook.

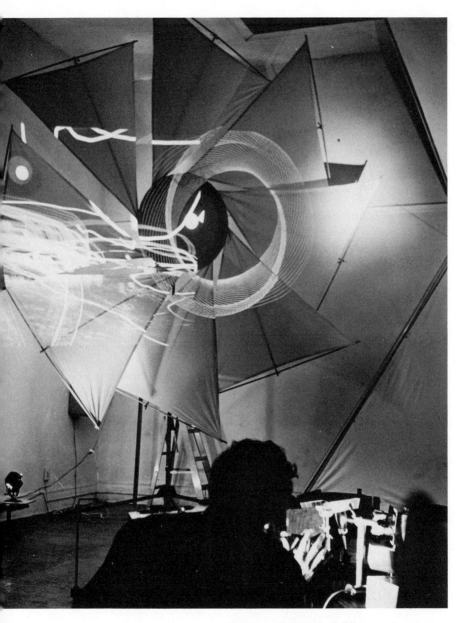

*Centers: A Ritual of Alignments,* as
performed by Milton Cohen in his Space
Theatre. 1969.

jectors to handle twelve-foot film loops projected sequentially on the fanlike screens, making one round every twenty seconds. Simultaneously various geometrical target patterns were rear-projected onto the core. The audience is seated on revolving stools in the twenty-foot area between the projection system and the screen. Their attention is polarized between the gyrating film and the free-floating slide imagery registering on walls and screens that define the total enclosure.

The multi-channeled sound is electronic, instrumental, and vocal, and moves in complex trajectories from speaker to speaker. The effect, according to Cohen, "is one of sound in flight; sound seeking target." This theme of seeking out the target is carried over into the visuals through the manipulation of the projection console in a discrete sequence of maneuvers that search out the center. "When and if this centering is won," Cohen explains, "the performance may proceed to the next film loop. But also ways must be discovered for other performers (live dance, live music, etc.) as well as the audience to contribute to the audiocentric and luminocentric probes. Ultimately there must be a common voyage for all to that identifying place which describes at once the center and the whole."

The ONCE group has explored structures other than Space Theatre. Perhaps the best known American intermedia theatre event was their *Unmarked Interchange* (1965), in which live performers interacted outrageously with the Fred Astaire–Ginger Rogers film *Top Hat* projected on a huge screen inset with movable panels, louvers, and large drawer-like sections. While a couple dined by candlelight at a table in one corner of the screen, a man read into a microphone from the pornographic novel, *Story of O,* at the opposite end of the projection surface; periodically a girl walked across a catwalk in the center of the screen and hurled custard pies in his face. In another opening, a man played a piano. And over all of this Fred and Ginger danced their way through 1930's Hollywood romantic escapism.

### John Cage and Ronald Nameth: *HPSCHD*

Computer-composed and computer-generated music programmed by John Cage and Lejaren Hiller during 1967–69 was premiered in a spectacular five-hour intermedia event called

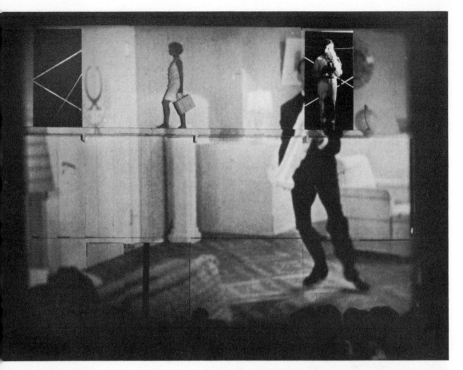

ONCE Group: *Unmarked Interchange.* 1965.
Live performers interact with projection of
*Top Hat,* starring Fred Astaire, Ginger
Rogers. Photo: Peter Moore.

*HPSCHD* (computer abbreviation for Harpsichord) at the University of Illinois in May, 1969. Computer-written music consisted of twenty-minute solos for one to seven amplified harpsichords, based on Mozart's whimsical *Dice Game* music (K. Anh. C 30.01), one of the earliest examples of the chance operations that inform Cage's work. Computer-generated tapes were played through a system of one to fifty-two loudspeakers, each with its own tape deck and amplifier, in a circle surrounding the audience. Cage stipulated that the compositions were to be used "in whole or in part, in any combination with or without interruptions, to make an indeterminate concert of any agreed-upon length."

The university's 16,000-seat Assembly Hall in which the event was staged is an architectural analogue of the planetary system: con-

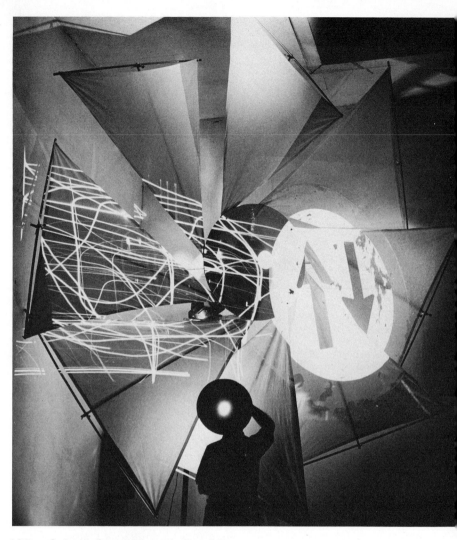

Milton Cohen's Space Theatre, Ann Arbor, Michigan. 1969. Sight and sound move in complex trajectories through a maze of shifting, revolving, faceted surfaces, seeking the target.

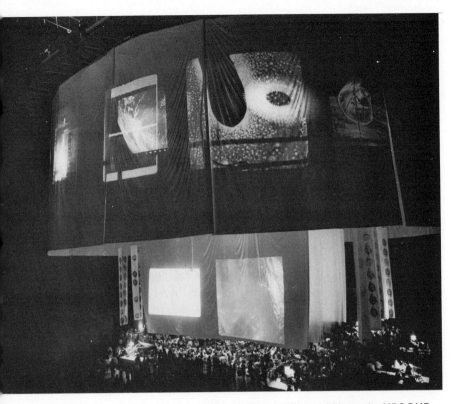

John Cage and Ronald Nameth: *HPSCHD.*
1969. Assembly Hall, University of Illinois,
Champaign-Urbana. Fifty-two loudspeakers,
seven amplified harpsichords, 8,000 slides,
100 films. Photo: courtesy of Ronald
Nameth.

centric circular promenades and long radial aisles stretching from
the central arena to the eaves of the domed ceiling. Each of the
forty-eight huge windows, which surround the outside of the build-
ing, was covered with opaque polyethylene upon which slides and
films were projected: thus people blocks away could see the entire
structure glowing and pulsating like some mammoth magic lantern.

Over the central arena hung eleven opaque polyethylene screens,
each one hundred feet wide and spaced about two feet apart. En-
closing this was a ring of screens hanging one hundred and twenty-
five feet down from the catwalk near the zenith of the dome.

Filmmaker and intermedia artist Ronald Nameth programmed more than eight thousand slides and one hundred films to be projected simultaneously on these surfaces in a theme following the history of man's awareness of the cosmos. "The visual material explored the macrocosm of space," Nameth explained, "while the music delved deep into the microcosmic world of the computer and its minute tonal separations. We began the succession of images with prehistoric cave drawings, man's earliest ideas of the universe, and proceeded through ancient astronomy to the present, including NASA movies of space walks. All the images were concerned with qualities of space, such as Méliès' *Trip to the Moon* and the computer films of the Whitney family. The people who participated in *HPSCHD* filled in the space between sound and image."

Seven amplified harpsichords flanked by old-fashioned floor lamps stood on draped platforms on the floor of the central arena beneath the galaxy of polyethylene and light. In addition to playing his own solo, each harpsichordist was free to play any of the others. Each tape composition, played through loudspeakers circling the hall in the last row of seats near the ceiling, used a different division of the octave, producing scales of from five to fifty-six steps. Only twice during the five-hour performance were all channels operating simultaneously; these intervals were stipulated by Cage.

Nameth has collaborated in several intermedia performances in addition to making his own computer films and videographic films, as well as conventional cinema such as *Andy Warhol's Exploding Plastic Inevitable.* In 1967 he worked with Cage in the preparation of *Musicircus,* an eight-hour marathon of sight and sound involving nearly three thousand persons—musicians, musical groups, orchestras, and composers in addition to a participating "audience"—all making music together.

In 1968–69 Nameth worked with Salvatore Martirano and Michael Holloway in a music/theatre/film presentation titled *L.'s G.A.* (Lincoln's Gettysburg Address), which traveled throughout the United States and Japan. Described as a mixed-media event "for gasmasked politico, helium bomb, three 16mm. movie projectors, and two-channel tape," *L.'s G.A.* was simultaneously a showcase for Martirano's electronic tape compositions, Nameth's multiple-projection cinema, and Holloway's poetry. Nameth employed video imag-

Two scenes from Ronald Nameth's triple-projection film *As the World Turns* for intermedia presentation *L's G.A.* 1968–69.

Two scenes from Robert Whitman's *Prune Flat.* 1965. Performers' actions were synchronized with their film versions. Photos: Peter Moore.

ery for his cinematic triptych *As the World Turns,* which he described as "the visual counterpart of Martirano's music." Depending on the physical limitations of the performance space, Nameth's film was projected in the form of two smaller images side by side within a larger image, all three images adjacent to one another, or all three superimposed over one another.

## Robert Whitman: Real and Actual Images

The higher ordering principle of intermedia, or what might be called "filmstage," is the simultaneous contrasting of an actual performance with its "real" projected image, so that the live performer interacts with his movie self. The New York artist Robert Whitman developed this technique in several variations during the period 1960–67, after which he abandoned film/theatre compositions for experiments of a more conceptual nature.

In *The American Moon* (1960) the audience viewed a central performance space from six tunnel-like mini-theatres whose openings were periodically blocked by plastic-and-paper screens on which films were projected. Persons in each tunnel could see through their screens to the flickering images on the screen of the opposite tunnel. Thus Whitman engaged cubic space, filmic space, real and projected images.

In his most famous work, *Prune Flat* (1965), Whitman utilized a conventional proscenium stage with a large movie screen as backdrop. Two girls performed various movements and gestures in person, while their filmed images performed the same action, and some different ones, on the screen. A third girl was dressed in a long white gown on which was projected a movie of herself removing her clothes. The girl's physical actions were synchronized with the film being projected on her: she pretended to "throw" her skirt into the wings as the filmed image did so, etc. Finally a nude image of the girl was projected on her fully-clothed figure.

## Aldo Tambellini: Electromedia Theatre

A pioneer in intermedia techniques, Aldo Tambellini has worked with multiple projections in theatrical contexts since 1963, always striving to cast off conventional forms, using space, light, and sound environmentally. In the spring of 1967 he founded The Black Gate,

Aldo Tambellini: *Black Zero.* 1965. Shown
at the artist's Black Gate Electromedia
Theatre in New York.

New York's first theatre devoted exclusively to what Tambellini calls "electromedia" environments.

His archetype, fully realized in *Black Zero* (1965), is a maelstrom of audio-visual events from which slowly evolves a centering or zeroing in on a primal image, represented in *Black Zero* by a giant black balloon that appears from nothing, expands, and finally explodes with a simultaneous crescendo of light and sound. Literally hundreds of hand-painted films and slides are used, each one a variation on the *Black Zero* theme. In addition to electronic-tape compositions, the piece often is performed in conjunction with a live recital of amplified cello music.

In *Moon-Dial* (1966) he collaborated with dancer Beverly Schmidt in a mixture of the human form with electronic imagery in slides, films, and sounds. With Otto Piene, he presented *Black Gate Cologne* at WDR-TV in Germany in 1968, which combined a closed-circuit teledynamic environment with multi-channel sound and multiple-projection films and slides as the participating audience interacted with Piene's polyethylene tubing. Another version of this piece was conducted along the banks of the Rhine in Düsseldorf, with projections on a mile-long section of tubing.

## Wolf Vostell: De-Collage

Although he works largely with television, both as object and information, the German intermedia artist Wolf Vostell is most significant for the way in which he incorporates his video experiments into environmental contexts. Actually, his videotronic manipulations are no more sophisticated than the distortion of broadcast programs using controls available on any common TV set. But this is precisely the point of his work: rendering the environment visible as "art" by manipulating elements inherent in that environment.

Since 1954 Vostell has been engaged in what he calls "de-collage" art, or decomposition art. This is not to be confused with destruction art, fashionable during approximately the same period, for Vostell destroys nothing: he creates Happenings or environmental theatre in which already broken, destroyed, damaged, or otherwise derelict elements of the environment are the central subjects. Beginning in 1964 he made the first of several versions of one film titled *The Sun in Your Head,* described as "a movie of de-collaged tele-

Aldo Tambellini and Otto Piene: *Black Gate Cologne.* 1968.
Tambellini's electromedia environment combined with Piene's
helium-inflated polyethylene tubing at WDR-TV in Cologne, West
Germany. Photos: Hein Engelskirchen.

Wolf Vostell: *Electronic Happening Room.*
1968. One of Vostell's de-collaged TV sets in
a multiple-projection intermedia environ-
ment designed to generate an awareness
of man's relationship to technology. Photo:
Rainer Wick.

vision programs combined with occurrences for press photographers and audience."

Basically, Vostell seeks in all his work to involve the audience objectively in the environment that constitutes its life. He seeks to break the passivity into which most retreat like sleepwalkers, forcing an awareness of one's relation to the video and urban environment. He sometimes describes his work as a form of social criticism employing elements of Dada and Theatre of the Absurd.

In *Notstandbordstein* (1969), the streets, sidewalks, and buildings of Munich became the "screen" on which a film was projected from a moving automobile. Vostell's *Electronic Happening Room* (1968) was an environmental attempt to confront the participant with all the technological elements common to his everyday life, from telephones to Xerox machines to juke boxes. As in most of his work, complex multiple-projections of films and slides were combined with sound collages taken from the natural environment. In New York, in 1963, he exhibited a wall of six blurred (de-collaged) television sets. In *21 Projectors* (1967) the audience was surrounded with a staccato barrage of multiple film and slide projections in complex split-second patterns designed to reveal the surrealism of life in the media-saturated 1960's. He describes his archetypal work as one in which "events on the screen and the actions of the audience merge: life becomes a labyrinth."

# Multiple-Projection Environments

In real-time multiple-projection, cinema becomes a performing art: the phenomenon of image-projection itself becomes the "subject" of the performance and in a very real sense the medium is the message. But multiple-projection lumia art is more significant as a paradigm for an entirely different kind of audio-visual experience, a tribal language that expresses not ideas but a collective group consciousness. It's obviously the beginning of what Stan VanDerBeek proposed in the "image library, newsreel of dreams, culture intercom."

"The purpose and effect of such image flow," wrote VanDerBeek in his 1965 *Manifesto*, "is both to deal with logical understanding and to penetrate to unconscious levels, to reach for the emotional denominator of all men, the nonverbal basis of human life." In the following pages we'll discuss multiple-projection environments on a level that might best be described as handicraft, with the possible exception of the Vortex Concerts; yet it's clear that the lumia performance is trending toward levels of cybernetic control far beyond the capabilities of a few individuals, no matter how sophisticated their equipment. Significantly, certain members of the now-defunct USCO group have abandoned the physical handicraft of multiple-projection to develop hardware and software for automated lumia display systems. It's the first stage in a pattern-event toward the kind of transnational communication that VanDerBeek holds essential for the success of global man: "Such centers around the world will have artists in residence to [program] the material for dialogues with other centers at a visual velocity of 186,000 miles per second."

Moreover, lumia art constitutes the promise of an evolving design science integrated architecturally into the fabric of daily life: certainly the true "city of light" has yet to be realized. Recent trends in the application of advanced technology to what might be called "functional aesthetics" indicate a transformation in urban design, the gradual convergence of functionality and beauty, the mundane and the mysterious.

Henry Jacobs (*left*) and Jordan Belson at
Morrison Planetarium in San Francisco,
California, for Vortex Concerts.

### The Vortex Concerts

The legendary Vortex Concerts conducted by Henry Jacobs and
Jordan Belson at Morrison Planetarium in San Francisco's Golden
Gate Park from 1957 to 1960 were quintessential examples of lumia
art integrated with sound in an intermedia environment. By present
standards one could not ask for a more perfect setting. "Simply
being in that dome was a holy experience," said Belson. "The entire
theatre was like an exquisite instrument." And Jacobs recalls: "It
was such an absurdly perfect situation that we just stopped alto-
gether after we left the planetarium; when you begin with the
ultimate there's nowhere else to go."

Vortex began in May, 1957, as a series of experimental and ethnic
music concerts from tapes owned by Jacobs, a poet and composer of
electronic music. Within a few weeks, however, he was joined by his

friend Belson, and Vortex became an experiment in visual and acoustical space. The sixty-foot dome was surrounded at its perimeter by thirty-six loudspeakers clustered in equally-spaced stations of three speakers each. There were two large bass speakers on either side and one at the zenith of the dome. Speakers were installed in the center of the room, bringing the total close to fifty sound sources. "The acoustics were very unusual," Belson remarked. "Very hushed, and you could hear any sound no matter how far away, as though it were right behind you, because sound carried over the dome."

The planetarium engineering staff installed a substantial amount of equipment especially for Vortex, including an audio keyboard with controls for addressing individual speakers or spinning sounds rotationally about the room—thus the title of Vortex. In addition, Belson supervised the installation of special interference-pattern projectors that were added to the hundreds of projection devices already assembled. "One of my greatest pleasures," said Belson, "was working with the star machine at a point when the entire dome was bathed in a kind of deep red. As the color began to fade away, there was a point when it overlapped with this beautiful starry sky; it was a breathtaking and dramatic moment.

"We could tint the space any color we wanted to. Just being able to control the darkness was very important. We could get it down to jet black, and then take it down another twenty-five degrees lower than that, so you really got that sinking-in feeling. Also we experimented with projecting images that had no motion-picture frame lines; we masked and filtered the light, and used images that didn't touch the frame lines. It had an uncanny effect: not only was the image free of the frame, but free of space somehow. It just hung there three-dimensionally because there was no frame of reference. I used films—Hy Hirsh's oscilloscope films, some images James Whitney was working on for Yantra, and some things which later went into Allures—plus strobes, star projectors, rotational sky projectors, kaleidoscope projectors, and four special dome-projectors for interference patterns. We were able to project images over the entire dome, so that things would come pouring down from the center, sliding along the walls. At times the whole place would seem to reel."

Planetarium projector shown equipped with
two interference-pattern projectors (*top
right*) for Vortex Concerts.

Sound-to-image relationships amounted to counterpoint rather than what Jacobs calls "Mickey Mouse synchronization." Vortex did not simply project sound into space, but employed dimensionality, direction, aural perspective, and speed of movement as musical resources. "Jordan controlled the performance with parameters of the time an image would begin, the amount of brightness, speed of rotation, and speed of enlargement. I would control the loudness of the sound, the equalization of the sound, and the spatiality of the sound." Music ranged from Stockhausen, Berio, and Ussachevsky to Balinese and Afro-Cuban polyrhythms, set against the geometrical imagery characterized by *Allures*. Jacobs and Belson conducted approximately one-hundred Vortex concerts, including two weeks at the 1958 Brussels World's Fair. In 1960 the planetarium withdrew its support and Vortex ended without ever realizing its full potential.

## Jud Yalkut: *Dream Reel*

Jud Yalkut has collaborated in dozens of intermedia performances throughout the United States since 1965, when he became resident filmmaker for USCO at their commune in Garnerville, New York. As filmmaker first and intermedia artist second, Yalkut displays a sense of control and orchestration that is the result of working closely with superimpositions within the film frame. Thus in the superimpositions of multiple-projection environments he is able to control not only the spatial and temporal dimensions of a performance, but the graphic composition and integrity of the images as well. The result is a "film performance" in the fullest sense.

In the spring of 1969 Yalkut joined with Yukihisa Isobe to present *Dream Reel*, a mixed-media performance in Isobe's "Floating Theatre"—a parachute canopy thirty-two to fifty feet in diameter anchored by nylon lines to the floor of the performance area. The Floating Theatre is elevated above and surrounds the audience, using air-flow principles and centrally located fans. In effect, it is a portable hemispheric projection theatre utilizing both front and rear multiple-projection techniques.

*Dream Reel* is divided into three sections: *Paikpieces, Festival Mix,* and *Mixmanifestations. Paikpieces* is an environmental tribute to Nam June Paik, incorporating the video-film collaborations between Yalkut and Paik discussed earlier. Performance time is ap-

proximately fifteen minutes, set against the tape composition *Mano-Dharma No. 8* by Takehisa Kosugi (1967) for two RF oscillators and one receiver. Equipment involves four to five 16mm. projectors including one with sound on film, four carousel slide projectors, and a stereo tape system. The contrast of Paik's electronic imagery with the airy buoyancy of the silky enclosure produces an ethereal, evanescent atmosphere.

*Festival Mix* is a multiple-projection interpretation of the 1968 University of Cincinnati Spring Arts Festival, originally presented as an eleven-channel, multi-media "feedback" mix as the final performance of that ten-day festival. In *Dream Reel* it involves three 16mm. projectors, four carousel slide projectors, and a four-track stereo tape system on which is played *Festival Mix Tape* by Andy Joseph and Jeni Engel. Sounds and images include those of Peter Kubelka, Charles Lloyd, Bruce Baillie, Nam June Paik, Charlotte Moorman, Ken Jacobs, Hermann Nitsch's Orgy-Mystery Theatre, Paul Tulley, The Fugs, Jonas Mekas, and the MC-5. "I was unnerved and numb from the tremendous impact this had on my senses," one person commented after the performance.

*Mixmanifestations,* the most complex section of *Dream Reel,* is described by Yalkut as "a nonverbal communion and celebration for all channels within a totally surrounding environmental performance." Visual elements include an exploding hydrogen bomb, the Living Theatre, the Jefferson Airplane, the Grateful Dead, Yayoi Kusama (from Yalkut's film *Self Obliteration*), and various be-ins and peace marches. These are blended and juxtaposed with abstract meditational motifs culminating in a centralizing mandalic experience utilizing both visual and aural loop techniques for the alternating pulse and phase-out of simultaneous temporal interference fields. The twenty-minute performance includes four to five 16mm. projectors, two 8mm. projectors, four carousel slide projectors, and two four-track stereo tape systems for the simultaneous playback of tapes and tape-loop cartridges.

## The Single Wing Turquoise Bird

The Los Angeles group Single Wing Turquoise Bird came out of the environmental rock concert and light show genre that characterized the pop scene of the mid-sixties. Initially they staged huge

Partially-opened parachute (*top*) becomes Isobe's Floating Theatre for presentation of Jud Yalkut's *Dream Reel* intermedia environment at Oneonta, New York, March, 1969. Photos: courtesy of Yukihisa Isobe.

three hundred and sixty-degree light shows for rock concerts at the Shrine Exposition Hall from 1967 to 1968. However, after the rock mania subsided, the group became affiliated with artist Sam Francis, who sponsored studios for them, first in Venice, then in an abandoned hotel on the beach in Santa Monica. In almost total obscurity the group perfected an art of light manipulation virtually unequaled by any mixed-media organization with the possible exception of USCO.

It's a combination of Jackson Pollock and *2001*, of Hieronymus Bosch and Victor Vasarely, of Dali and Buckminster Fuller. Time-lapse clouds run across magenta bull's-eyes. Horses charge in slow motion through solar fires. The hands of a clock run backward. The moon revolves around the earth in a galaxy of Op Art polka dots. Flashing trapezoids and rhomboids whirl out of Buddha's eye. Pristine polygraphic forms are suspended in a phosphate void. Exploding isometrics give birth to insects. A praying mantis dances across an Oriental garden. Spiraling cellular cubes crash into electric-green fossil molds. The organic symbiosis of universal man. A huge magnified centipede creeps across a glowing sun. Cascading phosphorescent sparks. Waffle grid-patterns strobe-flash over Roy Lichtenstein's 1930's Ultramoderne architecture. A butterfly emerges from its cocoon. New dimensions of space and time. Bodies become plants. White translucent squids wrestle with geometric clusters. The sound is Terry Riley and LaMonte Young and Mozart, seasoned with Pink Floyd, spiked with Cream.

Unlike other light artists, The Single Wing Turquoise Bird has no definite program; each presentation evolves from the interacting egos of the group working in harmony. What we see cannot be called a work of art as traditionally conceived: a unique, perishable, nonreplaceable entity reflecting the talents of an individual. They don't produce an object in the sense that a movie is an object; they produce software, not hardware. We witness an expression of group consciousness at any given moment. The range of their vocabulary is limitless because it's not confined to one point in time, one idea, one emotion. Depending on the variety of basic materials (they use everything from liquids to video projection to laser interferometry) they can continue into infinity, never repeating a single "word," always evolving visual-kinetic equivalents of the psychic-social cli-

Two images from the constantly-evolving lightworks of the Single Wing Turquoise Bird in their studio at Venice, California. Photo: Gene Youngblood.

mate of the moment. Their work strikes one precisely as a synaes-thetic movie, yet a movie in which each image emanates from its own projector, its own human sensitivity.

The group: Jeff Perkins, films and slides; Peter Mays, films and slides; Jon Greene, overhead projectors, liquids, technical innova-tions; Michael Scroggins, overhead projectors, liquids, technical innovations; Allen Keesling, slides, rheostats, improvised equip-ment; Charles Lippincott, group management.

"Previously," remarked Peter Mays, "all my experience in art was very personal where I had total control. Working with a group there's a whole different kind of feeling, a kind of communication, a collective vision and meaning that's like Hermann Hesse's idea in *The Glass Bead Game*—taking everything in all cultures and com-municating comprehensively on all levels of society simultaneously. In a sense that's what the new consciousness is about, comprehen-sive living. Our language definitely is anti-Minimal. It's a reaction to Minimal Art just as Minimal Art was a reaction to the complexities of Jackson Pollock's Abstract Expressionism. We're making Maximal Art. I see the whole history of visual art in one historical progression and the light show occupies a very crucial position in that line. It seems that the spirit of Abstract Expressionism has been distilled into a pure form in the light show; sort of carrying on the tradition while at the same time transforming it into something more uni-versal."

### Jackie Cassen and Rudi Stern: Theatre of Light

The image of a water fountain illuminated by strobe light from below—each droplet frozen in its arc like some priceless crystal in metamorphosis—characterizes the ephemeral beauty of Cassen's and Stern's "Kinetic Light" compositions. Their art is contemplative and peaceful as opposed to the chaos of most intermedia environ-ments. They seek to sharpen one's consciousness, not to overwhelm it. Almost symbolically, their studio/home "and small cosmic game room" in New York is situated just around the corner from the 1920's site of Thomas Wilfred's Art Institute of Light.

Reclining on black cushions in a black-draped room, one encoun-ters light used not as a backdrop for a rock-and-roll group but as "a medium struggling to stand quite independently, a catalyst for its

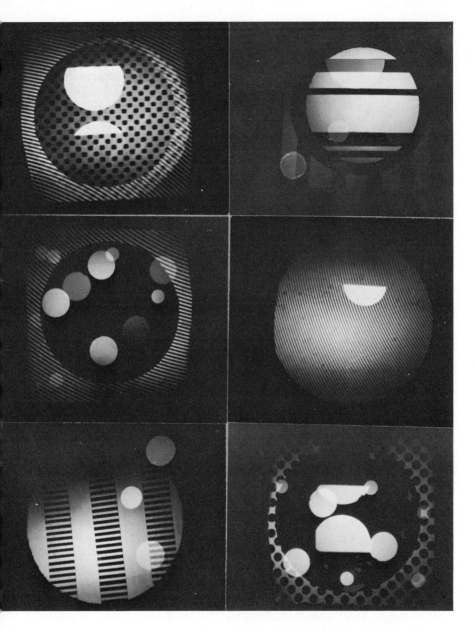

Sequence of images from *Circles,* a
kinetic composition by Jackie Cassen and
Rudi Stern, Theatre of Light, New York,
1969. Photo: Roy Blakey.

own kind of experience." A typical presentation may incorporate as many as six-thousand slides and twenty-five different projectors, many of them designed especially by Cassen and Stern. This Theatre of Light has been seen with opera, in Stravinsky's *Rake's Progress* for the Boston Opera Company; with dance, in the ballet *The Seven Deadly Sins* at Vancouver's Art Festival; with the music of Berg, Messiaen, Mozart, and Scriabin as played by Peter Serkin at the Festival of Two Worlds in Spoleto; for Lyndon B. Johnson at the White House; and for Timothy Leary's "Turn On, Tune In, Drop Out" psychedelic celebrations.

In collaboration with the visionary Japanese architect Yukihisa Isobe, they have performed kinetic-light events in black vinyl pneumatic domes, transparent inflatables, and other tensile structures. They have extended the use of fiber optics into dazzling perceptual exercises. In *Vibrations* at the New York Architectural League in the winter of 1967–68 they constructed a shimmering universe of mirrored mylar surfaces, water pools and fountains, plexiglass cubes, geodesic, and other polyhedral structures, front and rear projections, and light-activated sound events in which photoelectric cells responded to color as well as intensity.

Together they design and build devices that can be described only as "sculptural projectors"—one does not look *at* the screen in the Theatre of Light so much as one looks *through* it into spatial dimensions defined by omni-directional light from these sculptures. Their weekly, one-hour performances at the New York studio are composed of several brief presentations. For example, one fifteen-minute piece is called *City Windows*, a trip through an infinite night city of faceted windows, surrealistic night traffic, and what Stern describes as "white-line etched images," set against a sound track composed by Cassen and Stern of traffic noises and rumblings on a piano. Another composition, slightly resembling photos of Wilfred's Lumia displays, is divided into six movements corresponding to Bach's *Suite No. 1* for unaccompanied cello. Each movement is conceived as a different kind of "light pastorale."

Jackie Cassen and Rudi Stern seek "to build a repertoire of light-works, a kind of nonverbal electric theatre prototype for the future." Since they are helping to invent that future, it seems that in the Theatre of Light we actually are seeing through time.

# PART SEVEN:
# HOLOGRAPHIC CINEMA: A NEW WORLD

"Someday you'll be able to go to a party and be the only one there."

ANDY WARHOL

In April, 1969, overlooking the Pacific from the crest of Malibu Canyon in Southern California, I became one of the few persons to view the world's first successful holographic motion picture. There at Hughes Research Laboratories one can look across the canyon to see a Catholic monastery, Sierra Retreat, perched majestically atop its own mountain, commanding the same spectacular view of the earth, the sea, and the sky. This contrast impressed me perhaps even more than the technological wonder I had just witnessed: the temples of science and religion separated by a canyon as old as time, each in its own way dedicated to the same quest for God.

The art of holographic cinema *circa* 1970 is comparable to that of conventional cinema *circa* 1900. The few scientists who have made the first crude holographic films are the Edisons and Lumières of our time. Through the hologram window we peer into a future world that defies the imagination, a world in which the real and the illusory are one, a world at once beautiful and terrifying. It is certain that holographic cinema and television will be common by the year 2000; but more probably this will take place within fifteen years from now. Meanwhile, holographic cinema is still in its infancy; in the following pages I hope to dispel many of the misconceptions that surround it, and to provide some understanding of the possibilities inherent in this totally new way of making images.

# Wave-Front Reconstruction: Lensless Photography

The first enigma we encounter in holography is that no optical image is formed. Instead, the wave front or diffraction pattern of light waves bouncing off the subject is captured directly on a photosensitive surface without passing through lenses that would form it into an image. Each point on the surface of an object reflects light waves in constantly expanding concentric circles in much the same way that rings are formed when a pebble is dropped into a pool of still water. A collection of these circles and the interference pattern resulting from their intersecting trajectories constitute the wave front of light from the object. If one is able to "freeze" or store this wave front, one then has the potential of reconstructing a three-dimensional image exhibiting all the properties that a viewer would see if he were looking at the real object through a window the size of the photograph.

The secret of capturing and reconstructing wave fronts of light was discovered in 1947 by Dr. Dennis Gabor of the Imperial College of Science and Technology in London. Light waves are described by their intensity and frequency; ordinary optical photography records only the intensity of the waves, not the frequency; yet the frequency is the information necessary to reconstruct a three-dimensional image. Dr. Gabor found that it was possible to record both intensity and frequency of wave fronts by imprinting interference patterns of light on a photosensitive surface.

Just as rings in a pool of water tend to dissipate the farther they travel, so light waves similarly tend to lose their cohesiveness. Light is described as "cohesive" in direct proportion to the distance over which its waves remain "in phase," or in step with one another: ordinary "white light" (sunlight) has a very short cohesive length. Dr. Gabor recognized that in order to reconstruct a faithful three-dimensional image of an object, one would need very cohesive light. The ideal would be light whose waves all traveled at one frequency. Since no such light existed in 1947, he approximated it with a filtered mercury arc lamp. The images he obtained from the process, though extremely poor in quality, were called *holograms* from the

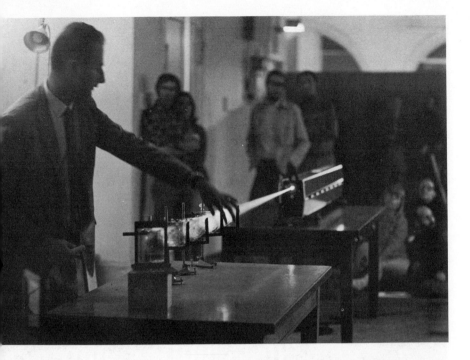

Diffusion of a laser beam as part of *Nine Evenings* intermedia presentations by Experiments in Art and Technology (EAT), New York, 1967. Photo: Peter Moore.

Greek root *holos* meaning whole, since they recorded a whole picture—both intensity and frequency.

In 1960 Dr. Theodore Maiman of the Hughes Aircraft Company in California invented an instrument called the *laser*, named from the initials of *L*ight *A*mplification by *S*timulated *E*mission of *R*adiation. As the name implies, the laser generates a beam of light that is totally coherent since it is all one wavelength. Then in 1965 Emmett N. Leith and Juris Upatnieks of the University of Michigan used the laser in a modification of Dr. Gabor's original holographic technique to produce the first completely successful three-dimensional image. Instead of using one beam like Dr. Gabor, Leith and Upatnieks used a prism to derive two beams from one laser. The subject beam was used to illuminate the object, while the reference beam was

Multiple-exposure photo approximates what
a viewer would see in animated hologram
made at Bell Telephone Laboratories. Either
the plate is moved across a laser beam, or
it remains stationary and the viewer moves
his head from left to right. The figure
appears to rotate in full three dimensions.
Photo: Bell Telephone Laboratories.

used to interfere with it, creating a pattern that was recorded on a photographic plate, forming the hologram.[1]

To reconstruct the image, another laser is directed at the hologram from the same position occupied originally by the reference beam. This beam emerges from the film shaped exactly in the form of the wave fronts reflected from the original object. A picture is formed that is identical with the object itself, in true three-dimensionality, requiring no lenses or polarizing glasses as in the stereoptic process used for so-called 3-D movies. The phenomenon that distinguishes true 3-D from stereoptic illusion is called *parallax*, or the apparent displacement of perspectives when one object is viewed from different angles. In holography, different areas of the picture become visible depending on one's angle of approach; if the photographic plate were large enough, one could actually move to the periphery and look behind objects, discovering areas not visible from a frontal view.

However, the ability to do this is restricted by the frame size of the photographic surface, either plate or film strip. Although images up to thirty-five feet in depth are considered possible through the technique of "panoramic holography," the largest holographic plates are only one- or two-feet square; the largest motion-picture film practical for any purpose is only 70mm. wide; thus the viewing effect is always one of peering through a small window into a larger three-dimensional space. This obviously restricts the size of an audience that can simultaneously observe one holographic display: no more than two persons can view a holographic plate with comfort, and film-viewing systems are restricted to the peep-show level of one person at a time.

[1] Emmett N. Leith and Juris Upatnieks, "Photography by Laser," *Scientific American* (June, 1965), pp. 24–35.

# Dr. Alex Jacobson: Holography in Motion

Until Dr. Alex Jacobson and his colleague Victor Evtuhov made their holographic movie of tropical fish in an aquarium at Hughes Research Laboratories, the only motion in holography had been artificially animated. Matt Lehman of Stanford University, Charles Ernst of the TRW Systems Group, and scientists at Bell Telephone Laboratories had created photographic plates on which many separate holograms of the same object were recorded in tiny vertical strips. To obtain the illusion of motion one either moved one's head from side to side or remained stationary and moved the plate horizontally across a laser beam. In each case, however, the motion was not recorded in real time: separate holograms were made for each stationary position of the image.

Jacobson's aquarium movie was the world's first real-time holographic film. He used a pulsed ruby laser, which emits light in bursts 35-billionths of a second in duration, each with 25,000 to 50,000 watts of peak power.[2] Such brief exposures are necessary in motion holography since any movement of the object more than one-thousandth of an inch during exposure will blur the image. Jacobson and his associates designed and built the camera apparatus, which exposed 100 feet of film at 20 fps, using a Hulcher Model 100 sequential-still camera with lens and shutter removed.

The film stock was AGFA-Gevaert 10E75 emulsion on a common acetate base in 70mm. format. The stock is designed especially for holography though its photochemical constituents are quite common. The only unusual requirement holography makes on film is very high resolution capabilities. Ideally, a holographic emulsion should be able to resolve two lines 25-millionths of an inch apart, or 1,500 readable lines per millimeter. (The price paid for this resolving power is speed: the first film used to make holograms, Kodak

---

[2] This amounts to approximately one millijoule of light, or one-thousandth of a joule. (Joule is the amount of energy required to heat one gram of water one degree Centigrade.) One billionth of a second is known as a *nanosecond;* so-called Q-switched laser emit pulses of light one-trillionth, or a *picosecond,* in duration.

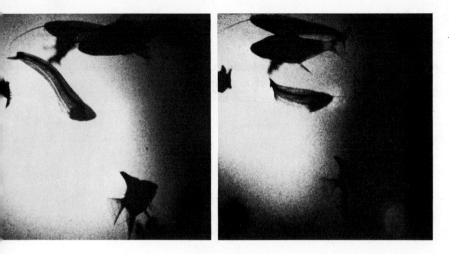

Two photos from a holographic movie of tropical fish made by Alex Jacobson and Victor Evtuhov at Hughes Research Laboratories, Malibu, California. 1969. Laser light was shined through the aquarium at camera. Dark area at right of photos does not appear in the actual movie. Photos: Hughes Research Laboratories.

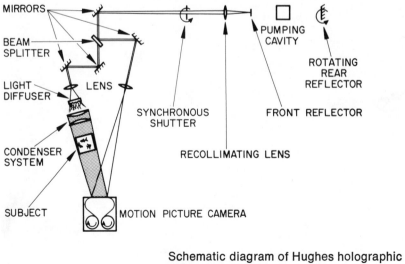

MIRRORS

BEAM
SPLITTER

LIGHT
DIFFUSER     LENS

CONDENSER
SYSTEM

SUBJECT

SYNCHRONOUS
SHUTTER

RECOLLIMATING LENS

MOTION PICTURE CAMERA

PUMPING
CAVITY

ROTATING
REAR
REFLECTOR

FRONT REFLECTOR

Schematic diagram of Hughes holographic movie system. Laser is indicated as "pumping cavity."

649-F spectrographic plate, had an ASA rating of .02.) Thus, after eight months and many thousands of dollars in equipment, Jacobson produced 30 seconds of film in which one peeked through a 70mm. aperture to find tropical fish swimming leisurely in three-dimensional space.

# Limitations of Holographic Cinema

Three types of lasers are used in holography, identified by the active element whose atoms are electronically charged to generate light: the helium-neon laser, the argon laser, the ruby laser. Since human images are essential to commercial holography, a pulsed laser must be used; this excludes the helium-neon laser, which is strictly CW (continuous wave) and cannot be pulsed. The argon laser does not approach the 35 to 50 nanoseconds required to make action holograms. This leaves the ruby laser, which produces a fiery red image of extreme graininess, and whose light is not so cohesive as the helium-neon laser.

Since black-and-white holography is not possible, one is stuck with a monochromatic red image unless full-color holograms are made. Dr. Ralph Wuerker, of the TRW Systems Group in Redondo Beach, California, admits that full-color holographic cinema is a possibility "if the government is ready to support that kind of research with all the money they have in Fort Knox." Wuerker, who has developed a special "holocamera" for recording holograms with low-coherence lasers, suggests that full-color holographic movies might eventually be made using two lasers instead of one, optically mixing their colors as in television: red from a ruby laser, and blue and green from a doubled neodymium glass laser.

Dr. Jacobson, however, does not consider this to be a major problem in the development of holographic cinema. "In the hierarchy of difficulties color might be considered a second-level problem," he said, "and granularity would be only a minor snag. People already have devised means of clearing up the graininess. But a first-level problem is illumination. I back-lit my fish because if I were to illuminate from the front I wouldn't have enough light to make a hologram. We barely had enough light as it was, and that's why I selected the small subject. If you want to make a commercial holographic movie, you at least have to be able to illuminate a room-sized scene. We estimate that in order to shoot a room-sized scene at twenty frames per second you'd need an input to the laser of something in excess of five million watts. Now I don't know how

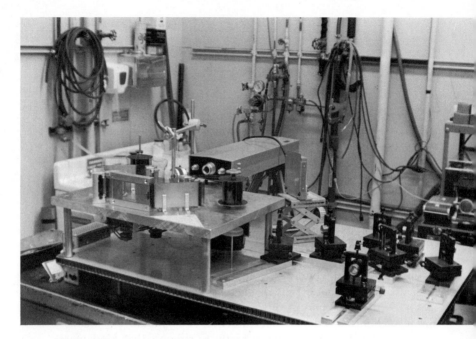

Hughes holographic projection system.
Viewer must peer through 70mm. aperture
of film transport table. Photo: Gene
Youngblood.

powerful Grand Coulee Dam is, but that's a large portion of its output."

Seeking a solution to this problem, for the last few years several firms have been working on white-light holography, in which ordinary illumination sources are used both to make and view the hologram. Optical systems are used to overcome the incoherence of white light. Another proposal is the technique called *integral photography* in which many ordinary photographs from different perspectives are combined in holographic form. The resulting image, although synthetic, gives all the properties of a true hologram of the same scene. And since the image is formed by conventional photography, any type of illumination can be used. The process is extremely complex and tedious, however, and it is practically inconceivable that a movie could be made in this manner.

Both Dr. Jacobson and Dr. Wuerker insist that holography depends on the use of laser light in recording as well as viewing the

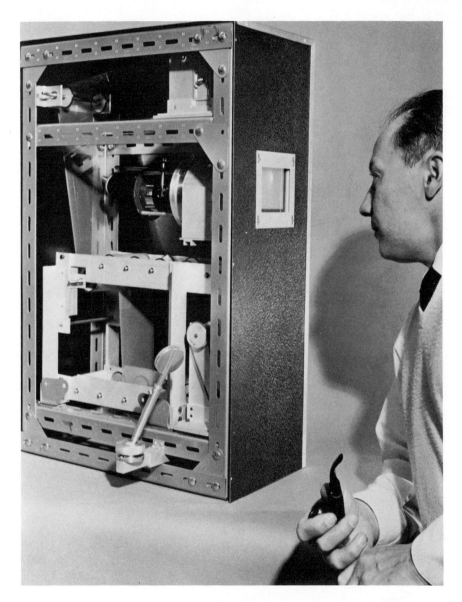

Holographic movie viewing system
developed by North American Philips
Corporation. Laser inside the box shines
through 70mm. film as it passes viewing
aperture. Photo: North American Philips
Corp.

image. "Using white light to reconstruct a hologram is like playing a stereo record through a Vitaphone," Dr. Wuerker said. "People accept it now because the field is young enough, just as they accepted inferior sound recordings in the early days of that field. But in holography, fidelity depends on laser light." Dr. Jacobson suggests that we will "just have to wait until a big laser comes along— big in terms of the amount of energy it puts out. You need two combinations: enough energy to illuminate the scene and expose the film, and you also need it in a very short time to avoid motion blur. Instead of using one illuminator you could use ten or fifteen lasers. That's a possibility. But the cost and volume of equipment would still be prohibitive."

# Projecting Holographic Movies

The popular misconception of a holographic image as something with which the viewer can interact—moving around and through it in three-dimensional space while viewing it—may become a reality in holographic cinema of the future. Since a hologram is not made with lenses it always creates what is known as a *virtual image* on the opposite side of the film from the viewer, as though one were looking through a window, because the image always appears exactly where it was when the hologram was recorded.

However, associated optically with the virtual image is what's known as the *real image,* which comes to focus on the side of the film nearest to the viewer. All that would be required to see the real image is a special optical system to reverse the holographic process. This system does not yet exist; but it seems that a technique known to the ancient Egyptians and practiced by magicians for centuries may provide the means for a future system of large-scale, real-image holographic movie theatres.

Known generally as "The Illusion of the Rose in the Vase," this simple process involves the use of a lens, concave mirror, and pinhole light source to transpose illusionistically an object into three-dimensional space in full color. In addition to floating an image in space, it can be used to magnify or miniaturize the image. As in the archetypal example, it can cause a natural-sized object like a rose to appear suddenly in an otherwise empty vase. Through a system of lenses and mirrors an object at another location can be suspended in space wherever desired.

In Japan this process is used to project tiny three-dimensional human beings onto the miniature stage of a puppet theatre: the actual persons are beneath the stage floor, dancing in front of a large mirror. Before we had holography an actual object was needed to create this effect, but now that we have three-dimensional images without three-dimensional objects it is possible to develop a system of holographic cinema based on this ancient concept. The object is simply replaced by a strip of holographic film. Even then,

however, the scene would be visible only to an audience of two hundred persons.

"If you get into an area much larger than that," explains Dr. Wuerker, "you confront the problem of what is and what isn't 3-D. You don't see much 3-D beyond twenty or thirty feet, so the effect would be lost if you had to sit very far away from the image. Either you'll have a projected image that's like a person on a stage where about a hundred people can observe him, or you'll have a personalized box like a TV set, or a hood over your head."

Wuerker also conceives of a holographic cylinder that would either revolve slowly or remain stationary while the audience rotated around it. "But now comes the reality," he warns. "And the reality obviously is a cylinder, so you're limited in your stage area. It wouldn't be much more than just one man. But you could have an interview with that man." Holographic movies may be severely limited by their total dependence on reality, Dr. Wuerker suggests. "When you make a movie, the cameraman focuses the camera. He forces you to look at this actor or this scene or whatever. In a holographic movie you don't have that. Your own eyes are the lens, just as in reality.

"For example, if you had two actors, one upstage, the other downstage, you'd focus on whichever one you wanted to. When the focusing is up to the viewer you're simulating reality even more closely; in fact as far as the viewer's concerned it *is* reality. But holograms can't be doctored once the image is on the film. You can't touch it up or edit. You can synthesize, and you can superimpose and you can multiplex, but you can't play with focusing as you can in photography. And you might find that in holographic movies things like jump cuts are not likely."

Dr. Wuerker also envisions cube holograms instead of plates or film strips. "You can use a thick medium rather than a thin medium. Someone will develop a glass block that is photosensitive, about a quarter of an inch thick. You coat this glass box holographically, putting a hundred images on it. You hold it up to a laser and as you rotate it your separate images will come out. You couldn't pack information any tighter than you could this way. This is definitely in the future and definitely in the viewing of movies. Holographic recording itself is at this point already. But if you compound that by

using depth in your plate as a third dimension—you have a thousand lines per millimeter so every cubic millimeter will have $10^9$ bits of information. And there you go. But still you won't be able to pull the tricks that are in movies or on TV because holography is too dependent on actuality."

# The Kinoform:
## Computer-Generated Holographic Movies

However, means have been devised through which even the holo-gram may no longer need "reality" to exist. Dr. Lou Lesem and his associates at IBM in Houston have developed methods of generat-ing three-dimensional holographic images digitally through com-puters. Using an IBM Model 360-44, Dr. Lesem calculated the pattern in which a laser's light waves would be scattered if they actually struck the simulated object. A computer-controlled laser interference system is then used to create this pattern on plates or film. The resulting image is called a *kinoform*.

"When they learn to perfect this system," said Dr. Jacobson, "you'll be able to make holograms as abstract as you can with con-ventional cinema. You could have a three-dimensional computer-generated holographic movie of the Stargate Corridor in *2001*. I don't think that's any further off than any of these other things. In fact it's probably closer. We might even be able to do it now."

Moreover, the ability of holography to record natural phenomena that exist beyond the range of human perception—shockwaves, electrical vibrations, ultraslow-motion events—could contribute to an experience of nonordinary realities totally beyond the reach of conventional cinema or television. And the most likely mode of viewing will be the individualized frame or enclosure. "The differ-ence between the window frame and the movie frame," observes Dr. Wuerker, "is that you can get your face up so close that the frame disappears and all you're seeing is the illusionistic world on the other side. You're in it."

# Technoanarchy: The Open Empire

"In another moment Alice was through the glass and had jumped lightly down into the looking-glass room. The very first thing she did was to look whether there was a fire in the fireplace, and she was quite pleased to find that there was a real one, blazing away as brightly as the one she had left behind. 'So I shall be as warm here as I was in the old room,' thought Alice, 'warmer in fact, because there'll be no one to scold me away from the fire.' "

LEWIS CARROLL

John Cage tells the story of an international conference of philosophers in Hawaii on the subject of Reality. For three days Daisetz Suzuki said nothing. Finally the chairman turned to him and asked, "Dr. Suzuki, would you say this table around which we are sitting is real?" Suzuki raised his head and said yes. The chairman asked in what sense Suzuki thought the table was real. Suzuki said, "In every sense."[3] The wise thinker is a true realist; he might well have been talking about the future of cinema.

I've attempted to bring the past, present, and future of the movies together in one image so that a vast metamorphosis might be revealed. One can no longer speak of art without speaking of science and technology. It is no longer possible to discuss physical phenomena without also embracing metaphysical realities. The communications of humanity obviously are trending toward that future point at which virtually all information will be spontaneously available and copyable at the individual level; beyond that a vast transformation must occur. Today when one speaks of cinema one implies a metamorphosis in human perception.

This transformation is being realized on the personal level as well as on the global front of the industrial equation itself, where it can be realized only through the synergetic efforts of all men applying

[3] Cage, *op. cit.*, p. 35.

all disciplines. While personal films, videotapes, and light shows will continue to expand human communication on one level, organizations such as PULSA at Yale University, and the various national chapters of Experiments in Art and Technology (E.A.T.) are suffusing art, science, and the eco-system of earth itself at that point where all converge within the purview of modern technology.

Not only do computer, video, and laser technologies promise to transform our notion of reality on a conceptual level, they also reveal paradoxes in the physical world that transcend and remake our perception of that phenomenon as well. A glimpse of the future of expanded cinema might be found in such recent phenomena as the spherical mirror developed by the Los Angeles chapter of E.A.T. for the Pepsi-Cola Pavilion at Expo '70 in Osaka. Although it developed from the synergetic technologies of computer science and poly-vinyl-chloride (PVC) plastics, it is triumphantly nontechnical as an experience. It's just a mirror—a mirror that is nearly two-thirds of a sphere made of 13,000 square feet of air-inflated mirror-ized mylar one-thousandth of an inch thick. It is ninety feet in diameter and fifty-five feet high, and weighs approximately 250 pounds.

There have been other mirrorized mylar (or PVC) spherical tensile structures, notably the Pageos and Echo satellites. But they weren't constructed as mirrors per se and, of course, one could not enter them. Thus once again, as in the case of *City-Scape,* we see that humanity's most ambitious venture into the frontiers of reality —the space program—contributes to the expansion of the world of art: both are efforts to comprehend larger spectrums of experience.

Essentially a full-scale model of the pavilion mirror that later was constructed in Japan, E.A.T.'s sensuous, transcendentally surrealis-tic mirror-womb was revealed to the world in September, 1969, in a cavernous blimp hangar in Santa Ana, California. There, sustained in 210-degrees of space and anchored by 60,000 pounds of water in two circular tubes at its base, was a gateway to an open empire of experiential design information available to the artist. An astonish-ing phenomenon occurs inside this boundless space that is but one of many revelations to come in the Cybernetic Age: one is able to view actual holographic images of oneself floating in three-dimen-sional space in real time as one moves about the environment.

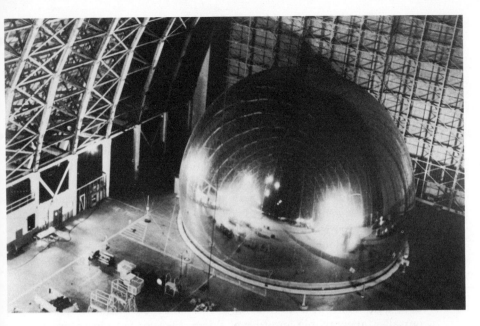

Hemispherical mirror developed by the Los Angeles Chapter of Experiments in Art and Technology for the Pepsi-Cola Pavilion at Expo '70 in Osaka, Japan. Shown in a blimp hangar at the Marine Corps Air Station, Santa Ana, California. Specifications: 13,000 square feet of mirrorized mylar 1/1000th of an inch thick, air-inflated to a 210-degree hemisphere, ninety feet in diameter and fifty-five feet high. Photo: David MacDermott.

Because the mirror is spherical no lenses or pinhole light sources are necessary: the omni-directionally-reflecting light waves intersect at an equidistant focal point, creating real images without laser light or hardware of any kind. Interfaced with perpetual fog banks and krypton laser rainbow light showers at the World Exposition, the mirror indeed "exposed" a world of expanded cinema in its widest and most profound significance.

The accelerating transformations of radical evolution often generate illusions of impending disaster: hence the overriding sense of paranoia that seems to cloud the new consciousness as we thrust toward the future. Yet surely some revelation is at hand. In 1920 W. B. Yeats (in his poem "The Second Coming") saw that things were falling apart: "The falcon cannot hear the falconer; / . . . the

centre cannot hold; / Mere anarchy is loosed upon the world, . . . / And what rough beast, its hour come round at last / Slouches towards Bethlehem to be born?"

Yeats didn't know what was coming, and thus like all of us he feared it. But in assigning Bethlehem as its birthplace he suggested that we were to be visited by a savior, however fearsome. That savior is technoanarchy and he is born out of the industry of man's ignorance, in spite of our petty copulations, in contradistinction to our minor misbehaviors. The term anarchy is defined as "a political theory . . . advocating a society based on voluntary cooperation and free association of individuals and groups . . . a utopian society having no government and made up of individuals who enjoy complete freedom." The biologist John Bleibtreu is an anarchist, then, when he speaks of ". . . a new sustaining myth which corresponds to reality . . . this new mythology which is being derived from the most painstaking research into other animals, their sensations and behavior, is an attempt to reestablish our losses—to place ourselves anew within an order of things, because faith in an order is a requirement of life."[4] Yesterday, man needed officialdom in order to survive. But technology has reversed the process: survival today depends on the emergence of a natural order. Thus we see that anarchy and order are one, because history is demonstrating that officialdom is no order at all.

Technology is the only thing that keeps man human. We are free in direct relation to the effective deployment of our technology. We are slaves in direct relation to the effectiveness of our political leadership. (Herbert Read: "Effective leadership is fascism.") The world is populated by three-and-a-half-billion human slaves, forced by the masters of politics continually to prove our right to live. The old consciousness perpetuates myths in order to preserve the union; it reforms man to suit the system. The new consciousness reforms the system to suit man. Water takes the shape of its container. We have no basis for postulating a "human nature" until there's no difference between the individual and the system. We cannot ask man to respect his environment until this difference is erased. This is anarchy: seeking a natural order. It is technoanarchy because it will be realized only through the instrumented and documented intellect that we call technology.

4 Bleibtreu, *op. cit.*, p. 8.

"As they are extended into mythologies, metaphysical systems allow mankind the means to abide with mystery. Without a mythology we must deny mystery, and with this denial we can live only at great cost to ourselves. It seems that we are in the process of creating a mythology out of the raw materials of science in much the same way that the Greeks and Jews created their mythologies out of the raw materials of history."[5]

The limits of our language mean the limits of our world. A new meaning is equivalent to a new word. A new word is the beginning of a new language. A new language is the seed of a new world. We are making a new world by making new language. We make new language to express our inarticulate conscious. Our intuitions have flown beyond the limits of our language. The poet purifies the language in order to merge sense and symbol. We are a generation of poets. We've abandoned the official world for the real world. Technology has liberated us from the need of officialdom. Unlike our fathers we trust our senses as a standard for knowing how to act. There is only one real world: that of the individual. There are as many different worlds as there are men. Only through technology is the individual free enough to know himself and thus to know his own reality. The process of art is the process of learning how to think. When man is free from the needs of marginal survival, he will remember what he was thinking before he had to prove his right to live. Ramakrishna said that given a choice between going to heaven or hearing a lecture on heaven, people would choose the lecture. That is no longer true. Through the art and technology of expanded cinema we shall create heaven right here on earth.

[5] *Ibid.*, p. xi.

# Selected Bibliography

## PRIMARY SOURCES

### A. Books

ARNHEIM, RUDOLPH. *Art and Visual Perception.* Berkeley and Los Angeles, Calif.: University of California Press, 1954.

BAZIN, ANDRÉ. *What Is Cinema?* Translated by HUGH GRAY. Berkeley and Los Angeles, Calif.: University of California Press, 1967.

BLEIBTREU, JOHN N. *The Parable of the Beast.* New York: Collier Books, 1969.

BRONOWSKI, J. *Science and Human Values.* New York: Harper & Brothers, 1965.

CAGE, JOHN. *A Year from Monday.* Middletown, Conn.: Wesleyan University Press, 1968.

CASTANADA, CARLOS. *The Teachings of Don Juan: A Yaqui Way of Knowledge.* Berkeley and Los Angeles, Calif.: University of California Press, 1968.

CHINN, HOWARD A. *Television Broadcasting.* New York: McGraw-Hill, Inc., 1953.

COLLINGWOOD, R. B. *Principles of Art.* Oxford, England: Clarendon Press, 1938.

CONZE, EDWARD. *Buddhist Wisdom Books: The Diamond Sutra, The Heart Sutra.* London: George Allen & Unwin, Ltd., 1958.

DEWEY, JOHN. *Art as Experience.* New York: Capricorn Books, 1958.

EHRENZWEIG, ANTON. *The Hidden Order of Art.* Berkeley and Los Angeles, Calif.: University of California Press, 1967.

EVANS-WENTZ, W. Y. *The Tibetan Book of the Dead.* New York: Galaxy Books, Oxford University Press, 1960.

FIEDLER, CONRAD. *On Judging Works of Visual Art.* Translated by HENRY SHAEFER-SIMMERN and FULMER MOOD. Berkeley and Los Angeles, Calif.: University of California Press, 1949.

FULLER, R. BUCKMINSTER. *Education Automation.* Carbondale, Ill.: Southern Illinois University Press, 1962.

――――. *Ideas and Integrities.* New York: Collier Books, 1969.

――――. *Operating Manual for Spaceship Earth.* Carbondale, Ill.: Southern Illinois University Press, 1969.

GOMBRICH, E. H. *Art and Illusion.* (The Bollingen Series XXXV.) New York: Pantheon Books, Inc., 1960.

HESSE, HERMANN. *Demian.* New York: Bantam Books, Inc., 1968.

――――. *The Glass Bead Game.* New York: Holt, Rinehart, and Winston Inc., 1969.

HUTCHINS, ROBERT M. *The Learning Society.* New York: Frederick A. Praeger, Inc., 1968.

KAHN, HERMAN, and WIENER, ANTHONY J. *The Year 2000.* New York: Macmillan, 1967.

KELMAN, KEN. "Anticipations of the Light," from *The New American Cinema,* ed. GREGORY BATTCOCK. New York: Dutton Paperbacks, 1967.

KLEE, PAUL. *The Thinking Eye*. London: Lund Humphries, Inc., 1961.

KRISHNAMURTI, J. *The First and Last Freedom*. Wheaton, Ill.: Quest Books, Inc., 1968.

LEE, DAVID. "A Systematic Revery from Abstraction to Now," from *Minimal Art*, ed. GREGORY BATTCOCK. New York: Dutton Paperbacks, 1968.

LILLY, JOHN C. *The Human Bio-Computer*. Miami, Fla.: Communications Research Institute, 1967.

MC HALE, JOHN. *The Future of the Future*. New York: George Braziller, Inc., 1969.

MC LUHAN, MARSHALL. *Understanding Media: The Extensions of Man*. New York: McGraw-Hill, Inc., 1965.

——— and FIORE, QUENTIN. *War and Peace in the Global Village*. New York: Bantam Books, Inc., 1968.

MILLERSON, GERALD. *The Techniques of Television Production*. New York: Hastings House, 1961.

MONDRIAN, PIET. *Plastic Art and Pure Plastic Art*. New York: Wittenborn, Schultz, Inc., 1945.

PAUWELS, LOUIS, and BERGIER, JACQUES. *The Morning of the Magicians*. New York: Avon Books, 1968.

PIERCE, J. R. *Symbols, Signals, and Noise*. New York: Harper & Brothers, 1961.

PLATO. *The Republic*. Translated by A. D. LINDSAY. New York: Dutton Paperbacks, 1957.

READ, HERBERT. *Icon and Idea*. New York: Schocken Books, 1965.

REISZ, KAREL. *The Techniques of Film Editing*. New York: Hastings House, 1968.

RENAN, SHELDON. *An Introduction to the American Underground Film*. New York: Dutton Paperbacks, 1967.

SCHON, DONALD. *Technology and Change*. New York: Delacorte Press, 1967.

SEGAL, MARSHALL H., CAMPBELL, DONALD T., and HERSKOVITS, MELVILLE J. *The Influence of Culture on Visual Perception*. Indianapolis, Ind.: Bobbs-Merrill, Inc., 1966.

SONTAG, SUSAN. *Against Interpretation*. New York: Delta Books, 1967.

TEILHARD DE CHARDIN, PIERRE. *The Phenomenon of Man*. New York: Harper & Row, Inc., 1959.

TRUFFAUT, FRANÇOIS. *Hitchcock*. New York: Simon & Schuster, Inc., 1968.

VORKAPICH, SLAVKO. "Toward True Cinema," from *Film: A Montage of Theories*, ed. RICHARD DYER MAC CANN. New York: Dutton Paperbacks, 1966.

WHORF, BENJAMIN. *Language, Thought, and Reality*. Cambridge, Mass.: M.I.T. Press, 1966.

WIENER, NORBERT. *The Human Use of Human Beings*. New York: Avon Books, 1967.

WITTGENSTEIN, LUDWIG. *Philosophical Investigations*. Oxford, England: Blackwell Press, 1963.

ZIMMER, HEINRICH. *Myths and Symbols in Indian Art and Civilization*. New York: Harper & Brothers, 1946.

# B. Articles and Periodicals

BELL, DANIEL. "Charles Fourier: Prophet of Eupsychia," *The American Scholar* (Winter, 1968–69), p. 50.

———— (ed.). "Toward the Year 2000: Work in Progress," *Daedalus* (Summer, 1967).

BLUE, JAMES. "Jean Rouch in Conversation with James Blue," *Film Comment* (Fall–Winter, 1967), pp. 84, 85.

BRAKHAGE, STAN. "Metaphors on Vision," ed. P. Adams Sitney. *Film Culture* (Fall, 1963).

BROWN, NORMAN O. "Apocalypse: The Place of Mystery in the Life of the Mind," *Harper's* (May, 1961).

BURNHAM, JACK. "Systems Esthetics," *Artforum* (September, 1968), pp. 30–35.

CALDER, RITCHIE. "The Speed of Change," *Bulletin of the Atomic Scientists* (December, 1965).

CLARKE, ARTHUR C. "The Mind of the Machine," *Playboy* (December, 1968), p. 116.

————. "Next—The Planets," *Playboy* (March, 1969), p. 100.

COPLANS, JOHN. "Serial Imagery," *Artforum* (October, 1968), pp. 34–43.

"Filming *2001: A Space Odyssey*," *The American Cinematographer* (June, 1968).

FULLER, R. BUCKMINSTER. "Planetary Planning," text of the *Jawaharlal Nehru Memorial Lecture*. New Delhi, India (November 13, 1969).

————. "The Prospect for Humanity," *Good News*, eds. EDWIN SCHLOSSBERG and LAWRENCE SUSSKIND. New York: Columbia University, 1968.

————. "The Year 2000," *Architectural Design* (February, 1967).

GORDON, THEODORE J. "The Effects of Technology on Man's Environment," *Architectural Design* (February, 1967).

KANTROWITZ, A. *Electronic Physiologic Aids*. New York: Maimonides Hospital, 1963.

KNOWLTON, KENNETH C. "Computer Animated Movies," *Cybernetic Serendipity*, a special issue of *Studio International* (September, 1968).

LAWTON, A. T., and ABROOK, G. E. "Large Scale Integration," *Science Journal* (August, 1968).

LEBEL, JEAN-JACQUES. "On the Necessity of Violation," *The Drama Review* (Fall, 1968).

LEITH, EMMETT N., and UPATNIEKS, JURIS. "Photography by Laser," *Scientific American* (June, 1965), pp. 24–35.

MALLARY, ROBERT. "Computer Sculpture: Six Levels of Cybernetics," *Artforum* (May, 1969), pp. 29–35.

MASLOW, A. H. "Eupsychia—The Good Society," *Journal of Humanistic Psychology*, No. 1 (1961).

MC HALE, JOHN. "Education for Real," *WAAS Newsletter*, World Academy of Art and Science (June, 1966).

————. "Information Explosion—Knowledge Implosion," *Good News*, eds.

EDWIN SCHLOSSBERG and LAWRENCE SUSSKIND. New York: Columbia University Press, 1968.

———. "New Symbiosis," *Architectural Design* (February, 1967).

———. "People Future," *Architectural Design* (February, 1967).

———. "The Plastic Parthenon," *Dotzero* (Spring, 1967).

NOLAND, RICHARD W. "The Apocalypse of Norman O. Brown," *The American Scholar* (Winter, 1968–69).

NOLL, A. MICHAEL. "The Digital Computer as a Creative Medium," *I.E.E.E. Spectrum* (October, 1967).

O'GRADY, GERALD. "The Preparation of Teachers of Media," *Journal of Aesthetic Education* (July, 1969).

ROSE, BARBARA. "Problems of Criticism, VI," *Artforum* (May, 1969), pp. 46–51.

ROSENBLATT, ROBERT A. "Software: The Tail Now Wags the Dog," *Los Angeles Times Outlook,* Sec. 1, p. 1 (June 29, 1969).

SCHNEEMANN, CAROLEE. "Snows," *I-Kon,* ed. SUSAN SHERMAN (March, 1968).

SCHNEIDERMAN, RON. "Researchers Using IBM 360 to Produce Animated Films," *Electronic News* (June 17, 1968).

SONTAG, SUSAN. "Film and Theatre," *Tulane Drama Review* (Fall, 1966), pp. 24–37.

SUTHERLAND, N. S. "Machines Like Men," *Science Journal* (October, 1968), pp. 44–48.

TAYLOR, W. K. "Machines That Learn," *Science Journal* (October, 1968), pp. 102–107.

THRING, M. W. "The Place of the Technologist in Modern Society," *Journal of the Royal Science Academy* (April, 1966).

TOFFLER, ALVIN. "The Future as a Way of Life," *Horizon* (Summer, 1965).

*Videa 1000 Newsletter.* New York: Videa International, Nos. 1–12 (1969).

WINKLESS, NELS, and HONORE, PAUL. "What Good Is a Baby?" From the *Proceedings of the A. F. I. P. S. 1968 Fall Joint Computer Conference.*

YALKUT, JUD. "An Interview with Frank Gillette and Ira Schneider," *East Village Other* (August 6, 1969).

## SECONDARY SOURCES

### A. Books

*Bhagavad-Gita.* Translated by SWAMI PRABHAVANANDA and CHRISTOPHER ISHERWOOD. Los Angeles, Calif.: Vedanta Press, 1944.

BRAITHWAITE, R. B. *Scientific Explanation.* New York: Harper & Brothers, 1960.

BROWN, NORMAN O. *Life Against Death.* New York: Vintage Books, 1959.

———. *Love's Body.* New York: Vintage Books, 1968.

BROWN, RONALD. *Lasers.* New York: Doubleday & Co., Inc., 1968.

CAGE, JOHN. *Silence.* Cambridge, Mass.: M.I.T. Press, 1966.

FULLER, R. BUCKMINSTER. *Nine Chains to the Moon.* Carbondale, Ill.: Southern Illinois University Press, 1966.

————. *No More Secondhand God.* Carbondale, Ill.: Southern Illinois University Press, 1967.

————. *Utopia or Oblivion.* New York: Bantam Books, Inc., 1969.

———— and MC HALE, JOHN. *World Design Science Decade (1965–1975),* Documents One through Six. Carbondale, Ill.: Southern Illinois University Press, 1963–67.

KNUTH, DONALD. *The Art of Computer Programming.* Los Angeles, Calif.: Addison & Wesley, Inc., 1968.

MC LUHAN, MARSHALL. *The Gutenberg Galaxy.* Toronto, Canada: University of Toronto Press, 1965.

————. *The Mechanical Bride.* Boston, Mass.: Beacon Press, 1951.

———— and FIORE, QUENTIN. *The Medium Is the Massage.* New York: Bantam Books, Inc., 1967.

NEBRICH, RICHARD B., JR., VORAN, GLENN I., and DESSEL, NORMAN F. *Atomic Light: Lasers—What They Are and How They Work.* New York: Sterling Publications, Inc., 1967.

READ, HERBERT. *To Hell with Culture.* New York: Schocken Books, 1963.

WIENER, NORBERT. *Cybernetics.* Cambridge, Mass.: M.I.T. Press, 1967.

## B. Articles and Periodicals

FULLER, R. BUCKMINSTER. "The Grand Strategy," *Los Angeles Free Press* (October 18, 1968).

MC HALE, JOHN. "2000 +," *Architectural Design* (February, 1967).

NOLL, A. MICHAEL. "Computers and the Visual Arts," *Design and Planning,* No. 2 (1967).

————. "Computer-Generated Three-Dimensional Movies," *Computers and Automation,* Vol. 14, No. 11 (November, 1965).

————. "Stereographic Projections by Digital Computer," *Computers and Automation,* Vol. 14, No. 5 (May, 1965).

# Index